A Mexican State
of Mind

Global Media and Race

Series Editor: Frederick Luis Aldama, The Ohio State University

Global Media and Race is a series focused on scholarly books that examine race and global media culture. Titles focus on constructions of race in media, including digital platforms, webisodes, multilingual media, mobile media, vlogs, and other social media, film, radio, and television. The series considers how race—and intersectional identities generally—is constructed in front of the camera and behind, attending to issues of representation and consumption as well as the making of racialized and antiracist media phenomena from script to production and policy.

Melissa Castillo Planas, *A Mexican State of Mind: New York City and the New Borderlands of Culture*

Monica Hanna and Rebecca A. Sheehan, eds., *Border Cinema: Reimagining Identity through Aesthetics*

A Mexican State of Mind

New York City and the New Borderlands of Culture

MELISSA CASTILLO PLANAS

Rutgers University Press

New Brunswick, Camden, and Newark, New Jersey, and London

Library of Congress Cataloging-in-Publication Data

Names: Planas, Melissa Castillo, 1984- author.
Title: A Mexican state of mind : New York City and the new borderlands of
 culture / Melissa Castillo Planas.
Description: New Brunswick : Rutgers University Press, [2020] |
 Includes bibliographical references and index.
Identifiers: LCCN 2019018783 | ISBN 9781978802278 (pbk.) |
 ISBN 9781978802285 (hardback)
Subjects: LCSH: Mexican Americans—New York (State)—New York. | Arts,
 Mexican—New York (State)—New York. | Popular culture—New York
 (State)—New York—Mexican influences. | United
 States—Civilization—Mexican influences. | New York
 (N.Y.)—Civilization.
Classification: LCC F128.9.M5 P55 2020 | DDC 974.700468/72—dc23
LC record available at https://lccn.loc.gov/2019018783

A British Cataloging-in-Publication record for this book is available from the British Library.

♾ The paper used in this publication meets the requirements of the American National
Standard for Information Sciences—Permanence of Paper for Printed Library Materials,
ANSI Z39.48-1992.

www.rutgersuniversitypress.org

Manufactured in the United States of America

Para todos aquellos que sueñan más allá de las fronteras
que ven las murallas como lienzos
como conversaciones y canciones
cultura y comunidad . . .

Para esa comunidad que siempre me ha aceptado e inspirado
con la creatividad de esos sueños . . .

Este libro es nuestra ciudad
La ciudad que soñaste
La ciudad que creaste
Nuestro Nueva York—
Gracias para siempre.

El sueño americano no es como se cree
hay humillación y injusticia mucha malicia
sólo un por ciento que se ve en noticias
quería que el mundo supiera mi verdad
quería que vieran la realidad.
—Raúl "Meck" Hernández, MC
Queens, New York

Contents

Contents

Preface

A Mexican *State* of *Mind* and Migrant Creativity

I had been working at the Orchard Restaurant for a few months in the summer of 2010 before I would have a real conversation with Raul Hernández, then twenty-nine, the bartender from our sister restaurant two blocks away. Raul would walk over to the Orchard, an Italian restaurant on the Lower East Side of New York City, to stock the bar at the smaller Apizz Restaurant, which lacked storage space.[1] One night after work, I stopped by at the invite of the manager, Diego, a Mexican immigrant from Mexico City, for a drink and a bite. As Raul expertly prepared one of the restaurant's signature cocktails and delivered a delicious prosciutto flatbread, the conversation meandered into music.

"Do you like hip-hop?" Raul asked.

"Sure," I said. In reality, I did not.

Growing up Mexican American in upstate New York, hip-hop was not part of my culture. And while the sounds of 1990s gangsta rap, followed by the commercial rap of the 2000s, played in the background, it was not a music that I identified with or sought out. Hip-hop was masculine and black and did not relate to my experience, and reggaetón was machista and sexist and often made me uncomfortable as a young Latina. I preferred "Latin Alternative," a genre whose very premise was nonconformity to a specific musical style or tradition, with a blend of rock, salsa, pop, electronica, cumbia, and anything else (including rap) that resonated with my hyphenated existence. Nevertheless, I went along with the conversation as Raul revealed to me that he was an MC and member of the trio Hispanos Causando Pániko. More

than that, the conversation highlighted an articulate young man who was especially knowledgeable about hip-hop's past and present, as well as musical and technical aspects of the genre.

"Do you want to hear a song?" he asked after the last customers trickled out.

As he played me a track, I found myself surprised by the classic sound and style of golden-era New York rap as well as the lyrical and sonic rejection of reggaetón. It had never occurred to me that amid the soundscapes of Caribbean Latinx and African American New York was an emerging Mexican migrant-conscious hip-hop voice:

Esto es lo que es holmes,	This is what it is holmes,
Yo no hago reggaetón	I don't do reggaeton
Solo hago hip hop en español de corazón	I only do Hip Hop in Spanish from the heart
Soy como como un cardiólogo con el diálogo	I'm like a cardiologist with my words
Porque todo lo que digo yo digo de corazón.	Because everything I say I say from the heart.
Recito mi canción como una oración	I recite my song like a prayer
Recibo una ovación	I receive an ovation
Soy un mexicano de corazón.	I'm a Mexican from the heart.[2]

What I heard was a Spanish language rap that wove together Spanglish chicanismos like "holmes" with a clear connection between a devotion to hip-hop and national pride. Moreover, I was surprised that this professional, lyrically expressive, sonically tight song was produced by the man who had earlier served me a drink. Not because I looked down on restaurant work—that was a major part of my life for twelve years while I was an undergraduate, masters, and doctoral student to the extent that I even considered a career in hospitality. Rather, I realized that even as a Mexican American in New York City who worked with undocumented Mexicans every weekend, I never thought of them as imaginative people with creative aspirations. While the mainly white fellow managers, waiters, bartenders (in this way Apizz was notably different), and guests often asked me to my annoyance whether I was an aspiring "actor, dancer, or model," the back of the house, largely staffed by black and brown immigrants, was never afforded this type of consideration.

I never afforded them this type of consideration.

Over the next eight years, Raul (fig. 1) would become a confidant, a collaborator, and the first person to be interviewed for this project in the spring of 2011—when I did not even know it was a project, but rather a class paper that had nothing to do with the doctoral studies at Yale to which I had recently been accepted. Blending stories about the Mexican community in Queens,

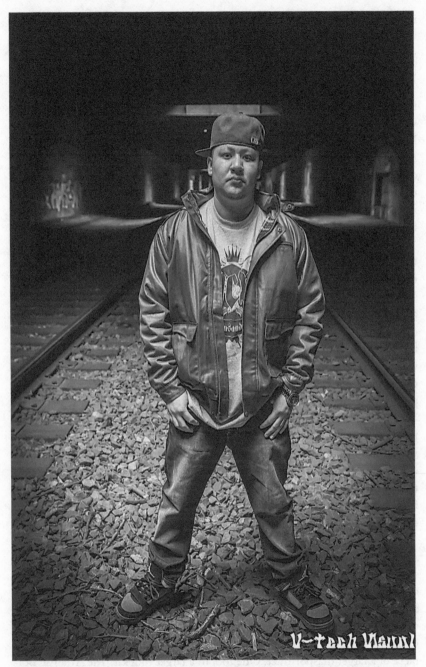

FIG. 1 Raul "Meck" Hernández in a promotional photograph for his hip-hop group,
Hispanos Causando Pániko. (Source: Raul Hernández)

immigration issues, and daily economic struggles in the city, with straightforward beats that never overshadowed the lyrical narrative, the music spoke to me in a different way. Until Hispanos Causando Pániko, I never thought that hip-hop could also be mine.

Raul, like the other young Mexican men and women who now breathe life into these pages, taught me so much, not just about hip-hop but about the ways in which Mexicans are viewed and approached, even by liberal-minded Mexican American scholars like me. They opened my eyes to a vibrant, young, Mexican, largely undocumented migrant community dedicated to creative expression in music and art, particularly the hip-hop arts, as a critical part of their New York City experience. Their stories revealed the ways Mexicans are not seen as creative peoples in New York City today and the implications of these narrow perspectives on conceptions of Mexicanidad.

A Mexican State of Mind: New York City and the New Borderlands of Culture is about Mexican migrant creativity in New York City since 9/11, and how that creativity is produced, developed, and shared within the context of a system of racial capitalism that marginalizes Mexican migrants via an exploitative labor market, criminalizing immigration policy, and racialized systems of surveillance. I explore these youth cultural productions, largely based in the hip-hop arts, and their relationship to labor through two lenses. The first is with the concept of containment. Explored through the image of the shipping container that gave rise to new levels of global trade and U.S. economic and political ascendancy in the 1990s, containment is concerned with structural and systemic forms of migrant control. The second, the Atlantic Borderlands, is a theoretical framework that places the realities of migrant containment within a longer history and consideration of Afro-diasporic experiences of constraint and exploitation. It posits New York City as a new borderlands metropolis composed of varied Afro-diasporic spaces in which Mexicans now find themselves and emphasizes the confluence between Latinx and African diasporic laboring subjects and their resistant cultural productions.

In the spirit of Gloria Anzaldúa's landmark *Borderlands / La Frontera: The New Mestiza*, the Atlantic Borderlands is inflected with a localized sense of space. At the same time, New York City is influenced by the national context of conflict and contestation at the physical U.S.-Mexico borderlands as well as a long history of U.S.-Mexican border experiences. Following the roots and routes perspective of Paul Gilroy's *The Black Atlantic: Modernity and Double Consciousness*, I argue that in Mexican New York, transnationalism is just one piece of a larger diasporic act. One tool in a larger tool kit. The Atlantic Borderlands helps rethink Mexican migrants in New York as part of a larger Mexican diaspora—as part of a living dialogue made up of multiple physical, imaginative, and cultural paths between diverse points in Mexico and the United States, as well as today's Afro-diasporic globalized hip-hop world.

I delve further into these theoretical considerations and the methodological considerations in the introduction.

Nevertheless, despite these theoretical underpinnings, this book developed out of *communidad*. I never planned to write this book; rather, while researching another project, I found refuge from an elite doctoral world in a proudly Mexican and welcoming creative one. As Raul introduced me to MCs, DJs, and *graffiteros*, I found myself regularly attending Har'd Life Ink and later Buendia BK shows. I became a fan of this music that I found profoundly connected to my own poetic work and was a source of inspiration for my first collection of poetry, *Coatlicue Eats the Apple*. Likewise, when I or any of my friends wanted an original high-quality tattoo, it was Sarck or Pisket (artists introduced to me by Raul) to whom I turned. As my community of Mexican artists grew, so did my knowledge of their networks and diverse projects. Still, although I wrote smaller articles and chapter-length pieces "on the side," the project did not formalize as a book project until years of engagement had passed.

Around the summer of 2014, I realized that the numerous interviews, observations, and photographs, as well as the music, I had gathered were in fact an important and unique archive. As I continued to spend time in these communities, at hip-hop and art shows, in homes and places of business, I found myself inspired by the creative output as well as the context from which these artistic communities have emerged. I came to acknowledge that these were stories that needed to be told and that I had the unique opportunity and responsibility to be that facilitator. I say facilitator because as this project developed I came to see this book as an act of collaboration with the men and women who had become my friends. Significantly, because this project developed organically, its direction was also guided by that community apart from any academic or research interests.

When Donald Trump became a candidate for president in the fall of 2015, delineating his candidacy by calling Mexican migrants murderers and rapists, this desire to speak to the creative and imaginative worlds of Mexican migrants in many ways became more imperative. This was not just because of the vitriolic "alternative facts" that further exacerbate the severe challenges of being an undocumented Mexican in New York, but also because the liberal backlash to these racist comments overshadowed a long history of anti-Mexican sentiment, immigration, and anti-terrorist legislation and policies (including under President Barack Obama), as well as racialized policing tactics that have affected this community since September 11, 2001. I also wanted to highlight the ways creativity is racialized as well as critique a whitewashed definition of art that excludes both hip-hop and working-class Mexicanidad.

In these pages you will find a new version of global Mexicanidad that is not rural nor solely focused on labor or immigration statistics. Rather, I present a vision of a Mexican community as young, edgy, creative actors for whom

hip-hop serves as a connection to both New York and their Mexican culture. Although the people I write about are quite distinct, they all speak to the significance of creativity in the communities they are making. Whether in service to a hemispheric feminist politics, an individual form of self-expression to cope with depression and substance abuse, or a community-building form of economic liberation, these young men and women narrate a path that imagines a radical new world of Mexican migrant self-acceptance.

These are their stories.

Note on the Text

In this book, I use the term "migrant" to describe those who cross national borders both legally and illegally. As Nicholas De Genova has highlighted, the terms "immigrant" and "immigration" "imply a one-directional and predetermined movement of outsiders coming in and thus are conceptual categories that necessarily can be posited only from the standpoint of the (migrant-receiving) U.S. nation-state" (*Working the Boundaries* 2). "Migrant" and "migration," on the other hand, refer to the movement of people from one place to another, encompassing both emigration (outward movement) and immigration (incoming movement) (Allatson 162); and as such, "migrant" is a term that more accurately describes Mexican movement in the United States, both historically and in the present day. While I refer to specific U.S. immigration law, policy, or politics as well as writing and statements around illegality, I rely on the category of migrant and systematically reject the term "immigrant" in order to retain a sense of the movement, intrinsic mobility, and indeterminacy surrounding the social processes of migration as well as the shifting meanings of the borderlands.

Nevertheless, as a number of my collaborators on this book lack a status as legally defined by the United States government, many will be referred to only by their stage names, graffiti writer names, or other pseudonyms used in their artistic or activist practice. The inclusion of their birth names was one solely based on individual preference and comfort. Last, as writing of this book project has extended long past the original conversations, the ages I provide reflect the age at last interview unless otherwise specified. I do this as to properly reflect the period of time in the interviewee's life and artistic development.

**A Mexican State
of Mind**

Introduction

■■■■■■■■■■■■■■■■■■■■■■■■

Mexican Manzana and
the Next Great Migration

Todos los grafiteros sabemos que el graffiti nació en Nueva York. Entonces como decir, ok si allí nació vamos a ver que hay allí. . . . Yo lo hacía más como oh voy a pintar a Nueva York y todo va a ser nice, tú sabes, cuando tú tienes 17, 18, quieres conocer el mundo. . . . Yo creo que todo mexicano aquí tiene una aventura no? Y yo también. Pasamos por algo duro porque yo no venía como para trabajar y hacer mi vida acá. Siempre lo vi como que sólo vine a pintar, a hacer lo que a mí me gusta. (Sorick, twenty-four, personal interview, 2 Nov. 2013)

These aren't people. These are animals. (President Donald Trump referring to undocumented migrants, May 2018 [Korte and Gomez])

I was able to get back up through music, writing. That's when I dedicated myself to Hip Hop. (JC Romero, twenty-seven, personal interview, 14 Nov. 2018)

Xochitl Ramírez López (fig. 2), twenty-five, is not your stereotypical Mexican migrant woman. Dressed in combat pants, white sneakers, a black hoody, and a black beanie, she is quiet and shy sitting across from me at Sunset Diner, in Sunset Park, a neighborhood that has become a major center of the Mexican community in Brooklyn. Feminized by long, flowing black hair and large silver hoop earrings, she describes how she migrated to New York from Mexico City, alone and pregnant at just nineteen. Although Mexicans are known for migrating to New York City to work and to improve the lives of themselves and their

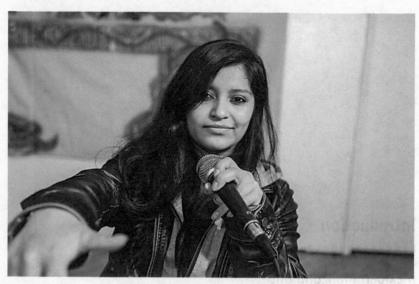

FIG. 2 MC Rhapy of Buendia BK, 2013. (Photo: Daniel "Solace" Aguilar)

families, such was not the case for Xochitl. As she describes her situation, "Muchos dicen que vienen por buscar mejor vida. A mí, realmente me atrayó no tener lo mismo. Quise ver otras cosas" (personal interview, 11 Nov. 2013).[1] Not only did she want to see something new—she wanted to see it in New York City. For Xochitl, who dropped out of high school and found herself living at home unemployed, her migration to New York City was deliberate. "No quería otro lugar. Siempre he estado en una ciudad. Entonces dije, me voy para allá" (personal interview, 17 Nov. 2013).[2] In particular, Xochitl, whose rapper stage name is Rhapy, was attracted to New York City because of its hip-hop history and her desire to be a part of that tradition. Young, independent, and adventurous, Xochitl represents a new kind of Mexican migrant and Mexican state of mind that is increasingly finding their home in New York City.

A Mexican State of Mind is about Rhapy and other young Mexican migrants' creative lives in New York City after September 11, 2001. In addition to introducing Mexican cultural productions outside the traditional Southwest—U.S.-Mexico border or California context—this book marks a period when Mexicans start to become a significant population in New York City. Between 1990 and 2011, for example, the Mexican population increased 443 percent from 61,722 to 335,592 according to the New York City Department of City Planning to the third-largest immigrant group (following Dominicans and Chinese). Due to the large undercount of undocumented Mexican migrants, however, these estimates range to 600,000, a demographic size developed by the Latino Data Project at the Center for Latin American Studies at the City University of New York's Graduate Center (Oliveira 7).[3] Significantly, this has made

New York City one of the top fifteen cities in the concentration of Mexicans in the United States, joining cities in Texas and California (Badillo, "Urban Historical Portrait"). At the same time, the aftermath of 9/11 in terms of anti-immigrant sentiment and increased security and surveillance of bodies of color specifically shaped the experiences of the young men and women in this study, who have found themselves to be increasingly racialized and criminalized over the past eighteen years. Nevertheless, rather than investigating anti-immigrant policies or looking only at traditional forms of labor insertion, this book takes the backdrop of illegality and labor in order to emphasize other aspects of their New York City experience, specifically the artistic, innovative, and imaginative ways Mexican migrants fill their lives. More than hobbies, music and art represent the ways in which Mexicans in NYC articulate their sense of culture, fulfill their need for creative expression, and protest a status quo built on daily migrant marginalization based on real or perceived documentation status and racialized systems of employment and criminal justice. In addition, by highlighting creativity over employment, the arts over immigration status, this book sheds light on the way Mexicans, especially undocumented migrants, are not often seen as creative people. While academic studies and mainstream media alike emphasize issues relating to border crossing and illegal employment, my questions revolve around artistic inspiration and creative work, which may or may not also become a form of employment. This is especially significant in a New York City Mexican context. Even though Mexicans are seen as the representative problematic racialized immigrant in both a current and long-standing climate of anti-immigrant sentiment, they are often seen as out of place in New York City. Despite its status as the multicultural capital of the world, and the historic immigrant gateway via Ellis Island, in New York, Mexicans are still seen as insignificant newcomers, if they are seen at all. However, at over 600,000, Mexicans are in fact quickly closing in on New York's other Latinx populations (Oliveira 7), which stand slightly over 700,000 a piece according to the Latino Data Project (Bergad, *Have Dominicans*).

My research is supported by a small but growing body of scholarship on Mexican New York that highlights the transnational practices of Mexican migrants like Rhapy.[4] However, unlike previous studies, my research is based on cultural production, specifically that of youth culture. As Jocelyn Solís argues, youthful experiences do much more than form the backdrop of their cultural expressions; indeed, they serve as the backbone of their perspectives. For Mexican youth in New York, illegality does not just make life difficult but is "a form of state violence that bears upon the formation of undocumented Mexican Migrants" (Solís, "Re-thinking Illegality" 15). When faced with the onslaught of discourses that classify Mexicans as "illegal," "criminal," "disposable" laboring bodies, the task for migrants becomes how to contest those discourses from the margins. According to Solís, "The challenge for undocumented

immigrants, therefore, is how to reclaim their identity as undocumented immigrants without invoking its meanings already established by structures of power and without provoking action to be taken against them" ("Immigration Status and Identity" 338). On a community level, for members of the art and hip-hop collectives I investigate, such as Har'd Life Ink, Buendia BK, The Practice of Everyday Life, and Hispanos Causando Pániko, the answer comes in forming alternative structures outside of those institutions that name them as undesirable. These alternative spaces are important not only in terms of artistic creation and identity formation, but also because on the most basic level they act as safe havens in a city that has come under increasing surveillance for people (especially men) of color.[5]

As such, this book makes several contributions to the field of Mexican/Chicanx/Latinx studies. In addition to centering New York City as a major space of Mexican culture and Mexican creativity that is also significant to New York Latinidad, this study brings African American studies into a larger conversation with Mexican and borderlands studies. This is done with the two lenses through which I investigate these youth cultural productions, largely based in the hip-hop arts and their relationship to labor.

The first is through the concept of containment, which connects the traditional area of Mexican studies, the borderlands, to New York. Inspired by the image of the shipping container, which gave rise to new levels of global trade and U.S. economic and political ascendancy in the 1990s, containment is a metaphor for the structural and systemic forms of migrant control as well as the failures of U.S. policy in Mexico, such as the North American Free Trade Agreement (NAFTA). While the U.S. public and body politic has engaged in a sustained and divisive debate over immigration over the past decades, it is one that does not often recognize the role of U.S. economic policy, particularly NAFTA, in that debate.[6] Specifically, as the journalist David Bacon has explored for over a decade, the passage of NAFTA in 1994 accelerated a neoliberal[7] form of economic growth in Mexico that drove poor farmers, particularly in the indigenous south, to lose their farms and their livelihoods. In response, young men, and increasingly young women, made the dangerous trek to the United States in search of work and an income to feed their families and keep their families from losing their farms. I also see NAFTA as marking an important shift in the current situation of Mexican migrants moving into new areas of settlement such as New York City. As Alyshia Gálvez has highlighted in Eating NAFTA, at the same time that the results of NAFTA are expelling "surplus people,"[8] many of them to New York, few pathways to authorized migration have been available to Mexicans (167). This marginalized status would be reinforced after 9/11 due to the rise of the war on terror through increased militarization of both the border and New York City, particularly the New York Police Department (NYPD).

Here, the image of "La Bestia" (the Beast) haunts. Owned and run by a Mexican wholly owned subsidiary of Kansas City Southern, the U.S. train company acquired the Mexican equipment and routes in 2005 to create a "NAFTA Railroad" intended to fit into a multimodal transportation technology so Chinese companies could deliver products into the heartland of the United States as an alternative to utilizing the West Coast ports of Los Angeles and Long Beach (Corsi). While "La Bestia" is most often associated with Central American migrants, preyed upon and intermittently supported by local Mexicans, in U.S. popular imagination it has been the single most reported method for crossing the length of Mexico to the United States before the 2018 caravans.

The second concept, the Atlantic Borderlands, offers a theoretical framework that places the realities of migrant containment within a longer history and consideration of Afro-diasporic experiences of constraint and exploitation. It posits New York City as a new borderlands metropolis composed of varied Afro-diasporic spaces in which Mexicans now find themselves and emphasizes the confluence between Latinx and African diasporic subjects and their resistant cultural productions. In the spirit of Gloria Anzaldúa's landmark *Borderlands/La Frontera: The New Mestiza*, the Atlantic Borderlands is inflected with a localized sense of space. Mexican migrant experience is unique to the Big Apple owing to multiple factors about the city, including its unmatched diversity,[9] its significance as an economic and artistic capital, the tremendous growth of Mexican migration in a short period of time, and the relative dearth of Mexican social or political capital as opposed to more traditional areas of migration. New York City is nevertheless also influenced by the national context of conflict and contestation at the physical U.S.-Mexico borderlands as well as a long history of U.S.-Mexican border experiences. Through the Atlantic Borderlands, I draw wider connections between U.S. policy influenced by NAFTA and migrant creative lives in New York as periodized by 9/11, alongside systems of racial capitalism and racialized criminalization often applied to African American and Afro-diasporic populations. Here, the concept of "racial capitalism" rejects treatments of race as peripheral to a purely economic project and counters the idea that racism is an externality, or aberration from the workings and structures of capitalism. Moreover, for the legal scholar Nancy Leong, racial capitalism is not just a system of economic injustice or marginalization but also a measure of value. According to Leong, racial capitalism is "the way that white people and predominately white institutions derive value from nonwhiteness" (2154). In other words, racial capitalism captures the way nonwhiteness is commodified and monetized whether as laboring bodies or as the goods produced from that labor and circulated in shipping containers around the world. Of course, the practice "of using nonwhiteness as a justification for the commodification of nonwhite individuals is older than America itself," as the history of slavery brutally demonstrates (Leong 2155).

These two lenses shine an important spotlight on the lived experiences of Mexican migrants within a neoliberal immigrant city when faced with a racial status quo that reduces them to faceless, nameless laboring bodies. These lived experiences are wildly creative but also represent various forms of political subjectivity and discursive expression. Whether their ingenuity and expression of culture come from their lives as artists or restaurant workers, overt political organization, or informal ephemeral expressions, this diversity of discursive styles represents an important statement in the face of political, media, and popular representations of Mexicans. This view of Mexicans as newcomers and oddities is key to understanding the context of their engagement around labor and art. Nevertheless, despite the perception that Mexicans do not live in New York, they are and have been an important and growing population for the past two decades.

Mexican New York: A New Nueva York

New York City is one of the most iconic immigrant cities, and yet, it is a city that is rarely seen in relation to this country's most iconic immigrant group, Mexicans. As the sociologist Robert Smith points out, Mexican newness is simultaneously somewhat real and a product of ignorance: "Mexicans in New York City are still and again the new ethnic group on the block. I say 'still and again' because the Mexican population in the city—despite its large size and steady growth for the last two decades—continues to be thought of as new, and New Yorkers often continue to be surprised by this remarkable growth" ("Mexicans: Civic Engagement" 246). As a result, they are also a group that has been largely understudied. Yet between 1990 and 2010, Mexicans were the fastest-growing immigrant group in New York City (Bergad, *Latino Population of New York City*). The first scholar to focus on this community, Robert Smith, outlines three stages of Mexican migration in New York, beginning in the 1940s–1980s, with a time in which there was only a small but tight-knit network of Mexicans, to the third stage in the late 1980s when New York City saw an explosion of Mexicans, mostly from the state of Puebla in south-central Mexico. A number of these immigrants could gain amnesty and eventually become eligible for permanent resident status through the 1986 Immigration Reform and Control Act (Smith, *Mexican New York* 22), allowing for many of the transnational links Smith and others have documented, such as frequent visits to Mexico and involvement in hometown politics. This anchored the city as a prominent destination for Mexican migration to the northeastern United States.

Since Smith's writing, New York City has witnessed a fourth flow of Mexican migrants from increasingly diverse areas of origin, most notably Mexico City and its surrounding areas (Risomena and Massey 9–10). As Risomena and

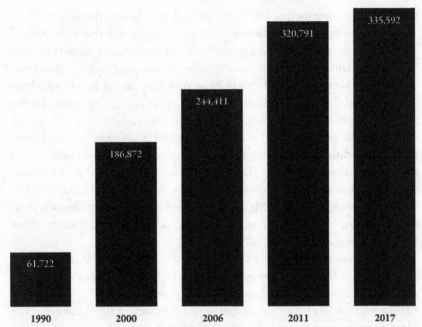

FIG. 3 Mexican population in New York City, 2017. (Source: New York City Department of City Planning)

Massey have outlined, in recent years, the spatial distribution of Mexican migrant sending regions has also shifted away from its traditional heartland in the central-west region (the states of Durango, Zacatecas, San Luis Potosí, Aguascalientes, Guanajuato, Jalisco, Nayarit, Colima, and Michoacán), which from the 1920s until recently had composed at least 50 percent of the total outflow to the United States but has now declined to just below 40 percent. Until the mid-1990s, the second most important sending region was the border region (20–28 percent), which includes the states of Baja California, Baja California Sur, Sonora, Sinaloa, Chihuahua, Coahuila, Nuevo León, and Tamaulipas. However, after the mid-1990s this share fell below 20 percent and then dipped to 11 percent by 2000 as the region came to house the most rapidly growing sector of the Mexican economy and now attracts many internal migrants. As a result, two new sending regions have become critical: the central region (Querétaro, Distrito Federal, Hidalgo, Tlaxcala, Morelos, Puebla, Guerrero, and Oaxaca) and the southeastern region (Veracruz, Tabasco, Chiapas, Campeche, Quintana Roo, and Yucatán). The central region, where Rhapy is from, was relatively unimportant until 1980, accounting for no more than 10 percent of migrants to the United States. However, in the past decades, that number rose steadily to reach just over 30 percent by century's end. At the same time, Mexico's southeastern region remained insignificant as a migration source

until recently, contributing less than 2 percent of migrants through the early 1990s. By the end of the millennium, migrants from this region composed 7 percent of the total, and more recently, this figure has gone up to 13 percent (9–10). In terms of New York more specifically, the geographic region from which most Mexican immigrants in New York City (about two-thirds) have come is called the Mixteca, a zone that includes the contiguous parts of three states: southern Puebla, northern Oaxaca, and eastern Guerrero. The second most common place of origin is Mexico City and the state of Mexico (about 11 percent), while the remaining migrants come from a variety of other places in Mexico, including Tlaxcala, Tabasco, and even Chiapas (Smith, "Mexicans: Civic Engagement" 247). Of the more than two dozen youths I interviewed in this study,[10] many came from Mexico City as well as the states of Tlaxcala, Veracruz, Morelos, Guadalajara, Puebla, and Baja California in addition to those born and raised in New York City.

Between 1990 and 2010, the city's population of Mexicans increased from one estimate as low as 56,000 to over 300,000, representing over a 400 percent population growth (see fig. 3) as opposed to 9 percent growth of the overall city population (Badillo, "Urban Historical Portrait" 107).[11] As of 2014, the Mexican-origin population is New York City's fastest-growing Latinx national group, representing 15 percent of an increasingly diverse Latinx community of more than 2.5 million (29 percent of the NYC population). Here, Mexicans migrate to a global Latinx city already composed of significant numbers of Puerto Ricans (719,444), Dominicans (747,473), Ecuadorians (211,131), and Colombians (98,807), among other nationalities (388,996), according to the 2013 American Community Survey (Bergad, *Have Dominicans* 60). If the larger metropolitan area is considered, the Mexican population almost doubles to over 600,000 (Bergad, *Mexicans in New York* 48). Moreover, the accuracy of these numbers is difficult to determine, because the majority of the population is not only foreign-born (56 percent) but also undocumented (57 percent). As Bergad concludes, "After 1990, over 260,000 foreign-born Mexicans arrived in the tristate area according to the 2010 PUMS census data, and this may very well be an undercount, which does not include many undocumented persons. From available statistical sources, it is impossible to determine the number of Mexicans living in the region who may have been omitted from the official census count of 2010" (*Demographic, Economic and Social Transformations* 49). The Mexican Consulate in New York, for example, estimates that there are approximately 1.2 million Mexicans in the region, a number twice the size of official data (Semple, "Immigrant in Run" A018).[12] Nevertheless, despite this likely undercount, even official counts project the Mexican population to become the largest Latinx national subgroup in the region sometime in the early 2020s (Bergad, *Mexicans in New York* 69).[13] This last phase of migration, as represented by youth like Xochitl and Sorick, which is much more

varied in terms of regions of origin, has added great diversity to both Mexican expression and experiences that thus far have not been studied. At the oldest, these families represent three generations of life in New York, while others have only a couple of years in the country.

Upon arrival, Mexicans concentrate in Brooklyn, Queens, and the Bronx (see figs. 4 and 5), where they face harsh housing and work conditions. Mexican immigrant households are more likely to experience overcrowding and to spend more than half their income on rent than those of any other immigrant group or the native-born population. As Kirk Semple of the *New York Times* described one building in Bensonhurst, Brooklyn: "A dozen of the building's 16 apartments are occupied by Mexicans, and most of those have two families per unit, sometimes more. Except for a few women caring for small children, all the adults—about 50—are employed. Most work long hours, six days a week, for minimum wage or less. Some have two jobs. The building is a microcosm of Mexican industriousness in New York City. And there are hundreds of others like it, bastions of low-wage work, crowding and hope" ("Immigrants Face"). Mexicans have to be industrious in New York City because they also have among the lowest household incomes and education rates, due to the large number of new migrants, many of whom arrive as teenagers or as young adults and so did not or do not complete high school (Bergad, *Latino Population*, 29–38).[14] Because of higher birth rates, and despite the fact that the migration to the New York City metropolitan region was composed mainly of adults, Mexicans represent the youngest population of any of the major Latinx nationalities, with an average age of twenty-five. Yet, despite their formal educational limitations, these conditions also foster a Mexican youth culture that is multicultural and transnationally tech-savvy (Bergad, *Mexicans in New York* 19–20). Thus, despite the challenges Mexican migrants and their children face, New York is home to an increasingly diverse young Mexican population that is largely male (60 percent) and yearning for creative outlets to add meaning and create community beyond their often-limited work options (Bergad, *Demographic, Economic and Social Transformations* 69).

Still, in an era where all migrants face limited work options, Mexicans are adept at finding and keeping work. Of the city's ten largest immigrant groups, they have the highest rate of employment and are more likely to hold a job than New York's native-born population, according to an analysis of census data (Bergad, *Demographic, Economic and Social Transformations* 53–56). They are even employed at a greater rate than Mexicans nationwide. Although some may take this as a sign of Mexican "industriousness" (Semple, "Amid Joblessness"), it also points to the marginalized status and desperation of their situations.

If anything, the situation for Mexican migrants in New York City has only become more dire as the decades have passed. Although economic factors in the 1980s and 1990s fueled the dramatic increase of Mexican migration to New

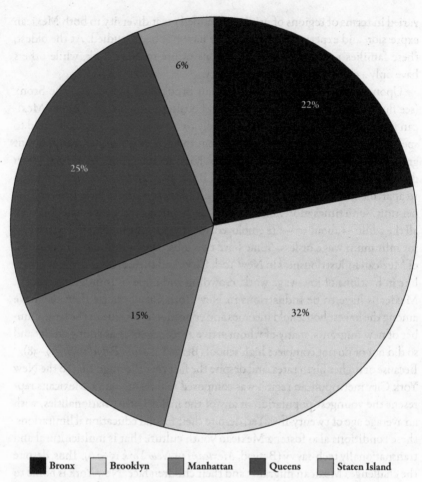

FIG. 4 Percentage of Mexicans Residing in New York City by borough, 2017. (Source: Melissa Castillo Planas)

York, especially for the first groups from Puebla, many of those earlier migrants could apply for temporary, then permanent, residency under the 1986 Immigration Reform and Control Act amnesty, and later sponsor the immigration of family members living in Mexico. Not surprisingly, this led to a substantial increase in the migration of Mexican children to New York during the 1990s. These options are no longer available to newer migrants, nor are traditional transnational migratory links. Before the 1990s, for every one hundred undocumented Mexican immigrants who came into the United States, an estimated eighty-five went back in any given year (Massey, Durand, and Malone; Massey, *New Faces*). This ratio fell as the border became harder, more dangerous, and more expensive to cross—changes that occurred during the same time period as Mexican migration flowed into New York City. As labor activist, hip-hop

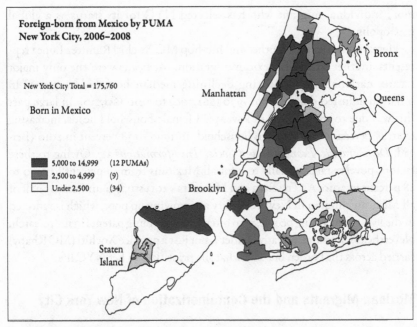

FIG. 5 Geographic dispersion of Mexicans in New York City by borough, 2006–2008. (Source: New York City Department of City Planning)

artist, and danza practitioner JC Romero described, "Back in '91 when my father crossed he told me it was just like a walk of like twenty minutes, a tunnel and you were good. But most recently my brother and my mother crossed and they told me it was like hell. It was like about three days of walking" (personal interview, 22 Sept. 2011).

Moreover, congressional reforms made the attempt to retain physical connections with Mexico even more challenging. For example, Congress instituted a ten-year ban on admission for any person who spent more than a year in the United States undocumented, a condition that would not be protected by marriage to a U.S. citizen or birth of children in the United States. Instead, U.S. citizen children were deported to Mexico alongside their parents, as the standard for suspending deportation increased from hardship to "exceptional and extremely unusual hardship" (Smith, "Mexicans" 248–249). Thus, isolated from both their home country and their families due to tightening borders and increased migrant surveillance, young Mexican migrants were forced to develop new strategies for survival, including the contemporary forms of cultural expression I focus on in this book. Thus, New York City simultaneously demonstrates features of both a traditional and a new phase of migration. At the same time a home to more traditional migrant enclaves like the one from Puebla that Robert Smith examines, another kind of migration has emerged, that of the

more individual migrant who has selected NYC for its status as a global metropolis.

Here, single Mexican mother and hip-hop MC Xochitl Ramírez López represents another trend of Mexican migration. Mexicans were the only major Latinx nationality experiencing declining median household incomes in inflation-adjusted dollars from 1990 ($62,700) to 2010 ($51,250). In large part this was due to the increase in lower-paid female household heads, increasing from 25 percent of all Mexican households in 1990 to 38 percent in 2010 (Bergad, *Demographic, Economic, and Social Transformations* 32). Owing to these factors, poverty rates actually rose for all Mexicans from 19 percent in 1990 to 28 percent in 2010. As Treschan and Mehrotra's 2013 study found, nearly half of all Mexican children in New York City are growing up poor, which is reflected in the lives of the young people, who often become young parents in my research. Nevertheless, music as a creative outlet is not just a practice Xochitl (MC Rhapy) carried across the border, but also what she prioritizes in her NYC life.

Mexican Migrants and the Containerization of New York City

> So, here's what I'm gonna do if I'm president. I'm gonna ask Fred Smith, the founder of FedEx, to come work for the governor for three months. Just come for three months to Immigration and Customs Enforcement and show these people. . . . We need to have a system that tracks you from the moment you come in. . . . And then when your time is up . . . then we go get you. Tap you on the shoulder and say, "excuse me, thanks for coming, time to go." (2016 Republican presidential hopeful and New Jersey governor Chris Christie, who later endorsed Donald Trump [Levine])

A major reason why Mexicans in New York have faced a harsher existence politically, socially, and economically over the past two decades is because of increased policing after 9/11. In many ways, the smoke and mirrors around Donald Trump's presidency overshadow an increasing anti-Mexican/anti-immigrant sentiment in government. The actions of three previous presidents, two of them Democratic, paved the way for Trump: Clinton with NAFTA and expedited removal of people with criminal records, Bush with the war on terror and the establishment of Homeland Security, and Obama with expedited removal of unaccompanied minors and increased deportation in general. Thus, casting Trump as a focal point in the debate about Mexican migrants obscures a much longer and pernicious history of targeted legislated attacks. News article after news article correcting Donald Trump's "alternative facts" about Mexican migration (for example, that immigration figures are actually on the decline, or that the majority of migrants are authorized) and migration more

generally fails to address the fact that anti-immigrant sentiment and policy *has never been about* reality.[15] It is also one that is historically rooted in two centuries of a racialized relationship with Mexico.[16] Both old and new, both part of a long history of racism and xenophobia directed at Mexicans, and part of a new phase of racialized control, the contemporary pressure on Mexican migrants, including those migrating to New York, is rooted, ironically, in the Democratic Party, first in Clinton's presidency and then in Barack Obama's, as well as the immigrant backlash after 9/11.[17] Still, this anti-immigrant sentiment is one pointed particularly south of the border, since—despite increasingly stringent immigration policies—the United States continues to be a top destination for millionaires.[18]

Chris Christie's attempt to out Trump's anti-immigrant rhetoric of course reflects nothing new. Still, though Mexican immigrants in particular have a hundred-year history in which they are alternately valued and welcomed for their labor and seen as invaders threatening a white America, these contradictions have become starker in an increasingly globalized world where people and goods travel more freely than ever thought possible. Here is where Donald Trump is significant for his identity as a New Yorker in embodying the ironies of so-called multiculturalism in the country's most diverse and immigrant city and thus the country as a whole. Jodi Melamed helps conceptualize what is unique about this latest phase of anti-Mexican racialization. As she outlines, "official antiracist regimes" have "fatally limited the possibility of overcoming racism to the mechanisms of U.S.-led global capitalism, even as they have enabled new kinds of normalizing and rationalizing violences" (xi). In the 2000s, "neoliberal multiculturalism," as Melamed terms, portrays the United States as the model multicultural democracy but is in fact based on a neoliberal system that systematically divides between those who are deemed valuable to capital and those who are not. Here, neoliberal means more than an economic theory: it "encompasses the entire complex of social, political, and cultural norms and knowledges that organize contemporary regimes of rule and becomes a name for the differentiated experience of citizenship" (xxi). Trump's own immigrant parentage (his mother was born in Scotland) as well as marriage to two immigrant wives while constantly railing against immigration demonstrates the logic of this differentiated experience (Frates). It is not just the racialized aspects of illegality but the way concepts of illegality are deployed to exclude Mexicans (and others associated with the southern border) with increasing intensity after 9/11 within both the borderlands and so-called sanctuary cities. For this reason, Trump can make a call for a border wall while employing undocumented immigrants for decades with no ideological conflict (Jordan; Beckwith). Immigrants of color (as opposed to European models) are disposable and are to be contained as needed—whether through the marginalization of underpaid labor or physically outside the country in

U.S.-owned maquiladoras. As most migrants enter the country legally via air and are entering at a decreasing rate, Trump's border wall is of course about the image and logics of containment, not its realities. The reality is that, wall or no wall, the systems at the heart of neoliberal multicultural containment continue thorough policing, surveillance, and societal and labor exclusions (Warren and Kerwin). Why "the Wall" is such a rallying call for Trump and his supporters is because it represents a visual image of the country's neoliberal multicultural containerization.

Released in 2003, Alex Rivera's *The Borders Trilogy* captures these racialized systems of containment at work. It consists of three videos that expose the contradictions of a globalized world in which products freely cross borders that people may not. The third video, "Visible Border," starts as a blurry silvery screen before the camera slowly pans out to reveal the outline of bodies. As the rotating image comes into focus, the voiceover comments on the technology's novelty and appropriateness for detecting "large-scale border crossings." Particularly, this voice tells us, these new technologies have a wide variety of uses; they can distinguish any number of "materials," from "cocaine" to "plastic explosives" to "the human body." In the end, what is left is a clear image of indistinguishable figures huddled compactly in a shipping container, disguised as and surrounded by bananas (see fig. 6).

Rivera's final haunting and yet immobile image of global labor and economy recalls another horrifying image: the infamous Brookes Ship cross-section (see fig. 7). The visual similarities of these government-sponsored x-rays to designs for slave ship cargo holds are disconcerting. It reminds us that the containment of Mexicans is based in a much longer system of capital "progress." Like the x-ray technology presented by Rivera, these older scientific drawings were exemplars of naval drafting's precision in schematic diagrams. They graphically illustrated how enslaved Africans were tightly packed as human cargo on slave ships and were accompanied by mathematical calculations describing the cramped space per man, woman, or child (Finley, *Committed to Memory* 5). Although they were later massively distributed by abolitionists[19] to demonstrate the immoral horror of the slave trade, these images also offered a voyeuristic view of the slave trip in a way that reduced slaves to faceless, nameless black outlines. Along the long, historical route of racial capitalism, the Brookes Ship and Rivera's "Visible Border" overlap.

The final visual of *The Borders Trilogy* haunted me for years even as I pursued other research interests. Apart from the way it represented the newest x-ray technology used by the U.S. government to detect border crossings, Rivera's commentary and his documentation of the confluence of economic liberalism and cultural xenophobia in the treatment of border crossers profoundly disturbed me. The image conjured up the ironies of U.S. immigration policy

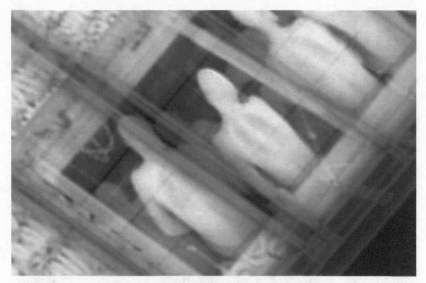

FIG. 6 "A Visible Border" from *The Borders Trilogy*, directed by Alex Rivera, 2003. (Source: Press photos from http://alexrivera.com/project/the-borders-trilogy)

and free trade, against the invisibility of the migrant worker. In "Visible Border," the migrant becomes perceptible as a possibly hazardous "material"—a body that must be kept out—a view in direct contradiction to the value assessed to goods produced by his or her labor just a few miles south of the border. It also reminded me of the realities I have witnessed of Mexican migrant life in New York City. So-called micro apartments of 300 square feet or less are not a fad for Mexican New Yorkers but a shared daily reality. Likewise, larger apartments of 750 square feet or less in which beds are rotated and shared (*cama caliente*) is also a common experience (Semple, "When the Kitchen"). In the case of MC Versos, for example, a three-bedroom apartment in Sunset Park is shared among three generations and multiple nuclear families ranging from infant to senior citizen (personal interview, 19 Oct. 2013).

In positioning New York City as both a "global city" (a reference to its diversity and its economic development) and a new borderlands metropolis, containers abound. It is in this "newness" that the recognition of past racial capitalism is highlighted. It is in containers that these histories become visible in the present. Although Mexican migrants rarely cross the border in containers, shipping container consumerism has been the economic engine and methodology for the re-commodification of brown bodies, post-slavery, post–civil rights. As a consequence of the 2006 Secure Fence Act and in reaction to the tragic events of September 11, 2001, a new border wall is expanding beyond the U.S.-Mexico border. With renewed concerns about security and terrorism,

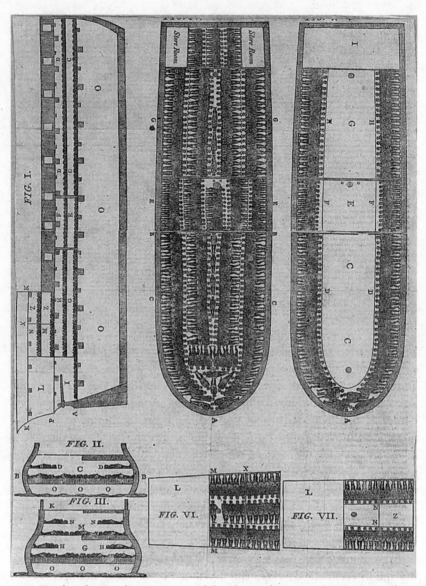

FIG. 7 The slave ship Brookes. The Liverpool ship the Brookes was used in the slave trade in 1781. In 1788, abolitionists in Britain commissioned a drawing of how people were squeezed on board the Brookes in order to raise awareness of the inhumanity of the slave trade. The image was so effective that it was soon reproduced and distributed widely around the country and abroad. (Source: National Maritime Museum [Open Government License])

the integration of North America heralded by NAFTA in 1993 has only encountered serious roadblocks (Leal and Limón 3).

Since the 1920s, when Congress adopted a "whites only" immigration system banning all Asian immigration, policy and economy have been at odds over the issue of Mexican migration. While advocates of the whites-only immigration system argued that Mexicans were racially unfit to become U.S. citizens, Western employers had already become dependent on Mexican labor. The result of this debate was the criminalization of Mexicans, when in 1929 Congress passed a bill that made "unlawfully entering the country" a misdemeanor and began imprisoning migrants. Clearly this was a bill targeted at Mexican migrants—throughout the 1930s, Mexicans never made up less than 85 percent of all immigration prisoners, and in some years that number rose to 99 percent (Molina, *How Race* 59–69). These numbers are mirrored today in detention and deportation statistics. Mexican immigrants have the highest detention rate (78 percent) and the lowest representation rate (21 percent) of all the nationalities studied (Eagly and Shafer).[20] Thus, on the one hand, Trump's popularity reflects the persistent existence of anti-immigrant sentiment and policies. On the other hand, it is also just the most recent aspect of centuries of systemic commodification of bodies of color.

The geographer Joseph Nevins argues in his book *Operation Gatekeeper and Beyond* that the realities of increased migration on a larger scale than at any point in U.S. history—as a real and important feature of the U.S. national makeup—against the upsurge of Mexican backlash,[21] speak to an important post-NAFTA, post-9/11 moment in U.S. history that is anything but post-racial. According to Nevins:

> The alleged problem of illegal immigration is, to a significant degree, made in the United States. By increasing the porosity of the U.S.-Mexico boundary through trade liberalization, the state must strengthen the boundary in other ways. This seeming paradox is consistent with the observation that globalization does not necessarily lead to a decline in nationalism. In fact, globalization can serve to enhance differences between citizens and so-called aliens. In this way, rising boundary-related illegality (such as unauthorized immigration) is an integral part of the NAFTAization of the U.S.-Mexico border region. (169)

In other words, the more "multicultural" we have become, the more complex the walls of containment. Structurally, these forms of racial containments are historically honed and strategically built with racial capitalism's ever-dividing walls.[22] In particular, the post-9/11 shift toward increased border militarization and New York City surveillance of communities of color came at a crucial moment of Mexican migration to New York City in which a young population was struggling to establish itself in a new city and environment.

While I agree with scholars of the border such as the historian Natalie Molina and the anthropologist Nicholas De Genova that the militarization of the U.S.-Mexico border over the past two decades is the result of a much longer history of racist rhetoric toward Mexicans and Mexican Americans in this country,[23] I also see NAFTA as marking an important shift in the current situation of Mexican migrants moving into new areas of settlement like New York City, a shift that 9/11 would later reinforce. It is also a shift that has been cemented via increased militarization of both the border and New York City. That Mexican migration is now declining (as in more emigration than immigration) only heightens the hypocrisy of U.S. treatment of these migrants.

The war on terrorism has further obscured the significance of U.S. neoliberal economic policy to migration. While "enforcement only" strategies had been on the rise for decades, the events of September 11, 2001, "haunt most of the current policy discourse surrounding U.S. immigration enforcement" (Brotherton and Kretsedemas 8) and greatly influenced President Bush's relationship with President Fox of Mexico. Specifically, the attack on the Twin Towers clearly derailed what would most likely have been the major expansion and liberalization of American immigration law that the Bush administration had promised Fox (Givens, Freeman, and Leal 3). Thus, Rivera's "Visible Border" reflects an intensification of immigration policy, enforcement technology, and globalization that was not necessarily predetermined.

Rivera's updating of the Brookes Ship also reminds us of the role of containment, whether in shipping goods or shipping people. Starting in the 1960s, the efficacy of shipping containers did away with numerous sources of domestic work and led to the overseas outsourcing of many industries. This new economy also resulted in increased migration to major cities in the United States, such as New York, as an expanded service sector emerged to cater to the wealthy elite. In *Expulsions: Brutality and Complexity in the Global Economy*, Saskia Sassen describes the neoliberal phase of capitalist globalization as distinguished from the previous Keynesian phase via the "extreme" brutalities that represent a "systemic edge." In the United States, this includes the mass incarceration of surplus populations via the private prison system that in the 1980s was expanded to include the indefinite detention of undocumented migrants. According to Sassen, "The past two decades have seen a sharp growth in the number of people, enterprises, and places expelled from the core social and economic orders of our time. This tipping into radical expulsion was enabled by elementary decisions in some cases, but in others by some of our most advanced economic and technical achievements. The notion of expulsions takes us beyond the more familiar idea of growing inequality as a way of capturing the pathologies of today's global capitalism" (Kindle locations 40–43). New York City—as both the center of these neoliberal capitalist changes[24] and home to large groups that are potentially subject to these expulsions—is key to understanding the significance

of this current moment of Mexican migration and anti-immigrant sentiment. In these unique times still reminiscent of the period of racial slavery in terms of racial capitalist systems, New York City's economy is once again buttressed by a system of segregated racialized labor supporting (via an ever-expanding service sector) an economy based on trade and exchange of capital. It is this monetarily excessive exchange of capital and not the production of goods that not just coexists but exists because of "extreme forms of poverty and brutalization where we thought they had been eliminated or were on their way out" (Sassen, *Expulsions,* Kindle locations 199–200). In the context of New York City, the shipping container is key to understanding these economic shifts that contain and expel the Mexican population.

Of particular interest here is how New York City became the center of the American financial and shipping industries dependent on slave-produced cotton. Though slavery may have ended in New York in 1827, the city's economy grew tremendously as a port for plantation slavery products. So did the British textile industry. Moreover, New York City's significance as an entryway to the United States is clear from the important historical role New York played in the slave trade. The Dutch West India Company imported eleven African slaves to New Amsterdam as early as 1626, with the first slave auction being held in New Amsterdam in 1655. As the recent discovery of the African Burial Ground in Lower Manhattan reminds us, for most of its history New York was a slave city. In fact, for much of the eighteenth century, New York City was second only to Charlestown, South Carolina, in its proportion of slaves in an urban population.[25]

Centuries later, perhaps most emblematic of these failures and contradictions of today's capitalist system is "La Bestia" (the Beast). Instead of a step forward in global trade, the Beast has become a symbol of NAFTA's failures for both Mexican and U.S. governments, as thousands of Central American migrants hop the freight train as a means of transportation across the length of Mexico. The Beast is not just inhospitable; it has become downright dangerous, as criminal elements target helpless migrants riding the train. It is considered to be "one of the most severe humanitarian crises in the Western Hemisphere" (Isacson, Meyer, and Morales), and Amnesty International estimated that as many as 70,000 undocumented migrants went missing in Mexico between 2006 and 2012 and that 80 percent of migrant women are raped on the journey (Martínez, Kindle location 15).

These Central American migrants fleeing extreme violence in their home countries are exactly the group that President Obama targeted for removal, rather than amnesty or refugee status.[26] As the Beast's spectacular violence demonstrates, the image of Central American migrant bodies alongside the shipping container is specific to trends over the past twenty years as well as a powerful reminder of the diversity of Latinx migration in this period. Thus, it

is not actually ironic that the original purpose of the Beast was to move standardized containers across the U.S.-Mexico border, yet ended up as a tragic symbol of migrant desperation.

Thus, the shipping container literally and metaphorically provides a through line to understanding the connection between traditional border crossing and historical Mexican settlement in the Southwest and Chicago, and the development of Mexican migration to New York City in a post-NAFTA, post-9/11 world. As standardized containers have made the movement of goods across borders an afterthought, Mexican migrants have extended their journeys into new borderlands. As NAFTA has crippled the Mexican economy, it has also paved contemporary New York City routes of racial capitalism over its slave roots. The container then also underscores the ways in which Mexicanidad shares a space with a broader Latinidad that concurrently has a much longer history and is also continually evolving and diversifying.

Moreover, while contemporary discourse on surveillance often posits 9/11 as the moment that initiated this era of unrelenting state vigilance, Simone Browne's *Dark Matters: On the Surveillance of Blackness* charts a long history of surveillance to present how contemporary practices are rooted in anti-black domination. For Browne, the rise of information and biometric technologies is not just the latest development in state control but what she terms "racializing surveillance." According to Browne, racializing surveillance is "a technology of social control where surveillance practices, policies, and performances concern the production of norms pertaining to race and exercise a power to define what is out of place" (8). Similarly, Stephanie Camp's concept of geographies of containment" focuses on the use of space and the ways in which it functioned both metaphorically and literally: "Their social 'place,' [*sic*] was reflected and affirmed by white control over their location in space, their literal place" (9). These technologies were founded in slavery, honed under Jim Crow, and expanded to racialize Mexicans who involuntarily become a part of the United States, and they are at their most advanced when hand in hand with the racial capitalism rooted in and routed through the global economic capital that is New York City. In other words, the shipping container is to racial capitalism what containment is to racializing surveillance. This is a national phenomenon of exclusion, but one that Mexican New York City most dramatically elucidates, as it is in New York where racial capitalism, economic exclusion, surveillance, police militarization, and the war on terrorism collide amid a supposedly multicultural liberal city. Donald Trump highlights that falsity.

Containment also has a corollary with incarceration. Although California's Proposition 187 or Arizona's SB1070 may offer more obvious examples of state surveillance targeted against Mexicans, a general attack on communities of color has long occurred in New York. On January 11, 2019, for example, the

NYPD entered migrant-owned acclaimed South Bronx Mexican restaurant La Morada and arrested Yajaira Saavedra, an owner and the daughter of chef-owner Natalia Mendez. Saavedra, an undocumented migrant and activist, was never given the cause for the arrest nor was a warrant produced. Called "crucible for resistance" in the South Bronx by the *New Yorker*, Saavedra is active in issues regarding rights for undocumented migrants and neighborhood gentrification (Upadhaya). Similarly, a 2008 study found that in 2006 out of a half a million stops by the NYPD, 89 percent of individuals stopped were nonwhite (53 percent were black, 29 percent were Latinx, 11 percent were white, and 3 percent were Asian). Moreover, 45 percent of black and Latinx suspects stopped were frisked, as opposed to 29 percent of white suspects. Yet when frisked, white suspects were 70 percent likelier than black suspects to be carrying a weapon (Ridgeway).[27]

These repeated acts of surveillance and racialized state violence on black and brown bodies of color are also enacted by the most militarized police force in the United States, only adding to migrant terror. As Philip Kretsedemas makes clear, migrants, especially Mexican migrants, face racial biases not just for suspected criminal behavior but also for suspected "illegality."[28] In the same way that stop-and-frisk policies in New York City and elsewhere are specifically targeting people of color, deportations are disproportionately skewed by country of origin. Mexico, Honduras, Guatemala, and El Salvador have accounted for 91 percent of total deportations, demonstrating how race, national origin, and ethnicity remain crucially important to the study of presumed migrant illegality (Menjívar and Kanstroom 17).

Even before Donald Trump's anti-migrant campaign, there was an increasing conflation between the Mexican migrant and the criminal, both of whom are marked for imprisonment and/or deportation depending on migration status. This can clearly be observed in New York. Between April 1, 1985, and December 31, 2006, the number of foreign-born inmates in the state of New York increased by 158 percent, nearly double the rate of increase of U.S.-born prisoners in the same period. Given the strong documentation of racialized stop-and-frisk practices, it should not be surprising that over 60 percent of those inmates were Latinx (Bosworth, "Foreigners in a Carceral Age" 108). At the same time, Immigration and Customs Enforcement's (ICE) presence has steadily increased in New York. From 2008 to 2010, ICE averaged 7,417 apprehensions per year, nearly a 60 percent increase since 2006, the first full year covered by the data. Of those who were detained, 80 percent were not given a bond setting (and of those who were, only 45 percent could pay it). Furthermore, 91 percent of New Yorkers detained are deported. Notably, 23 percent of those detained have U.S. citizen children, and Mexicans are by far the largest percentage of those detained (followed by people from El Salvador, Dominican Republic, Ecuador, Guatemala, and Honduras). As 19.8 percent of the

detained population in New York City is Mexican—a percentage that is in no way proportional to their representation in the population (approximately 6 percent in 2011)—this reflects a racially targeted practice in New York akin to stop and frisk but directly aimed at Mexicans (New York University School of Law Immigrant Rights, Immigrant Defense Project, and Families for Freedom 7). It is immigration enforcement as a form of racial governance upheld and supported by racialized NYPD practices and military-grade equipment. In the end, the NYPD and immigration enforcement are not as separate as they claim for a sanctuary city, a status New York City presumably celebrates. Instead, stop and frisk and detention are part of the same practice of state control and surveillance. The use of surveillance and an aggressive management of public space are crucial to New York City's combined crime-control and order maintenance initiatives. It is how New York attempts to control migrants and label them as threats, despite their significance to the economy. The stop-and-frisk campaign of the Street Crime Unit, at various times the focus of five government investigations and a federal lawsuit, is one of the more notorious ways in which the NYPD problematizes public space for people (especially men) of color. Rather than what the name implies, public space is not actually space open to all; it is space open to whites. It is space occupied by brown and black bodies at their own risk. As targets of both NYPD and ICE practices, Mexicans face a double policing and doubled state of racializing surveillance. For this reason, it is not surprising that Har'd Life Ink's tag is "Bassed in the Underground Culture."[29] There is little other ground to stand on for Mexican New Yorkers.

The point I am introducing here is the necessity of viewing these new forms of state control as part of the consumption of migrant people and as a vital function of a current period in the U.S. economy that is also built on historical systems of state-sanctioned racial violence.[30] Although containerization moved the shipping industry physically outside of New York, containment was nonetheless on the rise in New York City. Though physically gone, containers haunted the city in the form of increased surveillance, the continued criminalization of people of color, lack of housing, diminished educational and employment opportunities, and other daily marginalizations. Containerization worked hand in hand with deindustrialization to destabilize the working class—particularly people of color and migrant communities. In this light, the fact that New York's high demand for goods is hidden in the ports of New Jersey mimics the realities I explore in the following chapter about the restaurant industry, in which Mexican migrants are highly desired for the quality and affordability of their work and hidden from customers in mainly back-of-the-house positions. But as that chapter also explores, undocumented or not, fewer Mexicans are willing to remain hidden.

Locating and Theorizing the Atlantic Borderlands

The genesis for the "Atlantic Borderlands" comes from the collision of Gloria Anzaldúa's theorization of the Mexico-U.S. border in *Borderlands / La Frontera: The New Mestiza* (1987) and Paul Gilroy's interventions about the black diaspora in *The Black Atlantic: Modernity and Double Consciousness* (1993). As Li Yun Alvarado describes in her dissertation chapter "Chicana in New York: Gloria Anzaldúa's 'Tex-Mex with a Brooklyn Accent,'" Anzaldúa's time in New York City (1982–1985)—though rarely mentioned—was crucial in the development of her thinking, during which she wrote significant portions of *Borderlands / La Frontera* ("Interview by Karin Ikas" 268). According to Alvarado:

Indeed, her time in New York was critical for the development of her theories. Living in the city exposed her to dense populations of people whose multiple boundaries (ethnic, national, gender, spiritual, racial) were at once coexisting and being policed. That exposure in turn complicated her theorizations of borders and borderlands. Her experiences in New York also reinforced her desire to further develop a spiritual practice, or "spiritual mestizaje," that embraced multiplicity and could potentially serve as the (sometimes painful) path towards a life "sin fronteras." (124)

For example, in "To Live in the Borderlands," she conceptualizes a borderlands in which a Tex-Mex identity is in constant flux as it encounters and incorporates new influences:

To live in the Borderlands means to
put chile in the borscht,
eat whole wheat tortillas,
speak Tex-Mex with a Brooklyn accent;
be stopped by la migra at the border checkpoints (216)

Clearly, despite the regional rootedness of her work in her Tejana identity, her celebrated and much-cited concepts of *borderlands, mestizo, neplanta*, and the Coatlicue state also incorporated non-Southwest experiences.[31]

More than just incorporating the diversity of identities Anzaldúa faced in New York City or leaving city references in her poetry, this period is critical for two additional reasons. Following Alvarado's argument, the development of her "spiritual mestizaje" is also significant because of her introduction of Yemayá, the Yoruba female orisha. Overlooked in some of her most quoted lines opening *Borderlands*, Anzaldúa makes explicit references to West African diasporic spirit-practices. Important as a key referent of the African diaspora, Yemayá is the deity of fresh water in West Africa who became the "goddess of

the sea" during the Middle Passage. When African slaves threw themselves overboard in the Atlantic Ocean, their lives became offerings to this underwater force as they leaped into the arms of Yemayá rather than live as captives in the Americas (Díaz-Sánchez 154). Yemayá continues to be an important figure in spiritual practices in Cuba, Puerto Rico, and Brazil, representing a truly Atlantic diaspora among the Americas. In Anzaldúa's evocation of this goddess, Mexicanidad also becomes reconnected with its own African diaspora and slave legacies that had largely been erased in Mexican history except for limited sociocultural contexts (Gutiérrez, "El derecho de re-hacer" 164).[32]

Following Anzaldúa's lead, the Atlantic Borderlands theorizes Mexican identities that bridge Mexican diasporic experiences in New York City and the black diaspora in recognition that colonialism and interracial and interethnic contact through trade, migration, and slavery are all manifestations of a racial capitalism and technological development that today manifests at least in part via the shipping container. The shipping container connects the NAFTA freight trains from Tapachula to Juárez to New York City in ways that illuminate how different "cargo" feeds a late capitalist economy. This spatial move is important for two reasons: first, because Mexican migration is largely understudied in a New York–East Coast context, and second, because following Paul Gilroy's concept of the Black Atlantic helps devise an approach to understanding identities as fluid and ever-changing, as transnational and intercultural, and as developed through forms of resistance that emerge diasporically. As Gilroy sought to theorize race in a way that bridged hemispheres, the Atlantic Borderlands seeks to bridge Mexican New York with an Afro-diasporic Caribbean. It also seeks to bridge the influence of traditional borderlands identities of the Southwest and theories on Mexicanidad that connect Gloria Anzaldúa within this new Empire state borderlands.[33]

For many, Gloria Anzaldúa has become *the* representative for conceptual and geopolitical study of the border, in Latinx theory and Chicanx literature. For Anzaldúa the jagged wound of the border is inflected by the precise local geographies of her birthplace of El Paso, where the border is crossed and defined by bridges over the Río Bravo. In this project, however, "border" is more than a geopolitical divide. Like Tania Gentic's "Everyday Atlantic," it signals a space allowing for multiple and even seemingly contradictory meanings and identities in relation to a real site of U.S.-Mexico division. It is a border that incorporates not just questions of place but questions of language, gender, culture, race, and history, particularly the legacies of slavery on modern-day race relations and state modes of control.[34]

The Atlantic Borderlands is an approach to migrant studies that consciously dialogues with African American studies in terms of the way nonwhite bodies move and labor in the United States given the historically built economic and social structures that contain them. As Cedric Robinson extends in *Black*

Marxism: The Making of the Black Radical Tradition, colonialism, imperialism, and racial capitalism have long worked in tandem (2–3). Racism is more than just an aspect of a capitalist system; it is also a "material force" and "historical agency" of capitalism (2–3). Similarly, capitalism was not an economic system that broke with older forms of marginalization but one that evolved alongside racism to produce a modern world system that captures not just people of African descent in the United States but migrants as well. For scholars of the borderlands such as Natalie Molina and others,[35] Mexicans' lack of racial capital reveals the extent to which they remain racially suspect in the United States—"foreign until proven otherwise"—and thus understood in certain racially charged ways ("The Long Arc" 446). The contemporary diverse and immigrant New York City context privileges an economic form of racism that globalization makes harder to recognize. As Jodi Melamed describes in *Represent and Destroy: Rationalizing Violence in the New Racial Capitalism*, "neoliberal multiculturalism has disguised the reality that neoliberalism remains a force of racial capitalism" (42). I would also add that this neoliberalism disguises the ways in which free trade supports unequal exchange based on nonwhiteness.[36]

Paul Gilroy proposes an alternate theoretical space to describe the cultural and intellectual interchange and experience of the African diaspora. Emphasizing the transnational aspects of the African diasporic experience, he challenges the legitimacy of cultural nationalism and racial essentialism, and questions notions of regional intellectual autonomy. To emphasize the transnationalism of the African diaspora, Gilroy introduces the "image of ships in motion." This image is emotionally evocative and analytically important, because it references the legacy of the Middle Passage and a history of forced labor as well as the free movement of black thought, art, and politics. He recognizes a long history of exchange made up of diverse black subjects and varied black experiences.

While Anzaldúa emphasizes "a 1,950 mile-long open wound" (*Borderlands / La Frontera* 3), Gilroy's image of "ships in motion" focuses on the terror and legacies of the Middle Passage. In both, I find lived geographies forged by communities that must face these often unrepresentable memories cloaked in invisibility. They are both grounded in specific sites and filled with heavy histories—wall or sea. These are powerful images of containment, transnationalism, and diaspora. For Gilroy, the project of modernity was dependent on, as well as effectively produced, the terrors of slavery as part and parcel of its own formation and maintenance. As Petrine Archer further elaborates, "Forcibly removed from Africa and re-birthed in the Atlantic on the most modern vessels, diaspora blacks were crucial to capitalist enterprise and plantation economies that relied on their labor to produce sugar, cotton, tobacco and more. The contingency of their New World lives shaped their formation of imagined communities and identities based on transposed cultural forms and a forced

consciousness of race and its restrictions" (28). Rather than view slavery and its attendant horrors as divorced from the Enlightenment ideas associated with modernism, Gilroy considers them as part and parcel of it. In response, Black Atlantic peoples constructed what he calls a "counterculture of modernity." This "counterculture," according to Gilroy, "was shaped by the need to supply a counter-narrative of modernity that could offset the willful innocence of European theories that ignored the complicity of terror and rationality and in doing so denied that modern slavery could have anything to do with the sometimes-brutal practice of modernization or the conceits of enlightenment" (*The Black Atlantic* 37). In a similar way, the violent expulsions described by Saskia Sassen are built on a form of modernization that Gilroy describes as based on the brutal practice of slavery. Due to the pressures of the International Monetary Fund, the trade policies of NAFTA, and the Free Trade Area of the Americas,[37] unemployment rates of over 25 percent in countries such as Mexico and in Central America have produced large-scale migration to the United States. In the current era, the economic forces of global neoliberal capitalism are unrestrained by governments on both sides of the border. In Mexico, neoliberal policies such as federal subsidies for corn, sugar, and produce were ended and development projects stopped, devastating the countryside. Meanwhile, in the United States, after creating pull factors for migration, we made the migrant worker "illegal" to provide low-wage domestic labor and thus more profits for corporations.[38]

Like African Americans from an earlier diaspora, Mexicans in New York City have also founded a counterculture in response to their systemic racialized labor exploitation. Through creative work, Mexicans in New York find ways to circumvent the racialized capitalist system that tries to marginalize them. Faced with limited options for both employment and creativity, Mexicans create their own artistic spaces through mechanisms that at best are also self-sustaining financially. For example, in chapter 2, I focus on the Har'd Life Ink Arts collective, a group that boasts more than two dozen affiliated Mexican artists who attend weekly meetings, run various businesses and a performance space, and host monthly public hip-hop and art shows. They are not an isolated instance.

Through the overlapping spaces, identities, and histories of the Atlantic Borderlands, I consider Mexican migration to new destinations such as New York City as representing a different phase of Mexican identity that can be better described as diasporic rather than transnational. I agree with Robert Smith's argument in *Mexican New York* for the necessity of an expanded application of the meaning of "transnational life" to include a new view of transnationalism that includes practices and relationships "that have significant meaning and are regularly observed" (6). Yet, I also find that the term "transnational" for Smith reflects an identity rooted in two nations that does not reflect the global

diasporic lives of Mexican youth in New York. Although diaspora is not a term often used in the context of Latinx migrations but rather one used to describe the forced dispersals of Jewish and African peoples (R. Cohen 2), I find the term useful in this context to grapple with the increasing diversity of Mexican migrations. Thus, following Frank Andre Guridy's work on Afro-Cubans, which itself expands on Paul Gilroy, diaspora highlights "routes" instead of "roots" to stress the importance of relationships between diasporic communities outside of the symbolic homeland in the reconstitution of the wider diasporic consciousness (4–5). In a similar way, I see Mexican migration as part of a living dialogue made up of multiple routes not just between diverse points in Mexico and the United States but around today's globalized world.

In New York City, these racialized narratives are particularly pronounced. As a relatively new population, Mexican migrants in New York face extreme vulnerabilities. As will be described further in the next chapter, life in New York City is not just one of what Lisa Marie Cacho has termed "social death," but one in which the fear of deportation and the realities of surveillance, detention, and deportation are ever present. Although the trauma felt by Mexican migrants is distinct from Anzaldúa's due to the experience of immigration and difference in residency status, she nonetheless provides a key aspect of the Atlantic Borderlands' framework in her approach to the issue. Specifically, Anzaldúa's conception of trauma is one she connected not just to Mexican marginalization but also to black and Asian experiences in the United States. For example, in one of her interviews, she describes the lived trauma of these histories: "Dominant society has this great denial: these atrocities belong to people who are dead. This is the major trauma that this country is suffering under, but it's un desconocimiento, they're not acknowledging it. We, in our bodies, feel this trauma every day. It's like a repetition of the invasion, the genocide, the exploitation of nature. It's a major wounding on many levels, including a colonization on our minds and consciousnesses. They're still exploiting our energy" (Keating, *Entre Mundos* 55). As Anzaldúa writes, these traumas are felt in both the mind and the body, both the past and the present. Trauma is not just a personal experience but also includes the histories and legacies of the dead.

Anzaldúa's "New Mestiza" positioned her at the threshold of numerous groups and languages including the African diaspora to dialogue with each. Following her example, this book employs nepantla[39] as a key method and point of view, specifically in terms of seeking out methodology and theory from African American studies in addition to Latinx and Chicanx studies. Thus, as a "nepantlera," or "in-betweener," I mean to facilitate discussion between what is often thought to be unrelated fields and spaces—Black Atlantic and borderlands, African American studies and Chicanx studies, East Coast and Southwest, migrant studies and music studies, to name a few. Yet, as Anzaldúa's work and her life itself demonstrate, in this New Borderlands of New York City,

African diaspora, former slave economies, Mexican migrants, and migrant economies are not unrelated but intertwined in important ways. Nevertheless, though I engage with economic and social policies as well as processes of racial formation, my primary interest here is to document cultural politics and expressive culture, to reflect on the ways Mexican migrants have engaged with NYC given these socioeconomic conditions.

Here is an opening between two disciplinary areas (Chicanx and African American studies) that have often been thought of as only tangentially related or relatable despite a global city with a long history of African American and Latinx cultural exchange. I bring them together to grapple with the complexities of Mexican migrants in New York City because they represent a new phase of Mexican migration amid the repercussion of NAFTA policies and post-9/11 security interests, but also in an unprecedented age of globalization. Moreover, it is a way to approach the creation of a hip-hop practice (as I will explore in chapter 3) in which sampling Hector Lavoe is no more unnatural than Otis Redding for different Mexican migrant MCs of very distinct backgrounds. These artists center the importance of African diaspora studies in a way that mirrors the deep knowledge and respect the MCs have for their Afro-diasporic predecessors.

In my conception of the Atlantic Borderlands, Anzaldúa's incorporation of various diasporic identities found in New York is also key because it adds an important response to common criticisms of *The Black Atlantic* about its focus on middle-class male intellectuals. Although many of the spaces I explore in the pages to come are predominantly masculine, the stories I narrate cross gender and class lines, and apply a feminist analysis based in Anzaldúan theory regardless of the sex of the subject. Gender as recorded on the mind, body, and spirit is itself a borderland. Here, *"autohistoria-teoría"* remembers the physical body (gendered, racial, and sexual) within the social, political, cultural, and historical body to explain one's personal and collective stories. Unfortunately, those are also often the stories of those left behind, across borders, not seen again for years or decades, if ever. Thus, the Atlantic Borderlands is also necessarily in dialogue with Chicana feminist and Chicana lesbian feminist concepts of space such as Emma Pérez's "decolonial imaginary," Anzaldúa's "nepantla," and Chela Sandoval's "oppositional consciousness," who each articulated a third space of possible reconnection and creative self-invention.

As a result, one of the most striking, and maybe most disturbing, insights gained on the Atlantic Borderlands when thinking through the model of container politics is that international labor is not only feminized but also sexualized. To take a familiar case from Anzaldúa's local space of El Paso/Juárez, structurally speaking, in the borderlands, women's bodies are contained and interpolated onto specific labor sites. Thus, a young woman in Juárez has three options: an assembly worker; a doméstica (maid), if she has insufficient

education to be accepted at a factory; or prostitution, if she can't produce a recommendation for a maid position. Yet securing a factory job is not always the end of the story, as low salaries force many women to seek supplementary income from prostitution on weekends, putting them at higher risk for sexual predators and murder (Biemann 108). Sexual and labor markets interpenetrate within this economic order, and both rely on a category of brown laboring bodies treated as less than human. Ursula Biemann adds: "Their racialized, gendered figures become the articulators of the border, that fragile line marking the fringe of the national body. It is here, according to national(ist) discourse, that all disease, illegality, contamination, and poverty come from. This is the most vulnerable, penetrable site, the place where anxieties tend to concentrate. What better site to localize the panic of national identity? Above all, U.S. customers need to be assured that the offshore female bodies are not out of control" (103). As Biemann suggests, this new borderlands model relies on people simultaneously kept under control and in movement, and, according to this logic, disposable. Men and boys die in the nonspace of container transit; disposable women die in the maquiladora spaces of border feminicide. This mobility and immobility then form two ends of the same chain, two ways of dying, and two types of disposable bodies.[40]

The Atlantic Borderlands, then, helps address both the absence and the presence of women in spaces of New York Mexicanidad. For Audry Funk, thirty-one, an MC from Puebla who now resides in the Bronx, the lack of females in Mexican hip-hop in New York is both cultural and situational. While she describes the place of Mexican women in New York as "very marginalized" owing to both sexism and lack of work opportunities, like Gloria Anzaldúa she also sees Mexican culture as restrictive to women's expression. According to Funk, "Creo que, sí es bien cultural, creo que las mujeres de muchas partes del mundo no solo de México no han roto cadenas, sin embargo, no soy pesimista. Cada día veo más mujeres en proceso de desprogramación y de cuestionamiento. Creo que solo es cuestión de tiempo para que más compas empiecen a levantar sus voces" (personal interview, 10 Dec. 2018).[41] Following Funk's optimism as well as practice of sharing her story, the Atlantic Borderlands follows a feminist approach to oral history that emphasizes *testimonio* over subject interview as method. In *Telling to Live*, the Latina Feminist Group describes *testimonio* as a collaborative process about how to create knowledge and theory through experience (8). For this reason, I chose to develop a theorization of the Atlantic Borderlands that emphasizes New York as a new and important space of diversity of diasporic exchanges for Mexican migrants over the framework of cultural citizenship.[42] I found that the subjects of my interviews have a more fluid understanding of belonging that makes legal incorporation and citizenship less important. Rather than any shortage of affiliation with U.S. national society or its confining structures of incorporation and beyond formal politics

and confrontations with the U.S. state, I see young migrants in New York City engaging in other forms of subversion or "counterculture." More importantly, in these forms of expression, autonomy—not citizenship—is most valued.

The collaborative process expressed in *Telling to Live* also mirrors my methodology for the interviews as well as the way the artists and activists in this book approached their work as MCs, labor leaders, painters, and so forth. Specifically, I looked to Maylei Blackwell's process in ¡*Chicana Power!: Contested Histories of Feminism in the Chicano Movement* of "retrofitted memory." According to Blackwell,

> Retrofitted memory is a form of countermemory that uses fragments of older histories that have been disjunctured by colonial practices of organizing historical knowledge or by masculinist renderings of history that disappear women's political involvement in order to create space for women in historical traditions that erase them. It draws from other Chicano cultural practices such as the *rasquache* aesthetic, or customizing of cars, that use older parts (or what is spit out as junk in global capitalist forms of production and waste) to refine existing bodies or frameworks. By drawing from both discarded and suppressed forms of knowledge, retrofitted memory creates new forms of consciousness customized to embodied material realities, political visions and creative desires for societal transformation. (2)

By employing a feminist perspective to capture the memories and perspectives of my collaborators, I shed light on the lives of Mexicans—male and female— as well as the aspects of their lives that are systematically erased in order to maintain a view of Mexican men as interchangeable migrant laborers and Mexican women as left behind in Mexico. At the same time, the rasquache aesthetic of retrofitted memory helps highlight the ways in which Mexicans in New York adapt to their Afro-diasporic surroundings in order to express a Mexicanidad particular to this space and time.

At the New Borderlands: Cultural Productions of Mexican NYC

There are many important books about immigration but not enough about the immigrants themselves, especially in terms of their lives, dreams, and hopes outside of work. But as the stories in this book demonstrate, these creative worlds form a vital aspect of their lives. Far from assimilating into a singular U.S. national culture, young Mexican migrants are banding together in crews, artist collectives, and activist groups to maintain and develop a sense of Mexicanidad in a city that either overlooks this population, surveils them, or purposefully exploits them. Through these new communities, they are also maintaining and creating new linkages with Mexico as well as beyond, via novel forms of

diasporic work that involve the circulation of ideas, information, and material goods in the arts. Rather than circulatory migration, these connections are sustained by twenty-first-century technology, especially social media. The cultural production of Mexican youth in New York City reflects their country of origin and experiences crossing the border, as well as the multiethnic, multiracial realities of life in one of the world's most diverse cities. In my approach to Mexican migrant culture, I propose a consideration of New York City as a new borderlands metropolis. Both marginalized in New York City yet transnationally linked, this Greater México is nevertheless formed by localized identities.

For example, Rhapy (the MC name for Xochitl Ramírez López) is a member of Buendia BK, a hip-hop arts collective based in Sunset Park. In her artistic work, she has created a localized form of Mexicanidad through her Spanish-language lyricism that explores the experiences of a Mexican migrant woman living in Sunset Park as well as a larger Mexican hip-hop culture through Buendia's affiliation with INK, a hip-hop crew based in Mexico City. Although most Buendia-INK members have never met, and will never meet, they still share a sense of community membership across borders and miles through the act of envisioning a Greater Mexican diaspora, which I investigate in chapter 3. Likewise, Sorick's identity as a transnational graffiti artist similarly developed through his membership in Har'd Life Ink, an artist collective in New York that grew out of a crew in Mexico City. Transnational crew or collective affiliation, however, is not the only form of daily life in this Greater México, as other individuals and groups I introduce also maintain their connections to Mexicanidad via cultural work and alternative artistic genealogies that are more localized in a strong New York City immigrant-based identity. Moreover, these cultural workers highlight the implicit tension between what the empirical data tell us about the status of Mexicans in New York City and their own refusal to accept this status. For this reason, it should come as no surprise that cultural workers like Meck from Hispanos Causando Pániko are often also restaurant workers or former restaurant workers, or come from families of restaurant workers, the subject of chapter 1.

In each of the stories of these pages, the refutation of societal definitions of Mexicanidad or undocumented status is absolute. Whether via activism, hip-hop music, or work in the arts, each cultural worker analyzed in this book categorically refuses labels—negative or positive—commonly assigned to Mexicans in this country, even if that means creating new spaces where those definitions are not allowed entry. It is more than identity politics or immigrant testimonies that I listened to over the past eight years; rather, it is the creatively expressed politics of anti-deportation that inspired me and many others who have been fortunate enough to know them. It is my honor to share those now.

This book is composed of four chapters and an epilogue that explore the alternative and counterculture spaces created by Mexican migrants and

first-generation youth in New York City. The first chapter, "'Sólo Queremos el Respeto': Racialization of Labor in New York's Restaurant Industry," expands the context of Mexican migration to New York City since the 1980s, focusing on the economic changes undergone by the city due to the adoption of the shipping container from an industrial economy to one focused on finance, real estate, and service. Particularly iconic to New York City is the restaurant industry, for which the Mexican presence is both vital and largely invisible. Thus, chapter 1 uses the restaurant industry as a case study of Mexican migrant containment, to explore active forms of resistance. I find that despite the development of an industry that has been able to create, defend, and expand a system that is based on operating outside of the law, Mexican migrants are organizing, forming unions, and demanding not just workplace change but more importantly respect.

These types of social justice activism—though vital and powerful—are also the kinds of responses that are more amply documented and provided as examples of migrant empowerment. As such, in the following chapters I focus on creative responses to containment by exploring how Mexican migrants are expressing and advocating for themselves via the arts. Thus, while chapter 2, "Hermandad, Arte y Rebeldía: Art Collectives and Entrepreneurship in Mexican New York," focuses on the development of arts entrepreneurship and successful collectively owned businesses such as tattoo parlors that double as arts spaces, chapter 3, "Yo Soy Hip-Hop: Mexicanidad and Authenticity in Mexican New York," employs lyrical analysis of Mexican hip-hop to explore alternative forms of identity making. In each of these cases, Mexican migrants engage with Afro-diasporic traditions and at times collaborate with African American communities in vital ways. The final chapter, "'Dejamos una Huella': Graffiti and Space Claiming in a New Borderlands," describes the way Mexican migrants are claiming space and performing a politics of anti-deportation via the aggressive visibility of graffiti. Rather than the wall on the geopolitical border, Mexican graffiteros leave their marks on NYC walls, fully aware of the Afro-diasporic traditions that had possibly once shared the same wall, only to be demolished or painted over. Through this final form of writing, I also bring together the diverse ways that Mexicans in New York are contesting their identification as either good and docile workers or dangerous "aliens" and criminals.

I have turned to Paul Gilroy's *The Black Atlantic* because his work on the African diaspora highlights the circulation of ideas and alternative networks of people often not thought of as cultural producers. Like Anzaldúa's bridges, ships serve as metaphorical ways of connecting diverse populations and ideas that also represent economic realities and have capitalist implications. While Gilroy's *The Black Atlantic* identifies the generative role of ships as crucibles of creolization during the Atlantic slave trade and throughout the subsequent development of maritime markets, Anzaldúa's work represents the fertile

creativity of the borderlands both amid and resulting from a long history of crossings due to U.S. market demand for Mexican migrant labor. For Gilroy, Africa shifts from a static base of identity to one characterized by ethnic mixing and hybrid forms from the very beginning of the slave trade. It is this convergence of European ports and capitals, Caribbean plantations, American and African shipyards, and African cities that becomes coeval sites in an emerging Atlantic field that results in the plural societies, Pan-African movements, and expressive musical hybrids that develop as hallmarks of a distinctive counter-modernity.

Similarly, I maintain that Mexicanidad has always been a shifting identity based on centuries of cross-cultural dialogue that are most diverse and powerfully visible in the current moment of Mexican migration to New York City. Using Anzaldúa as a bridge, I bring Gilroy's powerful narrative of ships into the present, where NAFTA and containerization are creating the most diverse borderlands Mexican migrants have ever encountered. As Jonathan Elmer concludes, "It may be that Gilroy proved unusually influential not through sharpening analytic concepts, but from loosening them and encouraging their recombination in new configurations" (161). It is this same dynamic that I try to bring to the Atlantic Borderlands study of Mexican migration—an approach, or reorientation of viewpoint rather than a necessarily imperfect theory—a theory that would always be incomplete due to the nature of an ever-changing community and city. As Gilroy reminds his readers, the "history of the Black Atlantic yields a course of lessons as to the instability and mutability of identities which are always unfinished, always being remade" (xi). Simultaneously, Anzaldúa reminds us that these identities are not always male and that the politics, processes, and patterns of globalization are intimate. Men may often be the face of migration, yet whether or not she crossed international borders, the working woman's body holds an intimate knowledge of the global powers of transnational corporations, "displaced by poverty and held in place by global capitalism" (Mountz and Hyndman 457).

I developed this methodology in conversation with the few existing studies of Mexicans in New York, most of which draw on sociological or anthropological methods. To bring a new perspective to this topic, I add a focus on culture to these important studies by utilizing an interdisciplinary array of methods from scholarship honed in history, literature, and cultural studies to analyze materials including plays, films, poetry, graffiti, visual media, and hip-hop music and lyrics. These methods include close reading and lyrical analysis drawing from my experience in literary studies as well as visual cultural analysis that draws on both art history and media studies approaches. I also use the ethnographic techniques of participant observation and interviews with various subjects. It is an approach that I hope reflects the rich, multilayered representations of this Atlantic Borderlands framework, and posits alternative forms of knowledge.

By peering off into the Atlantic, I approach Mexican migration the way migrants do themselves: as part of a global city[43] whose reach goes far beyond the island of Manhattan. Mexican migrants to New York City, like the economies that attract them, are residents of a world of both tighter borders and greater global exchanges of which they are very much aware, as well as active participants. Mexican migration has been confined—contained—in the narrative box of illegal immigration based on the inevitability of new migrants that replace those who have either died, returned, or integrated. The history of the Atlantic Borderlands is at once richly filled with the stories of Mexican migrants, as well as the prior histories of the space in which they find themselves. It is a form of "palimpsest history,"[44] or a layering of historical templates in which prior events shape the understanding of and response to the present. Those histories of previous black and brown New Yorkers give Mexican migrants their texture. Consequently, in loosening the bounds of border and Mexicanidad, I find new identities that take surprising shapes. And following my subjects on the long journey to and within the Atlantic Borderlands, they teach me the significance of blackness in Mexican lives as well as black scholarship in Chicanx and migration studies, specifically in the ways race and racialization affect migrant lives. Here, there is so much more than comparison—rather, it is a rich flow of ideas that no border could ever impede.

Part I

The Container
■■■■■■■■■■■■■■■■■■■■■■■■■

It's the Intermediary
That Fucks You

1

"Sólo Queremos el Respeto"
■■■■■■■■■■■■■■■■■■■■■■■■■

Racialization of Labor in New York's Restaurant Industry

I came to the United States about two and a half years ago. I have sixteen years of kitchen experience from Mexico, which includes supervisory experience. When I first arrived in the U.S., I worked at a restaurant in Maine for about six months before leaving for Boston. When work dried up in Boston shortly after the tourist season, I came to New York City. I arrived in New York about one year ago and the only work I could get was working as a porter and doing maintenance cleaning at a restaurant during the graveyard shift. I did this for three months before moving on to do prep work. My employers claimed they were paying me $9.25 an hour but I would receive a check at the end of the week for $280 for 40 hours, which is about $7 an hour. On the check, they would claim they were paying me $9.25 an hour. Sometimes I had to do eight shifts per week, which is about 64 hours, but they only paid me for 7 shifts. They never paid overtime. At one point, after not having been paid for five days I told my boss I needed my wages. He got upset and said that if I didn't like it I could leave. He said that they were doing me a favor and that I shouldn't be asking him for money he owes me. There were repercussions after this. They would only give me two or three days of work per week—just because I had complained to him. This happened for about a month and a half. After this, he made me a dishwasher and reduced my pay by about $80 a week. (Carlos, Mexican food preparation worker, qtd. in Restaurant Opportunities Center of

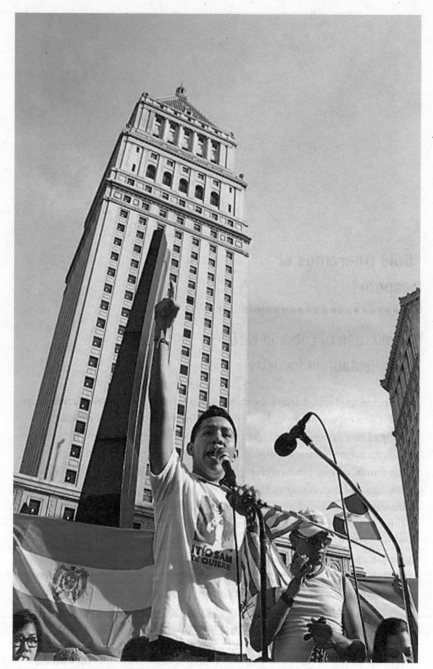

FIG. 8 Juan Carlos Romero, 2011. (Source: Juan Carlos Romero)

New York [ROC-NY] and the New York City Restaurant Industry Coalition, "Behind the Kitchen Door" 13)

Our Restaurant is located in fashion district in NYC. We do offer a full bar with happy hour twice a day. Searching for fabulous, outgoing attractive model types who have experience as a bartender and/or server. For servers and bartenders, we are looking to fill in day/evening shifts, weekends and brunch. Experience is necessary. As for the host position experience is NOT necessary. Please e-mail your resume along with 2 RECENT photos, thank you. (Ad: "Looking for Server and/or Bartender & Host [Midtown West]," Craigslist.com, 27 Nov. 2012)

There is a story that Juan Carlos (JC) Romero (fig. 8), twenty, tells every time someone asks him about why he got involved in the Restaurant Opportunities Center (ROC). It's about Rosando, a dishwasher from Ecuador with whom JC used to work. JC, who was born in Puebla, Mexico, had decided to take a year off to try to save up money to attend one of the several City University of New York colleges that had accepted him by working as a lifeguard and busser. Despite having worked closely for three years with Rosando, a man he describes as in his late forties, "a worn-out man but he still was very optimistic," JC says he never noticed how hard Rosando's life was. "This man would work from let's say from 10 in the morning all the way to almost until 12, 1 in the morning. No breaks, and he was never paid overtime," JC recalls. "Sometimes I would come into work and the restaurant wasn't busy and he would move a bucket by the dishwasher stations and just sit down and fall asleep. That's how tired he was. He was working seven days a week" (personal interview, 22 Sept. 2011). Although both Rosando and JC were working in the same restaurant in low-paying jobs, this story represents two seemingly different figures in New York City: one oppressed by a lack of options and contained in the kitchen, the other looking forward to college.

The differences of age and outlook grew once JC offered to take over one of Rosando's shifts so that Rosando could have a day off:

I started working as a dishwasher and that experience was brutal. I would work the same hours—for one day only—the same hours, from 10 in the morning to closing you know doing various jobs, not only dishwashing but also cleaning the oven, cleaning the restaurant in general, making sure it was properly put and everything and it was a lot. It was a lot. For one day, I would be dead. I would go home and I would just rest because that's how tired I was. But this man—I started realizing—he had to do it every single day and just realizing that that you know. (personal interview, 22 Sept. 2011)

Both JC and his coworker and cousin Raul "Meck" Hernández (MC of Hispanos Causando Pániko) tried to talk to Rosando and convince him that he deserved more, but Rosando always refused, saying he didn't want to cause problems. So when JC went to a presentation at the New School about an organization working for better conditions for people in the industry, the ROC, he thought he had found an answer. After attending its leadership institute, he went back to Rosando and told him that he was working with an organization that could help, but Rosando again refused. And JC, still new to the organization, didn't press the issue. "I stopped. . . . And until this day the reason that I tell people that I'm organizing that I'm actually—he is the reason" (personal interview, 22 Sept. 2011).

JC never went to college. Instead, when his father was detained by immigration he ended up using all of his college savings toward avoiding his deportation and never looked back. Since working as an office manager for ROC, JC, now twenty-seven, has worked for numerous local and national organizations, including Brandworkers International, Food Chain Workers Alliance, Center for Third World Organizing, Chinese Progressive Association, Casa del Trabajador, Immigrant Worker Center Collaborative, Communities United for Restorative Youth Justice, Workers Justice Project, and Local 1010 of LiUNA. At the same time, he has also developed as an MC and *danzante* (dancer), which he describes as "physical prayer" rooted in indigenous cultures and born out of protest (personal interview, 14 Nov. 2018). Yet it is the experience of restaurant work that has most shaped his perspective as both an activist and an artist.

JC contrasts the experience of growing up in the kitchen alongside his grandmother, learning that men weren't supposed to be in those spaces in a Mexican context, with that of going to work with his father in New York as a child because of a lack of childcare. The difference, of course, is the way in which labor relating to food is valued in varied contexts in relationship to gender. At age nine, JC would help his father, watching him rise from dishwasher to sous chef, a trajectory his father is very proud of. As a result, JC has mixed feelings about restaurant work. As he points out, "On the one hand, restaurants mean mobility. I knew that you could move up from dishwasher, to busser to runner." On the other hand, his own experience at the restaurant where Rosando and his cousin Raul worked was a bit different. Despite the fact that his cousin was a bartender and that the manager was also Mexican, JC was blocked by the owner from that same mobility. "The owner said he didn't want any more Mexicans in the front. I think he meant the shade of my skin," says JC, who describes himself as an indigenous person as opposed to others in the family like his brother who are "white passing." According to JC, "That was a pivotal moment in my life. I recognized institutional racism and I wanted to fight it. I realized I couldn't do it there, but I could in the larger industry. And it's something that

translates to a lot of industries. The restaurant industry showed me that" (personal interview, 14 Nov. 2018).

The restaurant industry in the United States thrives on the backs of migrant labor. This is not just an accepted but a desired aspect of the labor force for restaurant owners, lobbyists, and business leaders. JC and Rosando's story, along with the epigraphs to this chapter, highlights a tale of an industry that allows for and even promotes an accepted organizational model that directly violates the most basic standards of labor in this country. This is not insignificant, considering that the restaurant industry is the second-largest private sector employer in the United States, with an estimated 13 million workers nationwide. Led by the powerful lobby of the National Restaurant Association (NRA),[1] the restaurant industry has created and maintained an organizational structure that pays the majority of its workers below-poverty wages, risks the health and safety of its employees, and maintains a clearly race- and gender-segregated workplace.

I focus this chapter on the workers in New York City's restaurant industry for several reasons. First, the restaurant industry in New York City serves as a microcosm of this latest phase of racial capitalism of which the service sector is critical. Second, like JC and Raul (whom I introduced in the preface to this book), many of the people whose creative work I highlight in this book make their living in the service sector, and often in the back of the house of New York City's many fine restaurants. Last, while these trends highlighted are also present in other U.S. global cities such as Los Angeles or Chicago, New York City is critical to the story of Mexican migrant labor as it presents as the industry leader as well as an extreme case of migrant containment. Having worked in the restaurant industry myself for twelve years, I met and made friends with many of the workers, heard their stories, and saw firsthand the effects. Exploring the conditions of their work lives provides context for understanding their creative dreams.

Due to the distinctively diverse migrant population in New York, a largely male Mexican migrant undocumented population faces both severe isolation and an extreme lack of social capital. Unlike Mexicans in other cities, such as Los Angeles or Chicago, Mexicans in New York wield no political or cultural capital. Their history and community in New York is still too new and undocumented for many to acknowledge. Politically, Carlos Menchaca, elected in 2013 as the city councilman from Sunset Park, Brooklyn, is the first and only Mexican or Mexican American elected official in New York City's history. Similarly, New York Mexicans also have very limited mobility or visibility in New York's cultural institutions, a topic I explore further in the next chapter.

Over the past twenty years, the NRA has become a major lobbying force in both statewide and national politics. It is also the same period in which Mexicans have become a desirable undocumented labor force in New York City. The increased visibility of the NRA demonstrates not only that big business shapes

U.S. politics but also that its particular business model has become widely adopted and even touted as an industry best practice. Specifically, this is a business model that does not officially provide employees with a living minimum wage (currently set federally at $2.13 for tipped employees), health insurance, or sick days (Jamieson). Unofficially, restaurants often pay their workers below minimum wage, steal wages, and have some of the highest rates of gender and racial discrimination of any industry in the country, according to Restaurant Opportunities Center United, a coalition of 25,000 restaurant workers, 200 high-road employers, and thousands of engaged consumers united for raising restaurant industry standards (ROC-NY and the New York City Restaurant Industry Coalition, "Behind the Kitchen Door"; ROC-United, "Behind the Kitchen Door"; ROC-United et al., "Tipped Over the Edge"; ROC-United and Steven Pitts, "Blacks in the Restaurant Industry"). As Anthony Wright, executive director of Health Access California, a statewide health care consumer advocacy coalition of over 200 groups, asks, "But is what's good for the Restaurant Association good for America?"[2] Thus, the political engine sustaining an exploitative model based on racialized and gendered labor represents not just the current trends in racial capitalism but the way in which political and economic policy intertwine to control creative young men and women.

The restaurant industry and the service sector more generally in New York City are cases that form part of a larger labor trend in the late twentieth and early twenty-first centuries. I chose to focus on the restaurant industry both because it is so iconic in New York City culture and because it links the food harvested by largely migrant workers, a traditional topic of labor studies about Mexicans, to the preparation of food for NYC's elite. Similar cases of labor exploitation in New York City could be made for construction, hotel workers, childcare takers, and manicurists.[3] All these industries co-exist with growth in "the" economy, even if the space of that economy is shrinking. This co-existence of growth (as conventionally measured) and these constrictions further add to the invisibility of those workers (Sassen, "Language").

As the sociologist Saskia Sassen describes in her article "Global Cities and Survival Circuits," debt and debt-servicing problems for poor countries in the 1980s, along with the economic crisis of the 1990s and the structural adjustment programs implemented by the International Monetary Fund (IMF) and World Bank that followed, contributed to a vast increase in unemployment and poverty in the developing world (266–267).[4] The resulting influx of migrants to the United States bolstered a trend toward the services industries that began in the 1960s but that really has accelerated since the 1980s, with an increase of approximately 60 million employees in the 1970s, to a high of over 115 million in 2008 (Short).

New York City is demonstrative of a larger trend of service industry growth in the United States. As New York City is home to the largest undocumented

population in the United States (Cohen and Passel, "20 Metro Areas") as well as a significant immigrant population (regardless of status), employers took note and adjusted. The illegal and exploitative practices long documented on farms have expanded from coast to coast and from farm to table. In general, Latino/as are disproportionately represented in lower-paying jobs, but the largely undocumented who harvest and cook our food represent the most vulnerable.[5] Ironically, the invisibilizing of Mexican labor occurs in the context of the celebration of Mexican chefs' creativity in highly praised high-end restaurants. As Paloma Martínez-Cruz highlights, "Mexican and Chicana/o citizens and denizens of the United States get a sad laugh from the national condition that embraces its love affair with Mexican food at the same time as it evinces obsessive hostility toward the presence of its people" (239). This is especially curious in a New York City context that was long derided for its lack of "good" Mexican food by domestic migrants from the Southwest (Schulman and Lindeman). Today, New York is home to Mexican chef Enrique Olvera's restaurant Cosme (with Chef de Cuisine and now twenty-seven-year-old partner Daniela Soto-Innes), rated the twenty-fifth-best restaurant in the world in 2018, and Cosme Aguilar's Michelin-starred Casa Enrique, as well as hundreds of other Mexican restaurants and chains ranging from inexpensive street food to the $100-per-person meals served at Cosme. Still, as Martínez-Cruz points out, from New York City's high-end "New American" to French to even now Mexican, haute cuisine's embrace of farm-to-table designation of food quality and freshness still erases the farmworker while deepening notions of consumer privilege (246). It also erases the prep cook, line cook, and sous chef, who often do the bulk of the cooking.

We are used to a global world in which access to ideas, capital, goods, and people is cheaper and faster than ever before. This is a direct result of the techniques of rapid and inexpensive transport and communication, much of which was possible due to the invention of the shipping container in 1956 and thus marks the beginning of contemporary globalization as well as contemporary racializing surveillance. Although it might seem that in the age of cargo jets and air travel the ship is a thing of the past, trade carried by sea has grown fourfold since 1970 and is still growing. In fact, ships carry the vast majority of goods transported. In 2011, for example, the 360 commercial ports of the United States took in international goods worth $1.73 trillion, or eighty times the value of all U.S. trade in 1960. There are more than 100,000 ships at sea carrying all the solids, liquids, and gases that we need to live (R. George 3–4). Here, the significance of the invention of the shipping container becomes imperative. Although there are many parallels to earlier forms of globalization and shipping, the implementation and growth of the container also highlights the specifics of a contemporary moment: the mass voluntary migrations of people, the development of the service sector industry, and the growth of New York City

as a global economic power on a level not previously observed. More generally, the scale of trade and exchange of goods, ideas, and people is at a once-inconceivable level. As Rose George notes, today, "shipping is so cheap that it makes more financial sense for Scottish cod to be sent ten thousand miles to China to be filleted, then sent back to Scottish shops and restaurants, than to pay Scottish filleters" (18).

The parallel to the dramatic increase in global shipping container trade is, of course, not a coincidence. As noted in the introduction, the efficiency of the shipping container had a direct impact on local workers, whose loss of jobs freed them up for even greater labor exploitation. A major aspect of the shipping container boom in the 1960s was the early battles over New York ports, resulting in the construction of the Port Authority of New York and New Jersey, which decimated traditional dock work in New York and moved it to New Jersey (Levinson, Kindle location 134). This forever changed the face of New York City from a major center of trade to one where trade was no less significant but out of the public eye, and one that no longer employed a large number of unionized workers. As a result, shipping costs dropped rapidly, alongside the deindustrialization and devastation of the city in the 1970s and 1980s. In the 1960s, when New York was the world's busiest port, there were more than 35,000 longshoremen on the city's docks. Today, there are 3,500 (Feuer).

As Sassen points out, this development has had serious implications for the treatment of workers in late capitalist global economies more generally. She argues:

> It seems, then, that we need to rethink two assumptions: that the postindustrial economy primarily requires highly educated workers, and that informalization and downgrading are just Third World imports or anachronistic holdovers. Service-dominated urban economies do indeed create low-wage jobs with minimal education requirements, few advancement opportunities, and low pay for demanding work. For workers raised in an ideological context that emphasizes success, wealth, and career, these are not attractive positions; hence the growing demand for immigrant workers. But given the provenance of the jobs these immigrant workers take, we must resist assuming that they are located in the backward sectors of the economy. ("Global Cities" 261)

What Sassen does not discuss, though it is implicit in her commentary, is how service industries take advantage of assumptions about their workers to discourage scrutiny of labor practices. This commentary also doesn't look at how employees view their work.

For Mahoma López (fig. 9), respect for the labor of foreign-born workers was a turning point. At age thirty-three he emerged as the leader of the "Hot and Crusty" movement, in which he led twenty-three foreign-born workers in

FIG. 9 Mahoma López stands with a promotional flier for the film *The Hand That Feeds*, a documentary about how López led a mostly undocumented group of migrant workers at a New York City sandwich shop (a Hot & Crusty on the Upper East Side) to fight the abusive conditions under which they were working. (Source: Mahoma López)

an eleven-month labor campaign. As he describes, in his many years of restaurant work, wage theft was common, and migrants often lack knowledge of minimum-wage regulations. But even when wage theft was clear, this wasn't what pushed them into action. According to López, "Que te roban un dólar, ok. Dos dólares, ok. Que te hacen sentir inferior cambia todo la dínamica."[6] As López describes, this lack of respect is especially hurtful for Mexican men who come from a patriarchal society in which the expectation is that men do not wash dishes (personal interview, 15 Sept. 2015). Despite being threatened with firing and the calling of immigration officials, they stood fast—forming a union, and more importantly, consciousness of a life and possibilities outside this system of labor.

In the restaurant industry, the stagnation of wages and benefits and the frequency of discriminatory practices are directly related to the acceptance of a particular and recognizable organizational culture, in which the majority of its workforce is seen as nameless, faceless, silent racialized laborers here to fuel the economy and thus not necessitating basic allowances like breaks or proper medical attention for work-related injuries. It is a model that has developed in tandem with the growth of the service sector and the influx of migrant labor of color from Latin American, South Asia, and West Africa. As one employer commented: "They come in hungry, a bowl of rice is a luxury for them. They work harder than six or seven other workers in some cases. . . . This makes them

easier to take advantage of. It makes them work harder and it makes them more reliable. They have to do the work others will not and they're more willing to take on additional tasks, those outside their official duties, like cleaning bathrooms—without complaint" (ROC-NY and the New York City Restaurant Industry Coalition, "Behind the Kitchen Door" 35). Although the National Restaurant Association has fashioned an image that no other model is economically profitable, the industry's reliance on migrant labor is one that is relatively recent over the past thirty years and has profoundly changed the way business is done. The expectation of access to a continually renewed, quiescent, and undocumented labor force means that the whole industry is affected—documented and undocumented alike—creating salary and treatment differentials for presumed immigration status intimately tied to racialized notions of illegality. By examining the role of the migrant worker over the past twenty years, it becomes clear how an industry—one of the few that relies on a large domestic workforce—has been able to create, defend, and expand a system that is based on operating outside the law and devaluing the brown worker.

ROC-NY makes this distinction particularly clear:

> It is important not to conflate the terms "immigrants" and "people of color," particularly in the context of the New York City restaurant industry. While many of the people of color who work in the city's restaurants are also immigrants, not all immigrant restaurant workers are people of color—there are a number of Canadian, European, and Australian immigrants working in the industry. However, the experiences of white immigrants working in the city's eateries appear to be more consistent with those of their U.S. born white counterparts than with those of their fellow immigrants who are not white. For instance, one Mexican restaurant worker told us that she had recently met an Irish woman who had just arrived in the country the day before but had already found a job as a waitress in an upscale restaurant. She said that when she heard this, she began to cry because so many of her Mexican friends and family had such a hard time finding jobs, and of course none of them would ever get a job as a waitress. (ROC-NY and the New York City Restaurant Industry Coalition, "Behind the Kitchen Door" 33)

The erasure of the Mexican restaurant worker, migrant or not, undocumented or not, is a clear case of contemporary New York racial capitalism—one that highlights how immigration policy and labor markets work in tandem. It is the story of how New York City's economic shift to a heavy service sector over the past twenty years has transformed a now incredibly powerful and increasingly profitable industry, resulting in the criminalization of the worker of color, when in fact, under U.S. law, the worker is the one whose basic rights have been violated. It is the story of how the NRA has prevented any real industry change

benefiting workers over the past twenty-five years through a discourse of economic instability, despite a record of continuous growth and profit. It is the story of how some workers are starting to fight back. Finally, it is the story of how this struggle transformed their consciousness and forged an identity beyond that of labor.

What's at Stake? The Restaurant Industry and the Undocumented Worker

The restaurant industry is the nation's second-largest private-sector employer, providing jobs to nearly one in every 10 workers. . . . With the right policies, America's restaurants will be able to create even more jobs and provide greater opportunities to more *Americans*. (Scott DeFife, executive vice president of policy and government affairs for the National Restaurant Association, emphasis added)

As industry leader Scott DeFife points out, the restaurant industry is vital to maintaining a domestic workforce (National Restaurant Association, "National Restaurant Association Voices Support"). It is vital to the U.S. economy as well—restaurant industry sales are expected to reach a record $863 billion in 2019 (up 3.6 percent from 2018) representing 4 percent of the U.S. gross domestic product (GDP) (Ruggless). This is not a new trend. The NRA's 2017 Restaurant Industry Forecast, for example, projected an industry sales increase of 4.3 percent over 2016 sales, as the more than one million restaurants (up from 960,000 in 2011) continue to be strong contributors to the recovery of the nation's economy (National Restaurant Association, "2017"). Moreover, the total economic impact of the restaurant industry exceeds $1.7 trillion, as every dollar spent in restaurants generates $2.05 spent in the overall economy (National Restaurant Association, "Restaurant Industry Sales"). The importance of the restaurant industry to the nation cannot be overestimated, as Hudson Riehle, senior vice president of the Research and Knowledge Group for the NRA, points out: "Restaurant industry job growth is expected to outpace the national economy this year, emphasizing the importance of industry to the nation's economy. . . . The U.S. restaurant industry is an economic juggernaut whose annual sales are larger than 90 percent of the world's economies—if it were a country, it would rank as the 18th largest economy in the world" (National Restaurant Association, "Restaurant Industry Sales"). And it only keeps growing. In 1970, when restaurant employees were largely white, sales were $42.8 billion. By 1990 this number was $239.3 billion, rising to $586.7 billion in 2010 (National Restaurant Association, "2017"). Unlike other industries in the United States, however, the restaurant industry is not one that can move overseas or become outsourced, but instead must rely on a domestic

workforce. As such, it is one of the few bright spots for the future of U.S. employment—in fact, as the nation's second-largest private-sector employer (one in ten U.S. workers), restaurants will employ 14.7 million individuals in 2017, also the nineteenth straight year that the industry's employment has outpaced overall employment (National Restaurant Association, "2017").

For New York City, the more than 200,000 restaurant workers represent 8 percent of the city's workforce (National Restaurant Association, "New York" 1; ROC-NY et al., "Burned" 7). New York City is also particularly significant because of its long-standing position as the industry leader. Not only is New York home to the industry's most profitable restaurants, with thirty-one of the top one hundred grossing restaurants in the country, but it also has a higher concentration of famous chefs than any other city (NYC.com). New York City is by far the U.S. leader in fine dining, home to seven of the world's ninety-three three-star Michelin restaurants (PRNewswire);[7] in the United States, only San Francisco and Chicago are also home to three-star restaurants. This perhaps explains why, when rating the best restaurant cities in America, *Esquire* magazine deemed New York number one, stating, "No contest, really" (Mariani). In addition, New York City is a significant location to consider, because its 20,000 eateries must deal with some of the highest levels of competition as well as the highest rental and leasing costs in the country.

On a city level, the restaurant industry was crucial to New York City's recovery after the tragedy of September 11, 2001. Despite being hardest hit by job losses in the period immediately after the attacks, the industry recovered all lost jobs by 2003. This growth is part of a long-standing trend; since 1995, employment growth in the food services sector has outpaced that of New York City overall (ROC-NY and the New York City Restaurant Industry Coalition, "Behind the Kitchen Door" 3). Putting New York and the restaurant industry in context, the co-founder and co-director of ROC-United, Saru Jayaraman, notes, "When I took the job, I was unaware of the restaurant industry's importance. As the restaurant industry epitomizes the growth of the service sector nationwide, so too does the New York City restaurant industry epitomize the growth of service jobs in the city from the late 1970s onwards" (Jayaraman and Shahani 18–19). In the restaurant industry, the changing demography has allowed for jobs to be downgraded in terms of bargaining power, health and safety, wages, and basic rights protections. Thus, hidden beneath the debate over minimum wage, health care, and sexual harassment in the restaurant industry is the intimate connection of these labor issues to another vital matter in the United States today: immigration. As former restaurant worker and congresswoman for the Fourteenth Congressional District of New York, covering areas of the Bronx and Queens, Alexandria Ocasio-Cortez sees food as the most tangible indicator of our social inequities. According to Ocasio-Cortez, "The food industry is the nexus of almost all of the major forces in our politics

today.... It's super closely linked with climate change and ethics. It's the nexus of minimum wage fights, of immigration law, of criminal justice reform, of health care debates, of education. You'd be hard-pressed to find a political issue that doesn't have food implications" (qtd. in Cadigan). In New York, it is an industry that brings to the forefront migrant containment within the U.S. racial capitalist system that is buttressed by racializing surveillance.

The restaurant industry is an industry that thrives on breaking immigration laws on a massive scale. Out of the approximately 12.8 million workers in the restaurant industry in 2011, an estimated 1.4 million—both documented and undocumented migrants—are foreign born, according to the Bureau of Labor Statistics (qtd. in Kershaw). Moreover, according to the Pew Hispanic Center, an estimated 20 percent of the nearly 2.6 million chefs, head cooks, and cooks, and 28 percent of the 360,000 dishwashers are undocumented (Cohen and Passel, "Portrait"). Those numbers sound low to one Manhattan chef and restaurateur who admitted that one-quarter of his employees were undocumented: "We always, always hire the undocumented workers.... It's not just me, it's everybody in the industry. First, they are willing to do the work. Second, they are willing to learn. Third, they are not paid as well. It's an economic decision. It's less expensive to hire an undocumented person" (qtd. in Kershaw). It is easier to exploit an undocumented person; the restaurateur admits as much by acknowledging that these workers do not receive equal pay.

The likely undercount demonstrates the difficulty of accurately reporting a population that often strives to remain hidden, but also reflects the specific New York City context that this chef describes. According to ROC-NY, of the city's almost 200,000 restaurant workers, 70 percent are foreign born, of which 40 percent are thought to be undocumented (Sen, "Back of the House, Front of the House," 46). As Jayaraman also points out, it is not coincidental that this growth in New York's service industry has occurred during a period in which a large influx of migrants is changing the makeup of the country and the city. Nationwide, one in ten people is foreign born; in New York, one in three is foreign born (Jayaraman and Shahani 16). She elaborates: "New York is interesting to examine not only because of its complex race and immigration dynamics, but also because of how its economic trends shape the rest of the nation. Simultaneous to the dramatic growth of the service sector, millions of poor immigrants are filling its ranks. The restaurant industry, for example, has become a gateway for opportunity to immigrants from all over the Third World. Immigrants from almost every ethnic group work in restaurants as their first job in the country" (16). That New York City is one of the country's largest and most important centers of the restaurant industry and is also a city where a large number of undocumented workers are found is no accident. In this way, New York is an important example of what Saskia Sassen has termed a "global city" ("Global City" 27). As Sassen examines, "global cities" are both sites of

servicing, financing, and management of global economic processes and "also sites for the incorporation of large numbers of women and immigrants in activities that service strategic sectors in both shadow and formal economic activities" ("Women's Burden" 510).

For the restaurant industry in a city such as New York (and thus, by extension, as a leader in industry trends nationwide), this concept is crucial. Not only do restaurants serve the labor aristocracy but they are also sites where key decisions about the global economy take place (business dinners and lunches) as well as an important agent of the economy itself. On the flip side, it is where the "top-level professional and managerial workforce" comes into direct contact and yet for the most part refuses to acknowledge a largely female and migrant underclass that serves them. Finally, the restaurant is a site where "shadow and formal economic activities" co-exist, often within a single shift, in the experience of a single worker who is a member of a formal, supposedly regulated economy and regularly experiences or witnesses basic labor law violations.

Like Jayarman, Saskia Sassen has highlighted the way cities such as New York have an important relationship to elite global economic processes while also providing an invisible point of entry for an increasingly large service class that shadows the labor aristocracy. It is also a racial capitalist system and labor aristocracy that largely ignores immigration policy as an integral part of the current economic system. Sassen comments:

> A key issue in the case of immigration policy is the absence of any recognition that immigration may often be one of the trade-offs in these processes. There are a whole range of trade-offs, positive and negative, in all of these flows—in direct foreign investment, in off-shore manufacturing, in IMF austerity measures, in free trade agreements. Frequently these trade-offs are recognized and formalized into the policy framework. But immigration is never seen as one of the trade-offs—it simply is not part of the map. Immigration policy continues to be characterized by its formal isolation from other major policy arenas, as if it were possible to handle immigration as an autonomous event. ("Regulating Immigration" 36)

Yet, as I have already argued, by no means is immigration an autonomous event to the growth of either the service industry in general or the restaurant industry in particular. It is definitely not autonomous from the lobbying tactics of the NRA that have pushed the industry to record-breaking profits despite a recession that has stagnated the U.S. economy.

New York is an extraordinarily multiethnic community, with Latinx migrants from all regions of South and Central America; Asian, Arab, European, and Pacific Islander immigrants of every nationality; black immigrants from the

Caribbean and Africa; and African Americans. More than one in four (29 percent) New York City residents is of Latino/a origin, a similar percentage is black or African American, Asians make up approximately 10 percent of the population, and one-half of New Yorkers speak a language other than English at home (Camacho-Gingerich 15). Over the past twenty-five years, the restaurant industry's workforce has changed drastically with the influx of new migrants since 1965. The average restaurant worker in New York City today is likely to be young, male, and Asian or Latinx, and to have been born outside the United States (Mexicans and Central Americans make up the largest numbers). In 1980, less than half of New York City restaurant workers were born outside the United States—now, according to ROC-NY, more than two-thirds are (Sen, "Back of the House, Front of the House," 46). During this same time period (since 1991), the federal minimum wage for tipped workers, the majority of whom are found in the restaurant industry, has stagnated at $2.13 (Oliva).

These industry changes in workforce, while wages have largely been paralyzed, also occurred during a time of tremendous growth. In 1970, U.S. restaurant sales were $42.8 billion; in 1980, they were $119.8 billion; in 1990, sales doubled to $239.3 billion and doubled again by 2011 to over $600 billion (National Restaurant Association, "New York"). Jayaraman's reflection makes the connection between migrant labor and worker conditions crystal clear:

> The other thing that we need to think about is the way in which these industries have changed [as] increasing numbers of brown people work in them.... Just thirty years ago, many of the top restaurants in New York City were French, and there was not a lot of diversity. French restaurants employed almost completely French or other white European staff. Everybody working in the front and the back alike was all white. And the sector was actually much more unionized than it is now. If you went to midtown, anyplace in midtown was mostly unionized. Jobs were okay. Over the last twenty years—we've looked at census data and just published a report—the industry has become more Asian, Latino, African, Afro-Caribbean, and that's occurred coincidentally, or not so coincidentally, during the same time that wages have deteriorated, working conditions have deteriorated, and the union is almost nonexistent in the sector. Nonexistent! There are 165,000 restaurant workers in New York City, and less than 1 percent of them belong to a union, as opposed to a time thirty years ago when any restaurant in midtown you went to was unionized. ("Making Movement" 180)

This increased racial segregation is likely to be invisible to the customer in the restaurant, who sees the mostly white front-of-the-house personnel and may be unaware that the back no longer shares the same racial profile. Yet, the connection between this racial hierarchy and working conditions is extremely

important. Record-breaking profits have been achieved on the backs of migrant labor.

The restaurant industry has taken advantage of the transformation in its workforce to achieve economic success even in times of economic hardship. To do so, it has defined a worker to whom it is acceptable to pay poverty wages, deny basic workplace standards, and even break labor laws. This condition in the restaurant industry can partially be explained by the concept of the "racialization of labor" (Bonacich, Alimahomed, and Wilson 342), an important aspect of racial capitalism. Edna Bonacich, Sabrina Alimahomed, and Jake B. Wilson define this concept as follows: "The denial of full citizenship and related rights to subordinate racialized groups enables employers to engage in unchecked coercive practices, typically sanctioned by the state. Through the racialization of labor, capitalists seek to maximize their profits by employing workers of color for lower wages than their White counterparts, or sometimes for no wages at all. Moreover, capitalists are able to force workers of color to live and labor under much inferior conditions" (343). Bonacich et al. apply this concept to black labor in the South during the slavery and post-reconstruction periods (345) as well as to Latinx migrant workers in Southern California in the present (347). In this second example, the authors argue that immigration status becomes infused with race, as the term "illegal alien" becomes "a hidden racial code for Mexican, Central American, and Hispanic" (347). According to Bonacich et al., "These terms develop equivalence, where only Latina/o immigrants are perceived to be undocumented, and other categories of undocumented immigrants, such as Eastern Europeans and Canadians and even in some cases Asians, are not categorized in this way" (347).

In the restaurant industry, this racialization of labors divides the workforce into white and nonwhite divisions whereby the workers of color are coded as undocumented immigrants and thus necessarily grouped into lower-skilled, lower-paid positions. These workers may or may not be undocumented, and may or may not be migrants; however, despite their varying status and backgrounds, this racialization categorizes them as such. In contrast, white European restaurant workers, often people who overstay visas and are equally as undocumented as the workers of color, do not suffer from the same penalties, and continue to obtain the more prestigious, better-paying front-of-the-house jobs. This racialization as described by Bonacich et al. fits neatly into the "two narrow definitions of immigrants" that president and executive director of the Applied Research Center, New York, Rinku Sen sees in the current immigration policy debate: they are viewed either "as lawbreakers and potential terrorists on the one hand" or as "workers fueling the economy with cheap labor on the other" (43–44). Both definitions code migrant workers as people of color.

As Sen points out in "Back of the House, Front of the House: What a Campaign to Organize New York Restaurant Workers Tells Us about Immigrant

Integration," this dehumanization of the worker of color is exactly what provides the rationale for an industry design that thrives on treating a particular subset of its workforce as lesser, or invisible (43). It makes them desirable and is also used as a method to tell these workers not only that they must accept such treatment but also that they have no one to whom they might complain. As female pastry chef Cherisse Rodriguez described it:

> All these conditions create such a tense atmosphere, with misdirected anger, which just serves to cause a division among employees. I feel that everyone in the kitchen suffers from a type of post-traumatic stress disorder from the abuse that's deemed part of the industry. My most vivid memory is when, in a rage, a coworker threw an egg at me, splattered everywhere, and the owner did not do anything about it. It was so painful—but it was just part of the violence that happens when employees are not treated like people. The physical injuries become mental, it wears people down, it hurts them, and they don't even realize it until they are not part of the industry anymore—and many times, by then, it's too late. (ROC-NY et al., "Burned" 20)

As the quote from Rodriguez demonstrates, her experience as an employee in the restaurant industry is not one in which she feels her humanity is respected, where verbal abuse can explode into physical violence at any point. Returning to the quote from DeFife that opened this section, it is also a situation that the industry is committed to preserving. As DeFife emphasizes, the restaurant industry employs almost 13 million people, but is committed to providing opportunities strictly for "Americans" (or for white Europeans who "look American").

To the Back of the House: Organizational Culture and Hierarchy in New York City's Restaurant Industry

> I was a hostess there at night and I was a manager on weekends. So, I was there maybe a month shy of two years. I knew that restaurant like the back of my hand. I told my general manager, "I'm ready to take on more responsibility. I'm manager on the weekends and I have all of this other experience. Can you at least make me an assistant manager, or sales, or something related?" He turned around and hired someone that had no fine dining experience . . . instead of hiring from within. He knew I was interested and I was clearly capable because I ran the restaurant when he was out having surgery! [The manager] goes and hires someone else [for another assistant manager position]. And those two people that were assistant managers, I had to train them to tell me what to do![8] . . . I sent in my resume to this really nice steakhouse in Washington [for the maître d'

position]. My resume at that point was amazing. . . . I spoke with the general manager for like five minutes and we really hit it off, so it was really promising. In my mind, I knew I got the job. So, I get into the restaurant and the general manager is like, "You're Maya?" He was really taken aback by my appearance when he saw me, even though I was very well dressed. . . . He told me, "You don't have the look to be a maître d', but I can hire you as a hostess." The person that he eventually hired for the maître d' position was a tall white man and I had way more experience than him. I was extremely disappointed. . . . I felt like I need to go buy a tall white-man suit. Maybe then I could get promoted. I guess in this industry [experience and skill] don't really matter. (Maya Paley, African American, Washington, DC, qtd. in ROC-United et al., "Tipped Over the Edge" 20)

We don't have paid sick days. In the winter, I had a lot of colds, my throat closed, a fever, a headache. I had to work like that one day. Then I called to say that I wasn't going to work, but they said they would punish me because no one could take my place. They almost fired me, but I felt so bad but couldn't work so I didn't go in. [One time] when I was sick, I didn't go to work for three days. When I got my check, it was only $100 and I had to pay rent that day, which is $300—I couldn't buy food or my Metro Card. (Male line cook, qtd. in Food Labor Research Center and the Food Chain Workers Alliance 25)

What is key to the racialization of labor in the restaurant industry[9] is how the workforce is organized into a hierarchy that divides employees into two basic camps: front of the house and back of the house. This is in addition to the management level, which includes managers and supervisors and chefs. Front-of-the-house positions include all staff who have direct contact with the customer, including hosts and hostesses, servers, and bartenders. These positions offer higher levels of compensation, greater potential for mobility, increased access to training, better workplace conditions, and other important indicators of job quality compared with back-of-the-house positions. Back-of-the-house positions are those jobs that do not regularly involve direct contact with the customer, such as bussers, bar backs, food runners, cooks, and dishwashers (ROC-NY and the New York City Restaurant Industry Coalition, "Behind the Kitchen Door" 7). In this division of labor, there is an ironic reversal of expectations about skill and pay level. For front-of-the-house jobs, managers look for attractive people and do not necessarily require either experience or talent; candidates for back-of-the-house jobs, however, do need certain skills. As one manager in a New York City fine-dining restaurant described it:

For front of the house, I look for personality. Look, you've seen the studies— the taller, more attractive people make more money. It's a given. It's unfortunate, but that's what I look for. . . . What I look for in back of the house is

talent, and a good work ethic. We'd like to hire people with integrity. That makes a big difference. But certainly, front of the house people—those you see when you first come in—they have to be attractive. I just hired last year's Miss Oregon as one of our hostesses. (ROC-NY and the New York City Restaurant Industry Coalition, "Behind the Kitchen Door" 34)

Though these industry-specific divisions of labor have been developed and expanded by the NRA to increase profits and industry growth, they are still built on previous forms of racial capitalism. These racial divisions are possible because previous industries are built on similar racially segregated forms of labor.

Server Miguel Pico's experience shows how this division has come to be accepted by customers, who casually discriminate based on perceived ethnicity:

A mí me ha tocado donde trabajo ahora como mesero ir a una mesa y que la gente me diga, ¿y el mesero? No te ven como mesero, no te ven cómo puedes integrarte. La parte de tener la cara latina no te puedes integrar. Me acuerdo de una vez que me hacen una pregunta, me dicen, en inglés. "¿Cual tú escogerías, el pato o el pescado?" Demoré como 10 segundos pensándolo para dar una respuesta exacta, más confidente y la expresión de la otra persona—"no te preocupes él no habla inglés." "Don't worry he doesn't speak the language so don't waste your time." Y yo le comencé a reír. "I'm lucky that actually I speak two languages, Spanish and English, you should learn one more, too." Y el otro: "Dude, I'm so sorry." Y yo le dije, "no está bien no hay problema." (personal interview, 23 Sept. 2011)[10]

This experience is mirrored in media representations that for the first time have begun to represent a restaurant worker's point of view. For example, the film *En el Séptimo Día* revolves around José, an undocumented immigrant from Sunset Park, Brooklyn, who must decide between playing in his soccer team's league final and working a seventh day of the week at his boss's demand. From a practical perspective, the choice seems clear. He needs the work, and his boss has promised to bring him "out front" into the dining room from his position as delivery boy "soon." Of course, it becomes obvious that "soon" is a way to pressure José into working on his one day off, and that he is much less valued than it originally appears. The "best delivery guy" is fired at the end of the movie for his choice to jump in at the end of the soccer game. José was never going to be brought out onto "the floor" but instead continue to work a dangerous cycling job full of condescending customers. What *En el Séptimo Día* highlights is José's knowledge that working on the floor will provide a much better life financially for his family, and the ways in which the manager uses his undocumented status to attempt to control José despite his status as his "best guy."

In "Behind the Kitchen Door: Pervasive Inequality in New York City's Restaurant Industry," ROC-NY and the New York City Restaurant Industry Coalition concluded that "while there are a few 'good' restaurant jobs in the restaurant industry, the majority are 'bad jobs,' characterized by very low wages, few benefits, and limited opportunities for upward mobility or increased income" (ii). Not surprisingly, the study found that it is largely workers of color, and particularly migrants of color, who are concentrated in the industry's "bad jobs," while white workers disproportionately held the few "good jobs." In addition, approximately a third of the workers surveyed reported experiencing verbal abuse on the basis of race, immigration status, or language, as well as being passed over for a promotion on the basis of race, immigration status, and language. The survey also found that low-wage and below-minimum-wage workers are more likely to be exposed to poor health and safety conditions, and are less likely to be provided with job or health and safety training or to benefit from opportunities for advancement. On the other hand, accounts from workers earning living wages were more likely to report health insurance and benefits, as well as safer work environments (9). These findings were replicated on a nationwide scale in ROC-United's "Behind the Kitchen Door: A Multi-site Study of the Restaurant Industry," a combination of more than 4,000 surveys, 240 employer interviews, 240 worker interviews, and government data analysis released in 2011,[11] as well as a more recent study, *The Hands That Feed Us*, released by the Food Chain Workers Alliance in 2012. This study incorporated not just restaurant and food service workers but farmworkers, slaughterhouse and other processing facilities workers, warehouse workers, and grocery store workers for a survey representing almost 20 million workers and one-sixth of the nation's workforce. These are the people who nourish us but often go hungry themselves.

The image of Rosando, who, exhausted, attempts to snatch quick moments of rest in an otherwise nonstop fourteen-hour day, could not be more vital. As we enjoy an increasingly upscale Mexican cuisine, the experience of Mexican workers in New York is much different, especially for women. As Audry Funk describes: "Puedo decir que horrible, de terror y de explotación trabajando sin papeles las cosas cambian mucho, ser una mujer de clase trabajadora, morena y migrante no son los puntos más favorables, la explotación y el cansancio han sido al menos por el último año una constante en mi vida. La verdad es que el sueño americano dista mucho de ser UN SUEÑO, al contrario lo encuentro bien de pesadilla" (personal interview, 10 Dec. 2018).[12] Significantly, Audry Funk goes beyond a description of exhaustion with reference to her work in restaurants, describing it as one of terror. It is more than working hard; it is a life of fear and knowledge of your own exploitation.

As Albert Mills outlines in his study of the gendering of airline culture, *Sex, Strategy and the Stratosphere*, "Formal rules are expectations and requirements,

written or unwritten, routinely associated with the pursuit of organizational purposes, activities or goals, which are perceived as legitimate or 'normal'" (5). In the restaurant industry, certain "formal rules" are established to minimize labor costs that work both within and outside the confines of labor law. These "formal rules" are justified as necessary to a profitable restaurant and include the defense of legislation maintaining a low minimum wage and no employer responsibility for health benefits or sick days. These work alongside common but illegal practices such as employing undocumented workers, paying below minimum wage, and engaging in wage theft, and discriminatory treatment in hiring and advancement. As a result of these formal rules, the standardization of "informal rules" has also developed. "Informal rules," for Mills, "are those norms of behavior that arise within the context of workplace associations but which do not develop to meet the defined goals or activities of the organization" (6). In the restaurant industry, these practices include the high occurrence of physical and verbal abuse of nonwhite workers and the frequency of sexual harassment. While these "rules" do not clearly form part of the defined goal of profitability, I argue, they have become normalized as methods of containment for black and brown workers. Within an organizational culture that thrives on treating a certain segment of its workers as noncitizens and thus without rights, racialized forms of intimidation and control are synonymous with profit. To be clear, these practices have been developed from previous codes of racialized labor largely targeted at African Americans, and continue to harm both migrant and nonmigrant workers of color.

To maintain this racialized culture of profitability, the restaurant industry has made it a priority over the past twenty years to legalize as many of these formal rules as possible. This strategy begins with the normalization of a minimum wage for tipped workers that falls well below the legal minimum wage. This was not always the case. Originally, tipped workers received the same minimum wage as all other workers. The policy of paying tipped workers a subminimum wage was legally enacted in 1966, and employers were required to pay tipped workers at least 50 percent of the federal minimum wage. Since 1991, when this wage was frozen at the federal level at $2.13, the subminimum wage has been at the lowest share of the regular minimum on record (Allegretto and Filion 1–3). This creates two classes of tipped workers: those who pay little attention to their hourly wage as it is a negligible portion of their pay due to high tip earnings (generally white workers in fine-dining establishments)[13] and those whose earnings with tips do not make minimum wage or who earn little more than minimum wage. As one worker narrative demonstrates:

A friend of mine told me to work here and I was hired right away because the owner had just fired all the workers and needed new staff. I don't like the hours. I work ten-hour days without any salary—everything I make is in tips and it

averages out to less than minimum wage! My boss never pays overtime. I also don't receive health insurance from my employer or any other benefits. The managers say that we could make more money if we work harder but how can we possibly work any harder? (Sharif, Bangladeshi immigrant, server, qtd. in ROC-NY and the New York City Restaurant Industry Coalition, "Behind the Kitchen Door" 17)

Similarly, according to Henry, a twenty-four-year-old busser from Peru, he held one job for a year where he "made like $400 a week by working every day. Almost seven days. I used to maybe have one day off" (personal interview, 23 Sept. 2011).

As a result of these policies, labor costs are kept to a minimum, and tipped employees of color often find themselves living in poverty. Although the median wage for restaurant workers ($8.90) is above the minimum wage ($7.25), this wage is still below the poverty line for a family of three, meaning that more than half of all restaurant workers nationwide earn less than the federal poverty level (ROC-United, "Diners' Guide" 1). In a New York City context, ROC-NY and the New York City Restaurant Industry Coalition found in 2005 (when the New York State minimum wage was $5.15) that only 20 percent of restaurant workers earned a living wage ($13.47 and higher), while 23 percent earned a low wage ($8.98–$13.46), 44 percent earned a wage below the poverty line ($5.15–$8.97), and 13 percent earned below the then minimum wage (i.e., less than $5.15) ("Behind the Kitchen Door" 23). The effect of race and gender on wages is particularly startling here as well. After surveying 4,300 people across eight U.S. cities, ROC-United and Steven Pitts found a pay gap between black and white restaurant workers of over $4 an hour ("Blacks in the Restaurant" 2).

This gap becomes even more pronounced when gender becomes part of the category of analysis. The typical full-time, year-round female restaurant worker is paid 79 percent of what her male counterpart earns. Female servers are paid 68 percent of what their male counterparts are paid, and black female servers are paid only 60 percent of what male servers overall are paid, costing them a deficit of more than $400,000 over a lifetime (ROC-United et al., "Tipped Over the Edge" 2).

Education levels appeared to make little or no difference in workers' wages; yet while about one-quarter of black and Latinx workers and almost 40 percent of Asian workers reported earning less than the minimum wage, only 13.5 percent of white workers surveyed reported earning less than the minimum wage. Additionally, almost double the number of workers of color reported wage theft. Meanwhile, undocumented workers received a median hourly wage of $7.60 compared with $10 industry wide. When one takes into consideration that 40 percent of undocumented workers report wage theft (and much of wage

theft goes unreported), the amount of take-home pay that these workers are actually earning is criminal (Food Chain Workers Alliance 34).

Nevertheless, despite these clear wage discrepancies, paying more than half of its workers poverty-level wages is only possible given the context of racialized labor, an unlawful yet formalized practice in the restaurant industry based on discriminatory hiring and exploitative labor practices. New York State labor law does not differentiate between citizens and noncitizens, nor, as a matter of fact, do laws pertaining to housing, education, and health care; however, restaurants do. In front-of-the-house/back-of-the-house hiring, certain characteristics that demonstrate a regularization of discriminatory practices are considered desirable. Although a preference for "attractiveness" or "personality" is not overtly discriminatory, this rationale has obvious discriminatory impacts, based on the overwhelmingly white racial makeup of front-of-the-house staff, who are perceived as more "attractive" than workers of color. Whether consciously or unconsciously, these perceptions have a big impact on hiring and promotion.

In 2009, ROC-NY released the results from 138 matched pairs of audit tests, in which whites and people of color applied to the same server positions in New York fine-dining restaurants. Entitled "The Great Service Divide," the tester pairs were matched in every respect except for race and ethnicity. The results found that the white applicant was almost twice as likely to get a job offer as the applicant of color, despite slightly lesser qualifications. In addition, "workers of color earn 11.6 percent less than white workers, female workers earn 21.8 percent less than male workers, and immigrant workers make 9.7 percent less than non-immigrant workers, even accounting for differences in education, experience, and English ability" (ROC-NY, "Great Service Divide"). As Maya Paley's story, which opened this section, demonstrates, people of color, especially women, do not tend to get hired for the front of house in fine-dining restaurants (the most lucrative jobs), and even if they are able to obtain an entry-level position, such as a host or hostess, they are less likely to be seen as "management material" in the future.

As a rule, in the restaurant industry, people of color, especially Latinx migrants, are considered good back-of-the-house workers because of their work ethic, while white people are considered as the personality for the front of the house.[14] As one Latina server describes her former work at a national pancake chain: "There were a lot of older people—women in their 50's. They had children, families, some were single mothers . . . and $2.13 plus tips was all they had. . . . It really opened my eyes. It was Latinos cooking, white women working graveyard shifts, men working during the day. I saw the racism, sexism, and low wages in the industry. Everything I remember from that place was horrible" (ROC-United et al., "Tipped Over the Edge" 15).

As the ROC-NY research indicates, this notion of "work ethic" is a clear method to racialize the back-of-the-house positions and, as a result, keep wages low: "Further inquiry revealed that employers' perceptions of an employee's 'work ethic' generally related to willingness to work long hours for low wages, perform tasks that others were not willing to, and work under poor working conditions. The fact that back of the house workers are largely workers of color and immigrants suggests that employers' hiring decisions with respect to back of house positions are based, even subconsciously, on racialized perceptions of who possesses the type of 'work ethic' they are referring to" ("Behind the Kitchen Door" 34). These rules, while accepted, are consciously discriminatory and violate laws that prohibit such practices. As JC, then working as a busser at a downtown New York City restaurant, recalls: "I mean personally things like that you sorta accept it somewhat which is wrong. But you do, I accepted it where I work, I literally heard Diego, the manager, once say that John, the owner, didn't want people of color serving in his restaurant and I was just like, I really didn't think it was a big deal and then thinking about it and really analyzing what that meant, that I wouldn't have an opportunity or at least not as easily as someone who was white just because of their skin" (Romero, personal interview, 1 Oct. 2011). Even more incredible in this instance is that racism is so accepted in the industry that a white owner can make this type of overtly racist comment to his Mexican manager (in this scenario, Diego), and the Mexican manager, a rarity in the industry, is forced to accept this situation to keep his own better-paid position.

Clearly, this acceptance of discriminatory and unlawful practices is pervasive in the informal rulebook of the restaurant industry. New York State labor law sets standards for minimum wage and overtime, as well as breaks for meals. NYS labor laws require that workers receive yearly pay notices and proper wage statements. Employees are also supposed to be free from retaliation for complaining about possible violations of the labor law. As worker narratives and the numerous studies demonstrate, none of this is part of the formal rules for treatment of workers of color that make up the organizational culture of the restaurant industry that prioritizes profit through racism. Many migrant restaurant workers are not tipped workers but hourly workers (cooks, dishwashers), and for them the issue of overtime pay is especially important, as the lawful time-and-a-half pay (many report to be working as many as twenty or more hours of overtime) would boost their salaries significantly.

For example, Ezequiel, an immigrant from Mexico who has worked at Café Duke as a cook for eight years, works sixty hours a week for $10 per hour. He has never received overtime pay; however, if he had, his weekly salary would increase $100 dollars, meaning that over the past eight years his employer has robbed him of over $41,000 in lawful wages.[15] Similarly, breaks either for sickness or as mandated after four consecutive hours of work are infrequent,

especially for the back of the house, where the largest number of people of color and undocumented workers are found. As one male cook describes his situation: "I know other co-workers would punch out for their [lunch] break ... but then [my co-workers would] continue working because ... if they took a break, they would get behind [in their work.] Then at the end of 30 minutes, they would punch back in and keep working" (Food Chain Workers Alliance 27).

Wage theft is such a common issue that New York State passed the Wage Theft Prevention Act, which went into effect in April 2011. In 2010 lawsuits were brought against such big names as Michael White and Chris Cannon's restaurant group, which runs three upscale Italian restaurants in Manhattan, and Masaharu Morimoto of *Iron Chef* fame, as well as various lawsuits against Italian giants Mario Batali[16] and Joe Bastianich (Reddy). During the summer of 2010, ROC-NY organized approximately thirty-five former and current employees of Del Posto who complained of tip misappropriation, racial discrimination, and physical and sexual harassment, demonstrating how these abuses work in tandem. This combination of formal and informal rules comes together in the restaurant industry to manage its diverse workforce in a way that exploits workers of color to minimize labor costs. This is racial capitalism in New York City, much of which the city consumes every day, out of either complete acceptance or willful ignorance.

By racializing back-of-the-house labor and largely segregating workers of color into these positions, the formal rules about "the way things are" in the restaurant industry have also worked to control such an increasingly multiethnic, multiracial, and multicultural workforce. This separation of "good jobs" and "bad jobs," "citizens" and "others," "personality" and "work ethic," and "front of the house" and "back of the house" has also resulted in "informal rules" meant to intimidate and dominate. Here employer surveillance and control becomes an extension of state surveillance and control. The widespread verbal and physical abuse as well as high levels of sexual harassment that persist speak to the effect of these discriminatory practices as well as the existence of forms of "management" based on terrorizing tactics.

According to Jeffrey Mansfield, an organizer for ROC-NY who worked on the Mario Batali campaign, one of the major complaints that workers described was being verbally and physically abused on the job: "A lot of racial slurs were being used against Latinos. They were calling them 'fucking immigrant,' 'fucking stupid,' a lot of racist words, a lot of vulgar words but it was really only directed at the Latino staff members. And that was being done by management, by the person who at the time was the chef there. Also, there were people that were putting hands on people, getting physically violent with people—pushing people, kicking people, slapping a worker. So this was a huge issue for them. They felt totally disrespected" (personal interview, 14 Oct. 2011). Although

Mansfield goes on to describe their other complaints, which included wage theft and discrimination in promotions, the first and primary demand that the workers had was dismissal of the executive chef who regularly verbally abused them (personal interview, 14 Oct. 2011). This type of verbal abuse, especially that involving racial content in the back of the house, is not only common but accepted as part of kitchen culture (consider, for example, the popularity of Chef Gordon Ramsey, who is famous for his verbal tirades on shows such as *Hell's Kitchen*). In a ROC-NY survey, 33 percent of workers reported experiencing verbal abuse on the basis of race, immigration status, or language ("Behind the Kitchen Door" 37). For example, Ahmed, a Bangladeshi back waiter, reports, "The chef would always say to Muslim workers who had made a mistake 'Go to Iraq and die there!' or ask, 'Are you sending money to Al-Qaeda?' He would also tell Muslim waiters to taste food that had pork in it—when they wouldn't do it, he'd say 'you guys suck!'" (37).

I found stories of verbal abuse to be a frequent theme in my personal interviews as well. For example, server Miguel Pico recalled when a chef screamed at him so ferociously while he was working as a food runner that his face was covered in spit. The reason for this tirade was Miguel's doing his job and running the food to the table. His mistake was not reading the chef's mind, who at the last minute decided the tray was not yet ready. Miguel describes the situation, which he sees as directly related to his immigrant status:

En Porter House yo sabía que mi situación legal, era ilegal. Entonces al saber eso se veía la diferencia en la forma de tratarme. Porque los meseros no pasaron por lo que yo pasé. En Porter House me acuerdo una vez pasó un malentendido con la cocina. Jesse, el sous chef, manda la comida para una mesa y el chef, había decidido que no la mandara. Entonces al regresar la cosa lo primero que encuentro es un grito que me parecía que estaba lloviendo porque me estaba gritando en la cara, escupiéndome en la cara y con el dedo en el ojo, reclamándome el suceso. Entonces tratando de explicar—siempre he tenido una mentalidad de que no me gusta gritar a nadie porque las cosas se aclaran con una mente fría—eso es, era un abusador, realmente, porque yo creo que no lo hubiera hecho con uno de los meseros. Están dispuestos a la situación—o él es Latino, él es busboy, es runner, éste es al latino le gritamos. No estoy diciendo que es malo ser latino, soy orgulloso de ser latino y estar aquí. Pero eso me sucedió y ese hecho el saber que él, que el chef sabe mi situación ilegal. Y también me ha pasado en otros lugares.[17]

There are many more unsavory norms that can be added to these formal and informal practices that create an organizational culture built on a racialized workforce that suffers from poverty wages, racial and gender discrimination, and physical and verbal abuse.[18]

Not only is racial discrimination pervasive in the restaurant industry, but so are gender discrimination and sexual harassment, additional levels of prejudice faced by a largely black and Latina female workforce. As Linda Meric points out, "The restaurant industry is notorious for being a male-dominated environment ripe with inappropriate sexual conduct and comments." This notoriety is well justified. Although the restaurant industry employs approximately 10 percent of workers, 37 percent of sexual harassment charges and settlements reported by the Equal Employment Opportunity Commission in 2011 involved the food service industry (Meric; ROC-United and Forward Together). Moreover, about 11 percent of all workers ROC-United surveyed nationwide reported that they or a co-worker had experienced sexual harassment, a number ROC-United believes to be an undercount. Jayaraman describes: "Almost every female member of ROC has a story of sexual harassment to tell. They may not call it sexual harassment, or even recognize it as such because it is such commonplace practice in the industry. One server with five years' experience told us, 'A lot of the owners will fire you if you say anything back to them. Or if you don't flirt back at their flirting to you. They'll find an easy way to fire you'" ("Herman Cain").

Moreover, as stated previously, this informal practice is directly related to a formal practice that discriminates against women in wage earnings. The restaurant industry is one of the only sectors in which predominantly male positions have a different minimum wage than predominantly female positions: non-tipped workers (52 percent male) have a federal minimum wage of $7.25, while tipped workers (66 percent female) have a federal subminimum wage of $2.13. In many sectors, lower wages for women are often a product of discriminatory employer practices, but in the restaurant industry, lower wages for women are also set by law (ROC-United et al., "Tipped Over the Edge" 5). Not only are female restaurant workers concentrated in lower-paying segments such as quick-serve and family-style restaurants, where the tipped minimum wage is a significant portion of often-meager tips, but it is very difficult for women to access the highest-paying positions in the industry. In terms of hourly wages positions, for example, women (often women of color) tend to be confined to jobs as pastry and prep cooks, positions that earn less than line cooks. Additionally, at the highest levels, an overwhelming majority of restaurant managers, chefs, and owners are men—the United States has six times as many male head chefs as female head chefs. As Meric summarizes, "The reality is the majority of all food service workers earn poverty-level wages; it's just that women get an even worse deal."

The restaurant industry has taken advantage of the criminalization of migrants and their resulting status as "lawbreakers" to make them, and any positions associated with this status, undeserving of any consideration, rights, or benefits. The industry has also harnessed this narrative to surveil and thus contain black and brown workers in these exploitative positions. At the same

time, the restaurant industry, as represented in the discourse of the NRA, has employed two other tactics to protect and even strengthen this largely unequal and discriminatory organizational culture, with little to no public concern or governmental intervention. First, the NRA and its allies use the threat of economic collapse to oppose any changes that might improve working conditions, and second, they employ an excuse of unintentional confusion and/or human error to avoid any legal responsibility. An example of this first tactic can be seen in an editorial by John Gay, former head of government affairs for the NRA: "This is a trying time for the restaurant industry, with many restaurateurs struggling just to keep their doors open. But government does not ease up just because times are tough. Congress is working on a number of bills that have a bottom line impact on restaurants. Immigration reform may or may not make it to the finish line this year, but its success or failure remains critically important to the long-term health of the restaurant industry" (53). Gay paints the restaurant industry as the victim of overreaching government legislation when in fact what little legislation does regulate the industry is largely ignored by regulatory agencies. Currently, the NRA opposes any further federal- or state-mandated increases in the starting wage, arguing that an increase in labor costs means fewer jobs for entry-level workers and so does not reduce poverty. This conclusion is not supported in any way by studies done by such reputable sources as the Food Labor Research Center at the University of California, Berkeley (Food Labor Research Center and the Food Chain Workers Alliance "Dime a Day"), or immigration scholars such as Michael Wishnie ("Prohibiting the Employment") and Jennifer Gordon ("Tensions in Rhetoric and Reality"). Similar arguments are made around immigrant reform. The NRA argues that E-Verify, a way of checking immigration status, is too expensive to require nationally while also supporting comprehensive immigration reform—specifically, the creation of a visa system to fill jobs domestically ("Restaurant Industry Sales"). Thus, the NRA is pushing to protect its current practice of hiring undocumented workers by avoiding legal regulation, at the same time it is advocating a legal path to a cheap workforce.

This strategy is used in tandem with an excuse of confusion and human error when any sort of legal regulation is applied to the industry. When, for example, in April 2009, the Obama administration passed legislation taking a tougher stance on employers that hire undocumented migrants (Kershaw), the restaurant industry pleaded its employment of undocumented workers as an honest mistake. This is clear from a statement made by Clyde H. Jacob III, whose Coast Rose law firm is a member of the Louisiana Restaurant Association: "This needs to end. While there are some restaurateurs who are acting fraudulently, the vast majority are not. They are simply caught in the complexity of our nation's—and, more recently, our state's—immigration laws, and they

are not adept in the role of policing immigrants. Many are small employers who make good-faith efforts to cope with an increasing maze of federal, state and local laws while trying to run a business." Not only does Jacob's assertion go against what many chefs and owners willingly admit is the open hiring of undocumented workers,[19] but his assertion of honest mistakes is not credible, given the high numbers of unauthorized immigrant employment. Similarly, employers claim even wage theft is just an honest mistake. In a response to recent lawsuits, Andrew Rigie, director of operations for the city chapter of the New York State Restaurant Association, stated, "Small-, medium- and large-sized operators have the best of intentions to comply with all the labor laws, but they are fearful that a small mistake related to a complex labor law could potentially result in a suit" (S. Reddy). The response is similar to that of any other initiatives that seem standard, commonsense. The NRA supports it all *in theory*, but implementation is always either too costly or too complicated.

This second discourse of mistakes and confusion reveals an incredible level of hypocrisy grounded in worker disrespect. As Mahoma López points out, "Why do you think that the system doesn't work? You could steal an apple and they would call the police. But an owner can steal 5–6 years of wages and if you call the police they are not going to arrest him" (personal interview, 15 Sept. 2015).[20] What is striking about the NRA discourse is not just what López points out with respect to an uneven application of the law, but how when any regulation does occur—such as the stricter enforcement of immigration—it is still the worker who bears the brunt of the consequences. Why are immigration laws arbitrarily enforced—for example, the mass firings of long-standing undocumented workers at a Long Island City Bakery in April 2017—while wage and tip theft, discrimination, and illegal health and safety conditions persist unchallenged?

Demanding "el Respeto": Fighting against Racialized Dehumanization

Where would you rather eat? That's a real question. If you care about sustainability—the capacity to endure—it's time to expand our definition to include workers. You can't call food sustainable when it's produced by people whose capacity to endure is challenged by poverty-level wages. (Mark Bittman, *New York Times* opinion columnist, 12 June, 2012)

As the quote from Mahoma López, leader of the "Hot and Crusty" movement, demonstrates, Mexican workers are well aware of how they are perceived by their white employers as solely workers with no other interests or aspects to their lives. However, an important part of López's story is not just how he

emerged as a leader of the campaign but the way in which he developed a life as an activist outside work. After an eleven-month labor campaign against a corporate restaurant chain backed by a multimillion-dollar private equity investment firm, they won. Hot and Crusty agreed to reopen the store, recognize the workers' association, and sign a collective-bargaining agreement that included paid vacation and sick time for the workers, required wage increases, a grievance and arbitration procedure, and a union hiring hall that gives the association the power to hire new employees. According to López, the experience led him to realize that he had more interest in organizing than in his work. Today, Mahoma López organizes full time for the Laundry Workers Center, a community-based leadership development center geared toward improving the living and working conditions of workers in various industries. López started as a staff organizer, and in 2013 the LWC board elected him as president, followed by executive director in 2014 (personal interview, 15 Sept. 2015). As López reflected in his interview with me: "Ha cambiado mucho en el aspecto de que esa campaña me convirtió en organizador, algo que nunca pensaba que iba a pasar."[21] Significantly, organizing has transformed Mahoma López's profile from restaurant worker to a nationally known face of labor advocacy, one in which migration status is part of the argument. And this is much scarier for employers, as López points out, "La gente espera que sólo somos gente que se preocupa por ir al trabajo, pagar la renta."[22] While those used to be López's worries, he now worries not only about labor rights but also about the larger systems of injustice that support them. His identity is no longer worker, but leader.

For JC, who has worked with the ROC as well as a number of other movements (including Occupy Wall Street and the Dreamers), his experience in social movements was part of his personal journey in learning to accept his undocumented status. Today, JC, who used to hide his status from friends and girlfriends, regularly risks deportation by speaking out about his status:

> I realized that once I fear, once I put that in my mind that I'm undocumented, I label myself, just like everybody else is labeling me as an undocumented alien. I'm being what they want me to be, but I'm not that. I'm Juan Carlos. So, but even my culture, I love my culture, it's great, however, I don't let it define me. I'm Juan Carlos and you know people know me because of who I am not because of my nationality, my status or my seven-digit social. That's not what defines me. So that's personally what I think but it's hard to come to that. (Romero, personal interview, 22 Sept. 2011)

According to workers, what it all comes down to is a lack of respect. As with the ROC-NY members of the Del Posto campaign who demanded first and foremost that a physically and verbally abusive chef be fired, for Ezequiel of

Veracruz, Mexico, his substandard treatment is a matter of a lack of treatment not just as a worker but as a man. Ezequiel emerged as one of the main leaders of the ROC-NY campaign against Café Duke, which organized seventeen workers and was settled in 2012 due to its vigorous effort and solidarity as a group. When asked what they were seeking with the campaign, the first thing out of his mouth was "el respeto" (respect). What Ezequiel wanted was to be treated as people who are important contributors to the profitability of the restaurant. It turned out they were also seeking vacations, paid sick days, increases in salary, two-year contracts, and an end to verbal abuse, but respect was what he emphasized as the major motivator for the campaign. According to Ezequiel, "La diferencia fue cuando dije esto tiene que poner un alto, basta. Yo sé que si pierdo un empleo, lo pierdo. Puedo conseguir otro. Pero no se van a burlar de mí. No se va a burlar porque mi dignidad es mi escudo y lo voy a poner frente al señor" (personal interview, 14 Oct. 2011).[23] Mexican migrants in New York such as Ezequiel, JC Romero, and Mahoma López have emerged as leaders in the fight for worker recognition. Significantly, they have worked in the industry, advocated for restaurant workers, and see the restaurant industry as tied to larger labor issues, not just for Mexicans but for all exploited workers.

So has Enlace. Led by Mexican American executive director Daniel Carillo, just thirty-four himself, Enlace is an alliance of low-wage worker centers, unions, and community groups in Mexico and the United States that was formed in 1998. As Carillo describes his organization:

> The reality of abusive multisector transnational corporations means that to be effective, multiracial multisector alliances are necessary to target issues of racial and economic justice that go across borders. Since 2011, their priority has been The National Prison Divestment Campaign to target the investors of Corrections Corporation of America (CCA) and GEO Group (GEO), the two largest private prison companies in the United States. As the CCA and GEO are publicly-traded, the ownership is divided among institutions, mutual funds, trust funds, pensions, and individuals. Universities, churches, cities, and states invest in these for-profit private prisons through investment management companies such as Blackrock, Lazard, and Vanguard. As a result, many of us have a direct relationship with the private prison industry through employment, tuition, taxes, and donations without even knowing it. (personal interview, 2 Sept. 2015)

In other words, he has seen the container and refuses to be in it. A similar viewpoint can be seen in the perspective of Chef Daniela Soto-Innes, twenty-seven, who runs the Mexican restaurants Cosme and Alta. Soto-Innes is known for a non-hierarchical work environment in which her staff has time for their

well-being outside of work, are properly paid, and feel heard as contributors to the restaurants' success (Krishna).[24] Significantly, one aspect of this success is a menu that not only incorporates aspects of New York over traditional methods but embraces it as part of its identity. According to Soto-Innes, "Cosme represents a new state of Mexico. Oaxaca, Mexico City, the North—they all have different dishes because they use whatever they have. In Mexico, we don't use rhubarb, but we have it here in New York so we can use the techniques of Mexico with the incredible ingredients we have here" (qtd. in Price). This is Mexicanidad in the New York diaspora.

In each of these examples, Mexicans in New York bring their identities and perspectives to the forefront of their claim to respect their labor and make space for larger arguments about a racial capitalist system that aims to contain Mexican migrant creativity. This point of view comes to full clarity in the collaboration between Audry Funk and Yiwei Chen in their film about Funk's life in New York and the difficulty of her transition from Mexico. A feminist rapper and social activist from Puebla with significant musical stature and career, Audry Funk moved to New York in 2017 after falling in love with a Mexican American MC from the Bronx whom she met during a previous visit for a performance. However, as the film shows, New York is not hospitable to her. As she has described, her experience has been one of economic precarity trying to balance her music career, which often takes her to Latin America, with temporal restaurant work and even performing on the subway for money. Significantly, Audry's major conflict in the film is dealing with her nostalgia for Mexico and rebuilding her ego and pride as a woman, an immigrant, and an artist who is not welcomed in New York. According to Audry, "The most valuable lesson of this time of my life is dealing with my ego. I left behind a lot in Mexico but I am going to build a lot of things in the U.S." The end of the film shows footage of Audry Funk and her crew Bestia Bx (her husband) and DJ Loup Rouge performing at Harvard University as well as speaking about their experience of how to be an artist and activist.[25]

The film about Audry Funk as well as the film *The Hand That Feeds*,[26] about the Hot and Crusty movement, led by Mahoma López, and the activist expressions of JC Romero and others are significant because they demonstrate not only a Mexican perspective on working in the restaurant industry but also their lives outside of that space. This is vital because, at this time, these types of representations do not exist for Mexicans in New York in the larger media sphere. While shows based in East Los Angeles, such as *Vida* (Starz) and *East Los High* (Hulu), are groundbreaking for their predominantly Latino cast and crew as well as their centering of restaurant/bar spaces, they are very different stories from that of Audry Funk. Specifically, they center on Mexican-owned restaurants and do not demonstrate the marginalization experienced by Romero or López. The same can be said of *East WillyB*, an original web series produced

by and starring Latinos that is centered on a Puerto Rican bar owner in Bushwick, Willy.[27]

For this reason, in closing I want to offer a different perspective on racial capitalism and the restaurant industry that is not about the system but about the worker and the way Mexican worker consciousness is perhaps the most powerful tool for some undocumented migrants to become more than just laborers. It is a way to counteract the labor aspects of Mexican surveillance that go hand in hand with state practices. Here, Browne's theorization is again useful. In the face of widespread technologies of racializing surveillance, Browne argues that racialized subjects perform acts of "dark sousveillance," which entail "anti-surveillance, counter-surveillance and other freedom practices" (21). Daniela Innes-Soto's dismantling of the hierarchical system from within the industry like López's, Funk's, and Romero's development of their activist passions into new work lives represents some of these acts within the Mexican community. These form what Martínez-Cruz terms "decolonizing haute cuisine," which more than just break the "monopoly of Western aesthetic priorities" but also "sustain a commitment to reconfiguring communities and challenging the logic of domination in the food chains" (250). Other of these acts—including artistic and musical practice—are mirrored in the coming chapters.

Still, we can't begin to unravel these larger structures without first recognizing what is at stake in our most basic human act—eating. In New York City, that largely means dining out or getting takeout at a substantially higher level than in the rest of the country (58 percent of lunch and dinner in New York vs. 47 percent in the rest of the country) and at some of the highest prices in the United States (Reuters). Moreover, Mexican food has never been more popular. In New York City, blog after blog gushes over the cuisine's moment. With the addition of high-end Mexican restaurants like Enrique Olvera's Cosme, Mexican cuisine is finally getting the respect in the industry it has long deserved. Mexican workers are not. New Yorkers have become so accustomed to the invisible migrant worker, so ideologically contained by a system of racial capitalism, that even when eating a culture, this most obvious of connections is ignored. It is not a distant imagined farmer harvesting corn; it is a Mexican woman a few feet away making tortillas for mass American consumption. And yet we don't see her.

Thus, like Sassen, I ask that we "recapture the geography behind globalization" to include the workers, communities, and cultures of not just those who dine in Manhattan's restaurants but by extension the dishwasher in a fast service restaurant ("Global Cities" 257). In this way, these "global cities" will no longer be places where the worker is devalued so far as to become a nameless racialized other, but rather will be places where worker demands for respect are not lawsuit or rhetoric, but a right anyone can demand, a right that no one

should have to demand, a right that when demanded commands concern. When workers are valued again in this country, respect no longer must be demanded; it is granted and protected under our nation's labor laws regardless of race, gender, or immigration status. When workers are valued again in this country, they are no longer just workers but talented young men and women full of imagination and creativity. Their stories fill the following chapters.

2

Hermandad, Arte
y Rebeldía

■■■■■■■■■■■■■■■■■■■■■■■■■

Art Collectives
and Entrepreneurship
in Mexican New York

We're going to secure the border, and once the border is secured at a later date, we'll make a determination as to the rest. But we have some bad hombres here and we're going to get them out. (President Donald Trump, 16 Oct. 2016 [Gurdus])

Art is a struggle between the part of the molding we are encased in. Art is a struggle between the personal voice and language, with its apparatuses of culture and ideologies, and art mediums with their genre laws—the human voice trying to outshout a roaring waterfall. Art is a sneak attack while the giant sleeps, a sleight of hands when the giant is awake, moving so quick they can do their deed before the giant swats them. Our survival depends on being creative. (Gloria Anzaldúa [*Making Face*, xxiv])

Fridamania shows no signs of relenting. (Graham W. J. Beal, director of the Detroit Institute of Arts [Trebay])

Sarck HAR (fig. 10), thirty, is a soft-spoken, unassuming man. Despite a body covered with tattoos and an affinity for black clothing even in summertime,

FIG. 10 Sarck tattoos a customer at Har'd Life Ink. (Photo: Daniel "Solace" Aguilar)

he comes off as shy. When you enter his tattoo shop in Brooklyn, you'll find him either with a customer or intently hunched over a sketchbook. He is also the leader and co-founder of an arts collective that boasts more than two dozen affiliated Mexican artists who attend weekly meetings, run various businesses and a performance space, and host monthly public hip-hop and art shows.

On a Sunday in July 2015, for example, approximately one hundred young Latinos, the majority Mexican men from all the boroughs, converged to see approximately ten artists—seven from Mexico who reside in New York, another of Mexican descent who traveled from Chicago to perform, a Peruvian rapper, and a Puerto Rican rapper. Beginning with freestyling (rapping lyrics improvised in the moment), from 5:00 P.M. until 1:00 A.M. the crowd ebbed and flowed, drinking beers, chatting about artwork, or watching the live tattooing in the back room by both Har'd Life Ink (HAR) members and special guests from other shops. One artist in particular, Hugo Andrés (not a member of the collective), is highly sought after for his quality tattooing as well as his portraits of Mexican figures such as Cantinflas and Pancho Villa. Mostly the majority male crowd listened respectfully and appreciatively as MCs took their turns, organized mainly by who showed up at what time. A ska band got a small group of twenty or so dancing around 9:00 P.M. MC battles occur for fun, as there is no real competition or animosity. In fact, in over three years of attending Har'd Life Ink events, I have witnessed only one dispute—a drunk MC interrupted another's set forcefully and belligerently. He was escorted out peacefully and

the show continued. Sometimes even Sarck will throw down a freestyle, though rapping is not his specialty. "El punto es compartir nuestra cultura. . . . Tener un espacio aparte para nosotros," Sarck explains (personal interview, 1 Aug. 2015).

This sense of space is so important for Sarck and those who attend the shows because of their perception of containment in most every other aspect of their lives. With few exceptions, Har'd Life Ink members and those who attend the shows are mainly undocumented male migrants who arrived to New York as teenagers or young adults. While some arrived to join family and reside with them (e.g., Kortezua), others came for family, only to branch out on their own (e.g., Sarck), and still others came by themselves (e.g., Pisket, Sorick, and Rhapy). I find these latter individuals particularly significant; for the cases of Rhapy, Sorick, and Pisket, New York City was a destination they chose as artists. Nevertheless, as young migrants their options for education and workplace advancement are limited. As María Lugones has commented, in a different context: "The U.S. society places border dwellers in profound isolation. The barriers to creative collectivity and collective creation appear insurmountable" (qtd. in *Entre Mundos* 97). This combination of high levels of employment, high levels of poverty, and few moments of privacy creates a profound sense of isolation as well as an experience of surveilled containment. MC Kortezua, twenty-six, of the duo Forasteros (a name that unabashedly references and proclaims their outsider status in society), describes it this way: "Son muy pocas las oportunidades para mexicanos aquí, hay muy poco espacio" (Bello Cornejo, personal interview, 8 Oct. 2013).[1] Similarly, the youngest member of Har'd Life Ink, MC and videographer Wilberth Ulises Aparicio ("Sorick"), nineteen, describes how he came to the group after experiencing repeated rejections from other groups and settings when sharing his music. For this reason, he similarly expresses why this space is so important: "Nos desprecia más que nada," he says. "Lo que es, es pedir un espacio. Siempre pedimos un espacio para poder no sé . . . buscamos un lugar para dar lo que nosotros hacemos. En si ahorita es lo que estamos haciendo" (Sorick, personal interview, 2. Nov. 2013).[2] These comments by New York Mexican migrant artists remind us of how a relation to space shapes their self-analysis, and how this yearning for respect for their creative work echoes that for respect in the cheap service sector laboring world. Likewise, it evokes what Virginia Woolf, in a different context, and from a gendered perspective, called "a room of one's own" as a necessary condition for artistic production. These artist collectives represent a different type of Mexican migrant transnationalism than previously researched in New York City. They are spatial relationships that are transnational but not based in familial networks; instead, they are diasporic artistic connections shaped both by migration and by imaginative relationships maintained with Mexico City and beyond.

For those dwellers of this new Atlantic Borderlands, the sense of isolation can be particularly extreme and contains an inherent paradox. How does one

find a community when working long hours (as in the example of the restaurant industry), crowded together in tiny living spaces, and rarely alone? Where is the artistic space for like-minded musicians and artists to meet and to share their ideas and their work? Gathered Corona, Elmhurst, and Jackson Heights in Northwest Queens; Bedford Park, Mott Haven, Port Morris, and Soundview in the Bronx; Bushwick and Sunset Park in Brooklyn; and East Harlem in Manhattan: Mexicans find themselves in the poorest and most underserved neighborhoods in terms of city services and access to the arts (New York City Department of Planning).[3] Moreover, within these neighborhoods housing can present extreme challenges due to the increasing cost of living in New York City. As one 2008 study demonstrated, the average number of undocumented Mexicans who resided in a single room was 2.2 (Standish et al.), with it not being uncommon for families to double and triple up in studio or single-bedroom apartments (Sharman 107).[4]

In fact, as the Mexican population has grown in New York City, work and housing conditions have only become more difficult due to skyrocketing rents and the increasing inequalities that result from a racial capitalist system. For example, rental prices increased by 250 percent from 1974 to 2006, and these prices have not kept pace with the minimum wage, a wage many undocumented workers fail to even come close to achieving (Furman Center for Real Estate and Urban Policy 9). The combination of housing booms and economic downturns has resulted in a poverty rate among Mexicans in New York that rose from 19 percent in 1990 to 28 percent in 2010 despite reporting the lowest unemployment rate in 2010 (at 6.4 percent) of the major Latinx national subgroups in the region, and very high labor force participation rates at 66 percent (Bergad, *Demographic, Economic and Social Transformations*). In the face of Mexican migrants' significant contributions to the New York City workforce, the clear message is that their labor is not respected, as demonstrated by the discussion of restaurant workers in the previous chapter. Over and over, New York City tells Mexicans: there is no *space* for you here.

For those Mexicans engaged in the arts, the message is even blunter: your work is not desired nor is it *valuable*. Not only are 85 percent of museum and art gallery curators white (Schonfeld and Westermann), but even the selection of the Mexican curator Patrick Charpenel as the new executive director of El Museo del Barrio, the country's oldest museum dedicated to Latinx and Latin American art, demonstrates their marginalized position. In both, there are clear racial and class messages about who can and cannot be considered an artist (Moynihan). Perhaps that is why for Har'd Life Ink and Cultural Workers, the heart of their project goes beyond solely finding space for their creative worlds. It is about transforming their artistic labor into not just a practice that they economically control but also a labor that is evaluated by their own community standards and, as such, is highly valued on multiple levels.

Although a separate collective from Har'd Life Ink, Cultural Workers, founded by Mexican artist Gabino Abraham Castelán, similarly supports creative workers by reclaiming and revitalizing vacant or underused properties and putting on for-profit multidisciplinary events. In either Har'd Life Ink's tattoo parlor or the roving spaces occupied by the Cultural Workers, labor is not a commodity to be consumed by racial capitalism but a cultural practice they dictate, develop, and share on their own terms. In this way, Har'd Life Ink and Cultural Workers serve as a powerful rebuttal to consumer demands for cheap service sector labor in the form of the uncomplaining Mexican body.

As I outlined in my introductory comments, sociological approaches to immigration have not adequately examined how neoliberal globalization institutionalizes inequalities through ideologies and practices that require countries to espouse free markets and privatize state interests. Moreover, as Ronald Mize and Alicia Swords outline in *Consuming Mexican Labor: From the Bracero Program to NAFTA*, scholarly literature on consumption tends to gloss over the back-breaking realities of those workers and fails to address their social lives.[5] According to Mize and Swords, "Laborers are observed through a camera obscura whereby production labor is either rendered invisible or callously disregarded. The self-centered focus on consumers and on the satisfying of one's own wants at the direct expense of others ignores the conditions of production and capital accumulation, the exploitation of laborers, and treatment of workers as disposable bodies" (Kindle locations 386–389). However, while Mize and Swords attempt to remedy this oversight in some form by way of their scholarly attention to new forms of labor organizing, there are still limits to their critique of what Appadurai termed "the work of the imagination" for the privileged consumer (Mize and Swords, Kindle locations 373–381). Following Rebecca Schreiber's *The Undocumented Everyday: Migrant Lives and the Politics of Invisibility*, which focuses on the self-representation of Mexican and Central American migrants in documentary form, in these pages I present rich social and work lives that are also deeply creative ones.

The collective practices of groups examined in this chapter—Har'd Life Ink and Cultural Workers—represent a real-life consideration of the structural forces that attempt to make them invisible laborers, as well as their counteraction of visibility via practices of space claiming and arts entrepreneurship. Although these groups as well as the various artists whom they represent vary greatly in their artistic styles and practices, each represents the creative capabilities, and moreover desire, for organizing and art making that is not just collaborative but profitable. On an individual level, these artists also testify to the significance of their art as individual expression or career choice, while at the same time it is the community practice they most emphasize. Like the Dreamers who refuse to silently accept the discourses of illegality that positioned them as criminals and outsiders (Solís, "Immigration Status" 356),

these migrants are attempting to reclaim their identity beyond that of the ste-reotyped laborer through artistically based communal and public labor actions located in creative alternative economies. Although their legal status may not change, these art collectives are a way to publicly advocate for a Mexican iden-tity that is not based on migration status or laboring body, but instead is focused on cultural contributions and artistic skill that is also monetarily valued. Beyond resistance, these practices are an act of what I call "anti-deportation," in that they not only reject a narrow illegal identity but also establish artistic institutions. In a climate in which official government policy is promoting immigration enforcement strategies so inhumane that they encourage self-deportation, their acts of visibility not just as individual artists but as business owners are as brave as they are innovative.

Hermandad, Arte and Rebeldía: Mexican Art Collectives in New York

The name Har'd Life Ink stands for Hermandad, Arte y Rebeldía (Brother-hood, Art and Rebellion). According to Sarck, *hermandad* means "a true union," *arte* represents both creative capacity and artistic inspiration, and *rebeldía* is an act of not accepting the status quo (personal interview, 14 Oct. 2013). Har'd Life Ink was not founded in New York City, however, but in Mexico City as a graffiti crew named HAR in 1996. This adaption of a Mexican graffiti crew into a New York art collective represents the utility of an Atlantic Borderlands framework by highlighting how Mexicans engage with African American signifying practices. "Har'd Life Ink" is significant not only because it is an English name using the original Spanish letters as an acrostic, but also because it resonates with other urban vernaculars. Its meaning also serves as a response to the burdens of criminalization, labor exploitation, and racialization.

As 60 percent of Mexican migrants to New York City are men with an aver-age age of twenty-six, many find themselves for the first time without the pres-ence of female loved ones and face new challenges in creating communities (Bergad, *Latino Population of New York City* 8). The largely masculine spaces of hermandad (brotherhood) serve to curb the isolation felt from these absences. As Sarck Har, one of the co-founders of the Har'd Life Ink arts collective, describes it, forming the group was not just a diversion but a necessity. Accord-ing to Sarck, who has been away from all his family except for a sister in New Jersey since 2003, "Ya no quería estar solo. Quería relacionar con la gente. . . . Fue la necesidad" (personal interview, 14 Oct. 2013).[6] I find similar echoes of isolation and absence as well as the desire to form new social links in the lyrics of rap group Hispanos Causando Pániko, graffiti artist and MC Kortezua, and many others.

Despite the majority male makeup of these spaces, there is a handful of women who both perform and attend shows, and women are welcome. Women are members of Har'd Life Ink though not Cultural Workers, but more as a reflection of social circles than a stereotypical Mexican machismo. In these spaces there is no sense of what Robert Smith has defined as "ranchero masculinity"—that is, "one hegemonic configuration of gender practices that legitimize men's dominant and women's subordinate position" (*Mexican New York* 115). According to Sarck, women are encouraged to participate but tend to have less interest. The distinction for Har'd Life Ink is not between men and women but between crew members and collective members, as the latter are those who invest money in the business (personal interview, 1 Aug. 2015). Gabino Abraham Castelán recognizes the gender imbalance in his group and is actively seeking out female cultural workers (personal interview, 12 Dec. 2016). Moreover, his events involve topics such as eating disorders, which disproportionately affect women (personal interview, 5 Dec. 2018). In this context, I find the "narrative of the macho" and similar characterizations harmful and inaccurate. Here, Solórzano-Thompson's *Act Like a Man*, in which she presents the different and limiting ways Mexican and Mexican American masculinity has been examined through the lenses of both social sciences and the humanities, is particularly useful. Consequently, bringing Anzaldúa into the Atlantic Borderlands brings not only Mexican experiences to the East Coast but the voices of women to a largely masculine world and fields of scholarship.

On the flip side, young Mexican migrant women in New York often must figure out how to navigate these masculine spaces. Rhapy, twenty-five, a member of the Buendia INK collective I explore in the following chapter, describes her experience in New York's Spanish-language hip-hop scene as one of often being the only woman. As such, she walks the line between her belief that "la mujer aporta mucho en el género en hip hop" and the realization that "nunca van a estar tan aceptadas por los hombres" (personal interview, 11 Nov. 2013).[7] However, for Audry Funk, this is a function of women's position in the larger world, not so much these New York Mexican hip-hop circles. According to Funk, "Lo más difícil de ser mujer, pues es creo lo mismo que en cualquier ámbito de la sociedad que te tomen en serio, que no te vean a menos y que respeten tu poder. No es la música, es el mundo mismo" (personal interview, 10 Dec. 2018).[8] For Mexican women, their bodies serve as battlefields of the immigration debate in a way that is much different than for men. While a large male migrant population toils in the background, women's reproductive rights and access to health services[9] are at the center of anti-immigrant fears. For unlike slavery, under U.S. law, "illegality" is not passed from mother to child but instead U.S.-born children are granted citizenship, and supposedly all the rights that affords. As I have previously described, despite the promise of citizenship for U.S.-born children, it is not uncommon both historically

and in the present for mothers with U.S.-citizen children to be detained and deported. Nonetheless, despite numerous attacks, birthright citizenship continues to be a part of the Constitution and U.S. law (Farley). This is most certainly why President Obama's later deportation sweeps were aimed at women and children ("Shameful Round-Up") and why Trump made it a central part of his campaign to not only deport 11 million migrants but also revoke birthright citizenship of those he calls "anchor babies" (Farley).

The original Mexican HAR crew, which remains active, was where Sarck honed his skills. Sarck, who has returned five times for crew anniversaries and still considers himself a member of the Mexican crew, serves as a mediator between the U.S. and Mexico City groups, forming a transnational crew of sorts. All graffiti or murals, for example, done by the Har'd Life Ink group are tagged "HAR NYC—MEX," and they create links by sharing pictures of their work via Facebook.[10] Significantly, members of HAR-NYC, especially Sarck, risk the impossibility of return by traveling to Mexico to celebrate these events. In a truly bi-national organizational move, the affiliated music collective Buendia BK even sent two MCs (Versos INK, Mauro INK) to perform at the celebratory concert for the seventeenth anniversary of the HAR crew in Mexico City, alongside their transnational counterpart INK (T-Killa is the founder). Despite the current anti-Mexican climate and increased risk of border crossing, Sarck made the round trip yet again during the summer of 2017.

Sarck and the others are both physically and artistically border artists in multiple senses of the term: bridging countries, artistic practices and traditions, and communities. As Gloria Anzaldúa writes: "The border is a historical and metaphorical site, un sitio ocupado, where single artists and collaborating groups transform space, and the two home territories, Mexico and the United States, become one. Border art deals with shifting identities, border crossings, and hybridism. But there are other borders beside the actual Mexico / United States frontera" (*The Gloria Anzaldúa Reader* 184). As an individual artist and leader of HAR-NYC, Sarck represents the challenges and possibilities of borders in New York. A crosser of both physical borders and societal barriers, he has striven, alongside co-founder Fernando "Pisket HAR INK" Gutierres, twenty-nine, to create a space for alternative Mexican identities and artistic expression in New York City that is culturally relevant and independent of traditional artistic structures.

Sarck migrated to New York in 2003 following an older brother who arrived a few years earlier, and settled in Brooklyn. Like many, he took a bus from Mexico City to Sonora, where he paid a coyote to help him cross the border. Once he arrived in Phoenix, he took a flight to New Jersey, where his sister, married and with children, still resides. Struggling to find decent work, Sarck worked in a bakery, at a car wash, and in construction and cleaning until, while delivering food, he met Pisket of Mexico City, another delivery worker living in

Brooklyn. They quickly became friends as Pisket was also a graffiti writer, and they began to paint together at night three or four times a week (Sarck HAR personal interview, 1 Aug. 2015). As Sarck describes it, both were yearning for a community that would share their interests and give them a sense of purpose.

The turning point came, however, when Sarck and Pisket began to tattoo in 2008. After meeting other tattoo artists at a party, they collectively purchased a tattoo machine and began to practice on their friends. As lifelong artists, they learned quickly: "En 15 días, ya estaba tatuando"(Sarck HAR, personal interview, 14 Oct. 2013).[11] For Sarck and Pisket, tattooing became a livelihood that allowed them to explore their artistic expression, as well as a job that gave them free time to draw, paint, and airbrush. More importantly, it became a place of community and finally a space of both artistic and economic independence. In their labor as tattoo artists, there are no outside parameters on how they develop their style. After a few years of tattooing for others, Sarck and Pisket opened Har'd Life Ink, a tattoo shop and performance space in South Park Slope, Brooklyn, in 2012 (Sarck HAR, personal interview, 14 Oct. 2013).

By 2013, Har'd Life Ink had become the center of what Sarck terms "la cultura underground" in New York, a blend of Mexican popular art that includes tattooing, MCs, break dance, skateboarding, graffiti, airbrush, painting, sketching, photography, fashion, and poster painting (see figs. 11 and 12). Although Mexican individuals and small groups had participated in graffiti and other popular culture expressions since at least the early 2000s, they were isolated by the city and the pressures of everyday life and seldom knew each other (personal interviews). As MC and HAR-NYC member Kortezua of Cuernavaca describes that change, "El cambio ha sido muy drástico. Antes sólo vinieron a los shows los rappers y ellos mismos era el público" (Bello Cornejo, personal interview, 8 Oct. 2013).[12]

The founding of a space for Mexican art and hip-hop has not only created a public but also brought out many more Mexican youth looking for an artistic community with whom to share their work. Although these types of spaces have an important tradition and history in other cities such as Los Angeles, Houston, and Chicago,[13] they are a very new development for a Mexican population with little institutional representation.[14] Har'd Life Ink provides that space, as well as informal mentoring systems where older artists share techniques with younger ones. As Sarck describes it, "Eso es la importancia de la unidad—dejar de pensar sólo en ti y pensar en ellos también" (personal interview, 14 Oct. 2014).[15] In fact, HAR-NYC and Har'd Life Ink constitute a form of place-based identity and struggle, and a home for a group excluded from other places and cultures for reasons of race, class, and ethnicity. As a result, the members of HAR, like other Mexican collectives in New York, depend largely on such physical *places* to carve out their own sense of artistic space and identity.

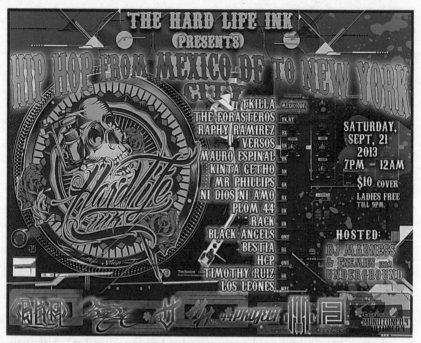

FIG. 11 Har'd Life Ink poster for hip-hop show on September 21, 2013. (Source: Sarck)

Originally a transnational graffiti crew, Sarck and Pisket quickly conceived of Har'd Life Ink as something bigger and formed an arts collective in 2013, and also expanded their operation to a second space in the Bronx. Their over two dozen members represent hip-hop's four elements, as well as multiple artistic styles. They hold weekly meetings in which they share work, make decisions about the group, and plan events. Older members like Sarck and Pisket also teach younger members—some as young as eighteen—the arts, including tattooing, so they can also be self-sufficient artists. Thus, at any given time, seven days a week, Har'd Life is a space for Mexican popular artists to work, find community, or learn new skills. And for more than just Sarck and Pisket, it has become a way to get out of a life of restaurant kitchen work, cleaning, or deliveries, as others have joined the tattoo roster. More than a half dozen members of the collective make their living tattooing in one of Har'd Life Ink's two locations, while others also sell clothing and other merchandise. Most importantly, no one is the boss—each works at the shops as an independent contractor, and all decisions are made collectively (Gutierres, personal interview, 19 July 2015). As such, they also build on an important history of mutual aid societies (but not hometown associations) in both African American and immigrant communities (Fox and Bada; Bada). In particular, African American mutual aid societies based in cooperative economics represented the recognition that capitalism was never going to finance black liberation

(Nembrand). However, for even those who are not economically sustained from the tattoo shop, Har'd Life Ink offers its community relatively low-budget, very mobile, and urban art practices in which people learn from each other and/or develop individually. Thus, these artistic practices themselves are also about space as many are both producers and audience.

More than just a business, this sense of community is held together by a set of core values as emphasized in their name. Beyond hermandad, arte reflects a sense of pride in the cultures of Mexico or what Sarck refers to as "Mexica culture." For Sarck, this is expressed in what he calls *estilo azteca*, which has a heavy emphasis on indigenous images and animals like jaguars, eagles, and serpents. On the other end of the spectrum, Eric Rodriguez, twenty-five, of Puebla, prefers abstract work and references surrealism (personal interview, 24 Oct. 2014). Of course, this is no less Mexican—surrealism has a strong tradition in Mexico as well (Helm 164). Still, among the visual artists of the group, pre-Hispanic themes are what dominate, followed by work that reflects the transitory nature of life (life/death).

Although Sarck acknowledges that many of their styles—skulls, flowers, lettering, and so forth—are reminiscent of a Chicano style, he says his work is different because it is based in indigenous roots and not gang lifestyles. While Sarck respects the Chicano culture and outlook, and recognizes commonalities, he also sees his more recent experience of immigration as well as the New York City location as distinguishing him from their experiences. "Ellos nacieron con otra mentalidad," Sarck says of Chicanos (personal interview, 24 Oct. 2014).[16] Nevertheless, Sarck's work has clear artistic echoes of the Chicano movement art as opposed to more recent expressions of what is termed Chicano rap, which has a more gangster style (though is not necessarily affiliated with gangs).[17]

Significantly, as the majority of the members of Har'd Life Ink migrated from Mexico within the past ten to fifteen years, their first encounters with popular art forms such as graffiti or muralism occurred in their hometowns in Mexico. For example, for Sarck, it was his move from San Luis Potosí to Mexico City at age seventeen that brought him into contact with a robust graffiti scene and the HAR crew. There, he learned from HAR founders Cosme and Honor (who are still active) and became a member of the crew after two years of practice. While understated in their own work, the cross-border tracings of aesthetic influence are complex. Historically, Mexican graffiti has been strongly influenced by the Chicano movement art of the 1960s and 1970s (Maciel 116), and Chicano movement art was strongly influenced by the legacy of the so-called *tres grandes* of Mexican post-Revolutionary muralism: José Clemente Orozco, Diego Rivera, and David Alfaro Siqueiros, who were commissioned for major U.S. mural projects in the 1930s. Young artists in Mexico are, of course, exposed to the great post-Revolution murals in many schools and other

public buildings in their home country. Thus, Mexican popular art in NYC actually represents at least ninety years of cross-cultural exchange that is only becoming more fluid with today's technology but is nevertheless rooted in a bi-national New York–Mexico identity and experience.

As Alicia Gaspar de Alba has studied, there are various relationships in art among place, identity, and aesthetic development and production, including race-based aesthetic diasporic aesthetics, and Aztlán aesthetics, the last of which is attributed to Chicano artists. Unlike Mexican artists in New York who still see their homeland as Mexico, the "Aztlán aesthetic is a representation of both territorial dispossession and cultural reclamation" ("There's No Place Like Aztlán" 114). There is a decolonial aspect to the aesthetic in terms of their relationship to the United States that does not exist for Mexican migrants in New York. Likewise, as opposed to some of the migrants in this book, Aztlán aesthetics is full of mythmaking about indigeneity rather than actual experience with indigenous communities. However, in the cultural reclamation as well as the connection to labor activism (i.e., the farmworkers movement) is where the Chicano movement influence movement and Aztlán aesthetic are significant. C. Ondine Chavoya's work on the artist Rubén Ortiz Torres, a *chilango* (Mexico City native) living in Los Angeles, is particularly instructive in understanding overlapping aesthetics. As Chavoya describes, "Torres is a transient citizen who recognizes that the coordinates of place and identity are tenuous and constantly shifting. The lived experience of more and more people, including transnational artists, migrant workers, diasporic communities, and exiles, occurs outside the cultural norms idealized by the state, and this situation often results in transnational cultural formations that move beyond ethnic and national lines" ("Customized Hybrids" 143). Thus, Mexican migrant artists in New York find themselves in conversation with a third phase of border artist whose concept of home insists on a barrier and is not about nationality, but rather "offers a combinatorial consciousness of a binational identity that is *both* rooted in the border zone *and* worldly, *both* committed to a politics of location *and* keenly aware of the hyperspace of postmodernity" (Berelowitz 340). While influenced by the Aztlán aesthetic of a Chicano movement with brotherhood as the principal mode of community building, there is also a practice of "diasporic aesthetics," which "explores the reality of being uprooted" (Gaspar de Alba 111). Specifically, this exists through the collaborative and independent business model that responds directly to the layers of marginalization for Mexican migrant artists in New York City. The Mexica aesthetic then is a "customized hybrid" of sorts. Like the border art produced by "Chicana/os, Latina/os, Mexicans, and multiethnic allies invested in cross-cultural exchange and coalition" before it (Chavoya, "Collaborative Public Art" 209), in New York "Mexica culture" represents a New York City borderlands of not just bi-national, cross-country, and cross-cultural exchange but also community building.

Mexican crews have often shared a revolutionary image and clear sense of purpose. In contrast with the transborder cholos who came from San Diego or Los Angeles and participated in mural and tagging activities during the 1990s in Tijuana, and who, according to Valenzuela Arce, tended to have about six or seven years of formal education (87), many of the members of the long-running HEM (Hecho en México) crew graduated high school, and some of them had university backgrounds (Sánchez López 46). During the 1990s, at the height of the Zapatista/graffitero conjunction, HEM wrote and circulated manifestos, like this one:

> Y los taggers decorarán la ciudad. Y esperamos que comprendan que este también es nuestro mundo, y que si a ustedes no les gustan los graffitis y los tags, pues a nosotros no nos gustan sus anuncios, ni la educación que nos imparten, ni su corrupción, ni su industria contaminante, ni sus guerras, ni sus vidas.
>
> Acabemos con el pasado. Cambien y cambiaremos. (Ilich 15)[18]

Thus, the history of political and artistic statements made through popular art is a long and complex one, running back and forth across the border, with a sense of a social and political purpose underscoring the artistic practice.

As the Chicana artist Judy Baca describes work like hers, "Chicano art comes from a creation of community. In a society that does not affirm your culture or your experience Chicano art is making visible our own reality, a particular reality—by doing so we become an irritant to the mainstream vision. We have a tradition of resisting being viewed as the other; an unwillingness to disappear" (qtd. in Griswold de Castillo et al. 21). That refusal to disappear, to hide out, or to assimilate is in every stroke drawn by HAR-NYC. Though they do not identify as Chicanos, the transnational dialogue among Chicano and Mexican popular art, neomexicanismo, and a graffiti sensibility has shaped Har'd Life Ink into a unique space for Mexicans in New York. Thus, the aesthetics pursued by HAR-NYC attempts to reverse the flow of conventional artistic practices in which community is redefined so as to include a diversity of subjectivities and positions. Second, there is an entrepreneurial aspect to the HAR-NYC project, a make-do attitude that says that having one's own business is a way of resisting the effects of domination in a racial capitalist society that recognizes *only* capital as a trademark of human dignity. In this way, Sarck, Pisket, and HAR-NYC seem to heed Anzaldúa's warning: "There are many obstacles and dangers in crossing into nepantla. Border artists are threatened from the outside by appropriation by popular culture and the dominant art institutions, by 'outsiders' jumping on their bandwagon and working the border artists' territory. Border artists also are threatened by the present unparalleled economic depression in the arts gutted by government funding cutbacks" (*Anzaldúa Reader* 181). Instead of depending on a society that sees them as outsiders, these

border artists carefully protect their work and independence. Moreover, their initiatives represent an Anzaldúan sense of "facultad," which Anzaldúa defines as an ability to capture the self, one that begins as a "survival tactic" and can develop into a higher stage of awareness (*Borderlands* 60). In a similar way, Sarck and Pisket's transformation from lone graffiti artists to collective leaders goes beyond a response to racial wounding or even narration of alienation. It demonstrates an analysis of their own formation as subjects in a racial capitalist state and creates a space for a different kind of critical cultural agency to be articulated.

Containment in this sense has little to do with a physical shipping container but signals a metaphorical pressure on these migrant artists. It is a figure for the specter of U.S. consumerist desire posed against the realities of black and brown control, balanced in the life that Mexican migrant artists must grapple with every day. Nevertheless, the economies of racism are not often considered in relation to Latinx artistic production. Yet, as Cheryl Finley's work highlights, the image of the slave ship, in particular through schematic designs accompanied by explanatory texts such as the Brookes Ship, has been significant for black visual artists working from the 1960s to the present. According to Finley, the reason for this is not just as a remembrance of slavery but because schematic diagrams such as *Description of a Slave Ship* represent the elements of a complex economic system, the business of the slave trade, in abstract form. In other words, they disconnected the human body from its economic output ("Schematics of Memory" 97). Mexican migrants in New York, who face the specter of brutal police policies such as Stop and Frisk and Broken Windows as well as ICE detention, similarly grapple with their desirability as low-wage laborers but not artists. Like the black visual artists, New York Mexicans have their own images of containment and liberation, which are indexed in their favored images (such as life and death, indigenous symbols, historical figures, etc.).

As Marta Sánchez succinctly reminds her readers, "Capitalist neoliberalism is Colonization 2.0" (Ramor). Thousands of miles from the border, these surveillance and divisionary practices nonetheless enact a peculiar sort of "border spectacle"[19] that is complementary to the one at the physical border, and this carries over into their artistic practices. Furthermore, in the face of "Colonization 2.0," the emphasis on indigenous themes in their New York art reflects not only a lifeline with their home culture but also a political response to neoliberal oppression.

What the shipping container metaphor also reveals is the economic ways in which migrants are contained via their labor. Illegality is another form of enclosure. Border artists in New York, such as Sarck, Pisket, Kortezua, Wilberth, and others in Har'd Life, came to the United States on their own volition as young adults, and refute the claims of legality, belonging, or citizenship. This entails a willingness to think past the structures of belonging that situate

national narratives as primary. On the one hand, within recent migration scholarship and the scholarship on illegality, scholars in the social sciences tend to subsume the stories of migrant lives under the rubric of historical evidence and/or quantitative/qualitative analysis. On the other hand, when focusing on illegality, many humanists employ social science scholarship as the context or discursive background for their analysis of migration.

Because the issue of cultural citizenship has been central to many Latinx studies in recent years, it is worth pausing to explore the central claims. Flores and Benmayor define cultural citizenship as the result of a broad range of activities that disadvantaged groups use to claim space and rights in society. More specifically, they define cultural citizenship as "the right to be different with respect to the norms of the dominant national community, without compromising one's right to belong" (57). For example, the immigrant marches during the spring of 2006 have been put forth as instances of claims for cultural citizenship—as a place for their public performances of civic participation and cultural citizenship (Chavez 79).

However, beyond formal politics and confrontation with the state, I find these migrants in New York engaging in many other forms of subversions that allow other forms of social membership to be defended and protected. Rather than belonging, it is autonomy that is most valued. In contrast with the broad claims of cultural citizenship, I propose a humanist approach that explores the ideas and cultural products that illegal subjects produce. In this way, I draw on African American studies scholarship in which a black subject has not always been a citizen. This is particularly important in Latinx studies, where, with some exceptions, the question of citizenship is often theorized via cultural citizenship frameworks and less so through theories of legality and governance. Moreover, this dialogue is especially significant in the context of New York City, where blackness is also a large part of the experience of illegality: New York has the largest black immigrant population in the country, with 910,000 black immigrants—nearly a quarter of the country's entire black immigrant population (Yakupitiyage).

Furthermore, as Leo Chavez points out in *The Latino Threat*, "feelings of belonging and desire for inclusion in the social body exist in a dialectical relationship with the larger society and the state, which may or may not find such claims for cultural citizenship convincing" (14–15). Here, Aihwa Ong's emphasis on the nation-state's role in defining cultural citizens is particularly instructive, highlighting the emphasis that cultural citizenship places on the agency of subordinate groups (264). This also simplifies and homogenizes migrant desires with a focus on political participation (W. Flores).[20] Instead, the subjects of my interviews have a more fluid understanding of belonging, which makes legal incorporation and citizenship more complicated. It is not based on affiliation with U.S. national society or its confining structures of incorporation but

rather is concerned with how to construct, defend, and maintain artistic community.

While the concept of cultural citizenship may seem to easily apply to the work of Mexican migrant art collectives in New York, my interviews reveal attitudes in which citizenship or belonging to a larger U.S. society has never been a goal. Moreover, in the case of Har'd Life Ink and Cultural Workers, this definition of cultural citizenship, as claiming the right to be different, is insufficient to address the unique aspects of their entrepreneurial practices. Rather, the work of Har'd Life Ink and Cultural Workers demonstrates subjects who look beyond borders and whose aspirations for belonging are not framed in nation-states. Amid controlling state structures, these groups demonstrate the desire not to enter current structures but to build alternative ones completely independent of these systems.

This desire is particularly powerful in the case of Gabino Abraham Castelán, who describes a life raised in institutions from the Boys Club to Hunter College, but nevertheless has decided to work outside those traditional artistic spaces as much as possible (personal interview, 3 Sept. 2015). Thus, Har'd Life Ink and Cultural Workers offer an alternative to more insular or exclusionary types of organizations. Sorick describes their goals: "Eso es una palabra buena—'compartir.' Nosotros queremos compartir lo que nosotros vivimos y tal vez a nadie le va a gustar pero tal vez a una se va a identificar con lo que nosotros hacemos. Por ejemplo nosotros somos ilegales . . . nos tratan como ilegales, bueno somos ilegales, pero nos desprecian" (personal interview, 2 Nov. 2013).[21] Rather than make an argument about his place in a nation-state that does not appreciate Mexicans as anything other than temporary labor, Sorick expresses an unflinching view of his noncitizenship status. In providing alternative forms of employment that are also creative, Har'd Life Ink and Cultural Workers critique and proactively address racialized economies based on nonbelonging and reveal racial capitalism's savage sorting.

Thus, in place of cultural citizenship, I frame the topic of Mexican art collectives in New York through a framework of illegality and economics. As a response to illegality, anti-detention and anti-deportation campaigns around the world have increasingly come to contest these regimes, struggling to assert or even retake the right to unrestricted movement and migration. For Peter Nyers, the abject diaspora of deportable or deported asylum seekers, refugees, undocumented migrants, "criminal aliens," and others constitutes a veritable "deportspora" that encircles the planet. Within this context, the political act of migrants engaged in audible and visible challenges to the sovereign state's claim to monopolize the parameters and possibilities of their protection is incredibly powerful. Their acts recognize that the politics of "protection"—regarding who will or will not be protected, or conversely who may be denied such protection (through deportation), as well as who may authorize the

protection and who will execute it—is a critical component of the nation-state's power.

In this manner, the rights-taking modes of being political, which Nyers identifies as the abject cosmopolitanism of the deported and the deportable, even as they remain distinctly circumscribed and utterly unprotected, are crucial practices of freedom (25–26). What Har'd Life Ink and Cultural Workers add is an additional critique of this deportspora. They recognize that these politics of protection extend to and greatly influence the arts. In between the "abject cosmopolitanism" of being either deportable or deported, freedom for them is the rejection of this status quo of marginalized subject-making, which they exercise by painting, drawing, spray painting, and doing woodwork, pottery, sculpture, and other visual arts. In coming together for events dedicated to celebrating Mexican culture in the arts, these practices are at their most visible. Moreover, in addition to projects like the collective graffiti and tattoo shops, an important aspect of Har'd Life Ink is community mural work. Their work at Tacos Los Brancos in Sunset Park, Brooklyn, and other businesses, often done for free or as some sort of artistic exchange, reflects a commitment to bringing Mexican art to a wider community.

Since 2013, the community building and collective work have continued to grow within both New York and Mexico. In 2016, Har'd Life merged with Buendia BK, a multinational group centered in Sunset Park, Brooklyn. Founded by Solace (Daniel Aguilar) and Versos, both of whom are of Mexican heritage and were born and raised in Brooklyn, the collaboration represents a reach back to a (slightly) longer Mexican presence in New York as well as a movement outward to engage with a more global hip-hop practice. Both Solace and Versos grew up participating in hip-hop culture, first forming a social club and then Buendia Productions in 2007 (Aguilar, personal interview, 1 Nov. 2013).

As will be further discussed in the next chapter, Buendia's work is very different from Har'd Life Ink's. Buendia's interest is more in the production of music and support of various MCs and musicians, although the collective also incorporates dancers and graffiti artists (or those who also do graffiti). Half of Buendia's members are U.S. citizens, and the membership comes from diverse backgrounds (Mexican, Dominican, South American, African American, etc.). Thus, while Har'd Life's mission is specifically focused on building an artistic movement for Mexicans in New York City, Buendia is about "building with everyone" to produce radically new forms of arts that are also socially conscious (Aguilar, personal interview, 1 Nov. 2013).

Significantly, the glue that binds Buendia and Har'd Life Ink together is an MC in Mexico City named T-Killa. Well known for winning numerous freestyle battles, T-Killa met Versos in Sunset Park on a visit to New York City in 2011. They soon became collaborators, and on his next visit in 2013, Har'd Life Ink served as a new space for the MC and founder of the INK Crew to

perform. INK joined with Buendia and HAR in both Mexico and New York, circulating art and music mainly via Facebook, YouTube, and yearly artist visits between groups for those for whom that option is available or who decide to take the risk. More than just an act of transnational collaboration, these collective movements and group expansions recognize that for Mexican artists in both Mexico and New York, resources are scarce. They also point to the new transnational possibilities via social media, in a Trump era in which physical means are less and less possible. In this era, beats and lyrics flow via email and Facebook messenger only to be recorded, mixed, and shared again on social media, SoundCloud, and YouTube to members and fans around the world. Similarly, while not so collaborative, paintings, murals, and graffiti shared on Facebook and Instagram similarly become part of an artistic dialogue through which members of this new borderlands develop their styles and skills with input from Mexico and a larger internet audience.

Un Espacio Aparte: Arts Entrepreneurship in Mexican New York

According to Dan Allen of NBC News, "2017 is proving to be a banner year for major Latino art shows, with many of America's top museums hosting important and innovative exhibitions." In the article "14 Latino Art Shows Not to Miss in 2017," Allen highlights shows that represent a "broad spectrum of styles, mediums, eras and regions—from 18th century Mexican painting to 21st century Chilean sculpture." Although for Allen these fourteen shows "highlight the constant evolution and incredibly rich diversity of Latino art," what they actually represent is the ignorance and tunnel vision relating to Latinx art. Not only are most of the artists represented not Latinx or even based in the United States, but rather Latin American and based outside the United States. In this narrow context, Mexican art continues to be limited to mainly Frida Kahlo and Diego Rivera. Moreover, there is not a single art show in Allen's article that is listed in New York City, despite New York's large Latinx population and robust art scene.

Clearly neither Dan Allen nor NBC News is an expert source about Latinx art. But what this example represents is the woeful misrepresentation of Mexicans in the arts, especially in New York City. Here, Mexican migrants, particularly new Mexican migrants, are laboring bodies, not creative beings. Thus, while the New York Botanical Garden may dedicate an exhibit to Frida Kahlo, it, and other major institutions, will not look toward Mexican art or artists in its own backyard.

This lack of attention is unsurprising given the context of a much larger oversight in art studies. Mexican art, and more generally Latinx art, in the United States has been understudied (Ybarra-Frausto, "Imagining" 9), especially considering its fundamental contributions to North American culture. This is

shockingly true in terms of popular art, in which Latinx contributions in muralism, graffiti, tattooing, street art, and performance art have been influential both within and beyond U.S. borders. Here, I define Latinx popular art in the tradition of Juan Flores's work on Latinx popular cultures. For Flores, popular culture is separated from the mass consumption of contemporary society, through its roots in folklore and the everyday people, whose cultures and traditions resist the social domination of those in power (J. Flores, *From Bomba* 17). In this way, the concept is both "rescued from its relegation to archaic and residual roles in today's global modernity and mass culture" and becomes a useful term of analysis for examining Latinx artistic expressions. "Popular art," then, becomes a way to interrogate the multiple levels on which Latinx artists construct individual and collective identities and create new hybrid forms to reflect their social and historical contexts (Habell-Pallán 6). For Mexican artists in New York City, the rapid growth of the Mexican population over the past twenty years represents a tremendous influx of creativity into the city's popular arts as well as a reflection of the everyday lives of Mexican migrants who survived in conflict and with contestation.

In terms of Mexican and Mexican American artists in the United States, the majority of scholarly research has been and continues to focus on art from the Chicano movement and the influence of the Chicano movement on contemporary artists of Mexican descent, including rich discussions of other artistic scenes alongside muralism and graffiti art such as the visual creativity in lucha libre and low riders. This work is increasingly seen in high art institutions and in specialized museums.[22] While some art historians are researching the contributions of artists who were not part of the Chicano movement but were or are Mexican American, this research tends to focus on the Southwest and California almost exclusively, as well as on artists who are not necessarily involved in the popular arts (Ybarra-Frausto, "Imagining" 9). Thus, the artists in this chapter have been largely understudied, lost behind the looming giant of the Chicano movement as well as the indifference of New York City's contemporary art community. Attention to their work presents a more expansive vision of Mexican art in the United States. This work includes graffiti, mural painting, tattooing, airbrush on canvas, printmaking (T-shirts and posters), and photography by Har'd Life Ink and its affiliates (see figs. 11 and 12). It also includes the work of university-educated migrant artists such as Gabino Abraham Castelán and his work to create community art spaces in Manhattan.

As Tomás Ybarra-Frausto comments in "A Panorama of Latino Arts," Latinx arts operate in a long historical continuum beginning with colonization in the sixteenth century, and the field also represents a vastly heterogeneous group of native-born citizens and immigrants from more than twenty countries (139). Thus, he clarifies that Latinx art is not only understudied but makes for a

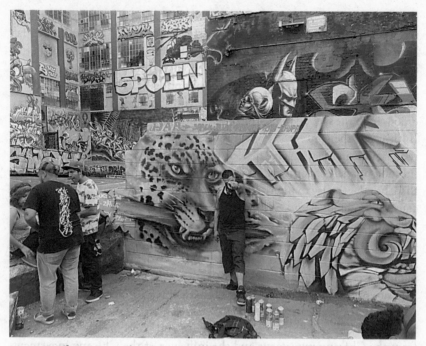

FIG. 12 Graffiti at 5Pointz done by members of Har'd Life Ink art collective prior to its destruction, 2012. (Source: Sarck)

complex study. According to Ybarra-Frausto, "In conceptualizing Latino art, we have what I would call a three-legged stool. One leg of the equation is the canonical culture of the United States. Another is Latin American visual culture. And the third is Latino culture, which is the most wobbly" (139). This is most certainly the case in terms of Mexican popular culture expressions in New York City. Many of the artists examined here are influenced by and in conversation with popular art and street art traditions in New York and Mexico, as well as Chicano artists in the Southwest and California. Meanwhile, Gabino Abraham Castelán finds inspiration in an international variety of artists, as well as his community, and master of fine arts (MFA) mentors. Here again, alternative theoretical methods help address new areas of inquiry.

In *Travel & See: Black Diaspora Art Practices since the 1980s*, the art historian Kobena Mercer examines the critical thinking based on the iconic image of ships navigating multidirectional journeys that was explored in Gilroy's *Black Atlantic*. This work was preceded by Keith Piper's installation, *A Ship Called Jesus* (1991): "For Piper and Gilroy alike, the ship acts as a multiaccentual sign. What matters in the oceanic interspace of migration and travel is the moment of 'turnaround' when colonizing voyagers of conquest and enslavement get rerouted by the acts of resistance in which diasporized subject metaphorically redirect the ship towards new destinations" (Mercer 14). The ways in which

Mexicanidad travels to New York City is both familiar and new. For instance, in his murals, Castelán displays Aztec symbols within urban New York landscapes. Similarly, Sarck's *estilo azteca* features Aztec calendars and gods, jaguars, and serpents that are nevertheless physically embedded into a contemporary New York landscape via street art practices and artistic stylings (see fig. 12). These individual artistic practices are ones that have been rerouted, from the streets to a tattoo parlor in the case of Har'd Life Ink, and from a traditional arts classroom to a repurposed real estate office in Long Island City, Queens, in the case of Cultural Workers, creating new spaces for Mexican arts in the United States.

For Sarck and Pisket, working for themselves is a crucial aspect of their art. According to Sarck, their main goal is "No trabajamos para nadie . . . no regalar el trabajo. Eso siempre fue el plan. Aprender el proceso bien y después sacar al intermediario, porque eso te joda" (personal interview, 1 July 2015).[23] For this reason, their tattoo work is as important as their graffiti, mural, or airbrush work, as it is an art form that they have cultivated and pursued as a means of economic independence. Using the same "Mexica style," Sarck, Pisket, and the at least half dozen other mostly self-taught tattoo artists that share the space favor similar themes—catrinas, Virgin Marías, indigenous patterns, and other displays of Mexican pride. Since their tattoo practice not only serves to fund the art collective, their community and clientele overlap in ways that often allow them to further develop as creative men and women.

This commitment to economic self-sufficiency for both groups is especially important because if Mexicans are not often thought of as artists in New York City, they are definitely not thought of as entrepreneurs. Their businesses are particularly precarious in an increasingly tense state of surveillance, but also incredibly difficult to sustain due to prejudice within the business community. Sulema Valdez in *The New Entrepreneurs* argues that an intersectional approach is key to understanding how individuals disadvantaged by particular combinations of race, class, gender, and ethnicity "carry their vulnerable status with them" as entrepreneurs. As she makes clear, Mexican migrants are one of the groups for which this discriminatory practice plays an important role. María Eugenia Verdaguer adds: "In all, scholars have continued to glamorize the cultural traits that distinctively endow 'successful' immigrant groups for entrepreneurship, enhancing their business practices and performance. In the process, they have primarily focused on entrepreneurial groups exhibiting high levels of commercial performance, thereby neglecting to examine those entrepreneurs less successful from an economic standpoint" (1). As a result, in painting a celebratory portrait of certain immigrant entrepreneurial success, the literature has left behind the stories of those less visible, of whom little is known (Valdez 3). There is also a tendency to homogenize Latinx entrepreneurial experiences, and in that process there is very little attention to arts entrepreneurship. In fact, it

should surprise no one that in the emerging field of arts entrepreneurship a discussion of Latinx businesses is nonexistent, as Latinx in the arts continue to be studied mainly as community art groups and/or through the lens of resistance.[24] In contrast, I build on the scholarship of Arlene Dávila, who in her 2012 book *Culture Works* explores the intersection of space, value, and mobility for culture workers who are intervening in urban economies in Puerto Rico, New York, and Argentina. In particular, she explores how culture workers "add value" in the case of tourist attractions, creating jobs, as well as in the case of microenterprises like the ones described in this chapter.

A relatively new form of scholarship, *Artivate*, the first peer-reviewed platform for arts entrepreneurship scholarship originating in the United States, defines the field as follows: "Arts entrepreneurship is a relatively new discipline in creative and performing arts higher education and is currently attracting attention due to the possibilities it affords to address graduate employability issues" (Chang and Wyszomirski 11). I find this definition incredibly elitist in its focus on higher education, excluding all the members of Har'd Life Ink and any other culture workers without that educational background as outside the realm of possible arts entrepreneurs.[25] Rather, I adopt a view put forth by Woong Jo Chang and Margaret Wyszomirski, who emphasize autonomy, innovation, strategy, and the pursuit of not just artistic but economic and social value. As they describe the field:

"Arts entrepreneurship" is a management process through which cultural workers seek to support their creativity and autonomy, advance their capacity for adaptability, and create artistic as well as economic and social value. This management process involves an ongoing set of innovative choices and risks intended to recombine resources and pursue new opportunities to produce artistic, economic, and social value. Identifying the emerging clusters from the meanings found in the literature, we conclude that to understand arts entrepreneurs, one must focus on the innovative combinations of strategy, individual skills, and mindset operating in each case of arts entrepreneurship and its context. (Chang and Wyszomirski 11)

Strategy is important here, because though both Cultural Workers and Har'd Life Ink have similarly collaborative management processes and a goal of economic and creative autonomy, differences do exist. Not only do group backgrounds and skill sets vary greatly, but so does the strategy based on those practices. While Cultural Workers emphasizes the creation of economically profitable spaces based on artistic interests, Har'd Life Ink operates as a business that allows its employees the space to openly pursue other artistic interests that may or may not be profitable. Nevertheless, in both a re-evaluation of the migrant laborer is key.

Cultural Workers and Practice of Everyday Life

According to the artist Gabino Abraham Castelán, project Cultural Workers is "a platform for art and culture through design intervention" (personal interview, 5 Dec. 2018). Most recently, Castelán with his collaborators in Cultural Workers presented Practice of Everyday Life-205, a multipurpose social space composed of drawings, paintings, murals, objects, and social actions (see fig. 13). During the opening night on April 20, 2017, Castelán cooked and sold black bean burgers. The black beans were illegally imported from his father's farm in Puebla, Mexico. He sold the burgers for $4 with a discount if the customer answered this question: "As an engaged citizen [politically active] living in the United States, what are your responsibilities in relationship to your fellow citizens and non-citizens?"

"I work in order to have leisure," explains Castelán. "I investigate how my artworks can function as tools to educate, inform, incite to action, or solely serve as objects of pleasure" (personal interview, 5 Dec. 2018). He elaborates, "These concepts of use are integrated into the collaborative production of my social installations to become spaces of relaxation, contemplation, and examining the notion of leisure in its modern form to unveil new realities." Practice of Everyday Life-205 included two workshops (one in collage storytelling, another in reusing discarded materials for sculpture and utilitarian objects), an open mic, a salsa-making workshop, a dance performance, and a discussion surrounding mental health issues.

Conceived by Gabino A. Castelán in the summer of 2015, and originally including five collaborators, Cultural Workers has put on several multiartistic events in vacant or repurposed spaces from Spanish Harlem, Queens, to the Lower East Side. They have also collaborated on projects such as furnishing apartments for individual clients, proposing and building each piece by hand with an eye for design and utilitarianism. For someone who comes from academia, Castelán's development of Cultural Workers as a practice and theory largely outside of those institutions is provocative. Unlike Sarck or Pisket of Har'd Life Ink, whose labor choices are a response to artistic institutions that they feel have completely rejected them, Castelán has successfully navigated the art world in many ways. Whereas for Har'd Life Ink the work of tattooing supports a life where creativity has both physical and imaginative space, Castelán's approach comes from a man who has long had this creative space but realized that he can create social spaces for others.

In 1993, Gabino A. Castelán and his family illegally immigrated from rural Santa Ana Necoxtla, Mexico, to East Harlem, New York City. Through his artistic practice he frequently references ideas of belonging and trespassing by reading past and current immigration policies from Mexico and the United States. He completed his bachelor of fine arts in 2012 and earned his MFA at

FIG. 13 Mexican Salsas "Mayan and Nueva": A Hands-on Workshop at Practice of
Everyday Life-205 (PoEL-205), 2017. PoEL-205 was installed at 205 Hudson Gallery,
located at 205 Hudson Street. (Source: Gabino Abraham Castelán)

Hunter College in 2017. He was a Joan Mitchell artist teacher from 2012 to
2016. In 2014, Castelán became an artist in residence at the Skowhegan School
of Painting and Sculpture. In 2015, while working on his MFA, Castelán
founded project Cultural Workers. In 2018, Castelán was nominated to travel
to Honduras as part of the U.S. Department of Cultural Affairs Arts Envoy
Program. Currently, Castelán is an artist-teacher for Creative Art Works, Boys
Club of New York, and KoKo NYC. Unlike many migrants, he feels he greatly
benefited from institutions such as the Boys Club of New York, which despite
his undocumented status helped him apply for and win a scholarship to CFS,
the School at Church Farm, a prestigious boarding high school in Pennsylva-
nia. Nevertheless, also like many migrants, he spent years working in Upper
East Side restaurants while pursuing his artistic interests.

Even before the group's formation, this experience in restaurant work was
reflected in his enduring focus on labor and consumerism. As Castelán explains
it: "I've come to accept that I am not here to change the world with my work,
nor am I trying to change anyone's view of it. I just want to show people an
interpretation of what I see, I don't want to change things but I want to open
a dialogue, so that everyone can be involved in trying to find a solution to dif-
ferent issues that we face not only here in the city but also around the world"
(Alexanders). For example, in his work titled *Paradise under Construction*,
Castelán takes the viewer back in time to Mesoamerican visions of the New
World to anchor a historical projection (personal interview, 5 Dec. 2018). We
are shown a Native American working in the field and then progressively move

forward visually through a history of black and brown labor into the industrial age and the modern-day construction worker.

In his practice he explores notions of abstraction and representation where dreams and realities blend together to depict conceptually layered environments. His work is born from personal stories, geometric textiles, high and low urban architecture, and contemporary and ancestral imagery of people performing their labor (see fig. 14). Similarly, some of his recent installations emphasize alternative visions for how a city should look in the face of contemporary consumerism. Thus, despite his access to a variety of materials, he prefers to use local and accessible resources such as charcoal, tape, projections, and recordings of people in the neighborhood. According to Castelán, "I'm really into tape right now. I like its temporary stickiness, how it changes with the weather, it's poetic. It's like a metaphor of life" (personal interview, 3 Sept. 2015).

Alongside what HAR members have described as the impulse to make their name known to the world (Sorick, personal interview, 2 Nov. 2013), Gabino A. Castelán represents an interest in making art accessible and useful. Thus, both express a more expansive definition of art and culture. It is a way of thinking of art that is as much about creating an experience as it is about investing in a tangible material object, and it is culture that begins in the home but is developed over time to incorporate elements of the past, present, and future, until it turns into something unique and personal (Castelán, personal interview, 3 Sept. 2015). Thus, the group's name came out of Castelán's own self-development and view of himself as more of a "cultural worker" than an artist. For Castelán, the word "worker" is not a synonym for "proletarian," but he does recognize that the words are significantly interchangeable. "Cultural workers," in his work, "is used in an anthropological sense; it implies a whole conception of 'human-kind'" (personal interview, 5 Dec. 2018). Castelán sees himself as a Cultural Worker that reveals "work" as the general law of a world that devotes itself to efficiency and productivity, even in leisure and rest. He works with a community of creative workers who are both skilled and purposeful in their desire to do intentional work. As Castelán states, "My installations are designed to construct a contemporary workers club where the public and myself can participate by pushing past our ordinary everyday work and become part of the artwork." Projects like an apartment re-design, which may seem routine, are approached differently—it is a way of demonstrating the impact and significance of a type of art that is innovative and community oriented (personal interview, 5 Dec. 2018).

This can be done on the individual client level, as in the case of the apartment, or, more often for the Cultural Workers, on a community level. For example, their first iteration of Practice of Everyday Life-184 was a monthlong project in August 2015, held in a space only a few blocks from where Castelán grew up on 109th Street in East Harlem. In that case, Castelán rented an

FIG. 14 Practice of Everyday Life-710 (PoEL-710), 2017, duct tape, house paint, handcrafted furniture, mylar, sheetrock, and existing architecture, total dimensions variable. PoEL-710 was installed at the Loisaida cultural center, located at 710 East 9th Street. (Source: Gabino Abraham Castelán)

underused party space, Enchanted Party, and both redesigned and repurposed the space into a place of artistic community engagement. In the daytime, they gave classes and held workshops on various artistic and storytelling practices, while in the evenings they held cultural events ranging from culinary adventures to literary and musical programs. After a month he returned the space, leaving the owner with a re-designed and improved locale and helping revitalize her business as well as the community. Another monthlong art pop-up in a real estate office in Long Island City held similar events but with a different impetus. In this latter case, Castelán's process was inspired by the Mexican and Latinx community that was increasingly being displaced from the area (personal interview, 3 Sept. 2015).

Clearly, Gabino Abraham Castelán and Har'd Life Ink founders Sarck and Pisket differ in significant ways, including educational background, migration histories, artistic training, and legal status. "The Practice of Everyday Life" alludes to Michel de Certeau's work of the same name and represents Castelán's deep theoretical development and academic training in support of the Cultural Workers initiative. Nevertheless, I read these two collectives together because they not only represent significant examples from New York City's vast Mexican migrant work in artistic practice but also share a common critique of labor as it relates to the Mexican experience in the city. Despite their differences, both groups put forth a strong critique of the way Mexican culture is consumed in

New York City from the perspective of a marginalized laboring body. Each critiques this consumption by way of alternative space-making practices that reflect—and respond to—the limited physical, creative, and economic spaces accessible to Mexicans.

Both Har'd Life Ink and Cultural Workers represent communities of migrants dedicated to creating alternative spaces to counter the sense of invisibility imposed on them by NYC society, as well as to foster pride and create opportunities for practical ownership. These movements are important to understanding the position of Mexicans in modern-day New York as well as the current shape of migration practices—practices that have greater repercussions for the state of surveillance and policing in today's society. The shift in border and immigration governance, evidenced in the intensification of militarized policing of immigrants in the borderlands and, increasingly, beyond the borderlands constitutes managed forms of violence. In this respect, the current specter and reality of constant policing and surveillance in New York City represent an additional layer of racial governance. And still, these collectives represent their own form of border crossing and free movement even if that movement at times can only be imaginative.

The creation of artistic spaces in which Mexican culture can be represented, explored, and celebrated represents an important act of anti-deportability by Mexican migrants. These projects, whether on an individual or collective level, are also a refusal to be invisible when intense surveillance demands it. It is a refusal to be purely unskilled laboring bodies. Instead, these artists represent powerful acts of visibility, a desire to leave a footprint (in Pisket's words) and to create a multinational movement. As such, artists like Sarck and Pisket from Har'd Life Ink and Gabino Abraham Castelán in his space-making practice also serve as bridges between multiple communities. They are modern-day nepantleros who, finding themselves in between spaces, create alternative ways of being.

As Anzaldúa writes, in these borderlands spaces of disconnection and isolation, for nepantleras, creativity emerges. She continues: "Bridges are thresholds to other realities, archetypal, primal symbols of shifting consciousness. They are passageways, conduits, and connectors that connote transitioning, crossing borders, and changing perspectives. Bridges span liminal (threshold) spaces between worlds, spaces I call nepantla, a Nahuatl word meaning tierra entre medio. Transformations occur in this in-between space, an unstable, unpredictable, precarious, always-in-transition space lacking clear boundaries" (Anzaldúa and Keating 1). But within an Atlantic Borderlands framework, this transformation becomes something more than Anzaldúa imagined. These artists' sensibilities are not so much transnational as multinational, not so much local as glocal.[26] Whether making connections with varied communities in Mexico and New York such as Sarck, or for Castelán within New York's diverse

artistic communities, these artists are engaged in creating new dialogues and artistic bridges.

Sarck and Pisket, at the most basic level, engage with their Mexican hip-hop community; however, they tattoo a diverse community mainly consisting of people of color, including a large segment of African Americans. They physically travel to Mexico to support the work of collaborators there as well as run Facebook, YouTube, and other online methods to support the artistic dialogue. They practice mentorship and collaborative art to share their economic independence with other young Latinx interested in the art of tattooing. For this reason, it is not surprising that Sarck's dream for HAR is to form more branches across Latin America's diverse countries (personal interview, 13 Sept. 2015). At the threshold of a new borderlands already, Sarck is still not satisfied. In the face of containment, he chooses movement.

Part II

The Atlantic Borderlands
■■■■■■■■■■■■■■■■■■■■■■■■■

"Un movimiento joven,
pero con mucho corazón"

3

Yo Soy Hip-Hop

■■■■■■■■■■■■■■■■■■■■■■■■■■■

Mexicanidad and Authenticity
in Mexican New York

A process of becoming powerful in the context of being told to disappear—
filmmaker Alex Rivera (Decena and Gray 132)

La nueva generación está creciendo, desobedeciendo.
En comunidades que están estremeciendo, venciendo para dormirnos.
Pero estamos vivos activos con muchos motivos constructivos.
En lugares destructivos, pero yo sigo.
Y no me rindo. (MC Versos)

"Gentrifucked," a Buendia BK[1] event held in Bushwick, Brooklyn, on May 20, 2016, was a powerful representation of a youthful desire for "a world where many worlds fit." The Zapatista saying was referenced by the NYC-based Mexican male-female MC duo who themselves performed in masks, named Ni Dios ni Amo (Neither God nor Master). The event exemplifies a Mexican-led but diverse and inclusive hip-hop–based call for space and recognition. Half of the more than a dozen MCs were Mexican, but like the members of the collective Buendia BK, they came from a diverse set of backgrounds, migration statuses, and citizenships. Their commentary on gentrification and their concern about limited space also varied. Dominican Buendia member Mauro Espinal focuses on the "la esencia de hip hop" (the essence of hip-hop), while

Mexican American group co-founder Versos takes an aggressive anti-police stance in the song "We Don't Care." Mikal Amin, a guest of Buendia, rocked a Black Lives Matter T-shirt and rapped about the prison industrial complex, while Rebel Diaz, a Chilean American MC bilingually declared "colonización is world-wide gentrification." Two MCs visiting from Mexico City also performed. This diversity of backgrounds and experiences was mirrored in the audience. What brought it all together was the language of hip-hop to express a concern for space, or moreover the lack of space in a racially capitalist global city. Whether performing in English, Spanish, or a mix, all the MCs believed in socially conscious hip-hop as a way to bring attention to problems of racism, xenophobia, and gentrification in New York City. In fact, for many of these MCs, these issues are intimately tied together, as are immigrant detention, police surveillance, and mass incarceration.

In his 2003 film, *The Sixth Section*, Alex Rivera describes the transformation of migrant activists as "a process of becoming powerful in the context of being told to disappear" (Decena and Gray 132). It is a process of anti-containment and a stance of anti-deportation in the wake of increasing post-9/11 xenophobia and anti-migrant sentiment. This film documents the efforts of migrant men living in Newburgh, New York, to create public works projects in their hometown of Boquerón, Puebla. As also documented in Robert Smith's work on NYC, these migrants represent the powerful transnational actions of East Coast migrants within their hometown associations. Discussions about hometown associations and remittances have long been a way of measuring immigrant transnationalism,[2] as are analyses of religion[3] and sports.[4]

What I present highlights how Mexican hip-hop in New York represents another form of migrant transnationalism that is youth led and directed not toward a homeland that they may or may not return to but toward commenting on conditions in New York City, a commentary that is still based on and in dialogue with a proud Mexican identity. Like the arts entrepreneurs explored in the previous chapter, Mexican hip-hop in New York represents a practice of claiming space. In fact, hip-hop becomes a way to strengthen transnational ties to Mexico, although these ties may not necessarily be with any specific hometown, but rather new ties that are forged via an international hip-hop community.

This is especially significant in New York City, where Mexican hip-hop has not previously been studied apart from two earlier pieces of mine, published in 2015 and 2016. This chapter builds on that work. To date, the limited though important research done on Chicano rap, mainly of the West Coast by Pancho McFarland, does not reflect either the experiences or the perspectives of Mexican rappers in New York, and employs the lens of *mestizaje* (McFarland, *Chicano Rap, Chican@ Hip Hop Nation*; Kelly, "Hip Hop Chicano"). As McFarland's more recent work—work that significantly expands

into the Midwest—acknowledges, "Mexican-born youth who have spent most of their lives in the United States (the 1.5 generation) have concerns and issues that differ from the urban Chicano neo-indigenous youth or other U.S. born youth of Mexican descent" (*Chican@ Hip Hop Nation* 81).[5] Although "Chicano" was originally a derogatory word used to describe poor Mexican migrants, the term was appropriated in the 1960s and converted into a symbol of pride by Mexican American civil rights activists. As such, although the term's political meaning can vary, it has come to refer more to Mexican Americans than new migrants (C. Jackson 2). McFarland's selection of the term "Chicano" as well as its regular use in Southwest hip-hop by MCs of Mexican descent here demonstrates a meaning in the context of hip-hop that is still in some ways based in a politicized identity that references the history of Mexican Americans in that region.[6] On the other hand, as the rappers I interviewed—either Mexican born or U.S. born in New York—do not identify with that term, I do not use it either. Specifically, they reference the newness to the city and country as reasons why they do not identify with a Chicano/a experience.

Although I follow this differentiation of Chicano and Mexican migrant concerns expressed by the MCs presented in this chapter, I also find that the New York City context complicates attitudes for some U.S.-born Mexican youth. For example, U.S.-born MCs Versos and Demente, and producer Solace identify with undocumented migrant populations forming hip-hop collectives, crews, and music groups in recognition of the way Mexicans as a new population to New York City are particularly marginalized and rendered invisible. As Versos describes growing up in Brooklyn, Mexicans were a very small community who stuck together. His parents, who arrived in the 1960s, have struggled to stay financially viable. Economic hardship and lack of space continue to mark their lives as a family, especially as gentrification has become a reality in his neighborhood of Sunset Park, Brooklyn. Here, a three-bedroom apartment is overwhelmed by bodies as home to Versos and his wife and daughter, along with his brother's and sister's families, as well as his parents (personal interview, 19 Oct. 2013).

Although Versos represents a *nueva generación*, that *está creciendo*, it is one that also shares similar hardships with the more newly arrived Mexicans in New York. He describes these hardships quite dramatically in the bilingual song "Mexicano from the Early 80s," part of which was quoted in the epigraph to this chapter. Versos continues:

Aunque me veas en el puto piso deprimido	Even if you see me on the fucking floor, depressed
La vida es como un hijo de la chingada	Life is like a son of a bitch

por eso suelto mi rabia en cada barra	for that reason I release my anger in each line
que no pueden borrarlas, olvidarlas	so they can't erase them, forget them
en esta vida jodida	in this fucked up life
llena de remembranzas.	full of remembrances.

Here Versos uses Spanish to build emotion and express anger as a hip-hop language that he layers with quick internal rhyme and greater density of language. Notably, he begins this song by grounding "these lyrics of Brooklyn, NY to DF." Although neither Versos nor his family is from DF, he links them together due to his connection to the Mexico City crew INK, of which he is also a member. Sonically, a simple cyclic drumbeat accented by a repeated synthesizer series of melodic patterns mimics the struggles of slowly pushing forward on a daily basis.

If only slight discussion exists about Mexican Americans in New York, then—as both Raquel Rivera and Juan Flores note in their scholarship on Puerto Ricans in hip-hop—even what little has been written about Latinx in hip-hop's birthplace largely represents an erasure. Yet, as Mark Naison describes the scene, "hip hop was born multicultural" (Castillo-Garsow, *La Verdad* ix). Born in the Bronx, its invention came out of the mashup of the sound system and culture of the Anglophone Caribbean, traditions of English-language vernacular improvisation by African Americans and West Indians, mambo dancing, capoeira, African drumming, the movements of James Brown and Bruce Lee movies, and much more (ix–x).[7] As Rivera's work of 2003 has demonstrated, Puerto Ricans were present since the first days of hip-hop, especially in the visual and movement aspects; however, as English-language rappers came to define hip-hop's public profile commercially, these contributions were often pushed to the side. In particular, as Mocombe, Tomlin, and Callender write: "In a racialized post-industrial capitalist social structure wherein the economic status of 'blackness' is (over) determined by the white capitalist class of owners and high-level executives and the black proletariats of the West, the black underclass, whose way of life and image ('athletes, hustlers, hip-hopsters') has been reified, commodified (by white and black capitalists), and distributed through the world for entertainment . . ." (12). In other words, hip-hop was easier to digest and easier to market as a popular music of the urban black underclass than the diverse and multicultural exchange it truly represented. Unfortunately, hip-hop scholarship has followed this trend and, despite its diversity of foci, has largely been relegated to black studies.[8] For example, P. Khalil Saucier and Tyrone P. Woods, in their unfortunately titled article "Hip Hop Studies in Black," make an argument to "reintroduce hip hop studies to black studies," which they define as "the political project emanating from the context of black revolution in the 1960s. . . . It melds the rich archive of black letters back to the

slave narratives with the Black Power generation's unwavering response to the structural impossibility of blackness" (271). Although this does not necessarily exclude Afro-Latinx who participated in these movements, the article's emphasis on blackness does exclude the diversity of Latinx who participated in and connect with hip-hop as an identity. This continues to be the trend even in a global hip-hop context, as titles such as *The Vinyl Ain't Final: Hip Hop and the Globalization of Black Popular Culture* demonstrate.[9] Or as Kitwana asks, "Will this generation's music, hip-hop, be appropriated by white America just as rock and roll was, leaving its Black originators all but forgotten?" (1). Thus, here again, I propose an Atlantic Borderlands reorientation that opposes racial categorizations of hip-hop and instead opens a pathway for a conversation between black and Latinx scholars.

Of course, I am not the first to see sonic or musical links between Mexican/ Chicano expressions and black traditions. Hip-hop is built on decades of Latinx and black exchange: in *pachucos* and African American hipsters wearing zoot suits and dancing to swing and doo-wop music (Alvarez, "From Zoot Suits"; Lipsitz; Macías; S. Loza); in the shared car-culture obsessions and soul-music enthusiasms of cholos, black inner-city youth, and gangster rappers (Johnson; Kelly; Lipsitz; S. Loza; McCarthy; R. Rodríguez); in the inspiration Chicano movement artists and activists drew from Black Arts and Black Power figures (Rod Hernandez; Johnson; McCarthy); and in Mexican American performance of rock music and the popularity of rock in Mexico (Avant-Mier; S. Loza; McCarthy; Zolov). These are just a few examples,[10] and contemporary Mexican youth carry on those syncretic traditions, adapting various cultural influences in creative ways to suit the sensibilities of the hip-hop generation. Moreover, some of these linkages are most pronounced in music as Gaye T. M. Johnson has shown tracing forty years of Afro-Chicano interactions in California between 1960 and 2000. The tremendous influence that Chicano and black musicians have had on each other's musical cultures is clear from the sounds of LA musicians Chuck Higgins, Richard Berry, and Ritchie Valens in the 1950s; in the 1960s and 1970s, WAR, Los Lobos, and Cannibal and the Headhunters; and in the 1990s Ozomatli, the Red Hot Chili Peppers, and Rage Against the Machine.

As the history of Mexicans in hip-hop began in California,[11] hip-hop for Mexicans in New York represents the latest iteration of these links that both builds on these exchanges and develops them in a new space. Space is key here, as I've shown in terms of understanding Mexican migrant life in New York City but also because of its significance to hip-hop. As Murray Forman has argued, space is vital to hip-hop in relationship to both the specific locations as historical markers of the music's development and the narrative trajectories in the music. Specifically, hip-hop can formulate an alternative value system in terms of spaces that are viewed as less desirable. Forman notes:

Within hip-hop culture, artists and cultural workers have emerged as sophisti-cated chroniclers of the disparate skirmishes in contemporary American cities, observing and narrating the spatially oriented conditions of existence that influence and shape this decidedly urban music. It is important to stress the word "existence" here, for as hip-hop's varied artists and aficionados themselves frequently suggest, their narrative descriptions of urban conditions involve active attempts to express how individuals or communities in these locales live, how the microworlds they constitute are experience, or how specifically located social relationships are negotiated. (8)

Thus, New York City is critical to understanding Mexican hip-hop in this space both because of hip-hop's history as a multicultural site of African and Latinx exchange, and because of more contemporary Mexican migrant experiences in this city. Likewise, Mexican hip-hop provides an opening into the Mexican "microworlds" of NYC.

Nevertheless, this regional affiliation has not changed the perception of rap as an exercise that is authentically "black." According to Pancho McFarland, "With some exceptions, Chicano rap acts have received very little airplay or national recognition. Most Chicano rap acts are known and supported in their hometowns and regions and work in small concert venues within a limited cir-cuit that primarily encompasses the southwestern United States, though may have taken their acts to other countries" (*Chicano Rap* 4). Thus, despite McFar-land's perception of Chicano rap as a "new millennial mestizaje/mulataje con-sisting of Mexican/Chicana/o, African (American) and European (American) elements" (*Chican@ Hip Hop Nation* 3), Mexicans are not necessarily embraced in this hip-hop history, especially outside certain regions. More common are conclusions like those of Alan Light, who writes, "Rap is about giving voice to a black community otherwise underrepresented" (164). More recently, the Latinx realm of hip-hop is often seen as limited to reggaetón, a music largely based in the Caribbean and East Coast, which again largely excludes Mexican contributions to hip-hop.[12]

Although all Spanish-language or even all-Mexican shows are no longer a fantasy for hip-hop aficionados in Mexican New York, outside the Spanish-speaking hip-hop community, Mexican rappers are still considered an oddity in the Northeast. Moreover, while some may fixate on a Latinx classification of hip-hop, practitioners have more expansive ways of defining their scenes. As a poster for the 2do Festival International de Hip Hop en Español New York (2nd New York International Hip Hop Festival in Spanish) highlights, coun-tries of origin, U.S. regions, and the cutouts of the different artists themselves offer a visual reference to the diversity of styles and performers. At the same time, the enumeration of the festival signifies a hip-hop scene that sees itself as recurring, permanent, and even growing.

Given this history and the global spread of hip-hop in general, that young Mexicans who have migrated to or grown up in New York would participate in this youth culture should not be surprising. And yet, as Hispanos Causando Pániko (HCP) finds, outside the West Coast and that community, it often raises eyebrows. Perhaps this is because Mexicans experience an invisibility not only in hip-hop but also, until recently, in New York City as well. Mexicans are both the largest and the fastest-growing Hispanic subgroup in the United States. They are simultaneously an old and new group—nationally they account for 77 percent of third-generation, 68 percent of second-generation, and 58 percent of first-generation Latinx (Rumbaut 34). Yet despite this large presence and long history in the country,[13] Mexicans are still a relatively new and largely overlooked population in New York.[14] Instead of the invisibility of Mexicans due to their perceived illegality, this new generation experiences what Nicholas P. De Genova calls "deportability in everyday life" ("Migrant 'Illegality'" 419).

As the stories of several of the rappers in this chapter will show, for the Mexican population who largely immigrated after 1986, the inability to return as well as the increased militarization of the border is palpable in their daily lives. They must decide where they can travel to perform and who can and cannot represent their music outside of New York. In the case of HCP, for example, the undocumented status of two of the three members signifies that travel within the United States is a risk they must heavily weigh, while travel to their fan base in Mexico and Latin America is thus far an impossibility (Hispanos Causando Pániko, personal interview, 18 June 2013). Three major aspects of the Immigration Reform and Control Act of 1986 continue to greatly affect them and other Mexicans in New York. First, the pathway to legal status is not and has never been available to the majority of this population. Second, new surveillance technology and increased staff at the border have meant that Mexican migrants in New York are largely cut off from their families and communities in their home countries. Finally, penalties on businesses that knowingly hire or continue to employ unauthorized immigrants have meant greater exploitation and fewer protections for undocumented Mexican workers. As the introduction initially theorized, the container in which they live, then, has less to do with particular routes of migration but instead is a metaphor for the way the economic system has evolved to almost "disappear" Mexicans into New York City. These economic systems are the roots of racial capitalism routed in new ways. This containment reality has only become more poignant for the young MCs of this chapter, who, in the aftermath of the events of September 11, 2001, have watched the United States' proclamation of a planetary "War on Terrorism" turn into a war on Mexican migration through the creation of the Homeland Security State (De Genova, "Production of Culprits" 421). Most recently this has manifested in Department of Justice

pressure on sanctuary cities including New York City to assist in mass deportations (Hanson, "Dear Director Glazer").

Latinx contributions to hip-hop are crucial not just because of their historical veracity but also because they have played an important role in the development, dissemination, and diversification of hip-hop culture. Without this diversity, as personal interviews demonstrate, it is unlikely that many of the MCs in this chapter would have turned to hip-hop as a form of self-expression. They were building off a hip-hop in Spanish that already existed, not just in the United States but also in Mexico. As Fernandes maintains, "The development of bilingual rap by Latinx artists in the late 1980s helped to erode the hegemony of the English language in global hip-hop" (9).

For this reason, my Atlantic Borderlands methodology offers an understanding of Mexican hip-hop in a New York City context that brings together a robust hip-hop scholarship largely focused in an African American or black studies context, with a Latinx studies perspective. A grounding in Latinx studies provides a significant music studies element alongside a way to grapple with migration issues. Here, the Atlantic location highlights the influence of Caribbean culture on Mexican identities on the East Coast, as this is not only a city where Mexicans come into contact with a large population of Caribbean immigrants (Puerto Ricans, Dominicans, West Indians), but it is famously a city where those Caribbean cultures have shaped the history of the city, in this case hip-hop.

In many ways this chapter follows a recent trend in black studies hip-hop scholarship toward regional studies. Meanwhile, the concept of the borderlands emphasizes the reality of daily crossings not just spatially but musically as well, while also building on West Coast and Midwest work on Mexican and Mexican American music in a variety of genres.[15] While the previous chapter described how arts entrepreneurs represent one response to containment in New York City that directly attacks racialized economies via the creation of alternative forms of labor, this chapter explores the role of hip-hop as a unique site of Mexican identity and cultural production in New York City. In particular, I find that hip-hop for Mexicans in New York represents a new way of understanding Mexican experience through an East Coast hip-hop legacy and context that is both anti-deportation and anti-assimilationist. Through hip-hop, young Mexicans in New York find a way to claim physical and imaginative spaces while also asserting an identity not bounded by traditional bi-national links. It is an unapologetic Mexicanidad locally based in New York City identities that are also transnational, but it is a broader form of diasporic identity than previously studied with Mexican migration to New York City, a Mexican diasporic experience, as outlined in the introductory chapter, largely disseminated and held together by cultural production shared via social media and email. This chapter presents a Mexican hip-hop history in NYC through

the group Hispanos Causando Pániko and Buendia BK, as well as highlights new Mexican identities in *La Gran Manzana*. In all of them, a clear message of Mexican pride is supported by transnational hip-hop links that bring together New York with Mexicanidad in ways that privilege a Mexican hip-hop diaspora.

The New Authenticity Debates: Hispanos Causando Pániko and the History of Mexican Hip-Hop in NYC

In their 2012 video "Recesión," or "Recession," the New York–based Mexican hip-hop group Hispanos Causando Pániko (HCP, fig. 15) consciously claims the history of New York's hip-hop as part of their call for a music-based Latinx "revolution," in the face of an unrealized "sueño americano" (American dream) as well as an authentic "rap en español" (rap in Spanish). Incorporating hip-hop's four elements—MC, DJ, graffiti, and break dance—and decked out in Yankees caps, the group demonstrates their allegiance to New York City traditions. From the old-school sound, to their choice of lettering, to the scratchy style of the video, their work is more reminiscent of classic hip-hop videos from the 1980s and early 1990s than most work produced today. Moreover, their incorporation of both a sense of crew and multigenre style is clearly meant to invoke a sense of hip-hop culture's origins as a community-based event (Dimitriadis 1). And yet, HCP's brand of hip-hop would have been entirely unrecognizable ten years ago and is still almost completely unrecognizable to many today. First, its classic New York sound is achieved almost entirely in Spanish; second, it is produced and performed by Mexicans based outside of the Southwest, Chicago, or Mexico; and third, its themes are grounded in a New York Mexican experience that is both relatively new and largely unexpressed.

The Atlantic Borderlands represents the opportunity to both re-emphasize hip-hop's multicultural and Afro-diasporic roots, while continuing to explore Spanish as a new frontier for rapping, and problematize a frequent scholarly connection between blackness and hip-hop authenticity. In *The Black Atlantic*, Paul Gilroy specifically questioned the notion of black authenticity. As he points out, hip-hop is significant for the black Atlantic because of its unique history of "cross fertilization of African-American vernacular cultures with their Caribbean equivalents" (103) despite the reality that "black music is so often the principal symbol of racial authenticity" (34). Thus, while hip-hop's popularization as the authentic black American culture is a powerful one, it is also a clear reflection of the status of nationality and national cultures in a postmodern era (34). Here we face a clear conundrum. If, as Gilroy argues, black music reflects a certain type of national authenticity, then the perception of hip-hop as authentically black American is problematic. It certainly does not reflect hip-hop's history, nor its present, but instead an act of erasure on the

FIG. 15 Hispanos Causando Pániko. From left to right, Raul "Meck" Hernández, Enrique "Demente" Trejo, Daniel "Nemesis" Gil. (Source: Daniel Gil)

part of the dominant culture to streamline U.S. culture into something racially categorizable.

The significance of "authenticity" claims in debates about hip-hop in particular and black music in general cannot be overlooked as they also play an important role in concepts of nationhood. As the foundational hip-hop scholars Mark Anthony Neal and Murray Forman explore in *That's the Joint*, questions of "authenticity" in hip-hop emerge with its commercial success. These debates include a feud between the West Coast and the East Coast,[16] and an essentializing of black culture as "hood," "poor," and "ghetto" in what Ronald A. T. Judy has termed "nigga authenticity" (58). Yet as Raquel Rivera and others have demonstrated, this is a hip-hop nation that essentializes blackness while pushing out those who helped build it. As a result, conversations about authenticity begin with a false premise that hip-hop is and always has been exclusively black American (despite its massive consumption by middle-class white youth), while Mexicans are migrants who refuse to assimilate to American culture.

Unfortunately, this concept of the hip-hop nation does not reflect hip-hop's very real presence south of the border. For the past several decades, visual artists, music producers, MCs, vocalists, and dancers from Latin America have

created localized art combining their surrounding culture with influences from north of the U.S. border.[17] Hip-hop in Latin America has grown to the point where Latin American artists are now major influences for some U.S. Latinx and non-Latinx artists, traveling around the world and performing in large non-English-language showcases. One excellent example of this is the Mexican poet, rap artist, scholar, cultural ambassador, and founder of the Quilomboarte Collective, Bocafloja. One of the most revered icons in Spanish-speaking hip-hop communities, Bocafloja travels widely and collaborates with numerous U.S. Latinx and African American artists, encouraging and spreading his redefined version of hip-hop's four elements: "decolonize, self-manage, transgress, emancipate" (*La Verdad,* "Collective Amnesia" 127). Significantly, his hip-hop collective is named Quilomboarte to recognize the quilombos, which during the colonial period on the American continent were communities established by fugitive black slaves (also known as maroons and cimarrones), indigenous peoples, and others who rejected colonialism's domination, who preferred to live as free people in communal form.

The Atlantic Borderlands serves to expand the concept of the hip-hop nation not just beyond the borders of the continental United States but also beyond the borders of an essentialized "nigga authenticity." They encompass Bocafloja's physical travels between Mexico City and New York City (and beyond) as well as his historical and musical travels. In the Atlantic Borderlands, for example, is Bocafloja's recognition of hip-hop's widespread acceptance in Mexico despite its own "collective amnesia"—as he terms it—of Mexico's African roots (*La Verdad,* "Collective Amnesia" 125) and a recuperation of that history from a hip-hop sensibility. It is a new borderlands where tracks like "El Día de Mi Suerte" (My lucky day), a song in which Bocafloja criticizes U.S. imperialist tactics over one of Puerto Rican Hector Lavoe's most famous salsa songs, are no longer an outlier but an important reflection of these new Mexican and New York stories. His work reflects a real dialogue and exchange between an artist who now resides at least part time in Brooklyn and the Afro-Latinx musical history that came before him, as represented in salsa rhythms. It also demonstrates how New York, as the newest Mexican city, cannot be fully examined without a longer view of history, one in which today's migrant markets overlay former slave economies as well as past and present black and Afro-Caribbean expressions.

For Hispanos Causando Pániko, their experience means collaborations with Chicano hip-hop contemporaries and a deep study of New York hip-hop history. It also means that a good beat can be a good beat. In "Viva México," an unabashed celebration of Mexican pride melds seamlessly with a sample of one of the most famous R&B songs, Otis Redding's "Try a Little Tenderness." HCP uses Redding's slow buildup to surprise the listener with the forceful

declarations of Mexicanidad: "Viva México," "Manos arriba," "HCP vino a brindar el corazón a los carnales," "Mexicanos arriba—No importa lo que digan," "Hip Hop está en el edificio," "Mexicano por fortuna, viva México," and "un mexicano sobresale."[18] Notably, these aggressive declarations of pride and value interject as Redding sings "squeeze her, don't tease her, never leave her," doubling the meaning of Redding's "her" to personify a connection to a female personified "La Patria" (homeland). Yet, this is not a use of black music to perform a hip-hop "authenticity"; rather, a New York City context means a global world of music has opened to them. Here, celebrating Mexico is not limited to rapping over banda, but rather alternative music choices can be used to surprise and draw attention to Mexican hip-hop in New York.

HCP was formed in Corona, Queens, in 2005. Its members, Enrique "Demente" Trejo, thirty-three; Raul "Meck" Hernández, thirty-three; and Daniel "Nemesis" Gil, thirty-four, consider themselves the pioneers of Mexican hip-hop in New York. Taking their name from the debut album of Chicano hip-hop groundbreaker Kid Frost, HCP features Spanish-language lyrics that describe the immigrant struggle in New York City with a sound inspired by the beats of Biggie Smalls (aka Notorious B.I.G.), Big Pun, and Wu-Tang. The reference to Kid Frost, despite the large difference in hip-hop styles, nevertheless is extremely significant. Though musically, stylistically, and even culturally quite different, it is a nod to the greater Mexican diaspora and the music that preceded them. Moreover, the choice of name also reflects an engagement with a long history of policing against Mexicans, regardless of status, and as such it demonstrates a strong stance of what I have presented as anti-deportability, a refusal to mold an identity or hide to fit society's expectations of Mexican migrants.

HCP has performed from NYC to LA, opening for Mexican hip-hop groups such as Kinto Sol (Milwaukee), Akwid (Los Angeles), Delinquent Habits (Los Angeles), and Jae-P (Los Angles), also demonstrating their links with a larger contemporary Mexican hip-hop diaspora. HCP independently sold 15,000 copies of their 2007 mixtape and are currently in the final stages of completing their debut album, *De Las Calles, Para Las Calles*.[19] As their album cover emphasizes, this album is as much about representing Corona, Queens, as their Mexicanidad, as their crossroads visual locates the group on 126th Street and Willets Point, not just a section in the heart of Corona but also the subway stop for the NYC Mets.

In the song "De Corazón" (From the heart) from their forthcoming album, HCP claims authority as rap artists in two sites: their Mexican identity and their *pasión*. These spaces overlap constantly throughout the song as the lyrics swing back and forth between representing themselves as skilled and sincere artists and representing themselves as Mexicans. This stance is clear from the song's opening and refrain:

Cuando entro en la cabina soy la verdad	When I enter the booth I am the truth
No me importa lo que te dijeron	It doesn't matter what they've said
Yo soy hip hop y no creo en la autoridad	I am hip hop and I don't believe in authority
Pero esta es oficial, real.	But this is official, real.
Reconoce real mi carnal y Yo	Recognize real my friends and I
vamos a rockanrolear hasta el final	we will rock and roll until the end
y soy leal a lo que represento	and I'm loyal to what I represent
Hispanos Causando Pániko y	Hispanics Causing Panic and
Mexicanos 100% de corazón ...	Mexicans 100% from the heart ...
Esto es lo que es holmes,	This is what it is holmes,
Yo no hago reggaetón	I don't do reggaetón
Sólo hago hip hop en español de corazón	I only do hip hop in Spanish from the heart.
Soy como un cardeólogo con el diálogo	I'm like a cardiologist with my words
Porque todo lo que digo yo digo de corazón.	Because everything I say I say from the heart.
Recito mi canción como una oración	I recite my song like a prayer
Recibo una ovación	I receive an ovation
Soy un mexicano de corazón.	I'm a Mexican from the heart.

Like Versos, a simple drum beat is enriched by a synthesizer melody, this time in the form of two repeating chords that enhance the rhythmic driven nature of the song and play up the confident delivery of the lyrics. This self-representation is just one indicator of the complex way HCP's performance of Mexicanidad alongside a New York hip-hop style is beginning to speak to a growing population of Mexican migrant, 1.5, and second-generation youths in New York City. By New York hip-hop style, I reference what HCP members describe as their desire to make a classic sound composed of clean beats that highlight the sonic possibilities of Spanish-language lyrics. While the choice of Spanish lyrics marks them as Mexican, the language itself allows for quicker and easier rhyming, impressing audiences with their ability to flow.

As Ignacio Corona and Alejandro Madrid indicate in *Postnational Musical Identities*, "Music has always been linked to the construction of regional and national identities" (ix); however, the simultaneous representation as "Mexicano 100%" and "Yo soy hip hop" indicates a unique construction of identity in New York that works on multiple levels. At the most basic level, what they argue is that these two identities are not mutually exclusive; instead, it is hip-hop that boosts their expression of Mexicanidad. In "De Corazón," HCP clearly aligns themselves immediately outside of what is considered the Latinx realm of

hip-hop (reggaetón) and instead differentiates their work as authentic hip-hop. As their discography demonstrates, it is a specific style of hip-hop that associates itself with a conscious evocation of New York's early history, as opposed to the more commercial sounds of reggaetón largely affiliated with Latinx hip-hop expression, or the gangsta style currently popular in Chicano West Coast rap.

Nevertheless, the nods to Chicano rap (i.e., in the slang word "holmes" as well as their name) demonstrate a complex layering of a specific regional identity that functions within a larger ethnic hip-hop nation history. Importantly, it indicates how hip-hop serves some Mexican youths, like the members of HCP, to both maintain a sense of pride in their Mexican identity and demand a form of belonging to an increasingly global hip-hop community via a claim to an "authentic" hip-hop based in New York.

It is a form of forced post-nationalism for a group of young people who recognize that U.S. citizenship or even acceptance is not a real option for them, while a return to Mexico would mean leaving behind strong musical roots. It is, in fact, to use Nicholas De Genova's term, "a politics of anti-identity" in their refusal to be Mexican on anything but their own terms. Stuck in between nations, the members of HCP represent a refusal to be an "illegal alien" while also embracing the influence of NYC hip-hop on their Mexican identity. In being authentically hip-hop, they are authentically Mexican. It is also this act that makes them authentically hip-hop as hip-hop is a genre which has always embraced varied elements of diverse cultural experiences.

HCP's intervention in hip-hop's authenticity debates highlights several aspects of identity in New York City. First, the members of HCP affiliate themselves with the East Coast while nevertheless celebrating their Chicano rap predecessors of the 1990s as pioneers of Mexican hip-hop in the United States. They recognize their significance and influence as pioneers and even collaborate[20] with other pioneering Chicano artists such as Sick Jacken,[21] although they view their lives as very different. At the same time, in the conflict of what is "the real" of hip-hop in commercial versus politically conscious rap,[22] their affiliations are clearly with the latter, especially in their rejection of the highly popular reggaetón. Their highly personal lyrics demonstrate their interpretation of a hip-hop authenticity, an integral component of which is to "know yourself" and is most evident in their choice to rap in Spanish. As Alastair Pennycock describes it, "Hip-hop forces us to confront some of the conflictual discourses of authenticity and locality, from those that insist that African American hip hop is the real variety and that all other forms are inauthentic deviations . . . to those who insist that to be authentic one needs to stick to one's 'own' cultural and linguistic domain, to draw on one's own traditions, to be overtly local" (103). Examining HCP through an Atlantic Borderlands framework provides a new lens to

understand the way an increasingly globalized form of authenticity has returned to New York roots and evolved Mexican.

HCP's story begins with the last phase of Mexican migration documented by the sociologist Robert Smith, a migration that is much more diverse in terms of region of origin (additionally more migrants come from urban areas). Moreover, many of these recent migrants plan to remain permanently in New York, especially the numerous cohort who arrived as children and have now spent most of their lives outside of Mexico. Both of these characteristics are reflected in the backgrounds of the members of HCP. Demente, who migrated from Mexico City at age twelve, arrived in East Harlem on 116th Street (before later moving to Corona, Queens) in the heyday of hip-hop and quickly started doing graffiti. He met Nemesis, who was born in Queens to parents from Mexico City, in Flushing High School in the eleventh grade, and they used to live near each other in Corona, Queens. There they faced isolation in the 1990s as Mexicans. For example, as Nemesis recalls, everyone thought he was Colombian and Asian. Ironically the pair didn't even recognize each other as Mexican (Demente says he thought Nemesis was Arab, and Nemesis thought Demente was Dominican) until Nemesis saw Demente with a *Lowrider* magazine.

Meck arrived at the birthplace of hip-hop, the South Bronx, from Puebla, Mexico, at age ten, and experienced taunts and racial epithets when attending a predominantly Colombian High School in Jackson Heights, Queens (personal interview, 12 Apr. 2011). For example, Meck describes meeting about ten Mexican friends with flags in his high school cafeteria on Mexican Independence Day, September 16. Immediately, the security guards warned them that they were going to get jumped. "It was tough when I was growing up. A lot of Mexicans formed gangs to protect themselves. I remember at one point there were like sixty Mexican gangs—and that's just the ones that were known. . . . I used to avoid hanging out with Mexicans because if they saw three of you walking together—you were a gang. . . . I was never in a gang but even so I used to get into a lot of fights" (personal interview, 12 Apr. 2011). Meck got his MC name for being one of the only Mexicans in a then-Colombian neighborhood. They used to call him "Mexican," which got shortened to "Mex" and then transformed into "Meck" (Hispanos Causando Pániko, personal interview, 7 Feb. 2011).

This proximity to the center of hip-hop culture as well as their experiences of marginalization led all three to explore hip-hop in an effort to identify with their surroundings (Hispanos Causando Pániko, personal interview, 7 Feb. 2011). For Meck, hip-hop at first was a way to learn English and a way to make friends. It was also a way to identify with the tough streets around him: "It was real. They talked about problems that happen in the neighborhood,

school, streets, home, drugs" (Hernández, personal interview, 31 Jan. 2011). Yet what inspired them to take their music seriously was more than just a love of hip-hop; it was their need for a version of the music that represented them. As Meck describes it: "I like Wu Tang, I like Nas, I like to listen to Biggie. . . . I wanted to listen to someone like this in Spanish." Likewise, Demente states that the only Spanish-language rap music of the time, reggaetón—which tends more to club-style music about partying and women[23]—didn't fit with their music interests or experiences. According to Meck, "They talk about girls shaking their ass, about bling which I don't have, money I don't have, cars I don't have" (Hernández, personal interview, 18 June 2013). Their rejection of this message is their form of authenticity both as hip-hop artists and as Mexicans in New York.

Significantly, the East Coast rappers (not reggaetoneros) referenced by HCP are not just African American but Latinx, though Latinx who rapped predominantly in English, like Big Pun. At the same time, although all three HCP members describe listening to West Coast Chicano rap such as Kid Frost (generally considered the grandfather of Latin hip-hop), Psycho Realm, and The Mexicans while they were growing up, and even take their name "Hispanos Causando Pániko" from Kid Frost's debut album of the same name, they see their sound and style as distinct. "We sound like New York because we grew up listening to East Coast rap," Demente says (Hispanos Causando Pániko, personal interview, 7 Feb. 2011).

Members of HCP clearly distinguish themselves from Chicano rap even though they often collaborate with artists on the West Coast. They also separate what they see as older Chicano rap from the gangsta rap that they see as more predominant today (Gil, personal interview, 10 Apr. 2011). Meck elaborates:

> When Chicano Rap started, it was full of pride of being Mexican-American, but now it's changed, it's more like gangster rap. . . . I don't consider myself Chicano, but me and those old-school rappers shared that Mexican pride. A Chicano is someone that was born in the U.S. and has Mexican blood. They don't call themselves Mexicans or Americans because in some ways they feel rejected from both races. Our hip hop is definitely different from the hip hop in the West Coast. We have different struggles, we are just learning how to get respect from everyone else, we jumped the border meanwhile the border jumped the West Coast. (Hernández, personal interview, 12 Apr. 2011)

Thus, while HCP members clearly share a respect for and knowledge of the history and importance of Chicano rap and the importance of that identity, they clearly see their music, struggles, and identity as separate.

Nevertheless, these Chicano rappers were also influential as the first hip-hop by Mexicans and the first hip-hop they heard that made use of Spanish

(Hernández, personal interview, 12 Apr. 2011). Due to these multiple strands of influence, HCP's hip-hop biography is distinct from both Chicano rappers and Puerto Rican MCs, in that it is built in dialogue with diverse versions of Latinidad and decades of transnational exchanges. The Nuyorican experience—the navigation between distinct Puerto Rican sensibilities and those derived from life in New York City—that marked so many of the first generation of Puerto Rican hip-hop artists is very different from those of "La Raza" rappers like Kid Frost and the Aztlán Underground, or Cuban American MC Mellow Man Ace and vice versa. While neither HCP nor any other Mexican rappers in New York make claims to Aztlán—they claim their neighborhood(s) in New York and Mexico—they do use the term "La Raza" to reference an imagined Mexican community. Thus, while they listen to, respect, and even collaborate with West Coast rappers, their struggle and their lyrics are those of a recent migrant battling to find work and respect as an undocumented person or someone who may have U.S. citizenship but is most often viewed and treated as illegal. Rather than engage East Coast–West Coast authenticity debates, they recognize the significance of the Chicano call for solidarity with "La Raza" and create their own call for Mexican pride in New York.

Transnational identities are not new in Mexican music. As Helena Simonett documents in *Banda: Mexican Musical Life across Borders*, immigration patterns are directly reflected in Mexican popular music and dance, since social themes and musical practices travel with people as they cross borders. Yet once across the border, new identities develop. As Cathy Ragland has argued in her study of *música norteña*, the collective experience of travel and the constant flow of information, ideas, and culture shapes a new form of Mexicanidad focused on the shared experience of Mexican migrants in the United States combined with nostalgic references to the past (18). For many of the MCs interviewed for this book, who arrived in New York as young adults already with their own sense of hip-hop in Mexico, their sounds develop as they engage with the streets (examples include Rhapy of Buendia BK and Kortezua of Har'd Life Ink). This is even more poignant for those like Nemesis or Meck, who came as children before their identities had taken a firm shape. In all of them—even those born here—there is a clear sense of nostalgia for *la patria*. What makes this case distinct are the multiple levels of transnationalism and hip-hop histories for Mexican MCs in New York as well as their choice of a musical genre not originally from Mexico.

In many ways, then, New York MCs like HCP or Versos share a great deal with contemporary Mexican migrant and Mexican American rappers such as Akwid, Jae-P, Kinto Sol, or Chingo Bling, who use hip-hop to express the struggles of Mexicans against the backdrop of anti-migrant sentiment, and choose to rap in Spanish or Spanglish. Moreover, Kinto Sol's expression of a midwestern Mexicanidad[24] represents a Mexican hip-hop diaspora continually pushing

beyond a geographical border zone. While scholars such as Néstor García Canclini have pointed out the dynamism of "border zones" as vessels for new expressive art forms (231–232), what these movements show is a practical expansion of Anzaldúa's theory. It demonstrates that such zones need not be located at actual geographic boundaries but can include the experiential borders simultaneously conflict-laden and culturally generative.

In fact, in hip-hop these traditions are even more at home as the genre itself is built on a rasquache aesthetic of collage and sampling (Chang, *Can't Stop, Won't Stop*). Alex Rivera makes the connection between the practice of rasquachismo and the Latinx artists associated with it, such as Guillermo Gómez Peña, Lalo Alcaraz, and Coco Fusco, along with a hip-hop sensibility that ties together people with limited resources. Rivera comments on how Latinx channel the creativity that responds to necessity, as people with limited resources turn to repurposing and recycling for their original work: "There's a lot of writing and awareness about the way so-called minority communities use sampling, whether it's in hip-hop or the recycled imagery of *Pocho Magazine* or the more traditional definition of what's rasquache: somebody fixing up an old car with pieces from three other cars; a collage aesthetic of the street.... It's ingrained in our spirit of survival, resistance, and innovation" (Guillen). In these long histories of cross-cultural exchanges as well as a shared rasquache aesthetic, contemporary West Coast and Midwest Mexican rappers have developed a new soundtrack to express their hybrid transnational lives in global cities. According to Josh Kun in his analysis of Akwid, "Rather than a politics of 'either/or' that asks people to choose between culture and politics, between class and race, or between distinct national identities, this cultural movement embraces a politics of 'both/ and' that encourages dynamic, fluid, and flexible stances and identity categories" ("What Is an MC" 739). Thus, these hip-hop expressions represent not the formation of new national identities but the formation of new transnational mobile ones.

In an increasingly globalized urban world, transnationalism works on multiple levels and in multiple ways for Mexicans in the ever-expanding borderlands that build diasporic webs of both identification and dis-identification. When the borderlands are routed from the geopolitical border to Milwaukee and then New York City, these dimensions become even more complex. As Mexicans in New York City, they draw on their immediate surroundings, a feature that is most noted sonically. In contrast to other styles, East Coast hip-hop music has prioritized complex lyrics for attentive listening over beats for dancing. Moreover in the 1990s (to which many of the artists point as inspirational), the sound of New York tended to be characterized by aggressive and hard-hitting beats. One other distinction is important here—unlike the previous

non–New York City rappers, for many of my subjects, rapping in Spanish is not a choice, as it is the only language in which they have the verbal facility for hip-hop. Still, as NYC Mexican pioneers in this genre as well as new arrivals, their music is also built on Mexican hip-hop from both sides of the border, a music that itself is built on decades of exchange.

Mexican hip-hop in New York City is both similar to and different from Chicano rap and other Mexican hip-hop in the United States and Mexico, because this hip-hop represents a vast musical diaspora that nonetheless has long been in dialogue. Moreover, though physical travels may be less and less viable due to increased border security, technology (e.g., email, social media, cellular phones) is making other forms of travel faster and more available than ever. Thus, what I explore in the rest of the chapter is two groups' perceptions of a long history of hip-hop conversations and where and how they choose to engage. If anything, they provide an important bridge linking a current Mexican hip-hop in the United States that, as McFarland has noted, proudly references *la patria*, strongly criticizes constructions of illegality and police surveillance (*The Chican@ Hip Hop Nation* 116), and, in New York, is powerfully macho without denigrating or sexualizing women. Although this heteronormativity still marginalizes women and gays and lesbians, as opposed to Chicano rap of the 1990s, it is not one that belittles or stigmatizes either.

As this small window into the experience of the members of HCP attests, their identities in New York are influenced both by a specific time in hip-hop history and by their migration experiences as Mexicans and their reception in New York. Regardless of their actual immigration status, as Mexicans in New York, the members of HCP and others like them have largely been viewed as "illegal immigrants" with all the negative connotations associated with that term. HCP's claim to an authentic hip-hop, thus, is also crucial as a method to navigate their often-unwelcoming surroundings, by embracing their own hip-hop identity. It is a hip-hop authenticity grounded in New York's historically central role, as well as their Queens upbringing and their identity as Mexicans.

While Mexican scholars of Mexican migration to the United States have tended to approach the topic from an analysis of U.S. capitalism and demands for low-wage labor, U.S. scholars have often approached the study via questions of "settlement" and "assimilation" (De Genova, "Migrant 'Illegality'" 434). For example, while Robert Smith has researched "Black Mexicans" in New York (i.e., phenotypically "Mexican-looking" youth who identified as black during adolescence and used this identity to become upwardly mobile), this is not HCP's story ("Black Mexicans" 517). Theirs is not an act of rebellion but a form of "politics of anti-identity" (De Genova, "Queer Politics" 110). Neither apologetic nor accommodationist, it is instead a profound statement of self-acceptance. Like the slogan "We are here and we're not leaving" in the wake of

the 2006 mobilization, HCP's brand of hip-hop is anti-assimilationist. As De Genova writes:

> The bold and fearless character of this posture, furthermore, was only surpassed by its uncompromising intransigence and *incorrigibility*: this was a profoundly *anti-assimilationist* gesture. *We are here*, they proclaimed, and by implication, they insisted: *We are who we are, and what we are.* The millions who literally put their deportable bodies on the line in this struggle—at least, when they chanted *this* slogan—were not begging anyone for their putative civil or human "rights," were not asking any authorities for permission or pardon, and did not seek anyone's approval or acceptance. ("Queer Politics" 103)

In a similar way, HCP refuses to either assimilate to the stereotypical Latinx's place in hip-hop (reggaetón) or become "Black Mexicans," though that is not a statement about Afro-Mexicanidad, an identity Bocafloja proudly asserts. From their sound to their lyrics, their music is an unapologetic explanation of who they are. For example, "Desde los ojos de un inmigrante" (From the eyes of an immigrant), written by Meck, relates the experience of crossing the border: from meeting the coyote, to trekking across the desert, to losing connections to family members. He also turns the personal experience into a challenge, naming himself as "sólo uno de millones que han cruzado la frontera" (I'm just one of millions who have crossed the border) and challenging his listeners to "ver la vida desde los ojos de un inmigrante" (view life through the eyes of an immigrant).

HCP's lyrics similarly demonstrate their negotiation of their Mexican identity within a diverse New York that also includes a hip-hop nation that was not initially welcoming and is still often skeptical. Meck's hip-hop "biography," "Así comencé" (This is how I started), demonstrates this experience of isolation within New York's hip-hop community as well as his sense of marginalization as a migrant.

Todo comenzó en Corona como una broma	Everything started in Corona like a joke
y en poco tiempo en la zona me decían que mi letra era cabrona	and in a little time in the area they told me my lyrics were tight
comencé a pensar que tenía talento	I started to think that I had talent
y en aquel tiempo en Nueva York	but in that time in New York
no había nadie con quien compartir ese sentimiento	there was no one to share this feeling
así que tuve que andar solo	so I had to continue alone
me sentí lejos de todo	I felt far away from everything
y si a alguien no le gusta lo que hago ya ni modo	and if someone didn't like what I did so what

pero no había de otra	there was no other way
si pierdo no importa	if I lose it doesn't matter
si no intentar es una automática derrota	to not try at all is an automatic failure
así que tuve que hacerlo no sólo por mí	so I had to do it and not just for me
por mi familia por mi raza es por qué me decidí	for my family and for my people is what I decided
tenía que expresar lo que pasé con mucha fe	I had to express what was happening with much faith
el sueño americano no es como se cree	the American dream is not what you believe
hay humillación y injusticia mucha malicia	there's humiliation injustice lots of malice
solo un por ciento que se ve en noticias	it's only one percent you see in the news
quería que el mundo supiera mi verdad	I wanted to world to know my reality
no es terquedad	it's not stubbornness
quería que vieran la realidad	I wanted them to see my reality

In this song, Meck describes the loneliness and isolation of pursuing hip-hop as a Mexican in New York during a time when there was no one with whom to share his interests. Stripped-down beats over a simple repeating string melody focus the song on Meck's crystal clear vocals, adding a somber tone. His decision to pursue this chosen medium despite hardship is "for his family" and "his race." He describes the need to express "his reality," which had very little to do with some fanciful "American dream" but instead was full of "humiliations" and "injustice."

Despite the simple sonic choices, the song nevertheless moves forward steadily in the style of Notorious B.I.G., building narratively until Meck delivers the heartbreaking lines: "Me quieren ver como un criminal, como un animal—mi único pecado es ser un ilegal" (They want to see me like a criminal, like an animal—my only sin is being illegal). After delivering these lines, Meck shows his skills as a rapper, launching into a breathless tour de force ten-second speed rap (also known as chopper style) before ending with a dedication to his family and a slow fadeout. Significantly, chopper style originally developed in the Midwest, further demonstrating HCP's cross-cultural hip-hop travels.

Meck, in describing the inspiration for HCP's lyrics, adds: "I think of what we went through. Everything we saw, all the suffering, crossing the border, living with twenty people in one apartment. My father used to make $200 a week as a dishwasher" (Hispanos Causando Pániko, personal interview,

7 Feb. 2011). These economic hardships of struggling to survive in New York as well as having to deal with small residential and creative spaces are a part of a shared experience of most every Mexican MC in New York. Here the drug-dealing chronicles of NYC rappers before them, like Biggie Smalls and Jay-Z, are replaced with raps about the repetitive nature of daily low-wage labor.[25] In songs such as "Recesión" (Recession), "Sacrificio" (Sacrifice), and "Medidas drásticas" (Drastic measures), they describe the socioeconomic hardships and lack of opportunities that cause despair.

For example, in "Recesión" they describe the difficulties of imagining upward mobility: "El sueño americano nos sale caro / desperdiciamos años fumando, tomando, culeando, atrapados en el barrio sin salida" (The American dream costs us a lot / We waste years drinking / Smoking fucking / we're trapped in the barrio without exit). Meanwhile, in "Sacrificio" they describe the costs of underemployment experienced by many Mexican men—from taking risks for the hope of some benefit, to working so much they hardly see their children. This feeling of living a trapped life due to their migrant status comes through full force in "Medidas drásticas," in which they rap, "A veces me siento que estoy entre la espada y la pared / y la seria infrared me tiene apuntado en la frente / y una gente me tiene la migra me quiere acabar con la vida" (Sometimes I feel like I am between a rock and a hard place / and the infrared rangefinder is pointing at my forehead / some people have me, ICE wants to end my life). In songs like these HCP paints a grim vision of what it means to be socially and economically contained as a Mexican immigrant in the United States. While they speak about their Queens experience, they privilege a more general Mexican one, and let their sound give their listeners a sense of New York's streets by evoking the style of Big Pun and Biggie, preferring simple, clean, hard-hitting beats that focus the listener on the narrative.

What makes their rap authentic, they feel, is not just the sound but also this storytelling tradition. According to Meck: "Hip-hop is like the newspaper of the streets. We tell the stories you can't find anywhere else" (Hernández, personal interview, 18 June 2013). Last, their choice of hip-hop in Spanish, establishing close connections to Latinx artists across the United States and Mexico, and making use of international artists in sampling, demonstrates their emphasis on strengthening a multifaceted Mexican identity in New York via a rasquachista aesthetic formulated for the Atlantic Borderlands.

While HCP builds from Chicano and West Coast hip-hop in terms of slang and iconography, and from New York City in beat-making and video visuals, their narrative lyrics (especially those written by Meck) represent a powerful form of *autohistoria* in the tradition of Gloria Anzaldúa. It is a technique of spoken-word, art-performance activism via hip-hop music by Mexicans in New York City employed to narrate both personal and collective stories. As Anzaldúa explains, "*Autohistoria* is a term I use to describe the genre of writing about one's

personal and collective history using fictive elements, a sort of fictionalized autobiography or memoir: an autohistoria-teoría is a personal essay that theorizes" (*This Bridge We Call Home* 6). Composed of personal stories as well as observations, HCP's lyrics reflect an attempt to both share their story and build community connections. Similarly, Mexican MCs' autohistorias reflect their experience in multiple worlds and contact zones within New York, their allegiance to hip-hop, and their exploration of questions of Mexicanidad. As Paul Gilroy says: "Artistic expression, expanded beyond the recognition from the grudging gifts offered by the masters as a token substitute for freedom from bondage, therefore becomes the means toward both individual self-fashioning and communal liberation. Poises and poetics begin to coexist in novel forms— autobiographical writing, special and uniquely creative ways of manipulating spoken language, and, above all, the music. All three have overflowed from the *containers* that the modern nation state provides for them" (*Black Atlantic* 40; my emphasis). Rather than choose a single style of hip-hop, perform or incorporate traditional Mexican music, or accept views of migrants as illegal or criminal, HCP instead bridges East Coast and West Coast rap history, hip-hop's musical travels across borders, the trauma of Mexican migration, and the realities of surveillance in a post-9/11 world laid down over classic Anglophone Caribbean inspired beats.

In this manner, HCP provides a lens to examine the ways that Mexican identities are negotiated and performed in spaces—in this case both hip-hop and New York—that have little or no recognition of them. It also demonstrates Mexican identities that are formed within a critique of racial capitalism that limits their economic and thus creative possibilities. Like the 2006 migrant activists who refused to be defined by discourses of illegality, HCP's claim to an authentic Mexican identity through hip-hop is similar to earlier responses to essentialized identities articulated by Stuart Hall ("Cultural Identity and Diaspora") and Paul Gilroy (*The Black Atlantic*).[26] As Stuart Hall points out, "Perhaps instead of thinking of identity as an already accomplished fact, which the new cultural practices then represent, we should think, instead, of identity as a 'production' which is never complete, always in process, and always constituted within, not outside, representation. This view problematizes the very authority and authenticity to which the term 'cultural identity' lays claim" (234). Likewise, HCP's insistence on authenticity is an important intervention against charges of "assimilation" or cultural appropriation, terms that have been used to dismiss Latinx artists who were seen to privilege hip-hop over Latinidad in the 1990s (R. Rivera, *New York Ricans* 152–163). They are authentic to hip-hop's New York traditions and history, but not to its more recent racialized inflections.

As scholars of contemporary transnationalism such as Saskia Sassen and Arjun Appadurai have observed,[27] an emphasis on movement also requires an

engagement with the particularities of place and location (or locatedness). For this reason, while Meck grounds his hip-hop origins in Corona, where he largely grew up and still lives, it is from this location that the global occurs. While the song "De Corazón" legitimizes them as 100 percent Mexican and 100 percent authentically hip-hop, the concept of "Hispanos" spreads their voice "desde Queens para todo el mundo" (from Queens to the world) and declares "Soy hispano soy Latinx 100%" (I'm Hispanic, I'm Latinx 100 percent). Here they expand the meaning of "raza" from Mexicans to Latinx, whom they are equally proud to represent, because "en NY los Latinx hablan español" (in New York Latinx speak Spanish). Though their stories are New York Mexican based, they see the plight of their gente (Mexicanos) as irrefutably connected to the question of Latinx in the United States, adding yet another layer to their sources of identification. In other words, their New York Mexicanidad travels via their hip-hop.

Thus, at the same time HCP uses hip-hop to legitimize their Mexican identity (and vice versa) as a powerful source of ethnic pride, this pride and music exist on an unapologetically transnational plane. Their Spanish-language music is diffused throughout Latin America, and they regularly perform with artists from other countries. In a New York context in which "Latinx" has largely meant Puerto Rican, or more generally Caribbean, these links also indicate a Mexicanization of East Coast Latinidad not often recognized in current studies of Mexican transnational flows, since those studies tend to focus on the borderlands and Mexican-U.S. relations.[28] While clearly Mexico for HCP is an imagined community they draw on for ethnic social capital in New York, their participation in a global Spanish-language "hip-hop" and larger U.S. Latinx communities demonstrates a much more complex formation of cultural identity.

The members of HCP, like their hip-hop music, find themselves in a very particular in-between place. In not having chosen their own migration, they were made transnational, while their choices in music reflect a struggle to adapt and survive in the United States. Their negative reception in New York, and their use of hip-hop to emphasize Mexicanidad, indicates that their continued expression of a transnational Mexican identity is a choice, a "deportable" identity they have chosen to embrace. For HCP, "Yo soy hip hop" allows them to move in and out of multiple identities through which they can connect to multiple audiences. It is a political identity, a method of community building, and a form of musical expression. It is Mexican and Latinx and Latin American. It is old-school hip-hop and reflects new media platforms (YouTube, Facebook). "Yo soy hip hop" is more than just a statement; it is also a complex, ever-shifting identity dependent on situation, audience, context, and surroundings. But it is a Mexican identity that could not exist without hip-hop. Here, the medium and the message intertwine to represent a new expression of Mexicanidad, from the streets of Corona, Queens, "para el mundo."

Transnational Imaginaries: Mexican Hip-Hop Crews across Borders

In the film *The Sixth Section*, Alex Rivera documents how in Newburgh, New York, over 300 people from Boquerón, Puebla, formed Grupo Unión, a "hometown association" dedicated to raising dollars in America and using the money to revitalize their hometown in Mexico. With so many people from Boquerón now transplanted to Newburgh, they refer to themselves as the "sixth section" because Boquerón itself is divided into five sections, or neighborhoods, of which they now see Newburgh as the sixth. This type of transnationalism based on remittances is not uncommon; indeed, it has come to be viewed as the typical example of transnational life in much scholarship.

As Robert Smith's *Mexican New York: Transnational Lives of New Immigrants* documents, even in New York migrants have used their economic powers to establish a political presence in their hometowns since the 1970s. For example, Smith narrates how the formation of a political "committee" or hometown association by first-generation migrant men from Ticuani has raised money and supervised numerous public improvement projects from 1970 to the present, including paving and lighting the town square, building primary and secondary schools, renovating a church damaged by an earthquake, and constructing a potable water system (57). Unfortunately, in this focus on a tangible form of transnationalism, the diasporic practices of the second generation or alternative collectives are often overlooked.

As Smith notes, the concept of "transnational communities" has been debated from the mid-1990s to the present but has often been dismissed as an ephemeral phenomenon not likely to be sustained in the second or third generation. Likewise, many scholars, especially in the social sciences, conclude that transnational activism among the second generation is of little importance because—as Alba and Nee and Kasinitz, Mollenkopf, and Waters have argued—most children of migrants have no plans to return to live in their ancestral homes and may not be completely fluent in their parents' mother tongue. Moreover, for a generation of people like Meck or Nemesis, who arrived as children, return is no longer a viable option while deportation is a risk they take when traveling within the United States to perform or collaborate. However, while Smith makes the case that the second generation may not engage in transnational practices at the same frequency and intensity as that of their parents, these practices cannot be overlooked given their impact on socialization and social networks.

Mexican hip-hop in New York demonstrates the way layers of diasporic identification extend beyond making connections with an ancestral home or place of origin. It is a form of connection that aims to increase webs of Mexicanidad in not just bidirectional but multidirectional ways. Thus, just as Gilroy's "Black

Atlantic" delineates a distinctively modern, cultural political space that is not specifically African, American, Caribbean, or British, but is, rather, a hybrid mix of all of these at once, so too Mexican hip-hop in New York reflects new forms of transnationalism whose connections go far beyond a city of origin and a city of settlement.

HCP's ambition is to make "classic" music that will reach not just Mexicans but all Latinx ("Real hip-hop heads" [Demente]) and sell internationally in Latin America (Hernández, personal interview, 12 Apr. 2011). This goal indicates how promoting their own version of hip-hop allows HCP to create a music about their Mexican migrant lives but also relate to the world around them. It is Mexican, pan-Latinx, diasporic, and transnational. HCP's music and lyrics are a desire that crosses borders and boundaries and demonstrates a vision to represent not just Mexicans in New York but also all those who are marginalized and racialized. Simultaneously, theirs is also a vision to tell a larger audience about the realities of Mexican life in New York, as well as the socioeconomic hardships and racism facing people of color (especially Latinx) more broadly. It is a mission to make understandings of Mexicans more complex, to disrupt the stereotype that Mexicans are antithetical musically to hip-hop, that their only cultural center is as Chicanos in the Southwest, and that Mexican migrants are purely victims in the New York hierarchy. As Calafell writes in her research on Mexicans in North Carolina: "There is a new experience that has yet to be named. Born out of a specific historical context, *Chicanismo* may not be a viable option in these situations, especially if Mexican Americans or Chicana/os want to make political coalitions across Latinx groups or generations in these spaces" (16). It is a more expansive view of Mexicanidad that includes the multinational conversations via Facebook, email, Skype, SoundCloud, and other forms of information and music collaboration. It involves, as Jorge Duany defines transnationalism, both "the creation and maintenance of multiple social ties across borders and boundaries" (3) and "the construction of dense social fields through the circulation of people, ideas, practices, money, goods, and information across nations" (20). Thus, while HCP's form of musical identity reflects mainly a circulation of ideas, other Mexicans on the Atlantic Borderlands are exploring other arrangements, such as the development of transnational or multinational hip-hop crews.

The previous chapter introduced the hip-hop culture collective Buendia BK, a group based in Sunset Park, Brooklyn, and founded by Solace and Versos in 2007. It started as a social club and then became Buendia Productions in 2008. What brought them together was the fact that "we all had problems, but we can't let life beat us down," says Solace, inspiring their name, representing their belief that "from now on, every day will be a good day" (personal interview, 1 Nov. 2013). Unlike two of the HCP members, as well as most of the

members of Har'd Life Ink explored in the previous chapter, Solace and Versos were born and raised in New York, specifically Sunset Park, Brooklyn. Although this area now has a significant population of Mexican migrants (N. Foner, *One Out of Three*), their experiences of isolation and lack of space for hip-hop by Mexican migrants parallel HCP's experiences in Corona, Queens. As Versos, thirty-two, describes his background, "When I was growing up there were no Mexicans that I heard of doing it in New York—not out here. Not too many people support Latin hip hop, but it's growing now" (personal interview, 19 Oct. 2013). For Versos, his style as an MC comes from his experiences of hardship growing up in Brooklyn in the 1980s and 1990s. As his parents struggled financially, Versos ended up dropping out of high school in the ninth grade to help his family, and now works in packaging at a whisky distillery. Significantly, Versos, who acts as the lead MC on the NYC side of Buendia BK (his counterpart is T-Killa in Mexico City), is both extremely rooted to his Brooklyn background and transnational in a unique form of his own making (see fig. 16). For it is not with his parents' Puebla, Mexico, roots that he alongside Solace and other members of Buendia BK INK form their transnational ties, but through a both real and imagined international hip-hop community that now includes Buendia Mexico and Buendia Japan.

Versos, unlike the members of HCP, raps equally in English and Spanish, often switching languages within a song or even a lyric. For example, in an August 2015 video, "A Beautiful Day," he raps, "It's a beautiful day in my neighborhood . . . dropping this NY street fast / because that's where I be at / where's that weed at / so we can put me in a mucho relajo / reminiscing every moment at we laugh / estamos muertos de la risa escuchando pistas."[29] Uniquely, his English and Spanish flow is differently inflected by his multicultural NYC upbringing that incorporates African American vernacular. According to Versos, "People say I sound like a Moreno. I'm not trying to sound like a Moreno, it's just I was born and raised in Brooklyn so that's how I talk" (personal interview, 19 Oct. 2013). Perhaps this is a result of the influence of major rappers such as Kool G Rap ("he's the one that fathered the flow") and Biggie ("like Biggie said, spread love is the BK way"). All his music videos are set generally in Sunset Park (where he was born) or other iconic areas of Brooklyn, such as Coney Island or beneath the Brooklyn Bridge.

Over the past decade, however, Versos has turned his gaze from Brooklyn to Mexico City for Mexican rap role models. According to Versos, "Mexico City is awesome—the movement in Mexico is huge. . . . Like hip-hop in the 1990s here" (personal interview, 19 Oct. 2013). One of those artists is T-Killa, a well-established rapper[30] from (and raised in) Mexico City, who ironically was born in Los Angeles. As a result, T-Killa's major influences in hip-hop were West Coast Chicano rappers such as Cypress Hill and Puerto Rican rappers such as

FIG. 16 Versos and T-Killa perform at Har'd Life Ink, 2013. (Photo: Daniel "Solace" Aguilar)

Mexicano 77 (personal interview, 14 Oct. 2013). Perhaps this is why he describes his rap as having a Mexico City style with "Slang de allá" (slang from over there). In comparison with HCP's long, multisyllabic verses—especially those spit by Meck—T-Killa favors low-pitched vocals that develop into slower yet more melodic cadences. This style is even more emphasized, as in recent years T-Killa's music, as displayed in his latest album *INKsanidad*, has reflected a heavy interest in reggae. Thus, both Versos and T-Killa, like HCP, demonstrate a hip-hop identity that even at its foundations is transnational and multidirectional in often Afro-diasporic ways that far surpass remittances and hometown organization-based exchanges.

For Saskia Sassen, in the context of globalization, the centrality of place is crucial to understanding contemporary claims to citizenship that are both more urbanized and less formalized and founded on transnational economic, subjective, and political acts ("Nomadic Territories"). This glocal development in the Atlantic Borderlands is key to understanding Mexican hip-hop in New York City. In a New York setting of informal economies, global technologies, and migrant deportability, claims to place are increasingly significant. HCP's assertion about their roots from both an increasingly imagined Mexico and the Corona, Queens, of everyday life reflects the denationalizing of urban space. At the same time, their dedication to authentic hip-hop reflects an alternative approach to belonging other than citizenship. Likewise, Versos's identification verbally and visually to Brooklyn reflects a very real response to experiences of

dis-belonging and dis-identity despite having known nothing else. Versos is only authentically Mexican if he is authentically Brooklyn and vice versa. In this way, HCP and Versos complicate a Mexican New York, where they are only seen to be temporary transnational laborers without a claim to the city.

Solace, thirty-one, who acts as director and producer of Buendia Productions, is the person who truly expanded the scope and vision of the project. Solace emigrated from Ecuador at age four and grew up in Williamsburg. He sees hip-hop as a way to find his own piece of American culture. He says that he grew up observing how it had historically been an outlet for minorities and the disenfranchised (personal interview, 2 Feb. 2014). Originally a graffiti artist, he often stayed away from Mexicans because in his experience (parallel to Meck's) they were often gang affiliated out of self-protection. Instead, he became close to fellow graffiti artist Glazer, who is Mexican, and later Versos, forming a sort of social club. As they collectively bought equipment (turntables, mics, editing equipment) and converted a tiny room into a recording studio, more and more youths began crowding into the room. "I remember at one point the room was really full—there was like twelve people in this room. It was a home away from home and I just thought to myself, people are going to talk about this room" (personal interview, 2 Feb. 2014).

By 2008 Buendia Productions was created, located in their small, one-room, self-made Sunset Park studio. Self-defined as "a collective group of artists, musicians, dancers, and film makers looking to pioneer a radically new form of art that is acutely in-sync with the social changes that shape our human consciousness," their outlook is a bit different from HCP's. Though Buendia Productions was founded by two Mexicans (Versos and Glazer) as well as an Ecuadorian (Solace), and is affiliated with T-Killa's Mexico City crew INK, membership is based not on shared ethnic, racial, or neighborhood backgrounds but on an understanding of and dedication to furthering hip-hop's foundations. Returning to the four pillars—MC, DJ, graffiti, and break dance—Buendia hopes to revive an "authentic" hip-hop, which in contemporary commercial settings has lost contact with its core elements. As Solace clarifies, "Versos is an MC—Drake is a rapper. Versos is an MC because he is part of the four elements" (personal interview, 2 Feb. 2014).

Hip-hop pioneer DJ Disco Wiz offers this take on hip-hop's trajectory:

In the beginning hip hop was about the people and for the community that really had nothing else. After I came home, it was no longer that. When hip hop became a business it changed its essence and became something new and very different from what we had created so many years earlier in the streets of the South Bronx. Exactly when that happened, I can't pinpoint. But in my opinion the change was neither good nor bad. It was a change that helped hip

hop become global. And it is a business that has helped many. I truly believe that for anything to survive it must reinvent itself and change with the times, and hip hop is a perfect example of this. People reclaim it every day. Today, real hip hop lives in the grass roots and underground movements. In some places, it is still about the people and for the community. (Resnik 89–90)

Frustration with the hip-hop industrial complex is a common theme in underground hip-hop. To provide some context for the shift, Fernandes explains how the 1996 Telecommunications Act ushered in an era of conglomerates that monopolized the airwaves. According to Fernandes, by 2000, 80 percent of the music industry was controlled by five companies: Vivendi Universal, Sony, AOL Time Warner, Bertelsmann, and EMI (14). Within this context, for Buendia a hip-hop authenticity is based in both artistry and shared knowledge. Solace's statements, like those of HCP against reggaetón, reflect the dichotomy between the commercial music scene and the underground as one of the underlying narratives of contemporary hip-hop music, representing their insertion into a larger dialogue.

Buendia BK is now an artists' collective producing murals, music, shows, videos, photography, and clothing. It is also an independent label and resource for like-minded youth, extremely local in its setting and yet global in its thinking. Although much of the artists' work occurs in a radius of a few blocks in Sunset Park between the studio and the homes of a few of the members who live in the neighborhood, their membership is multiethnic, multiracial, and international. Though composed of at least 50 percent Mexican migrant artists who rap in Spanish (including female MC Rhapy), their makeup also includes Dominican MC Mauro Espinal of the Bronx (who raps in Spanish), New Jersey singer-songwriter Timothy Ruiz (English), African American MC and spoken word artist Bill Phillips (English), Japanese Bboy and MC Kokushyo (Japanese), and many others.[31] Modeled after the Zulu Nation, the first international hip-hop awareness group formed by hip-hop artist Afrika Bambaataa in the Bronx in the 1970s (Chang, Can't Stop, Won't Stop 101–106), Buendia BK from its very particular Mexican New York neighborhood nonetheless imagines a new and glocal hip-hop nation in the face of today's commercialization. It is one where hip-hop is the language, and the underground is a place of safety and free expression. As such, despite the large diversity of styles, backgrounds, and even languages, this passion for hip-hop culture is what ties the collective together. As Solace explains, "One way or another, we all feel a little out of place" (personal interview, 2 Feb. 2014). And though Solace admits that in the end he has the last word on the direction of the group (decisions are made through voting), there is no management or dictating of artistic choices (personal interview, 2 Feb. 2014).

This ability to unite hip-hop artists of various backgrounds, especially black, Latinx, and Afro-Latinx, is a unique and important aspect of Buendia's formation and vision. Though these types of collaborations were part of hip-hop's foundations, as hip-hop has become increasingly identified as an "authentically black" cultural expression, separations by race, language, and ethnicity or country of origin have become more frequent. Rather than the rainbow hip-hop nation Afrika Bamabaataa once imagined, Latinx and African Americans have developed what Robert Tinajero has described as a "tenuous solidarity" in hip-hop. According to Tinajero,

> I propose that Latinx Americans and African Americans—highlighted here through the lens of Hip Hop—are in a constant state of tension *and* solidarity. Here I offer a new term which I feel may capture best this relationship— *tenuous-solidarity*. The two groups interact in a physical, linguistic, and rhetorical borderland (Anzaldúa) and co-exist in what LuMing Mao might refer to as a state of "together-in-difference" (434). They "meet, clash, and grapple with each other" (Pratt qtd. in Mao 434) in a brutally beautiful manner that is indicative of many racially (or otherwise) divided people throughout the world. (xx)

What Buendia BK represents, then, is the rare creation of a different type of community and citizenship in which Latinx and African Americans, Spanish-language rappers, English, and Spanglish (and in this case, additionally Japanese) are considered equal members with equal claims to hip-hop culture. As African American MC Bliss comments, though he cannot understand Spanish, "You can hear the cadence. You can hear how they hit and ride the beat. And you can appreciate melodies and how they engage the crowd. Rhapy for example—she spits so fast" (personal interview, 2 Feb. 2014).

While HCP's stating a hip-hop identity presents an anti-assimilationist narrative and politics of anti-identity, Buendia BK's community-building objectives are simultaneously local and global. Versos, alongside Buendia's constant representation of not just Brooklyn in general but Sunset Park more specifically, demonstrates a particularly local Mexican identity that is even more emphasized than HCP's mentions of Corona. At the same time, trips between collective members (who are able) to Mexico City to visit T-Killa's INK, and vice versa, epitomize transnational music flows. Last, Buendia's conception also comes from their love of Gabriel García Márquez, the Nobel Prize–winning novelist from Colombia who spent much of his life in Mexico. They were such fans of *One Hundred Years of Solitude* that they took to calling the studio Macondo, the fictional town described in the novel, demonstrating the hemispheric vision of the group as well. That these transnational visits, like

their conceptual frameworks, are multilingual and multicultural in aspect, incorporating MCs and influences from diverse backgrounds, demonstrates an expansion of Mexican hip-hop identity beyond the United States and Mexico borderlands or national boundaries that is representative of the imaginative possibilities of the Atlantic Borderlands.

Beyond the Sixth Section: Greater Mexico in the Atlantic Borderlands

In 1983, Benedict Anderson famously defined the nation as "an imagined political community" (5). Anderson goes on to list the various characteristics that make a nation as such, one of which is that the nation "is imagined because the members of even the smallest nation will never know most of their fellow-members, meet them, or even hear of them, yet in the minds of each lives the image of their communion." (6). Mexican migrants in New York face a peculiar situation in that they are members of one nation from which they are often completely isolated physically, while living in another nation that desires their labor but not reminders of their presence. In this in-between space, some migrants, like the ones presented in *The Sixth Section* by Alex Rivera or the ethnographical work of Robert Smith, forge deeper roots with their home-towns, in many ways becoming more committed citizens albeit at a distance.

Alyshia Gálvez's work demonstrates a different migrant perspective. In her research on the Guadalupan devotion of undocumented migrants, for example, she finds a claim for citizenship in their new home. Gálvez finds that through their Catholic faith, undocumented migrants develop the will and vocabulary to demand rights, immigration reform, and respect. While this powerful statement of citizenship echoes HCP's declaration of hip-hop presence in its espousal of an anti-assimilationist narrative, I nonetheless contend that hip-hop functions differently for Mexican migrants, reflecting the unique context of New York. For the members of HCP, their identity as expressed through hip-hop includes an engagement with both East Coast and West Coast hip-hop; an acknowledgment of and knowledge about its New York Afro-diasporic roots; a respect for and implementation of the sounds, styles, and traditions that come from those roots; and an expression of that authentic hip-hop culture comes about in a mixed Mexican (mostly Mexico City, occasionally Chicano slang) Spanish to narrate their experiences in New York. It is an identity that embraces African American culture in a way that is not a form of appropriation but reflects the numerous musical and cultural flows that occur within these five boroughs, which have long occurred historically, and a sixth borough—the imaginary Mexico. Unlike the migrants from Boquerón, whose "sixth section" is Newburgh, New York, their sixth section is an imagined diasporic México that is ever shifting and changing.

Perhaps it is for this reason that HCP is also careful not to play into stereotypes of Mexicans as victims or solely undocumented people.[32] Here it becomes clear that despite discrimination, as well as economic and structural factors keeping Mexicans down, they see hip-hop as a route toward change:

Siento que he hecho mucho y sigo en el mismo lugar	I feel like I've done a lot and am still in the same place
y en vez de agüitarme debo mi esfuerzo triplicar	but instead of being depressed I try three times harder
porque no es fácil llegar donde quiero llegar	because it is not easy to get where I want to get
y la competencia no está en mi mente	and the competition isn't in my mind
mi meta es llegar al corazón de mi gente	my goal is to arrive to the heart of my people
eso me motiva eso me da vida eso es la medicina	that motivates me gives me life it's my medicine
que día en día mi dice que siga	that day in and day out inspires me to continue
Yo no me puedo detener	I can't slow down
Yo tengo fe en HCP	I have faith in HCP
y sé que lo haremos	I know we will do it
No nos detendremos.	We won't stop.

Significantly "mi gente" (my people) is a fluid community that, in their music, can mean Mexicans, undocumented migrants, hip-hop heads, Latinx, minorities, or any combination of these groups. This sentiment is echoed in the glocal community-building efforts of Buendia BK who take into consideration Mexican marginalization while still forming new ties. These ties, however, are not only transnational but also diasporic and multicultural, demonstrating a real commitment to a Greater Mexico that is not just diasporic but global. It is a new way of belonging in a hip-hop nation that is Mexican, hemispheric, and yet also profoundly New York.

Increasingly, it is also slowly becoming a space in which women take part, both individually, as part of these collectives (in the case of Rhapy of Buendia), and in female lead efforts. MC Audry Funk, born in Puebla and now of the Bronx, for example, is no stranger to collective feminism within a hip-hop context (see fig. 17). By collective feminism I mean a demand for gender equality that is founded and directed by women with the intention of creating a group of women who work individually and have individual beliefs but also come together for collaborative action. For example, in 2009, Funk helped found Mujeres Trabajando (Women at Work), a group of Mexican hip-hop artists dedicated to music that promotes positive messages about women. Eight years later, Audry

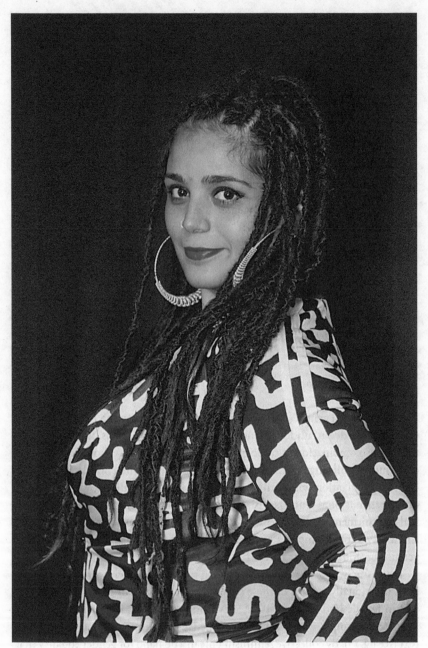

FIG. 17 Audry Funk. Photo: Grendy Galliari. (Source: Audry Funk)

Funk continues to be a member of the group, formed by women who practice break dance, graffiti, visual arts, photography, and other media forms in addition to rapping. As Funk explains, this type of project is important not just to promote women in hip-hop but to support them in their personal lives as wives, mothers, daughters, border crossers, and so forth so that they can continue to be hip-hoppers as well (RD Staff). With members now from Puebla to Juárez and all over Mexico, they continue to put on shows while expanding into other areas such as a clothing line called Funky Beast.[33] Mujeres Trabajando makes an important statement about valuing the labor of women in hip-hop, but also helping to support all the other labor women often must shoulder due to gender roles and expectations so that continuing to do hip-hop is possible.

Audry Funk is one of the best-known female MCs from Mexico, having performed in national and international venues including Chile, Bolivia, El Salvador, the Dominican Republic, Ecuador, and New York. Her personal music style is a unique mix of hip-hop with reggae, soul, and funk over which she raps in her powerful and deep vocals about the nuances of life as a Mexican woman, with themes from love to discrimination to defying expectations. One of these is about standards of Mexican female beauty. According to Funk: "I really want to dignify the beauty of women. Here in Mexico on the television you just can only see blonde girls and skinny girls. In Mexico we are not all blonde and we are not all skinny. So why do the systems want to make you feel bad about your size, your color of the skin, the color of your eyes? Like me, I'm not a skinny girl. I'm a big mama. So I always say I'm a big sexy mama and what? Why do I have to feel bad about that" ("In Mexico"). This stance is particularly clear in her song "Máscaras," her contribution to the album *Latinxamérica Unida*, in which she also defies listeners' expectations of her. Unlike many of her videos, in which bright clothes and city backdrops encourage movement and positive energy, "Máscaras" has a sobering, edgy, anti-discrimination message. Shot in black and white, the video features a stripped-down Audry Funk in a hoodie and dark, thick eyeliner. In it she powerfully describes the cages of societal views that limit women. And while domestic violence is one aspect of this cage, gender violence runs much deeper, with roots that extend and oppress in many ways.

Perhaps for this reason, in her bars on the final track she encourages female strength and unity as well as points out systems of gender oppression:

Y nos juntamos todas las guerreras	And we unite all the (female) warriors
Disolvemos fronteras	Dissolving borders
Qusieron separarnos	They wanted to separate us
Acusarnos de hechiceras	They accusing us of being witches
Consignar en el olvido	To consign to oblivion
A las que dan vida a la esfera	Those that give life to the planet

"Guerreras" is an important way of conceptualizing Audry Funk's form of feminism. Female warriors are a recognizable symbol of female power, and this symbol is one that does not diminish women's importance as the gender that also literally carries and gives life to the future. It is one that reaffirms women's place as mothers while also questioning gender roles that diminish women as weak followers rather than strong leaders.

For this reason, it should come as no surprise that Funk is a member of multiple hip-hop collectives such as Somos Mujeres Somos Hip Hop and Mujeres Trabajando, collectives that see one woman's success as essential to advancing the calls of all femcees. Funk is also a member of Somos Guerreras (We Are Warriors), led by Guatemalan MC Lane. Somos Guerreras is a tour that Lane, Funk, and other female artists are taking through Central America. In addition to concerts, the objective behind the tour is to shoot a documentary about women in hip-hop as well as give workshops that help facilitate female networks among a new and younger generation of women.

Despite her frequent travels, Audry Funk is settled in the Bronx, an experience that she says has fundamentally changed her: "Hay una Audry antes y después de NYC" (personal interview, 10 Dec. 2018).[34] The Bronx is significant for Funk not just because it is where hip-hop was born but because it was hip-hop that changed her life (personal interview, 10 Dec. 2018). Her New York City experience is one that she has described as both terrorizing because of the realities of being a migrant woman of color and also a space of hip-hop diversity she has never experienced before. Although the Mexican hip-hop scene in NYC may still be young, according to Funk, "El hip hop en NYC es diverso como la ciudad misma. Puedes encontrar más de 10 flows en un evento y todos son agradables, de diferentes países, de mezclas, de colores distintos es una experiencia bien diversa." And while in many ways Audry Funk has had to start over in New York in terms of her status as an MC, it is this opportunity to reach an increasingly diverse audience that drives her. Funk says, "Creo que cada escenario que piso es un logro más, cada medio que se interesa, cada persona que confía esos son los mayores logros y espero que cada día más personas confíen en este proyecto que tiene mucho corazón" (personal interview, 10 Dec. 2018).[35]

As Ramón Saldívar explored in *The Borderlands of Culture: Américo Paredes and the Transnational Imaginary*, the transnational imaginary of "Greater Mexico" presents both a challenge and an alternative to traditional notions of nation as presented by scholars such as Benedict Anderson. According to Saldívar,

> As an imaginary space of real political and historical effect, Greater Mexico represents an early, direct challenge to the traditional language of citizenship and liberal democratic notions that tie it indissolubly to state membership. . . . Today, both trends exist. As almost every item in the news these days confirms,

we are far from abandoning the idea of the nation as a viable category of political and personal identity. At the same time, however, something else has also become visible on the political horizon, namely, a loosening of national categories on various levels. (59)

Thus, like Anzaldúa's South Texas borderlands context, I extend Saldívar's "Greater Mexico" to New York, where both the United States and Mexico as nation-states are ever present in migrant lives. While this loosening of national categories has increasingly become cause for alarm in a post–September 11 world, perhaps best represented by an inescapable rhetoric of tightening borders (or in the case of President Trump, building a wall between Mexico and the United States), it also presents an important opportunity for rethinking the traditional borders and boundaries of Mex-America.

In addition to the inescapable rhetoric of illegality, criminality, and "bad hombres," Mexican hip-hop in New York faces constant questions of authenticity. Not only are the Spanish language and Mexican identity seen as antithetical to hip-hop (that is not reggaetón) by a largely white consuming public, Mexican hip-hop artists (whether MCs or artists as the previous chapter explored) tend to face greater forces of containment spatially, educationally, and economically than other Latinx groups in NYC. Thus, they also provide the opportunity to explore the cultural and social productivity of a transnational imaginary pushed to its limits. For all these artists, from HCP to Versos and Solace, to Rhapy and Audry Funk, the imaginative possibilities of multiple migrations of hip-hop traditions become a way for the members to both find their place in NYC and imagine a place in a greater diasporic Mexico for which a physical return, in many cases, has not been realistically possible for two decades and continues to be a distant dream.

4

"Dejamos una Huella"

▪▪▪▪▪▪▪▪▪▪▪▪▪▪▪▪▪▪▪▪▪▪▪▪▪▪

Graffiti and Space Claiming
in a New Borderlands

America is being attacked by invaders from faraway lands.... The container invasion begins here with products you use every day. Products come to America from around the world and they come in shipping containers.... Containers were meant to be constantly in transit from an export to an import and back again, but this plan has gone terribly wrong. Containers arrive in record numbers, but they are never filled again with products for export. The abandoned containers are slowly taking over. (Alex Rivera, "Container City," *The Borders Trilogy*)

A quienes se quedaron en medio de ninguna parte. (Hugo Alberto Hinojosa, 2)

Dejamos una huella que estuvimos aquí. (Pisket HAR INK, twenty-nine, personal interview, 15 Nov. 2014)

In the video installation "Man in a Box," the contemporary Ghanaian artist Mawuli Afatsiawo depicts a man in a shipping container–like space. Literally boxed in on all sides, the man, his body naked and painted red, appears crouched and confined inside. As he crawls on hands and knees, desperately trying to find an exit, his contorted figure moving within the enclosed space is seen against a collage of images: children playing a game, scenes of urban street life in Ghana, construction machinery, and colonial era monuments. With deep irony, the

artist contrasts this picture of imprisonment and entrapment in a shipping container against a backdrop of bustling shops and markets highlighting the free and unrestricted flow of goods and commodities (Pugliese 149). Thus, in this five-minute video, Afatsiawo graphically materializes the material incoherence of globalization: that the free flow of commodities is predicated on the restrictive movement of the subjects of the global south.

A similar statement in a New York context can be found in Ed Cardona Jr.'s play *La Ruta* (The route), which depicts the last leg of an immigrant journey from Mexico to Texas. Performed in New York, the play forces the audience (limited to thirty) to become part of the journey through its immersive staging. First, audience members must enter a tent, representing a safe house, then move into an actual forty-eight-foot tractor-trailer. In this way Cardona demonstrates what it means to live life in a container both literally and figuratively. Like many migration experiences, a "coyote" (smuggler) is an intimidating figure shouting orders. Like many migrant daily lives, the mood is tense and claustrophobic. In a city of already very little space, the audience must endure with even less. Roving throughout New York City with performances in Manhattan (Harlem), Queens, and Staten Island, the 2013 show demonstrated the presence of the borderlands in New York, the existence of the container in a global city.

In a U.S.-borderlands context, filmmaker Alex Rivera's work demonstrates a similar point. Here, container trade provides an important link between traditional images of the borderlands as traumatic via the physical separation between Mexico and the United States and the new realities of Mexican migration to the United States as juxtaposed with globalization's supposed freedoms. Composed of three two-to-three-minute videos, *The Borders Trilogy* begins with "Love on the Line," a transnational border picnic (or "día del campo" as the participants describe it) at Border State Park in San Diego / Playas de Tijuana. This video emphasizes the personal and familial effects of immigration laws in traditional documentary style. Like Afatsiawo, however, Rivera contrasts this emotional scene with a stark picture of the ever-expanding realities of global trade. The second video, "Container City," is flooded with images of leftover shipping containers piled higher and higher in Newark, New Jersey, as local residents complain about the eyesore. Their complaints are eerily prescient of President Trump's unsubstantiated claim that border patrol agents were forced to admit undocumented immigrants "so they can vote in the election" (Joseph). In this different kind of border town, the border crossers are fifty-feet-long shipping containers, and they actually *are* taking over. In this way, Rivera exposes the irony of racial capitalism that serves a country obsessed with consumerism yet offended by its by-products.

Though I developed the concept of the Atlantic Borderlands to capture this new phase of racial capitalism and the New York Mexican/Latinx place within it, this concept is built on a long, diverse history of racialized capitalist

formations. Like the shipping container, the Brookes slave ship previously serviced the triangular trade, and its image fueled both the profiteering imagination and the abolitionist imagination. While in both cases the image performed a dehumanization of the people as cargo, as Paul Gilroy emphasized in *The Black Atlantic: Modernity and Double Consciousness*, there were living and breathing people on those ships. And those people made connections: "It should be emphasized that ships were the living means by which the points within the Atlantic world were joined. They were mobile elements that stood for the shifting spaces in between fixed places that they connected. Accordingly, they need to be thought of as cultural and political units rather than abstract embodiments of the triangular trade. They were something more—a means to conduct political dissent and possibly a distinct mode of cultural production" (18). In a similar way, I have tried to give life to the x-rayed migrants, the invisible back-of-the-house restaurant workers, the deliverers, and construction workers to give a sense of their thoughts, dreams, and creative lives. More than just a sign of globalized containment of the global south, shipping containers also represent possibilities of new exchange, cultural production, and migrant creativity. Like the ships that carry them from one place to another, shipping containers are more complicated than just transport.

The Portals project is one example of an artistic project that illuminates this relationship.[1] A global arts initiative founded by Amar Bakshi, a Harvard- and Yale Law–educated artist and journalist born and raised in Washington, DC, Portals was created as a way to get people from very different cultures standing face to face and talking via the mechanism of the shipping container. Anyone in one of the portals locations can enter these gold shipping containers that are equipped with immersive audio and video technology and converse live with someone in another location. Built in more than three dozen locations to date,[2] from Austin, Texas; to Gaza City, Palestine; to Berlin, Germany; to Kigali, Rwanda, these portals, though idealistic in their imaginary scope, are nevertheless also elite experiences still limited to the lucky few. These creative reimaginings of shipping containers still represent a disconnection from the mass movements of migrants today. In a similar way, the current fad of repurposing shipping containers into houses, art installations, pop-up restaurants, and more[3] is also an end product of migrant containment rather than representative of the possibility of an alternative to racial capital formation.

Yet, in the work of Afatsiawo, another vision is possible for the people of the global south. As he describes the project, rather than a dream of connectivity, as in the Portals project, the audience becomes voyeurs on hopeless isolation: "Then there is a man kneeling in a confined space, yet within this space he defines himself, readjusting his limbs periodically. All the while the earth is being moved, portions of it are relocated and its form changed. . . . Yet still the

man continues his movements within the box and kids in Ghana still play *Amp;* its rhythm echoes on in our lives. What if the man stepped out of the box? Are we boxed in by our own definitions of our culture?" ("Digital Africa"). In a parallel way, I wonder not just how Mexican migrants are boxed in by the current anti-migrant climate as well as over a century of migration history, but more importantly, how they see the box.

In Mexican New York, the container serves as both a metaphor through which to explore the meaning of the border for migrants who live thousands of miles from the iconic borderlands of the Southwest, a geography that has become inextricably tied to Mexican and Mexican American experiences and imaginaries, and a way to capture the development of a New York economy that has attracted a previously unseen number of Mexican migrants. But it is also more than that. While shipping containers reference the economic and political climate of New York City created by the changes to global trade as a result of the rise of the shipping container in the 1960s and 1970s, they also highlight the cultural creations of Mexicans currently living in *La Gran Manzana* in response. In a life of containment based in an experience of racialized everpresent migrant marginalizations, the container also allows me to explore the men and women outside of the box. And as I find in the vast creative expressions ranging from muralism and graffiti to hip-hop and other literatures, Mexican migrants refuse to be boxed in by traditional definitions of culture, and step outside stereotypes of what a Mexican migrant life should look like.

As I explored in chapter 1, in New York, the growth of the service sector industry has created systems of racialized labor hierarchies designed to exploit the most work from migrants for the least investment, whether socially or economically. Particularly iconic to New York City is the restaurant industry, for which the Mexican presence is both vital and largely invisible. Significantly, while in 1980 less than half of New York City restaurant workers were born outside the United States, now more than two-thirds are (Sen 46).[4] As a result, the average restaurant worker in New York City today is likely to be young, male, and Asian or Latino, and to have been born outside the United States, with Mexicans and Central Americans making up the largest numbers. At the same time, led by the powerful lobby of the National Restaurant Association (NRA), the restaurant industry has created and maintained an organizational structure that pays the majority of its workers below-poverty-level wages, risks the health and safety of its employees, and perpetuates a workplace segregated along race and gender lines. Although the NRA has fashioned an image that no other model is economically profitable, the industry's reliance on migrant labor is one that is relatively recent over the past thirty years and has profoundly changed the way business is done. However, I also explored in chapter 1 how Mexican migrants are rejecting their status and treatment as cheap, replaceable labor and are demanding respect for their contributions to the city's food

industry. In rejecting the NRA container, migrants like JC Romero and Mahoma López have not only demanded respect for the value of their labor but also transformed themselves into activists. At the same time, coalitions such as Enlace have connected labor to larger structures of containment across borders, highlighting the connections between mass incarceration and mass detention.

But this is only one way to see the box. For Har'd Life Ink and Cultural Workers, their response to what Gloria Anzaldúa termed the "molding we are encased in," the "apparatuses of culture and ideologies" operate to create alternative spaces. Here, the shipping container illuminates the realities of the lack of space for Mexican migrants figuratively and creatively. In a city of skyrocketing rents and where gentrification is expanding to formerly African American and Latinx neighborhoods with increasing speed (i.e., Harlem, East Harlem, Bushwick) and in ways that are making survival increasingly more difficult, these young migrants represent both a labor and an artistic strategy to address the limited opportunities and the cramped space of their home lives. In collaborating to open tattoo shops in the case of Har'd Life Ink or art pop-ups in the case of Cultural Workers, each business project represents an attempt to address a lack of artistic spaces as well as create work opportunities that are also creative. They are border artists in the sense that their creative crossings bring Mexican cultural expression to a new borderlands, demonstrating a diverse Mexican diaspora. But more than that, the entrepreneurial aspect is a bold statement against the service sector as well as consumer desires for limited forms of Mexican culture represented by the Fridaization of Mexican art and the popularity of the taco.[5]

This radical Mexican diaspora has similarly found a voice in the growing hip-hop movement, one composed of global Mexican-led crews such as Buendia BK and the New York–developed sound of Hispanos Causando Pániko. In both cases, Mexican hip-hop expression in New York represents decades of transnational music conversations between Mexico and the United States that have now expanded back to hip-hop's site of origin on the East Coast. In bringing the border to New York, HCP both references and builds off traditions of Chicano rap while also arguing for the difference of their experience in New York. They also represent an aggressive demand for visibility in a city where Mexicans are largely invisible or seen only as labor. In choosing hip-hop as their vehicle, they boldly engage a politics of anti-identity in rejecting simple assimilationist positions of some white or black American culture and argue for an authenticity that is both hip-hop and Mexican in an NYC context. Similarly, Buendia's attempt to build a transnational and even international coalition represents an exciting argument for the cultural and creative relevance of a Mexican-led dialogue across borders in a context of increased border security and migrant policing.

An important aspect of these arguments is a bold anti-deportation stance based in a demand for respect. Significantly, *respeto* and *dignidad* have historically been the refrains of Latinx civil rights and labor struggles throughout the United States, something of which labor activists in New York are clearly aware. Yet, they are also building on a form of respect based in a hip-hop visibility with transnational traditions. As Jorge Sánchez López notes, citing Shente, a member of the venerable HEM (Hecho en México) graffiti crew, who has largely made a crossover to paid artistic work as a muralist, even the more established crew members need to occasionally and deliberately work outside the law: "No se respeta a quien sólo hace graffiti con permiso, para conservar el prestigio en el graffiti se require: salir a las calles a hacer tags, throws, o de perdida pegar posters" (157–158).[6] It is, again, a matter of respect.

In making themselves visible, these culture creators knowingly face the possibility of an unplanned return to Mexico. Though JC Romero gave up his college fund to save his father from deportation, he nevertheless risks deportation himself as a public face of undocumented Mexicans in New York. Despite his family's concern, the possibility of deportation is part of his argument against it:

> The reason I don't fear it is because I'm not scared to go back to Mexico. I think it would be, the reason, in my case I'm not doing anything illegal, I'm not doing anything I shouldn't be doing. I'm doing what everyone else has the right to do—speak out, first amendment protects you so I know what's going on, however, if I was ever to be deported or whatever, I think a lot of people would do something about it. Or, it would be a story. It would be a story. I wouldn't stay quiet. If I've spoken out when I was an illegal, I would keep speaking out, knowing that I was having to go back. (personal interview, 1 Oct. 2011)

Thus, the potential of impermanence hangs over each of these labor or artistic actions. This is especially poignant in the practice of graffiti by undocumented migrants, a practice that is actually illegal and pursued by the NYPD anti-graffiti task force. Thus, in what follows I present what is perhaps the most aggressive statement against anti-deportation: the graffiti practice of Mexican migrants as represented by Sarck, Pisket, and the transnational collective I presented in chapter 2 through discussion of their business model and tattooing/ art operation.

Travels of Mexicanidad: Graffiti across Old and New Borders

The work of an undocumented Mexican graffitero is both precarious and bold. As Jocelyn Solís has succinctly commented, the repercussions of being classified as "illegal" mean that "one cannot have an identity unless one is named"

("Immigration Status" 337). In the age of Trump, this means more than just a technically illegal immigration status; it means being classified as "bad hombres." As graffiti artists, Mexican migrants not only develop their own named identities, but they do so publicly, and they do it outside the law. Thus, despite the risks of continuing a graffiti practice in New York City, it serves Sarck, Pisket, and others as both an act of rebellion and re-naming. "Es parte de la técnica," explains Sarck. "Es una forma de la libertad y una manera de sacar coraje sin ser violento. . . . Y aunque tú pintas sin permiso, si lo haces bien hecho lo sientes. Nunca va a perder su esencia aunque lo destruyen" (personal interview 14 Oct. 2014).[7]

By taking on these risks, graffiti acts serve as a refusal to live life in fear of the repercussions of illegality, while the use of graffiti names provides a different identity on their own terms rather than accepting the naming of them as "illegal." Their act of rebellion is one that occurs on multiple levels. At the most basic, tagging acts at the level of individual identity by taking control of how they are named and where their name is written. Second, the act of creating what is considered "illegal" art, either individually or as a member of a crew, signals their rejection of the "bad hombres" criminalizing views of Mexicans. Finally, the formation of collectives offers an alternative form of belonging, in which collective decision-making and artistic skill, not country of origin or color of skin, determine membership and ownership. At the same time, the choice of graffiti as a medium represents the multiple ways Mexicanidad in New York travels and develops in conversation with a globalized black and brown art world.

As the art historian Kobena Mercer has noted in his work on the art of the African diaspora, "contemporary artists offer intriguing insight into the often surprising ways in which blackness travels" (227). While I reiterate that the forced migration of African slaves cannot and should in *no way* be compared to the exploitation faced by migrant workers, forced migrations have been thoughtfully examined in African American studies and provide an alternative model for thinking about trade, capitalism, and labor. Specifically, it provides a diasporic model that allows for rethinking the borders of Mexicanidad. Understanding how blackness travels in the arts, for example, through the model of Kobena Mercer's work, or Mawuli Afatsiawo's performance, provides important insights into the artistic productions of Mexican migrants in New York City: "In the networks of Afro-modern world-making where a multitude of populations traverse cities and continents with identificatory attachments to a plurality of histories and geographies, the anthropological conception of cultural belong that assumes organically boundaried totalities gives way to textual models of cross-cultural traffic in which transnational flows of images and information are constantly recombined and remontaged" (Mercer 16). In particular, Mercer provides a model of alternate genealogies of art that when

traced in the case of Mexican graffiteros in New York help understand Mexican diasporic creativity. These alternate genealogies highlight the significance of artistic dialogues across borders, as well as the numerous and varied influences on Mexican graffiteros in contemporary NYC.

Significantly, since the majority of Har'd Life Ink members migrated from Mexico within the past ten to fifteen years, their first encounters with popular art forms such as graffiti or muralism occurred in their countries of origin. For example, for Sarck, thirty, it was his move from San Luis Potosí to Mexico City at age seventeen that brought him into contact with a robust graffiti scene and the HAR crew, which inspired the name Har'd Life Ink and introduced him to members of the crew to which he is still affiliated.

As previously mentioned, the significance of the period beginning with the Chicano movement of the 1960s and 1970s and extending to the Latino/a arts movement[8] has resulted in the most concentrated scholarly attention on Mexican art production in the United States. Nevertheless, Chicano artistic expression predates the movement. In addition to *los tres grandes* (Orozco, Rivera, and Siqueiros) as well as the work of the portraitist Frida Kahlo, Chicano arts of the 1960s drew on the flamboyant and nonconformist *pachuco* street style of the 1940s as well as gang graffiti in Los Angeles, which dates back to at least the 1930s (Benavidez 13, 15). These antecedents contributed to the evolution of Chicano art, the results of which can be seen in Har'd Life Ink today. They include (1) a critique of the status quo, (2) the establishment of a unique aesthetic sensibility in which art is measured on its own terms, (3) a differentiation between convention and Chicano values, (4) an aspect of cultural self-affirmation, and (5) the use of montage (Benavidez 16). From these foundations, the Chicano movement in its most idealistic and incipient years (1968–1975) resulted in the production of community-oriented and public art forms including posters, murals, and the development of art collectives. As Goldman and Ybarra-Frausto write, "Art was part of a whole movement to recapture, at times romantically, a people's history and culture and formed part of the struggle for self-determination" (84). In search of art that generated both ethnic pride and a sense of community, artists sought themes from pre-Columbian culture, family life and religious practices, immigration and the border, and cultural icons or heroes of Mexican descent (Erickson, Villeneuve, and Keller 10).

While by 1975 divisions in the movement were reflected in a schism between artists who chose to continue serving the working-class majority Mexican population and those who chose to enter the mainstream art world of museums, galleries, and collectors, the early idealism, styles, and themes had widespread impact (Goldman and Ybarra-Frausto 93).[9] The artistic expression inspired by the Chicano movement did more than produce an important collection of plastic arts, painting, visual arts, and literature; it offered Mexican Americans a critical view of their status in the United States as well as the creative tools to

express that perspective. The valorization of Mexican heritage and themes of Chicano artists facilitated increasing contact between artists on both sides of the border and led to exhibitions of Chicano art in Mexico as well as collaborations between disparate groups of artists (Maciel 116). Perhaps it is not surprising, then, that the 1980s saw the rise of neo-mexicanismo among Mexican artists, a reaction to then-current artistic trends, and characterized by a critique of the supremacy of Western tendencies of surrealist and expressionist schools over Mexican elements. Neo-mexicanists, as a result, sought to highlight the artistic values of popular culture in similar ways as Chicano muralists, who in turn had learned their trade from the inspiration of the post-Revolutionary Mexicans (Maciel 117).

As George Sanchéz's foundational work, *Becoming Mexican American: Ethnicity, Culture and Identity Los Angeles, 1900–1945,* makes clear, culture in Mexico has never been static. Migrations to and from Mexico bring new cultural expressions to both sides of the border. In describing what Juan Flores and George Yúdice first termed "trans-creation," Sánchez reflects, "The movement between Mexican and American cultures is not so much a world of confusion, but rather a place of opportunity and innovation" (9). Nowhere is this exchange better witnessed than in the creations of the artists in this chapter whose tattoos, murals, prints, and paintings reflect decades of conversation between Mexican and Mexican American artists.

According to Chavoya, the historical context for collaborative border arts is the contradictions of a nation of immigrants against the lived reality of exchange at the U.S.-Mexico border ("Collaborative Public Art" 210). By taking a more expansive view of the borderlands, we can see how Mexican popular art in New York reflects both Chavoya's concept of collaborative border arts and what Anzaldúa has described as "the mestizo border artists who partake of the traditions of two or more worlds and who may be binational. They thus create a new artistic space–a border mestizo culture" (*Anzaldúa Reader* 181). Just as Paul Gilroy argued that African diasporic culture was a result of a long history of cross-Atlantic conversations, New York reflects a new frontier in Mexican artistic development. Moreover, what the migrants in these pages have demonstrated is that Mexican cultural and identity formations are much more diverse in form and ideological commitment, shaped not only by where migrants are from but also by where they settle and a myriad of other factors.

Moreover, what New York represents is also a history of pan-Latino conversations. As Elsa B. Cardalda Sánchez and Amílcar Tirado Avilés point out in their work on Puerto Rican muralism in El Barrio (East Harlem), murals "represent an affirmation of puertorriqueñidad" as well as a "symbolic cultural resistance in the face of material poverty and spiritual desolation" (265). They are also a public claim to space in a city that has often displaced them.[10] But this claim is built on strategies developed in their activist practice and

influenced by two important precedents: (1) the work of Mexican artists, including the previously mentioned *los tres grandes* and the Federal Arts Project of the New Deal Period, and (2) the muralist movement of the Chicanos in the Southwest and on the West Coast (Cardalda Sánchez and Tirado Avilés 269–270). In a way, these dialogues form an alternative triangular trade of public art among New York, the Borderlands, and Mexico, and among African Americans, Puerto Ricans, and people of Mexican descent. Likewise, in New York, prior Latinx migrants and older cultural institutions such as El Museo del Barrio have helped anchor their cultural production as well as further complicate conflicts over space and resources (Dávila, *Barrio Dreams* 153–180, *Culture Works* 73–92).

Tomás Ybarra-Frausto's landmark 1990 essay, "Rasquachismo: A Chicano Sensibility," describes rasquachismo not as a specific aesthetic style but as "a *posture*, an *attitude*, a *taste*, an *insider private code*, a *visceral response to lived reality*, a *worldview*, a *perspective*, or an *irrepressible spirit*" that finds its expression in the work of artists. For Ybarra-Frausto, rasquachismo is drawn from a base of "Mexican vernacular traditions" but has found its strongest expression as a "bicultural sensibility" among Mexican Americans. It can be understood as "an underdog perspective—a view from *los de abajo*—an attitude rooted in resourcefulness and adaptability, yet mindful of stance and style." In a call similar to Gloria Anzaldúa's cry for "las Hijas de la Chingada" to reclaim their names, Ybarra-Frausto describes rasquachismo as "to be down, but not out (*fregado pero no jodido*)" (156). It is above all a coping strategy in response to material realities of existence or subsistence. In this "world of the tattered, shattered, and broken: *lo remendado*" to be rasquache is to hold things together with spit, grit, and *movidas*. Resilience and resourcefulness spring from making do with what is at hand ("hacer rendir las cosas"), which leads to hybridization, juxtaposition, and integration (156–160).

Following Ybarra-Frausto, Alex Rivera sees his work as following a practice of "rasquache aesthetic" in filmmaking. *The Borders Trilogy*, for example, combines political satire, documentary, mockumentary, and surreal elements. Here, the tearing apart and rebuilding of cultural images adds texture and depth to the work. Similarly, his short film *Cybraceros* (1997) was launched with a fake company website (cybraceros.com), which provided robotic technology for companies in distant countries to employ workers called Cybraceros. The website provided a link for investing opportunities and even fooled several media outlets. As Rivera notes, "People without resources always turn to recycling and repurposing, making new dreams out of old materials. It's ingrained in our spirit of survival, resistance and innovation" (Guillen). Thus, this work represents what Rita González, Howard Fox, and Chon Noriega have termed the "phantom sightings" of the Chicano movement art—its political influence taken in untraditional often multimedia directions.

Rivera makes two important interventions here. First, he expands the practice of rasquachismo to a wider net, recognizing the way communities of color always had to make do despite varying cultural traditions and histories. Second, he adds the imaginative quality, "the new dreams," demonstrating how the act of collage is also a conscious and conscientious cultural practice. For Mexican migrants in New York, rasquachismo is both a necessity and a practice. Like their African American, Puerto Rican, and Chicano predecessors, this growing but new Latinx population of very limited economic means necessarily seeks out an accessible form of creativity. It is not surprising that Mexican migrants are attracted to artistic forms ingrained in and analogous to the activist spirit of resistance found in labor movements previously discussed.

For members of Har'd Life, their spheres of influence go beyond Mexican art and Chicano art to incorporate the multiethnic, multiracial graffiti art that is one of hip-hop's four elements. It is significant that Sarck and other members of Har'd Life describe their graffiti practice as learned in Mexico but still traced back to hip-hop. According to Sarck, "Eso es el verdadero hip hop. Tratamos de regresar a los raíces fundamentales. Así como hablamos de cultura, el graffiti es uno de los cuatro elementos esenciales" (personal interview, 14 Oct. 2013).[11] Kortezua, twenty-nine, an MC and graffiti artist, echoes Sarck: "El graffiti es muy importante. Es uno de los cuatro elementos, parte de la historia desde los 70" (personal interview, 8 Oct. 2013).[12] Graffiti, then, is not merely an act of rebellion but a practice that is respected and honored by these Mexican artists who see themselves within a much longer tradition of Latino–African American conversations. Creating a Mexican artistic expression in New York for them is supported by the history and legitimacy of graffiti as one of the four original hip-hop elements.

Although writing on walls dates back to the earliest of times (and, as previously mentioned, was a practice of Chicano gangs as early as the 1930s), graffiti as it is known today, based in simple name tags unaffiliated with gang territorial disputes, arrived in New York City via Philadelphia in the late 1960s (Felisbret 1–10). Made famous by TAKI 183, a delivery boy who lived on 183rd Street in Washington Heights, when he was written up in the *New York Times*, graffiti in its incipient stage was about getting one's name in as many places as possible. Subways, in particular, became the canvas of choice as writers could send their names from as far away as the top of the Bronx to the tips of Brooklyn. By the mid-1970s, graffiti had developed from simple tagging to elaborate individual styles, with themes, formats, and techniques that were designed to increase visibility and status (Rose, *Black Noise* 198). In this way, graffiti established itself as one of hip-hop's four elements by incorporating hip-hop slang, fashion, and rap lyrics, while at the same time graffiti's styles (bubble letters, wild style, etc.) became a part of the music's visual expression from album covers to posters.[13] As "writing" became art, and art became more complicated,

graffiti writers formed crews, which provided both community and collective evaluation. As Austin writes: "At the most basic level, crew members are committed to writing and to each other. . . . Crew members serve as lookouts for each other, particularly while executing works in places where they might be seen (like the yards). They are trusted to protect the identities of fellow members when questioned or arrested by authorities. These are common forms of mutual support that can be found in successful churches, unions, peer groups, benevolent associations, and street gangs" (120). Consequently, while "writing" at best may seem like an insignificant act of youthful rebellion and more generally seen as criminal and gang-related behavior, it also provides much more to youth. Graffiti also represents the foundations of identity and community building, as well as an accessible form of artistic expression for those without resources or other creative outlets. As a result, despite the fact that graffiti assumed crisis-level importance inside the bureaucracy and the public relations of New York City mayoral administrations and the Metropolitan Transportation Authority for almost two decades[14]—to the level that an anti-graffiti task force *still* exists today[15]—graffiti enjoyed a renaissance in the 1990s and is still a vibrant part of New York City's landscape. This is especially true in neighborhoods such as Spanish Harlem, where, as Arlene Dávila notes, street art has "long served as visual markers of Latinidad" (*Barrio Dreams* 183). Nevertheless, as demonstrated in the 2014 destruction of hip-hop historical site 5Pointz in the name of development, street art is still in a precarious position. For while street artists can be prosecuted as criminals, the same artistic space, when sold for commercial advertising, sells for thousands of dollars. Members of Har'd Life Ink descended on 5Pointz before its demolition to pay their respects, and their writings were among those destroyed (see fig. 12 in chapter 2).

Across Mexico, but especially in Mexico City, thousands of young people practice graffiti, most often illegally, but also legally in the form of mural painting (Valle and Weiss 128). Graffiti arrived in Mexico City in the mid-1980s from the border,[16] moving from Los Angeles to San Diego to Tijuana, Aguascalientes, Guadalajara, and Nezahualcóyotl in Mexico City. Like the Chicano muralists of the 1970s, many of the youth in Mexico City who engaged in graffiti had already been politicized and influenced by the student movement of 1968,[17] in which street art and murals were employed to spread their political messages (Cruz Salazar, "Instantáneas sobre" 143). As Tania Cruz Salazar describes this history, like its origins in New York, for young Mexicans,

la calle y la pared son espacios de socialización que simbolizan la libertad de expresión, la libertad de ser. Ser joven en México es difícil, el aceso a espacios educativos y laborales es restringido, muchos de los jóvenes urbanos que se dedican al *graffiti* pertenecen a un estrato social bajo, por lo que abandonar la escuela para ir a trabajar es algo muy común a pesar de que las garantías

laborales sean precarias. Pertenecer a una familia donde la presión por aportar un ingreso es la constante y en la que los espacios de convivencia son reducidos—dos o más familias viven hacinadas en casas pequeñas—les incita a buscar espacios en donde sea posible proyectar su identidad y vivenciar su juventud. ("Yo me aventé" 200)[18]

For the members of Har'd Life—either coming from lower-income families in Mexico City or having left their families at a young age—this is a familiar story. Graffiti and the crews that came with them represented an important community of practice.[19] As such, in their projects, Mexican migrant artists sample from disparate elements in a new borderlands' take on rasquachismo, learning to make do with limited resources and building on historical processes.

New York graffiteros' version of rasquachismo heavily employs the practice of hip-hop sampling at the basis of the practice. Sampling as an aesthetic framework has been discussed in various academic writings as an example of postmodern pastiche as well as a specifically African American response to the fragmented aesthetic of postmodern contemporary culture (Schloss 65–66). But in the case of Mexican migrant graffiteros in New York, sampling reflects both an experience of fragmentation and a hip-hop tradition of creation out of nothing that goes hand in hand with the ingenuity of a make-do Mexican approach to recycling. To this Chavoya adds the concept of "customized hybrids," in which "staples of national identity [that] have been transfigured in popular use and circulation" are reconfigured again (143). In all, the significance lies in the way elements are fused together despite the diversity of their origins.

Although sampling is most commonly discussed in music practices, it is also an important aspect of graffiti, especially for its role in the creation of an artistic community—one must be a member of the community to be aware of the references of images or tags. Thus, whether HAR members are referencing others' tags, repurposing materials to make new artistic canvases, or incorporating different members' skills to pull off a joint mural or video, Mexican graffiti artists in New York consciously and unconsciously work within a number of traditions.

In a day and age when street art has become gallery art, HAR graffiti also represents the "historical permeability of the line between 'legal' and 'illegal' categories" (Menjívar and Kanstroom 3). In both cases, "illegality" is something that is historically and legally produced and changeable. According to Menjívar and Kanstroom,

First, we recognize that the binary categories of "undocumented" and "documented" or "authorized" and "unauthorized" often used to study the effects of legal status on immigrants' experiences have become problematic in

contemporary analyses of the experience of illegality/legality. Not only do they reify bureaucratic classifications that often fail to match lived experiences but they often fail to match lived experiences. . . . Thus we give primacy to experiences of "liminal legality" (Menjívar 2006), "precarious statuses" (Goldring et al. 2009), or "permanent temporariness" (Baily et al. 2002) to highlight the blurring to these legal categories. Recognizing these in-between, gray zones of illegality helps us to capture today's experiences, questions taken-for-granted dichotomies that grow out of political maneuvers, and problematize . . . approaches that seek to clearly demarcate citizenship (and belonging) and alienage. (9)

Illegality is a "historically specific and socially, politically, and legally produced" condition and social formation (Abrego 7). By highlighting illegality, experienced by both people and art, I reject simplistic notions associated with viewing unauthorized migration as innate or as a result of an individual's decision (Abrego; De Genova, *Working the Boundaries*). Instead, the concept of illegality has broader relevance for the Mexican-origin community, impacting not only the unauthorized population but also the authorized Mexican immigrant and Mexican American communities (De Genova, "Migrant 'Illegality'"; Menjívar and Kanstroom). Similarly, graffiti, in its legal and illegal applications, its blend of impermanence and aggressiveness, mirrors the gray zones of Mexican migrant life while granting a liberatory moment that is both artistic and rebellious.

For example, as can be seen in Sarck's piece in figure 18, he consciously weaves his work within an existing hip-hop tradition. The woman depicted in purple on the left side was from a previous artist, which Sarck then incorporates into his piece, in a form of graffiti recycling. Favoring a 3D lettering, Sarck writes and rewrites his crew's name "HAR" in various styles. It emerges structurally in turquoise in a form that is reminiscent of indigenous pyramids, while also shining down in yellow like a sun. More than just bringing brightness among the red landscapes, he is also connecting his two HAR worlds—Mexico and New York. He is both painting over a previous artist and working off that inspiration. The piece itself is also a collaboration between Sarck and another HAR member tagged ARLECK.

Sarck's artistic choices reflect not just the travel of hip-hop and graffiti to and from New York but also decades of transnational flows between Mexican artists on both sides of the border as well as the practices of rasquachismo and sampling. What the graffiti of Har'd Life Ink adds, then, is another layer to Mexican popular art in the United States that offers a new way of understanding Mexican/Latinx experience through an East Coast legacy and context. Moreover, their interactions with NYC's hip-hop history both before migration and upon settlement highlight the influence of Caribbean migrants and

FIG. 18 Graffiti by Sarck HAR, 2012. (Source: Sarck)

artistic practice on Mexican identities on the East Coast, as this is the only city where Mexicans come into contact with a large population of Caribbean immigrants (Puerto Ricans, Dominicans, West Indians), whose graffiti cultures have shaped the history of the city.

Mexican Graffiti in the New Age of Surveillance

Sarck's *estilo azteca* features Aztec calendars and gods, jaguars, and serpents, recognized emblems of Mexican indigenous culture. In addition to graffiti and tattoo, Sarck's major passion is airbrushing in black and gray. Other themes reflect the influence of Chicano style: red roses to contrast with black-and-gray work, Mexican flags, La Virgen de Guadalupe, pinup women, and even lowrider cars. Common themes for both Sarck and other HAR members, whether in tattoo or painting, are those related to death, reflecting an engagement with border culture among graffiti stylings. As Anzaldúa explains: "In border art there is always a specter of death in the backgrounds. Often las calaveras (skeletons and skulls) take a prominent position—and not just on el día de los muertos (November 2nd). De la tierra nacemos, from earth we are born, a la tierra regresaremos, to earth we shall return, a dar lo que ella nos dió, to give back to her what she has given. Yes, I say to myself, the earth eats the dead, la tierra se come los muertos" (*Anzaldúa Reader* 184). In a similar vein, Sarck describes his interest in figures of death as directly related to his passion for

life: "Representa lo transitorio de la vida, per también, lo bonito. La vida y la muerte son parte del mismo sistema" (personal interview, 1 Aug. 2015).[20] Thus, Sarck's artwork is as much a reflection of the precariousness of his life as an artist in the Atlantic Borderlands as it is a reflection of the joy he takes in his work.

Sarck, like Pisket, is a painter, graffiti artist, tattoo artist, and sketcher. I chose, however, to focus on graffiti because I believe it represents the strongest stance in the face of migrant policing and New York City surveillance. The art's illegal status is an in-your-face action against his own status as deportable and replaceable. It is an aggressive expression of existence when invisibility would be so much safer. It is also a way of venting his own anger within his marginalized situation. Like the black Puerto Rican flags, the black Mexican flags that grace his work represent the absence of a flag, the absence of a nation. His jaguar at 5Pointz (see fig. 12 in chapter 2), one of many done over the years, is an aggressive assertation of his place in the NYC graffiti landscape.

Three major themes appear in Sarck's graffiti and muralism (both legal and illegal): (1) an attempt to spread the HAR name across borders, (2) an attempt to spread his own name, and (3) a celebration of Mexican pride through work that reflects on indigeneity. But at its core, more than just throwing a tag, as Sarck describes it, his purpose is to leave quality. With quality work, even ephemera lives on via artistic reputation. This is the importance of Sarck's earlier comment: "Aunque lo destruyen no va a perder su esencia" (personal interview, 14 Oct. 2014).[21] In other words, quality art changes the viewer's perspective of its illegality and leaves a trace even if the work (or the artist) is erased. And in living temporarily in the illegality of graffiti, Sarck is able to experience a temporary freedom from structures of containment. "Hago lo que quiero, donde quiero. Estoy aquí—soy aquí." (I do what I want, where I want. I'm here [personal interview, 24 Oct. 2014].) In moving from "estoy" to "soy," Sarck expresses how claiming space, even temporarily, has become a core part of his identity. In choosing to do something deemed illegal, he responds to government rules he had no part in making, despite their daily impact on his life. In responding via graffiti, then, if only for an hour, he refuses to accept or live by rules of illegality.

Similarly, Pisket HAR INK's name in Queens over the 7 Line in figure 19 demonstrates his artistic mastery and affinity for wild style graffiti (Sarck also frequently employs this style in addition to 3D). An intricate form of graffiti and considered one of the most difficult to master, wild style incorporates interwoven and overlapping letters and shapes. In doing so, Pisket likewise demonstrates to the graffiti community his skill and daring as a writer.

In addition to tagging and painting pieces from the Bronx to Queens to Brooklyn to Manhattan and even New Jersey and Washington, DC, both Sarck and Pisket have frequently painted trucks, both legally and illegally. On one

FIG. 19 Graffiti by Sarck HAR INK and Pisket HAR INK, 2014. (Source: Sarck)

picture posted on Facebook in the spring of 2017, located outside the Long Island City flea market, Pisket comments, "Saben que dejamos huella a donde quiera que vamos."[22] Thus, this enterprise serves as an updated version of moving subway art, one that comments on the products transported across the city and country. This truck graffiti serves as a public claim, written on shipping containers, about capitalism, from the perspective of migrant labor. It is also a public statement that Mexicans are here in New York City and that their culture is making an impact. In addition to leaving a footprint, as both Sarck and Pisket have described it, graffiti work, specifically bombing, is a quick attack on the structures of containment.

As an artist, Sarck acknowledges that graffiti represents "another technique." It is primarily a technique in which he "sentí una forma de libertad" (felt a form of freedom) (personal interview, 14 Oct. 2014). Whether they are targeting construction companies or trucking companies, tagging or bombing these moving vessels—or reproducing them in murals, as above—their graffiti serves as an act of presence in a city that would rather forget the essential work of Mexicans both here and across the border. As such, these walls of graffiti represent countercultural spaces (both in practice and in their physical nature) of expression that defend their presence in the global city.

In these pieces, jaguars, indigenous figures, and skulls are major themes. *Guerrero águila*, or "eagle warriors," represent a way to take back the eagle from

the symbolism of the Mexican national flag that has lost touch with both migrants and indigenous culture, as well as to remind viewers of the indigenous Aztec warrior elites of the pre-conquest times. For Sarck, his commitment to the essence of graffiti as one of hip-hop's elements is mirrored in his "Mexica" style, which attempts to express Mexican culture at its roots, the traditions that existed before the Spanish colonization. He sees it as a way to remember what makes them Mexican and why there is pride in that identity. It is also a style that is more important in New York than in Mexico, as the distance creates an appreciation for what previously did not have to be daily contested (personal interview, 24 Oct. 2014).

But it is also more than that. On one Facebook tag of a dual Pisket-Sarck bomb over the subway in Brooklyn, Sarck writes, "Esto es lo que soy . . . desde el principio hasta el fin."[23] In another dual mural, Pisket writes, "Sarck and Pisket born to paint." It is an act of anti- deportation, an aggressive response to containment and illegality, an expression of Mexican culture, a part of an NYC graffiti dialogue, and it is a proud Mexican identity forged out of border crossing and painting.

In 1993, Gloria Anzaldúa wrote of border artists. As she saw it, "now is the time of border art. Border art is an art that supersedes the pictorial. It depicts both the soul of the artist and the soul of the pueblo. It deals with who tells the stories and what stories and histories are told. I call this form of visual narrative *autohistorias*. This form goes beyond the traditional self-portrait or autobiography in telling the writer/artist's personal story, it also includes the artist's cultural history" (*Anzaldúa Reader* 183). Over two decades later, it is again the time of border art, but a border art that is no longer necessarily physically situated on the geopolitical border. It is border art at a new borderlands, a borderlands that is mobile. As Mexican migration to the United States becomes more regionally diverse, the border takes on new and varied meanings. Thus, while Anzaldúa describes a Southwest reality in which generations of Mexican-descended people had been stripped of history, language, identity, and pride, border Atlantic artists do not yet have to dig for their "cultural roots imaginatively" (*Anzaldúa Reader* 176). Instead, they are inspired by the new city in which they find themselves and the very recent memories of the Mexican culture(s) that traveled with them. They do not have to dig, but they still must fight. Significantly, the containment culture of the Atlantic Borderlands means collaboration and community are not just a practice but a statement against deportation practices.

In this spatial and temporal move from the long-established Latino/a pueblos of the Southwest to the newer borderlands of the Atlantic, illegality has changed the perception of the border and containerization has altered New York, playing an important role in Mexican migrant graffiti. Before the 1920s, there were no illegal aliens, because there were no laws to violate. However,

between 1924 and 1965, exclusion based on national origin as a racial category was written into law via quotas,[24] paving the way for the continuous expansion of inequalities seen today (Semuels).[25] Moreover, as the shipping container economy has supported the move from a post-Fordist to a neoliberal economy, illegality has only expanded its reach. Today, illegality is a condition not just limited to undocumented migrants, but has grown to include legal aliens who violate certain laws and can become illegal, as well as citizens, largely of color, who lose numerous rights both during and after imprisonment. And it includes artwork deemed of no value because of its occupation on the streets.

Consequently, the current situation of illegality should also be considered in light of the U.S. economy's long-standing reliance on undocumented workers and deep historical patterns of movement and recruitment that have long been part of U.S. history. At the same time, New York City played a key role in the growth of the shipping container, and the shipping container also greatly affected the development of the city. New York City, situated by a large, natural harbor on the East Coast, was a natural port, such that by 1900 New York was the busiest port in the United States and by some estimates the busiest in the world (Levinson 76). Although today a majority of goods brought to New York via container pass through New Jersey's ports, it was the Port Authority of New York (now known as the Port Authority of New York and New Jersey) that inaugurated the era of container trade in 1956. In fact, New York City was at the forefront of embracing the containerization of trade, a major engine of the city's economy. In 1951, as operations were returning to normal after World War II, more than 100,000 New Yorkers were employed in water transportation, trucking, and warehousing, not counting railroad employees and workers in the municipal ferry system (79). Levinson describes the significance of New York City's role in global trade and vice versa: "About three-fourths of the nation's wholesale trade in the early 1950s was transacted through New York, even if the goods did not always pass through the city. Across the country, about 1 in 25 private-sector workers (excluding railroad employees) worked in merchant wholesaling in 1951, but the ratio in New York was 1 in 15.4. In 1956, according to a conservative estimate, 90,000 manufacturing jobs within New York City were 'fairly directly' tied to imports arriving through the Port of New York" (79–80). Unfortunately, it was also geography that made this important pier obsolete after the invention of shipping containers. In the first half of the twentieth century, piers weren't tucked away in some remote location but stretched out along the shores of Lower Manhattan and Brooklyn. Manufacturers crowded near the shoreline to be near shippers. Ironically, it was this original success and the economic vitality it brought to the city that also ended the shipping trade in New York, in favor of New Jersey. Again, simple geography played a major role. Despite attempts at infrastructure improvements and large financial investment, trucks headed for the New York docks would

still have to fight traffic in the Holland and Lincoln tunnels and along the waterfront (Levinson 88).

On August 15, 1962, the Port Authority of New York and *significantly now New Jersey* opened the world's first container port, Elizabeth-Port Authority Marine Terminal, which soon became known as "America's Container Capital." Ironically, New Jersey was successful because it embraced the shipping container that New York City had originally inaugurated, going on to become home to the busiest container port in the world until 1985 (Levinson 92). New Jersey continues to be the busiest container port on the East Coast, while New York industry suffered greatly in the 1970s. Because of the move, one in four residents of Manhattan and Brooklyn packed up and left, part of a long downward spiral that took the city to within a hair's breadth of bankruptcy in the mid-1970s. By the middle of the 1970s, the New York docks were mostly a memory (97).

Thus, a major aspect of the shipping container boom in the 1960s was the early battles over New York ports, resulting in the construction of the Port Authority of New York and New Jersey, which decimated traditional dock work in New York and moved it to New Jersey (Levinson 96). This forever changed the face of New York City from a major center of trade to one where trade was no less significant but out of the public eye, and one that did not employ a large number of unionized workers. As a result, shipping costs dropped rapidly but also played a role, alongside de-industrialization, in the devastation of the city in the 1970s and 1980s. In the 1960s, when New York was the world's busiest port, there were more than 35,000 longshoremen on the city's docks. Today there are 3,500 (Feuer).

The decline of the docks reverberated throughout New York City's economy, most strongly in the poorest neighborhoods of Brooklyn (Levinson 97). In the end, however, New York City, long the state's most industrialized city, could flourish despite de-industrialization in the 1960s and 1970s when half of the factories closed. In fact, the de-industrialization of New York and the United States has become such an accepted fact that by 1986 numerous scholarly studies existed on the topic, including such titles as *Reindustrializing New York State: Strategies, Implications, Challenges*. Such analyses felt little need to explain the *de-industrialization process* that occurred first. Yet this de-industrialization did not have the same effect on New York as it famously did in sites like Buffalo and Detroit, as the city had other options for economic growth, in the form of the stock exchange, corporate headquarters, banks, insurance, real estate, advertising, publishing, wholesale, retail, and foreign trade, as well as culture, food, and tourism. These other sectors had room to grow and sustain the economy (Reitano 258).

By focusing on the financial and service sectors, New York not only recovered from a major fiscal crisis in 1975 but also flourished as a global economic

power again. Yet the recovery, parallel to the history of the shipping container, massively increased the wealth of the already wealthy to the detriment of the poor. In a United States in which the income gap between the rich and the poor was already growing, New York could claim the largest gap of the nation (Reitano 258). This is not surprising, as Saskia Sassen points out, because in this new economy both consumers and workers become less important; products (in the form of capital), not people, are what matter (*Expulsions*, Kindle locations 182–189). The results were severe for the working and middle classes, who were displaced by unaffordable housing, high levels of minority unemployment, and high levels of homelessness amid unprecedented prosperity. One stark example of this was the physical, economic, and social destruction of the Bronx in the 1970s.

A working-class neighborhood, the Bronx was among the hardest hit by de-industrialization, and its residents were left with few options for employment other than low-wage service-sector jobs like the fast-food industry (Dunlap and Johnson 312). During the same period, the Bronx saw an increase in crime and heroin usage (Rooney 271–272). Moreover, in the 1970s the Bronx suffered several catastrophic fires. Some came about from arson, some were a tragic result of disinvestment and lack of social services, but cumulatively they resulted in whole blocks burning and an entire generation left to rebuild their community without any significant resources. By 1980, out of the ninety-five most populated cities in the United States, New York City contained "15% of the most severely distressed Black households and 55% of the most severely distressed Hispanic households" in the country (Dunlap 309). With increased crime, unemployment, urban flight, a heroin epidemic, and the destruction of whole city blocks by fire, the Bronx and other minority-inhabited neighborhoods were primed for crack—or for the hip-hop revolution.

Thus, in 1980s and 1990s New York, when new Mexican migrants began to arrive, they found themselves pushed into neighborhoods already suffering from the neglect of public services, including poor schools and restrictive welfare practices. The war on drugs was in full swing, which, as Michelle Alexander explores more fully in *The New Jim Crow*, included the passage of mandatory and racialized sentences that targeted communities of color, where the crack epidemic was most devastating, and resulted in the massive disenfranchisement of people of color. As a result, Mexicans arrived when the fully de-industrialized New York economy offered only poorly paid jobs as options, and living settings in which crime and drugs were at their height (Thabit x).

They also arrived in neighborhoods, though thoroughly devastated, that were also finding creative expressions and outlets in the form of hip-hop. Hip-hop, in its original four elements, was not just imbued with a reaction to the war on drugs but haunted by the long history of racialized labor. The racial capitalism I described in the restaurant industry, for example, is not new; rather,

captive, disenfranchised workers have been a feature of the U.S. labor system for generations, from slavery to the present. African Americans post-slavery were constructed as racialized and criminalized in ways that now haunt discourses around migrants in the current day. And it influences the way migrants respond in kind.

In his 2017 convocation address at Cornell University, former vice president Joe Biden criticized President Trump not for his words or opinions but for representing "some of the ugliest realities that still remain in our country." According to Biden, Trump "strok[ed] our darkest emotions." Yet though he "thought we had passed the days when it was acceptable . . . to bestow legitimacy on hate speech," what Biden's comments demonstrate is that we had also accepted that hatred continues to exist. Here Trump's biggest misdeed is not that he shared these racialized, prejudiced ideas of hate but that he spoke them aloud from a place of power, both economic and political.[26] In other words, the hauntings were already there, if officially suppressed.

They were certainly already in New York City. During the nineteenth century, New York City was the Charleston of the North, the center of slave trade. It was the organizing center of the transnational labor market and the procurement of racialized migrant labor then, and it continues to be today. Wall Street is haunted by the slave market it was literally and economically built on, and yet men and women representing the upper echelons of capitalist success are not the ones who are haunted. As always, it is the poor who are most deeply injured; it is the undocumented migrants whose lives are most affected by the foundations of New York City's wealth. Their lives are filled with hauntings of a history of racial capitalism rubbing up against the realities of the current racial capitalism. These hauntings are pushed to the extreme because there is so little space, and Mexicans in New York have the least space of all. In this place of limited space and limited opportunities, Mexican migrants are responding in increasingly creative ways—dialoguing across borders, across cultures, and across histories and artistic traditions in a new triangular trade of Atlantic Borderlands and rasquache practices. And in doing so they are finding new way to express a Mexicanidad that is always in transit, always developing, and never x-rayed.

JC Romero reflects on his trajectory as an activist by weighing in on his co-worker's inability to fight for his rights:

> I never really pushed him. And until this day the reason that I tell people that I'm organizing that I'm actually—he is the reason. Stories like his because he's not the only one. There's many like him in my family, in general, that are being unjustly treated and unjustly paid. So that story, for me, not being able to push him and not having that leadership or initiative to push him, it's always in my mind because he went back to his country and he was well off for a couple

months and then once again he was struggling. And it wasn't just money, but it would have been a lesson for him as well, because to sort of accept the conditions that we have to work for that's like where the root problem really is. (personal interview, 1 Oct. 2011)

A few years later, in dialogue with labor activists, Dreamers, and Occupy Wall Street activists, JC became that leader and began to speak out publicly about being undocumented in New York City. With a similar openness and dynamism, the members of HCP have drawn on various sites of hip-hop history and its legacies to pronounce and share their truth. And perhaps, most contentious of all, Sarck and Pisket of Har'd Life Ink categorically reject arbitrary categories of illegality by "leaving a footprint" of their time in New York, however long or short. Each represents a strong rejection of the surveillance, targeted deportation, and labor exploitations of Mexicans by refusing to be terrorized. In their stance of anti-deportation they stay, precariously, but only on their own terms. New York City is their home, but only for so long as they can be proudly Mexican in whatever form that expression means to them. In their literal, figurative, creative, and web travels, the borderland expands, not just as a space but as a way of living between cultures and without countries. More than blackened figures or x-rayed bodies, these are Mexican states of mind that refuse to be contained.

Epilogue

■■■■■■■■■■■■■■■■■■■■■■■■■

Hauntings and Nightmares

I will build a great wall—and nobody builds walls better than me, believe me—and I'll build them very inexpensively. I will build a great, great wall on our southern border, and I will make Mexico pay for that wall. Mark my words. (Republican presidential nominee Donald Trump in his campaign announcement, 16 June 2015)

How to comport your soul at a dinner party with wealthy young artistes, liberal do-nothings and the really wonderful, remarkable girl innocently seated next to you, when you happen to own a secret slave ship in New York Harbor.... He's sick of being reminded, of feeling angry and guilty everywhere he goes, that's all, because everywhere he goes he sees them: bus-boys, McDonald's, even working in pizza parlors now instead of Italians and Greeks, lined up outside that taco truck on the corner of Ninety-fourth and Broadway, in the subways, working in delis, the Koreans always sending them down into the basement to bring up your bag of ice and they come up holding it, dark eyes anxiously scanning customers for someone who looks like he's just standing around waiting for his bag of ice because they don't even know enough English to ask, Who's waiting for ice? (Francisco Goldman, *The Ordinary Seaman*, 304–305)

It's a wonderful-horrible feeling when your dystopia comes true. (filmmaker Alex Rivera [Miranda])

In December 2012, JC Romero, then twenty-one, began his first organizing job with Brandworkers International (see fig. 1, preface). For four months he went undercover at a bread factory to try to build a campaign from the

bottom up. During his night shift, which began at 7 P.M., he observed not only wage theft and a lack of overtime pay but the terrible working conditions and the grave effects they had on the workers. "The people were suffering from a lot of addictions," he says.[1] Not only did workers abuse alcohol in order to cope with the difficulty of the work, but they also abused drugs in order to stay awake; and the company also provided energy drinks.

The work also started to affect JC. "You're a machine," he says. As a result of the experience, he also started drinking heavily. "It messed up my health."

Since that experience, JC, now twenty-seven (see fig. 20), has had a long and varied career in organizing, which has taken him to Massachusetts and California. In addition to the Restaurant Opportunity Center and Brandworkers International, he has worked for the Food Chain Workers Alliance, Center for Third World Organizing, Chinese Progressive Association, Casa del Trabajador, Immigrant Worker Center Collaborative, Communities United for Restorative Youth Justice, and Workers Justice Project. Today he works for Local 1010 of Laborers' International Union of North America, consisting of New York City pavers and road builders.

Despite his success at a young age, during those years of organizing he continued to self-medicate with drugs and drinking. By his own admission he was hiding severe depression. "It was about not being able to go to college," JC says. "I can point back to that now—I never processed that." As I previously described earlier in the book, JC had taken a year off to save money for one of the colleges that had accepted him; however, he ended up using those savings to help his father after he was detained. That loss, alongside having to grow up very quickly, affected him dramatically. While his father worked in restaurants, his mother worked long hours at a factory. While the family was living in a very small apartment in Corona, Queens, his older brother, who missed the DACA (Deferred Action for Childhood Arrivals) cutoff by a few months, was jumped. JC felt caged.

Significantly, for many years, JC resisted getting DACA. As he argues, "Immigrants are seen as a labor force and they are manipulated as a labor force." As JC points out, in DACA there is no pathway to citizenship, which gives DACA recipients the message that you are only here for your labor: "We've been surviving without papers for a long time." Nevertheless he eventually got it four years later, because it made his life a bit easier.

Though the Movement Activist Apprenticeship Program of the Center for Third World Organizing took him to California, giving him some reprieve, during the summer of 2015, a month after he returned, his partner at the same organization committed suicide. As a result of all these stressors, JC ended up in Lincoln Hospital in the Bronx. It was his mother's birthday. He had been drinking and abusing drugs. He had begun to cut himself. Undocumented at the time, a friend took his wallet and gave a fake name so he could receive medical care without fear. He says: "It was one of the lowest moments of my life. . . .

FIG. 20 Juan Carlos Romero, 2018. Source: (Juan Carlos Romero)

The doctors said if I had gone a little deeper on my arms I would have messed up the tendons and needed surgery and never been the same."

Two things, in addition to conventional therapy, helped to heal JC, who today has covered the marks on his arms with tattoos of danza and hip-hop. Originally introduced to danza while in California, he realized that there was very little art/culture incorporated into organizing but that the arts could be very powerful. Danza is ceremonial performances and workshops through shared indigenous dances and songs. While learning about a Chicano identity and finding himself for the first time in a majority Mexican community, he found danza to be an alternative way of organizing community and promoting healing. More than that, he learned about the history of indigenous resistance and connected to his own indigenous heritage. He comments: "We are fighting the same battles ... calling myself indigenous was not something I did before. It became part of my identity." He adds: "It's very powerful because they tried to eliminate us."

Back in New York, JC joined the open circle Cetiliztti Nauhcampa, a group formed by people from various parts of the Americas that takes its traditions from the Anahuac (Aztec). In this group he also found an alternative way of healing for himself. "Danza introduced that there are many ways to heal. I've cried many times in front of them and that was ok.... Elders gave me information about what it means to be a man."

At the same time, JC says, he was able to lift himself up through his own music—writing his feelings into songs. "That's when I dedicated myself to hip-hop."

JC was first introduced to hip-hop by his older cousin Raúl "Meck" Hernández of Hispanos Causando Pániko. Raúl lived in the same house in Corona at age seven, and JC would hear the sounds of Nas, el General, and Michael Jackson. When he was eight, his family moved back to Mexico and hip-hop had made its way there (they returned a year later after his parents' divorce). In particular he remembers the raw sounds of Control Machete, which spoke to the struggles of Mexican migrants. Again in his hometown of Puebla, the kids in the community bought a plywood floor and began experimenting with break dance.

When he was eighteen, JC began to follow in his cousin's footsteps. He began by hanging out in the Bronx and ciphering with his cousins. But as he was abusing alcohol and drugs during that time, most of his freestyle rapping was done under the influence. However, after his friend's suicide and his own hospitalization, things began to change. He began writing down his songs. The first song was dedicated to his friend. "I started recording and showing it to Raúl. He would give me feedback about bars, breaking it up."

A few years later, on October 10, 2018, he performed at the Bronx Museum, as part of "Bronx Speaks: Dreamers Melodies & Migrations Street Studio," a two-night program of beats and biographies around the importance of immigration and the struggle for equity and rights within the American dream. JC is not thinking about commercializing his sound, but sees it as a powerful way to connect. Like danza, hip-hop heals and helps organize: "It's my medicine so I just want to share my message." He connects his hip-hop to his indigenous understanding: "We had cantos. Chants to water, air, mother earth . . . they were also poets."

Like his border-crossing background, JC raps in Spanish, English, and Spanglish. Like his New York City upbringing, his lyrics are inflected with various vernaculars and cultural influences. As JC describes himself: "Growing up in the Bronx was a lot of mixing with the Caribbean community. My hip-hop has a lot of influences—Dominican words." Still, the most important aspect for JC is sharing his journey:

> Ladi dadi we likes to party
> Me and ma crew, we drink mexcal
> Shit might get rowdy
> Fuck it if it does
> That means I'm out b
> Aint trynna b
> Caught up in a case
> I'd rather hear that base
> And rap bout ma day
> Show where I stay

Paint a perfect picture
Bout how we gonna change

Here, JC traces his trajectory from drinking and partying to prioritizing writing about his experiences and learning to change. Not surprisingly, today JC is thinking about college again. He is also applying for a music apprenticeship to further his expression. "I do it because it healed the shit out of me. It saved my life. I'm still working through a lot of shit but it saved my life."

According to JC, Mexicans in New York City will soon be a recognized presence, especially the next generation. Ironically JC has put a positive spin on Trump's presidency, which he says hasn't affected him one way or another ("I'm still broke; I'm still brown"): "The president as bad as he wanted to hurt us he also put us on the map. There's a new wave not ashamed to be Mexican. . . . I'm not scared and I don't think we should be scared. When we're scared we're lost."

Instead, JC is moving forward every day with his music, his activism, and his community work. Connecting to his roots, writing his own future, JC continues forward:

Estamos de regreso	We have returned
Hambriento como un sabueso	Hungry as a hound
Tieso	Upright
Como el valor de los ancestros	Like the value of the ancestors
Empezamos de abajo	We're starting from below
Pluma es el peso	The pen is the weight
La meta es El Progreso.	The goal is progress.

Acknowledgments

This book is dedicated to the Mexican migrants and their children of New York City who opened their hearts, homes, and most importantly minds to this project. Their creativity seeps from these pages, and every worry, holdup, and writer's block I ever experienced was from my desire to do you justice. This book does not exist without your demand for a space of Mexican migrant creativity. This book exists because you let me into your world.

From the first hip-hop tracks that Raul "Meck" Hernández shared with me after a night of work at Apizz Restaurant, to Versos, who opened his home on multiple occasions, this book exists because of the generosity of these young artists to share their creativity and stories. In particular, I am indebted to Meck and the members of Hispano Causando Pániko, Enrique "Demente" Trejo and Daniel "Nemesis" Gil, who first gave me entre into the world of underground Mexican hip-hop in New York. Similarly, this book—like much of this artistic creativity—would not exist without the leadership and candidness of Har'd Life Ink founders Sarck HAR and Pisket HAR, who gave me time, countless interviews, and invitations, and even opened their doors for one of my book events. Like many of the other members of Har'd Life Ink who shared their stories and art (Sorick, Vampiro, Kortezua, Eric Rodríguez), Har'd Life Ink became a special place for me where I found complete acceptance for my Mexicanidad whether it was in carrying out my research or in my getting another tattoo. I proudly wear the artwork of Sarck and Pisket—pieces of Har'd Life Ink and Mexican migrant creativity in New York are carried with me always.

I am also indebted to the members of Buendia BK who always embraced me as well. Thank you, Solace, Blis, Rhapy, Versos, Mauro, Reko, Kombate, Glazer, EB Phillips, Timothy Ruiz, Rack, and T-Killa. Shout-out to T-Killa for meeting up with me in Mexico City and showing me underground hip-hop there.

To Hugo Andrés: when Mexican men are being called terms I refuse to acknowledge, this book celebrates what an amazing Mexican father looks like. It's beautiful to watch you pass on your art to a next generation.

To Gabino Abraham Castelán: your philosophy is as visionary as your art. Thank you for sharing that with us all and always prioritizing community first.

To Audry Funk: thank you for always representing and fighting for a space for women. You are a goddess—fierce and joyful simultaneously.

To JC (Juan Carlos Romero): a single conversation with you one night marching for Occupy Wall Street completely changed my life and the course of my research. It was your words and your thoughts that helped me initially recognize the connection among labor, capitalism, and illegality and how that context shapes migrant creativity. You helped me see the container as well as my own containment. Even at eighteen you were one of the smartest people I have ever met, as well as one of the bravest.

As a former longtime New York City restaurant worker, I want to acknowledge the tens of thousands of migrant workers who make up almost 70 percent of the restaurant workforce, most often in the lowest-paid positions and who are rarely recognized as people. Your stories—Henry, Miguel, Gonzalo, JC, Raul, Ezequiel—shaped this book in important ways. Here, your labor is respected. Here, you are valued not only as laborers but also as people with full, three-dimensional lives outside of work. Thank you to those activists who took time from their important work to speak to me—Mahoma López (Laundry Workers Center), Daniel Carillo (Enlace), Shailsesh Shrestha (the Restaurant Opportunity Center of New York)—as well as all those others who dedicate themselves to these fights. You are needed now more than ever.

Last, I would like to acknowledge all of those who helped me turn this maze of admiration and ideas into a book. Thank you to Alicia Schmidt Camacho, Robert Stepto, and Albert Laguna for supporting every single dramatic curve this project took. Thank you to Arlene Dávila and Keeanga Yamahtta-Taylor for your pointed and detailed reading of my manuscript, and thank you to the Charles Warren Center for Studies in American History at Harvard University for organizing and supporting this work through a postdoctoral fellowship and manuscript conference (Arthur Patton-Hock, Monique McCall, Walter Johnson). It is no exaggeration to say that postdoctoral year changed my life and work, making possible the position I am in today as an assistant professor at Lehman College. I am indebted to all my colleagues (Tejasvi Nagaraja, Juliet Neblon, Christopher Clements, Micol Seigel, and Garrett Felber in particular) who gave me feedback on the manuscript. This book has had numerous lives throughout the years. An earlier version of chapter 2, "Hermandad, Arte y Rebeldía: Art Collectives and Entrepreneurship in Mexican New York," appeared in *The Routledge Companion to Latino/a Popular Culture*, edited by Frederick Luis Aldama for Routledge in June 2016. Likewise, an earlier version

of chapter 3, "Yo Soy Hip-Hop: Mexicanidad and Authenticity in Mexican New York," appeared in *La Verdad: The International Reader of Hip-Hop Latinidades*, co-edited by me and Jason Nichols for Ohio State University Press, Global Latino/a Series, in 2016.

I am so grateful to my editor, Frederick Aldama, who has been a long and steadfast supporter of my scholarship, providing multiple opportunities for so many important publications in my career. Fede, you are a tireless advocate for Latinx studies, for popular culture research, and for my career, and there was no one else I would entrust with this most important work that is also so close to my heart. I am so honored to be one of your series authors again.

Four last people were absolutely the bedrock of this book. I am especially indebted to my longtime mentor and friend Mark Naison, who read multiple drafts and always supported the project with speaking and teaching opportunities. Doc, I am so grateful to have you in my life. More than just scholarly support, you have been the most loyal friend and family to me.

To my father, Carlos Castillo Chavez: you gave me the most precious gift, my Mexicanidad. But more than that, you also instilled in me the drive, determination, and discipline that have been the foundation of this work.

To my mom, Debra Castillo: there aren't really words to acknowledge the ways you have been there for me. Your love and belief in me leave me speechless. You are the most amazing woman and mother I could ever imagine. I don't deserve you, but I'm so glad you're in my corner.

And last but not least—

To the man who taught me the meaning of Infinity,
my love, my light, my partner
para siempre,
always
for Tony.

Notes

Preface

1 Both the Orchard and Apizz Restaurants are now closed.
2 All lyric translations are done with the approval of the lyricist and are meant to best translate the content, not mimic or approximate the MC's flow.

Introduction

All interview translations throughout the book are mine.

Epigraph translation: "All those who do graffiti know that graffiti started in New York. So, how to say it, okay if it started there we are going to see what's there.... I did it more like, oh I'm going to go paint in New York and everything is going to be nice, you know, when you are 17, 18, you want to know the world.... I think that all Mexicans here have an adventure, no? And me too. We go through difficult things because I didn't come to work and make my life here. I always saw it as I am just coming to paint, to do what I like to do."

1 "Many people say they came here to look for a better life. In my own case, I was attracted to not doing the same thing. I wanted to see other things."
2 "I didn't want anywhere else. I have always been in a city. So I said to myself, I'm going there."
3 Researchers estimated that 350,000–450,000 Mexican immigrants live in the five boroughs of New York City, and each year undocumented arrivals made up perhaps as high as 80–85 percent of the total—and certainly exceeded the number of—overall legal immigrants (G. López 3–4). As López points out, "That would rank New York's Mexican immigrant population—both documented and undocumented—as roughly as large as San Diego and San Jose, cities with longstanding immigrant populations, in geographical areas once part of Mexico and long the destination of Mexican immigrants" (4). Moreover, José Manuel Saiz-Alvarez estimates there is more than 1 million Mexicans in the tristate area (410). The population estimates of 600,000 in New York City and 1.2 million in

the area are also supported by the Mexican Consulate of New York City (Semple, "Immigrant in Run").

4 At about this time, scholarly works about undocumented Mexicans in New York included Robert Courtney Smith's book-length sociological study, *Mexican New York: Transnational Lives of New Immigrants*, as well as the articles "Racialization and Mexicans in New York City," and "'Mexicanness' in New York: Migrants Seek New Place in Old Racial Order"; Jocelyn Solís, "Immigration Status and Identity: Undocumented Mexicans in New York" and "The (Trans)formation of Illegality as an Identity: A Study of the Organization of Undocumented Mexican Immigrants and Their Children in New York City"; Jocelyn Solís and Liliana Rivera-Sánchez, "Recovering the Forgotten: The Effects of September 11 on Undocumented Latin American Victims and Families." Especially significant to the field are Alyshia Gálvez's important book-length studies, *Guadalupe in New York: Devotion and the Struggle for Citizenship Rights among Mexican Immigrants* and *Patient Citizens, Immigrant Mothers: Mexican Women, Public Prenatal Care, and the Birth Weight Paradox* as well as her numerous articles such as "*La Virgen* Meets Eliot Spitzer: Articulating Labor Rights for Mexican Immigrants," "'She Made Us Human': The Virgin of Guadalupe, Popular Religiosity and Activism in Mexican Devotional Organizations in New York City," "'I Too Was an Immigrant': An Analysis of Differing Modes of Mobilization in Two Bronx Mexican Migrant Organizations," "Resolviendo: The Response of a New York City Mexican Immigrant Organization to September 11th and the Formation of a Movement," and "Immigrant Citizenship: Neoliberalism, Immobility and the Vernacular Meanings of Citizenship." Most recently, Gabrielle Oliveira published *Motherhood across Borders: Immigrants and Their Children in Mexico and New York*. There are also a number of more social-policy-related studies, including Lazar Treschan and Apurva Mehrotra, *Young Mexican Americans in New York City: Working More, Learning and Earning Less*; Luis F. Nuño, "Notes from the Field: Mexicans in New York City"; Gerald P. Lopez, "The Health of Undocumented Mexicans in New York City"; and demographic reports from the Latino Data Project headed by Laird Bergad at the City University of New York Graduate Center.

5 In particular I am referencing official New York City Police Department policies such as Broken Windows, which has been shown to disproportionately target African Americans and Latinos. See Harcourt; Provine and Lewis; and Ridgeway.

6 Alyshia Gálvez's 2018 book *Eating NAFTA* helps to remedy this with her study of the role of trade and food policies on the epidemic of diet-related chronic illness in Mexico.

7 I define neoliberalism as an economic policy that advances the ideas of "free markets," minimal state interference, minimal state social services, and the support of global corporate interests. Yet, as Lisa Duggan has demonstrated, since the 1990s the meaning of neoliberalism has advanced beyond these economic policies to encompass current tendencies in global politics that advance a form of capitalist imperialism centered in the United States. Important examples of neoliberal policy, for example, were U.S. interventions in Latin America alongside violent suppressions of dissent. Thus, as Duggan argues, since the 1970s "neoliberalism as a state policy (rather than a utopian theory opposed to the state) began to appear as a practical set of strategies for maintaining capitalism in the face of

global social movement challenges and for reinforcing or installing elites with access to an increasing share of economic and political power" (181).

8 Gálvez defines "surplus people" or "those who do not have a place in the Mexican economy" and "are colloquially referred to as 'ni-nis' (short for *ni estudiando, ni trabajando*, people who are neither working nor studying)." As Gálvez explains, "Many people today find economic survival to be precarious and contingent on a reorientation of their lives, obliging them to commute long distances, migrate to other regions within Mexico, or cobble together multiple part-time and contingent occupations. While some of these shifts are common to contemporary life in neoliberal economies, there are aspects of Mexican experience that have been underacknowledged" (*Eating NAFTA* xvi). Significantly, before their migration to New York City, many of the artists in these pages would be described as "ni-nis."

9 Like the rest of the country, following the 1965 Immigration and Naturalization Act, which granted family sponsorship and skills-based entry into the United States, large numbers of new Latino/as and Asians migrated to New York City (NYCDCP). After 1970, however, not only did the city experience tremendous growth in the numbers of Dominicans, Haitians, and Guyanese, but it also experienced a new diversity of immigrants. The 1965 act also drew in Asians and Russians after the fall of the Soviet Union, and in the early 1990s, Bangladeshis were the fastest-growing nationality in the city, exceeding even growth trends among Latino/as (Waldinger). As a result, New York is an extraordinarily multiethnic community, with Latino/a immigrants from all regions of South and Central America; Asian, Arab, European, and Pacific Islander immigrants of every nationality; black immigrants from the Caribbean and Africa; and African Americans. More than one in four (29 percent) New York City residents is of Latino/a origin, a similar percentage is black or African American, Asians compose approximately 10 percent of the population, and one-half of New Yorkers speak a language other than English at home (Camacho-Gingerich 15).

10 My interview process was based on a mixture of both journalistic and ethnographical training involving participant observation and unstructured interviews.

11 As Lazar Treschan and Apurva Mehrotra observe, there is debate about the number of Mexicans living in New York City. Their analysis of the American Community Survey finds 311,927 individuals of primarily Mexican origin using a pooled sample from 2009 through 2011. Examining just 2010, however, they found 324,349 individuals of Mexican origin. According to the Census Bureau figures on its website through its American Fact Finder function, the totals were 305,664 in 2009, 319,458 in 2010, and 320,791 in 2011 (Treschan and Mehrotra 28). Separately, some scholars such as Gabrielle Oliveira, and the Mexican Consulate of New York argue that there are high numbers of New Yorkers of Mexican origin who are not captured by census data. I am inclined to agree with the latter, though I am not a social scientist.

12 As Durand and Massey note, "Migration data are among the weakest and least reliable statistics routinely collected and published by the federal government, and they were among the last to receive systematic methodological attention in the profession" (2).

13 For example, as opposed to census estimates of 56,000 in 1990, 187,000 in 2000, and 319,000 by 2010 (New York City Planning, Department of City Planning), Smith estimates the numbers to be 100,000 for 1990, 300,000 for 2000, and 450,000 for 2010 ("Mexicans: Civic Engagement" 248).

14 The rate of those not graduating from high school increased among all Mexicans from 43 percent in 1990 to 49 percent in 2010, but this was almost entirely because of the high rate of foreign-born migrants. Some 54 percent of the foreign born did not graduate high school, but only 15 percent of domestic-born Mexican adults (twenty-five years of age and older) did not graduate high school. College graduation statistics also declined from 17 percent in 1990 to 11 percent in 2010 for the same reasons. In the 2010 report, only 6 percent of foreign-born Mexican adults achieved a BA degree or higher compared with 40 percent of the domestic born (Bergad, *Demographic, Economic and Social Transformations* 39–42).

15 As Saskia Sassen, author of *Globalization and Its Discontents*, so succinctly states, "Public opinion and public political debate have become part of the arena wherein immigration policy is shaped" (9). The scholarship of Natalie Molina and Kelly Lytle Hernandez shows that racist attitudes have been powerful motivators in official U.S. policy regarding migration for one hundred years.

16 From the robbery of lands both before and after the Treaty of Guadalupe in 1848, to the forced Mexican Repatriation of the 1930s, to Operation Wetback and Operation Guardian, Mexican labor continues to be abused while Mexican lives and contributions are forgotten. Not only have people of Mexican origin been citizens of the United States since the inception of this country—and in significant numbers for over 165 years (since the Treaty of Guadalupe Hidalgo), vastly shaping the culture and character of what it means to be (North) American—Mexican bodies have also been the engine of the U.S. economy on both sides of the border. But economies aside, the lifeblood of the United States, like that of our forty-fourth president, is migrant. As a result of one of the largest mass migrations in modern history, during which more than 16 million Mexicans migrated to the United States between 1965 and 2015, the United States is now more than one-tenth Mexican and increasingly so as a result of birthrates, not immigration (Stepler and Brown).

17 In particular, I am referring to immigration legislation passed in 1996 that expanded the category of migrants eligible for removal and introduced "expedited" removal for those with criminal convictions. Moreover, it stated that judges could not consider relief in removal proceedings for those with criminal records. Nevertheless, it was Obama who deployed this to fuller effect, prioritizing the removal of "criminal aliens" by focusing on the criminal justice pipeline, those migrants with the fewest resources, rights, and supporters.

18 The United States is the second most popular destination for millionaire migrants behind Australia. An estimated 10,000 millionaires moved to the United States in 2016 (Frank).

19 One of the most famous abolitionist pamphlets was "Description of a Slave Ship, Society for Effecting the Abolition of the Slave Trade, 1789," which used the schematics of the Brookes Ship. This image is an important topic of Finley's *Committed to Memory: The Slave Ship Icon in the Black Atlantic Imagination* (see fig. 7).

20 In contrast, Chinese immigrants had the lowest detention rate (4 percent) and the highest representation rate (92 percent). If you expand the category to all Latinos, this represents 92 percent of all immigrants imprisoned for unlawful entry and re-entry (Lytle Hernández).

21 Taken from the pamphlet by Thomas Clarkson, *The History of the Rise, Progress and Accomplishment of the Abolition of the African Slave-Trade by the British Parliament*, published in London in 1808.

22 As the political scientist Aristide R. Zolberg relates, the pattern of deliberately leaving the country's "back door" open to Mexican workers, then moving to expel them and their families years later, has been a recurrent feature of immigration policy since the 1890s and thus a crucial aspect of a twentieth-century racial capitalist system (10). At a crossroads between the move toward integration and rejection, 9/11 followed the pattern of commodifying migrants that had been enacted through the Bracero program of the 1940s and 1950s and more recently in NAFTA.

23 Molina argues that the rhetoric used to define racial categories during the period 1924–1965 in U.S. immigration policy still dictates the way Mexican Americans and Mexicans continue to be associated with illegality (*How Race* 1).

24 Sassen elaborates: "One such process is the ascendance and transformation of finance, particularly through securitization, globalization, and the development of new telecommunications and computer-networking technologies. Another source of inequalities in profit making and earnings is the growing service intensity in the organization of the economy generally, that is to say, the increased demand for services by firms and households. Insofar as there is a strong tendency in the service sector toward polarization in the levels of technical expertise that workers need, and in their wages and salaries, the growth in the demand for services reproduces these inequalities in the broader society" (*Expulsions*, Kindle locations 377–382).

25 For more on New York's slave trade, see Harris; and Harris and Berlin.

26 For more about the Beast and the migrants who risk the journey, see Martínez.

27 Studies have found the same racially skewed data for decades. For example, Andrea Mcardle and Tany Erzen's 2001 *Zero Tolerance: Quality of Life and the New Police Brutality in New York City* made similar conclusions about the 1990s.

28 I place "illegality" in quotes because "illegality" is a term that must be interrogated, especially in light of the U.S. economy's long-standing reliance on undocumented workers and deep historical patterns of movement and recruitment that have long been part of the story of "illegal" immigration to the United States.

29 That is their spelling.

30 U.S. policy and attitudes toward migrant control have evolved alongside the development of what has been termed the prison industrial complex. As David Brotherton and Philip Kretsedemas vividly express: "It appears that the prison cellblock has become a more fitting metaphor than the melting pot for the experience of today's low-income immigrant. This is, perhaps, a fair illustration of the dual status of the United States as the world's leading immigrant nation and the leading exemplar of the global penitentiary. But it also begs the question, Should the Statue of Liberty be holding the sword of freedom in one hand and a pair of handcuffs in the other?" (4). In addition to the expansion of the prison industrial complex to contain the detention industrial complex, another aspect of racial capitalist development has been an increasing trend toward boundary making and divisions based on race and ethnicity, at the same time that global economies have become increasingly fluid and intertwined. As Joseph Nevins writes: "The greatest significance of these boundary fortifying developments is that they embody the pinnacle of a historical geographical process that has made the territorial divides of the United States and their accompanying social practices seem increasingly normal, 'natural' and unproblematic" (*Operation Gatekeeper* 11). Thus, at all levels—from the militarization of the border to the militarization of

police, from the prison industrial complex to the detention industrial complex, from targeted deportation on national, state, and city levels to public vitriolic statements from this country's forty-fifth president—Mexicans, alongside Muslims, have become the "foreign" representatives of a state practice to keep poor and nonwhite components separate from mainstream populations (14).

31 Though an incredibly important figure, Anzaldúa herself would have critiqued how this position actually represents a marginalization of Latina studies, in terms of both the lack of attention to other Latina and Chicana thinkers and the continued attention to limited aspects of Anzaldúa's body of work that "fit" with recognizable aspects of Chicano/a culture, such as the border. As Anzaldúa wrote, "I got tired of hearing students say that *Bridge* was required in two or three of their women's studies courses; tired of being a resource for teachers and students who asked me what texts by women of color they should read or teach and where they could get these writings. I had grown frustrated that the same few women-of-color were asked to read or lecture in universities and classrooms, or to submit work to anthologies and quarterlies. Why weren't other women-of-color being asked?" (*Making Face* xvi). Anzaldúa, like Mexican migrants in New York City, was much more diverse in her thinking and influences than often acknowledged.

32 For more on the erasure of Mexico's African past and present, see Carmen Boullosa's *Azucar Negra*; Jones; L. Gutiérrez 2012.

33 Milton M. Klein proposes in *The Empire State: A History of New York* that the name may have accompanied the success of the Black Ball Line in 1818 "because of the signal advantage the regularity of shipping gave to New York's merchants over those in other coastal cities" (xix). He claims that, by 1820, it was clear that "Empire State" was in wide use, though he is doubtful that a clear origin of the term will ever be determined.

34 Here I am referencing works such as *The New Jim Crow* by Michelle Alexander and *Are Prisons Obsolete?* by Angela Davis.

35 On racial capitalism in the Southwest, see Shah; Foley; Guidotti-Hernández.

36 An inquiry into the relationship of gender and racial capital here is also fruitful. As Grace Kyungwon Hong argues, "Racial capital transitioned from managing its crises entirely through white supremacy to also managing its crises through white liberalism, that is, through the incorporation and affirmation of minoritized forms of difference" (90). Those minoritized forms of difference, as her analysis of queer Chicana writer Cherríe Moraga demonstrates, also depend on gender and sexuality.

37 For further discussion about the role of NAFTA and on Mexican migration to the United States, see Bacon, *The Children of NAFTA*; Nevins, *Operation Gatekeeper* and *Operation Gatekeeper and Beyond*; Overmeyer-Velázquez; Ganster; Leal and Limón.

38 As Bacon argues, "In the global economy, people are displaced because the economies of their countries of origin are transformed, to enable corporations and national elites to transfer wealth out" (*Illegal People* 69).

39 According to Anzaldúa, "I found that people were using 'Borderlands' in a more limited sense than I had meant it. So to elaborate on the psychic and emotional borderlands I am now using 'nepantla.' . . . With the nepantla paradigm I try to theorize unarticulated dimensions of the experience of mestizas living in between overlapping and layered spaces of different cultures and social geographic locations, of events and realities—psychological, sociological, political, spiritual, historical, creative, imagined" (Keating ed. *Entremundos* 6).

40 It is also significant to note that containers are a crucial part of the maquiladora industry (assembly plants operating along the border in a zone exempted from import and export duties and tending to employ young women for low wages). The Border Industrialization Program initiated in 1965 to supplement the end of the Bracero Program facilitated the establishment of maquiladoras, where a Mexican, mostly female labor force assembled Asian-made components into products that were then moved across the border to warehouses and stores in the United States. These operations clearly could not have succeeded if it were not for the low transportation costs that resulted from the introduction of the shipping container (Short). The container was to the global production of consumer goods what the moving assembly line was to Ford's organization of factory production or—as I would add—the trade and slave ship to slavery times. In fact, the efficacies of containers lowered shipping costs in most instances to less than 1 percent of the total cost of production and distribution (Levinson).

41 "I believe it is cultural, I believe that women in many parts of the world, not just Mexico have not broken the chains, nevertheless, I am not a pessimist every day I see more women in the process of deprograming and questioning. I believe it is just a matter of time until more women start to lift of their voices."

42 See, for example, the work of Silvestrin, Flores, and Rosaldo in the seminal text *Latino Cultural Citizenship*, edited by William V. Flores and Rina Benmayor.

43 As Sassen examines, "global cities" are sites of servicing, financing, and management of global economic processes at the same time that they are "also sites for the incorporation of large numbers of women and immigrants in activities that service strategic sectors in both shadow and formal economic activities" ("Women's Burden" 510). See also Sassen, "The Global City."

44 This term comes from Rosalind Shaw's concept of "palimpsest memories," which according to Apter and Derby "represent a layering of historical templates in which prior conflicts and encounters shape the apprehension and recollection of subsequent events. . . . The concept of palimpsest memories is important because it allows us to get beyond the idioms of collective recollection to the actual pasts that they codify and invoke, explaining how repressed historical memories can actually return, even if dimly apprehended or 'fetishized' as sorcery. Against the presentism of political revisions in oral history and ritual reproduction is the historicism of prior rupture and conflict as invoked to address and inform the present" (xx).

Chapter 1 "Sólo Queremos el Respeto"

1 According to the National Restaurant Association website: "Founded in 1919, the National Restaurant Association is the leading business association for the restaurant industry, which comprises 960,000 restaurant and foodservice outlets and a workforce of nearly 13 million employees. Together with the National Restaurant Association Educational Foundation, the Association works to lead America's restaurant industry into a new era of prosperity, prominence, and participation, enhancing the quality of life for all we serve" (National Restaurant Association, "About"). The organization achieves many of these goals through lobbying. In 2011, for example, the NRA spent more than $2 million on federal lobbying, employing thirty-seven lobbyists, and landing a place on the "Heavy Hitters" list for the one hundred biggest donors in federal-level politics since

1989. In 2012 the association spent more than $2 million on thirty-nine lobbyists, thirty of whom had previously held government positions ("National Restaurant Assn."). The NRA's lobbying has also been prominent at the state level. For example, the California Restaurant Association was the lead opponent and main financial backer against SB2 in 2003 and Prop 72 in 2004, an initiative in California for the expansion of employer-based health coverage. In San Francisco, the Golden Gate Restaurant Association led political opposition to the Healthy San Francisco plan, even after the law was signed, becoming the lead plaintiff in the lawsuit to overturn the San Francisco ordinance. The battle went all the way to the Supreme Court, where the association lost (Wright). Most recently, the NRA was successful in blocking a paid sick day's bill in Denver (NRA Staff, "Denver Rejects") and is now lobbying to repeal President Obama's health care bill, or win an industry exemption from it (Jayaraman, "Herman Cain").

2 Herman Cain certainly thinks so. When running his presidential campaign, Cain described how he would take charge of an ailing nation, citing his experience running Godfather's Pizza and the National Restaurant Association (Thompson and Davis). According to Dave Jamieson, "In his work as the CEO of Godfather's Pizza and later as president of the National Restaurant Association, Cain worked diligently in Washington and in the media to see that low-wage restaurant workers could legally be paid as little as possible, as *In These Times* has noted. In fact, Cain's time in the restaurant business was marked by a long and largely successful battle against minimum-wage increases, and even today, some 15 years later, many of the nation's waiters and waitresses have Cain and the restaurant lobby to thank for a federal minimum wage of $2.13 for tipped workers."

3 See Constable; Ehrenreich and Hochschild; Hondagneu-Sotelo; Parreñas; Resnik and Benhabib; Rollins; M. Romero; and Mize and Swords for other studies on service sector labor. A particularly feminized New York City case can be found in the increasingly popular and expanding business of nail salons. There are now more than 17,000 nail salons in the United States, according to census data. The number of salons in New York City alone has more than tripled over a decade and a half to nearly 2,000 in 2012. In a 2015 study of 150 nail salons, the *New York Times* found rampant labor abuses similar to those found in the restaurant industry. According to its research, "A vast majority of workers are paid below minimum wage; sometimes they are not even paid. Workers endure all manner of humiliation, including having their tips docked as punishment for minor transgressions, constant video monitoring by owners, even physical abuse. Employers are rarely punished for labor and other violations" (Nir).

4 For more details about the debts of Asia, Africa, and Latin America, see Sassen, "Women's Burden."

5 See Sanchez, Delgado, and Saavedra for detailed labor statistics. These disparities also highlight the brutal nature of gender disparities. According to the National Women's Law Center resource published March 28, 2017, Latinas will have to wait 232 years to close the wage gap with white men, if current trends continue. By comparison, white women can expect to see equal pay with white men by 2056, and black women are forecast to hit the milestone in 2124. While the wage gap plagues American women of all races, Latinas are hit the hardest of any ethnic subgroup, research shows. Over the course of a forty-year career, a Latina can expect to earn $1,043,800 less than a white man. Perhaps the most disheartening data show how things are getting worse, not better: the real median annual

earnings for full-time, year-round employed Latinas have gone down 4.5 percent in all but California, Iowa, Nevada, New Mexico, Wyoming, and Washington, DC. Thus, Mexican women in New York are struggling with less, not more (National Women's Law Center, "NWLC Resource: The Lifetime Wage Gap, State by State.").

6 "That they steal one dollar, ok. Two dollars, ok. That they make you feel inferior changes all the dynamic."

7 The Michelin three-star rating is one of the highest recognitions in the culinary world. To learn more, visit http://www.michelinguide.com/.

8 Both assistant managers were white men.

9 There are different types of restaurants. In general, the food services sector is considered to be made up of four distinct industries: full-service restaurants, limited-service eating places, special food services, and drinking places. The restaurant industry as it is being examined here is understood to include the first two of these: full-service restaurants and limited-service eating places.

10 "Where I work it has happened that I go to a table and the people ask me, and the waiter? They don't see you like a waiter, they don't see you as if you could integrate. I remember one time they asked me a question, and they said to me, in English, 'What would you pick, the duck or the fish?' I hesitated like 10 seconds thinking it over in order to give them a more exact answer, more confident and the expression of the other person—'Don't worry, he doesn't speak English. Don't worry he doesn't speak the language so don't waste your time.' And I started to laugh. 'I'm lucky that actually I speak two languages, Spanish and English, you should learn one more, too.' And the other: 'Dude, I'm so sorry.' And I told him, 'don't worry, there's no problema.'"

11 According to the report, "Racial discrimination is widespread in the restaurant industry." For example, "28 percent of workers that have been passed over for a promotion reported that it was based on race. This discrimination is reflected in workers' wages, as the median wage for white workers is $13.25 compared to $9.54 for workers of color." Furthermore, although there has not been a great deal of academic work studying racial disparities and/or the impact of immigration on the restaurant industry, those that have reach similar conclusions. See Bailey; Morales; and Bendick, Rodriguez, and Jayaraman.

12 "I can say horrible, of terror and exploitation working without papers things change a lot, to be a working class woman, brown and immigrant are not the most favorable points, the exploitation and the exhaustion have been at least for the last year a constant in my life. The truth is that the American Dream is far from being A DREAM, on the contrary I found it to be a nightmare."

13 These observations are also supported by more than twelve years of personal experience and observations in New York City's restaurant industry, which included front-of-the-house positions at Aquagrill Restaurant, Artisanal Fromagerie and Bistro, Porter House New York, Oceana, the Orchard Restaurant, and Rosemary's Enoteca and Trattoria.

14 Worker and employer narratives confirm this perception: "The waiters are mostly white and the runners are Hispanic. Most of the people in the back are Hispanic. Management positions are opened to white guys and unless you went to college or you have exactly what they are looking for, it is very hard to find a general manager who is Hispanic."—Eddie, Puerto Rican, food preparation/salad maker. Meanwhile, another comment from an employer concludes: "Kitchen work is hard

work. Latinos—they're good workers." (Both qtd. in ROC-NY and the New York City Restaurant Industry Coalition "Behind the Kitchen Door" 33–34.)

15 This is without even taking into consideration that in eight years, he has received only one raise (Ezequiel, personal interview, 14 Oct. 2011).

16 Mario Batali faced accusations of sexual misconduct in December 2017. He has been publicly removed from the Bastianich partnership (though he is still a co-owner) and was forced to step down from his hosting position on *The Chew*. Police investigations did not result in charges (Detroit Free Press Staff).

17 "At Porter House, I knew that my legal situation was illegal. So, knowing that I saw the difference in how they treated me. Because the servers never experienced what I experienced. While working at Porter House, I remember one time there was a misunderstanding in the kitchen. Jesse, the sous chef, sent the food out to a table, and the chef had decided that it wasn't ready to go out yet. So when I went back to the kitchen, the first thing I encounter is a shout that seemed to me like it was raining because he [the chef] was shouting at me in the face, spitting all over my face and putting his finger in my eye, complaining about the event. So I tried to explain—I've always had the mentality that I don't like any one to yell at any one else because things are clarified with a clear mind—but that was abusive, really, because I don't think they would have done it to one of the servers. But they are used to that situation—he's Latino, he's a busboy, he's a runner, he is Latino and we shout at them. I'm not saying that it is bad to be Latin, I'm proud to be Latino and be here. But that happened to me, and the fact is that I knew that the chef knew my immigration status. And it's happened to me at other restaurants too."

18 Health and safety issues are another major concern for restaurant workers, especially those in the back of the house. Only 9 percent of workers surveyed reported receiving paid sick days, only 21 percent received vacation days, and only 37 percent of workers were insured. Lack of access to health benefits increased the likelihood of workers committing actions that put the health of the general dining public at risk. According to one restaurant owner in New York City, "You know it's one of the jokes in the restaurant industry: the restaurant industry keeps New York City sick because we don't take days off. We single-handedly keep New York sick during the winter months because we don't take days off. . . . We're passing on all the illnesses to the customers" (ROC-NY et al., "Burned" 5).

19 As Kershaw describes, "Until recently, immigration enforcement had been notoriously lax, with a kind of universal wink at kitchens filled with employees working either off the books or with false documents, government officials and industry experts say." A similar trend can be observed in regard to health and safety standards, for example, that lead to employees regularly working sick or injured despite the risks posed to customers (ROC-NY et al., "Burned"). A chef commented that "those who provide him with Social Security numbers are paid by check. Others receive cash, which allows restaurant owners to avoid paying taxes. He insisted that he did not pay anyone less than the federal minimum wage of $7.25 an hour. 'If they give me a Social Security number, I don't ask questions,' he said. 'That's what people do.'" High levels of undocumented migrant employee as well as individual worker interviews confirm this. According to Henry, "Yeah. They know. When you apply it's like you have papers? But when they see your ID they just ignore it. They know it's fake. . . . We call it chocolate. Do you have your chocolate with you? That's what you normally say to contacts. Do they accept

chocolate? Yeah, they accept chocolate. Of course some employers say I don't accept this or your number is not registered. So it's cool. It's just a yes or no. I don't mind. I've been rejected so many places" (personal interview, 23 Sept. 2011).

20 Another example of this exists in the health care debate. For instance, the NRA asked the U.S. Department of Health and Human Services to give employers an additional eighteen to twenty-four months to comply with a provision of the health care law that requires employers that offer health insurance to provide employees with information about health care plans in a new format starting March 23, 2012. According to an NRA staff release: "While we agree with the intent of the proposed regulation, we are concerned about the timing of the implementations of the rule and the potential confusion that some of the proposals may create for employees" ("NRA Comments").

21 "It has changed me greatly as the campaign converted me into an organizer, something I never thought would happen."

22 "People imagine that we are only people who worry about going to work, paying the rent."

23 "The difference came when I said this has to be stopped, enough. I know that if I lose a job, I lose it. I can get another. But they are not going to make fun of me. They are not going to make fun of me because my dignity is my shield and I am going to put it up against the man."

24 According to Soto-Innes, "I am so over people trying to own things.... There is not one chef coming up with dishes by herself. That's a lie. You can't execute an idea by yourself." She continues, "You just need to let go of micromanaging.... As long as you have a team that is equal, then you all grow together at the same time" (Krishna).

25 Information from viewing of the film I attended at the People's Forum, New York City, on 18 Sept. 2018.

26 For more about the film, visit http://thehandthatfeedsfilm.com/.

27 Nevertheless, I want to emphasize the importance of these series in terms of representations of the media. As I have previously written about, Latina women, if cast in mainstream media, are often hypersexualized (Castillo-Garsow, "Opinion"). Meanwhile, Latino men tend to occupy the space of criminals and, most recently, drug traffickers (Tobar).

Chapter 2 Hermandad, Arte y Rebeldía

1 "It's very few the opportunities for Mexicans here, there's very little space."

2 "We're despised more than anything.... What it is, is asking for a space. We are always asking for a space to be able to, I don't know ... we're looking for a place for what we're doing and right now, that's what we're doing."

3 Queens has one-third of the Mexicans in the city, while Brooklyn and the Bronx are home to 27 and 23 percent, respectively. Although immigrant Mexicans in Manhattan and Brooklyn have grown substantially since 2000, both boroughs saw a decline in their shares of the Mexican population. This was because of exceptionally high growth both in the Bronx, where the Mexican-born population doubled, and in Queens, where it increased by two-thirds (New York City Department of Planning).

4 Also see Nathan.

5 According to Mize and Swords, "The scholarly literature on consumption is widely varied in its approaches, but a most prominent perspective is advanced by Appadurai (83) who claims the work of consumption '. . . is the hardest sort of work, the work of the imagination.' It seems egregious to us to claim consuming imaginations are the hardest sort of work when compared to the sheer dangers associated with back-breaking, physical, manual labor in construction, day labor jobs, farming, mining, and factories. Even in service jobs, the face work needed to maintain a subservient role in power relations, along with the arduous aspects of cleaning, childcare, landscaping, repetitive service tasks, and stroking the egos of the privileged, is certainly more taxing than the mental work of consuming imaginations. Clearly, consumption is built upon the backs of those who produce goods and services. To privilege the work of consumption belies the social relations that shape both consumption and production" (Kindle locations 373–381).

6 "I didn't want to be alone anymore. I wanted to relate to people. . . . It was the necessity."

7 "Women contribute a lot to hip-hop. . . . It's [women's contributions] never going to be completely accepted by men."

8 "The hardest thing about being a woman, because it is the same in any area of society that, is to be taken seriously, that they do not see you as less and your power respected; it's not music, it's the world itself."

9 For more about the experiences of Mexican migrant women and reproduction, see Gálvez, *Patient Citizens*. In this book, Gálvez examines the experiences of Mexican women in the public prenatal care system in New York City and why recent Mexican immigrants show favorable birth outcomes in spite of socioeconomic disadvantages. Moreover, she also explores how the reception of immigrants in some public institutional contexts can result in the marginalization of cultural practices that offer protective health benefits.

10 In the United States: https://www.facebook.com/Har.dlifeink; in Mexico: Har Destroyerz Cru.

11 "In two weeks, I was tattooing."

12 "The change has been very drastic. Before, the only people who came to shows were the rappers, and they themselves were the audience."

13 For histories of Mexican/Chicano arts movements in other major cities, see Benavidez; Erickson, Villeneuve, and Keller; Gaspar de Alba; C. Jackson; Maciel; Navarro; and Goldman and Ybarra-Frausto.

14 These institutions include cultural programming at the Mexican consulate (which runs the Mexican Cultural Institute of New York) or the CUNY Mexican Studies Institute (founded in 2012). In addition to other organizations that emphasize immigrant advocacy and socioeconomic development (Mixteca Organization, Asociación Tepeyac), Mano a Mano is a small nonprofit organization specifically dedicated to culture and the arts. Clearly this still represents few opportunities for Mexican migrant practice and visibility in the arts.

15 "That's the importance of uniting, to stop thinking only about yourself and think about others."

16 "They were born with a different mentality."

17 For more about Chicano rap, see Pancho McFarland's *The Chican@ Hip Hop Nation* and *Chicano Rap*.

18 "And the taggers will decorate the city. And we hope you understand that this is

also our world, and if you don't like the graffiti and the tags, well, we don't like your ads, or the education you give us, or your corruption, or your polluting industries, or your wars, or your lives. Let's get rid of the past. Change and we will change."

19 As Nicholas De Genova has theorized: "It is precisely 'the Border' that provides the exemplary theater for staging the spectacle of 'the illegal alien' that the law produces. The elusiveness of the law, and its relative invisibility in producing 'illegality,' requires the spectacle of 'enforcement' at the U.S.-Mexico border that renders a racialized migrant 'illegally' visible and lends it the commonsensical air of a 'natural' fact" ("Migrant 'Illegality'" 436).

20 For a further discussion of cultural citizenship, see Bosniak; W. Flores and Benmayor; W. Flores, "New Citizens"; Gálvez, "Immigrant Citizenship"; Oboler; and Rosaldo, "Cultural Citizenship."

21 "That is a good word—'share.' We want to share what we experience and maybe no one will like it but maybe someone will identify with what we do. For example, we are illegal . . . they treat us like illegal, well we are illegal but they look down on us."

22 In 2017, actor Cheech Marin announced plans to establish a center dedicated to Chicano art in Los Angeles (Boucher).

23 "We don't work for anyone . . . or give away work. That was always the plan. To learn the process well, and then remove the intermediary, because that is what screws you."

24 For scholarship about Chicano art, see Goldman and Ybarra-Frausto; Gonzalez, Fox, and Noriega; C. Jackson; and Maciel.

25 Most scholarship on arts entrepreneurship tends to focus on educational or marketing practices. See Henry; Eikhof and Haunschild; Fillis; Hong, Essig, and Bridgstock.

26 In other words, characterized by both local and global considerations.

Chapter 3 Yo Soy Hip-Hop

"The new generation is growing, disobeying / In communities that are shaking, overcoming to go to sleep / but we are alive, active, with so many constructive motives / In destructive places, I keep going / and I do not give up." All translations are mine and are meant to be the most literal possible. They do not attempt to translate or mimic the rhythms, rhymes, and wordplays present in the music.

1 Buendia BK describes itself as "a collective group of artists, musicians, dancers, and film makers looking to pioneer a radically new form of art that is acutely in-sync with the social changes that shape our human consciousness" (Buendia BK, "about me"). Members' information, music, and films are available at http://buendiabrooklyn.com.

2 For a consideration of migrant transnationalism, see Bada; Bedolla; De la Garza and Lowell; Duquette; Goldring; Ramakrishan and Viramontes; Schoenaur-Alvaro; Smith and MacQuarrie; and Smyth. Xóchitl Bada's book in particular is helpful with its extensive bibliography on hometown associations.

3 In a New York City context, Alyshia Gálvez explored the involvement of Mexican migrants in *comités guadalupanos*, organizations dedicated to the Virgin of Guadalupe, which became sites for mobilizations for immigrant rights in New York in the early 2000s (*Guadalupe in New York*). See also Badillo, "Religion and Transnational Migration in Chicago."

4 See Pescador.

5 To this, Gómez-Peña adds, "The mestizaje model was originally created to try to grapple with the fusion between the Spanish and the indigenous. But what do you do with the Post-Mexicans? We're the product of several racial mixtures and many overlapping subcultures. . . . We're an expression of a double process; the Chicanoization and Americanization of Mexico and the Mexicanization of the United States" (para. 29).

6 According to McFarland, "I prefer the term 'Chicano' as opposed to other ethnic identifiers for several reasons. First, often the rappers of Mexican and Mexican American descent in the United States on whom I focus here use 'Chicano' as their central racial/ethnic identifier. Second, any in-depth examination of the genre will be able to draw a clear line between the music, lyrics, attitudes, language, and politics of these rappers and Mexican American, Mexican, and Chicana/o history and culture. Chicano rap as I define it in these pages is clearly a part of a tradition that begins in the Valley of Mexico several hundred years ago, continues through the Spanish and U.S. conquests of the colonial period (1519 to the early 1900s), and culminates in the Chicano movement of the 1960s and 1970s. These rappers are part of the historical legacy of the fateful period in Mexican and U.S. history when the United States of America took possession of Mexico's northern frontier through warfare. Chicano rappers are the sons and grandsons of Mexicans who were dispossessed of their lands after the Mexican-U.S. War (1846–1848) or who because of the United States' dominance of Mexico since the war have chosen to (or been forced to, depending on one's perspective) migrate to what was once northern Mexico. Third, 'Chicano' is as much a political identifier as an ethnic one. These young men (and some women) challenge the postcolonial, postindustrial politics of the United States of America. Their rebellious attitudes, independent spirits, and often radical rhetoric are implicit, if not always explicit, critiques of contemporary U.S. society. In the 1960s 'Chicano' became the identity of choice for young people who similarly challenged U.S. society. For these reasons I choose the term 'Chicano' as opposed to 'Mexican,' 'Mexican American,' 'Mexican-American,' 'Mexicano,' 'Latinx,' or 'Hispanic'" (*Chicano Rap* 11).

7 For a history of these exchanges in the Bronx, see Jeff Chang's *Can't Stop, Won't Stop: A History of the Hip-Hop Generation*; and Kugelberg's *Born in the Bronx*. N. George; Light; and Watkins also provide important historical overviews.

8 For example, Tricia Rose's *Black Noise: Rap Music and Black Culture in Contemporary America* continues to be studied and held up as the landmark it is in hip-hop studies. Nevertheless, following this basis, the study of hip-hop, which now spans over two decades, generally uses black popular culture as a backdrop. Following Rose, scholars in black / African American studies, including Michael Eric Dyson, Cornel West, Anthony B. Pinn, Nelson George, Bakari Kitwana, and Murray Forman, were among some of the first scholars to give hip-hop legitimacy in academia. See Chang, *Total Chaos*; Dyson; M. Forman; N. George; Kitwana; Rose. More recent areas of study are gender/feminism (see J. Morgan, *Chicken-heads*, "Hip-Hop Feminism"; M. Morgan; Perry; Pough; Pough et al.; Rabaka, *Inheritance* and *Amnesia*), regional trends (see Faniel; M. Miller; Schmelling, Sanneh, and Welch), and commercialization/mainstreaming (Asante; Rose, *Hip Hop Wars*; McWhorter; Watkins). A few scholars have focused on West Indian influences (Seyfu Hinds; Hebdige).

9 Another example is Nitasha Tamar Sharma's *Hip Hop Desis: South Asian Americans, Blackness, and a Global Race Consciousness.*

10 Here, Luis Alvarez's historical insights on Chicano youth subcultures are key: "There was a demographic explosion in the 1930s and 1940s of Mexican, Latina/o, Filipina/o, Japanese, and African-American communities in metropolitan areas as a result of the wartime economic boom and related Great Migration, immigration from Asia, Mexico, and Puerto Rico, and the growth of first-generation U.S.-born children" ("From Zoot Suits to Hip Hop" 57).

11 Since the early to mid-1980s, Chicano artists like Kid Frost were participating in the creation of a unique West Coast hip-hop scene, and they were soon followed in the early 1990s by groups such as ALT, A Lighter Shade of Brown, and Cypress Hill. In addition, the huge dance parties of Chicano LA's 1970s dance scene were primed to embrace hip-hop. Despite the spread of hip-hop to Mexican groups like the largely successful and well-known Control Machete, Cartel de Santa, and Molotov, in the United States, the best-known Chicano rappers are almost exclusively located in California, with a few groups representing Arizona, Texas, and occasionally the Midwest.

12 For more on reggaetón, see Rivera-Rideau; and Rivera, Marshall, and Pacini Hernandez.

13 See Tellez and Ortiz for a comprehensive history of Mexican Americans in the United States from the mid-nineteenth century to the present.

14 As Salomon reports for the *New York Times*: "Mexicans are the fastest-growing immigrant population in New York. But they say they often feel invisible in a city where the word Chicano is far more likely to evoke the streets of Los Angeles, or border towns in Texas, than Queens, Brooklyn or the Bronx."

15 There have been a number of important studies that reflect the cross-border traffic of both Mexican and American music and its impact on Mexican musical life in the United States, from banda to rock, punk, narcocorridos, and hip-hop. See S. Loza; Feixa; Morrison; Ragland, *Música Norteña* and "Communicating"; Simonett; Viesca; Wald; Zolov. I will draw further on these studies as I delve into Mexican musical transnationalism in New York.

16 "At the core of the East Coast versus West Coast conflict was a fundamental belief that the experiences of those on one coast marked them as more authentic—more gangsta, more ghetto, more hardcore—than those on the other. In other words, one 'hood was deemed more authentically hip-hop, and by extension, more authentically black, than the other" (Forman and Neal 57).

17 Unfortunately, very little work exists (at least in English) on Latin American hip-hop either. Notable exceptions include Dennis's *Afro-Colombian Hip-Hop: Globalization, Transcultural Music, and Ethnic Identities* and the volume *La Verdad.*

18 "Long live Mexico," "Raise your hands," "HCP is here to offer its heart to the brothers," "Mexicans rise—it doesn't matter what they say," "Hip Hop is in the building," "Luckily Mexican, long live Mexico," "A Mexican shines."

19 This biographical information is sourced from the Hispanos Causando Pániko website (http://www.hispanoscausandopaniko.com)—a collaboration between the author and the group members.

20 One example of this collaboration is the song "La Verdad," recorded in 2010 when Sick Jacken was visiting NYC and heard some lyrics he could not resist. That very day Jacken recorded a verse for the new song by HCP. A classic hip-hop tale of

survival and street life, "La Verdad" is significant because it represents both the history and the future of Latinx hip-hop in the United States. A member of Psycho Realm and frequent collaborator with Cypress Hill, Sick Jacken has been an important member of the West Coast hip-hop scene since the early 1990s.

21 For more on Sick Jacken, see McFarland, *Chicano Rap* 40–45, 118–127.

22 In his chapter in *That's the Joint*, Alan Light suggests that hip-hop was often driven by two divergent camps—the hardcore versus the pop-lite, or the ghetto surreal versus the politically conscious. According to Light, "Hip-hop is first and foremost a pop form, seeking to make people dance and laugh and think. To make them listen and feel, and to sell records, by doing so," but hip-hop also "by definition has a political content. . . . Rap is about giving voice to a black community otherwise underrepresented, if not silent, in the mass media." Light admits that "these differences are irreconcilable . . . the two strains have been forced to move further apart and to work, in many ways, at cross purposes." Light's comments highlight the diversity inherent in any popular form, but that is largely denied to the African American purveyors of hip-hop music and culture (59).

23 For more about reggaetón, see Rivera, Marshall, and Hernandez; Rivera-Rideau.

24 For more about the hip-hop of Kinto Sol and Chingo Bling, see McFarland, *Chican@ Hip Hop* 85–117. For more about Akwid, see Kun, "What Is an MC"). For more about Jae-P, see Tickner; Fránquiz and Salazar-Jerez.

25 Examples: Meck works in a restaurant, as does much of his family. Demente works in construction. Versos works in a whisky distillery on the factory floor (personal interviews).

26 According to Gilroy, "Though largely ignored by recent debates over modernity and its discontents, these ideas about nationality, ethnicity, authenticity, and cultural integrity are characteristically modern phenomena that have profound implications for cultural criticism and cultural history" (*The Black Atlantic* 44).

27 See Sassen, *Globalization and Its Discontents*; and Appadurai.

28 For example, the important work of Robert Smith, *Mexican New York*, on Mexican migration to New York focuses on transnational linkages between migrants and their hometowns. I would argue that equally important are the linkages formed and maintained between Latinx migrants and their home countries as well as across national and ethnic borders. Equally significant, especially in a New York context, is the transnational linkages Mexican migrants are forming with other immigrant groups as well as across Latin America and the Caribbean. These are significant, understudied circuits of influence that have increasing impacts on cultural identity formation.

29 "We're dying of laughter listening to tracks."

30 T-Killa has released eight CDs in the past eight years and was best known early on in his career for winning freestyle battles.

31 For more about Buendia's eclectic group of artists, visit http://buendiabrooklyn .com/Artists.

32 Smith elaborates, "The image of Mexicans as powerless and victimized in New York was strong from the late 1980s to mid-1990s, when they first become a visible group and received attention in the mainstream and Spanish-language media" (*Mexican New York* 164). Instead, HCP fights back against this grim reality and takes pride in their Mexican heritage, imagining themselves as *soldados* descended from the Aztecs in songs like "Nada Que Perder" (nothing to lose). Within the same song described above, they fiercely maintain their Mexicanidad, turning this

seeming ethnic vulnerability into a strength. They call for a revolution to overcome "Recesión" ("como Zapatistas ponte pilas alista las armas para la revolución" [Like Zapatistas get ready, prepare your weapons for the revolution]) and find in "Sacrificio" (sacrifice) the opportunity to move upward and provide a good example to their children. They lay out their determination most powerfully in "Todo lo puedo lograr" (I can achieve everything).

33 For more on this project, visit her website: http://www.audryfunk.com/funky -beast.html.

34 "There is an Audry before and after NYC."

35 "The hip-hop in NYC is as diverse as the city itself. You can find more than 10 flows in one event and they are all nice, from different countries, from mixtures, from different colors it is a very diverse experience" (translation, first quote). "I believe that each stage I get up on is another achievement, each media that is interested, each person that trusts are the greatest achievements and I hope that every day more people trust in this project that has a lot of heart" (translation, second quote).

Chapter 4 "Dejamos una Huella"

1 Visit the project website: http://www.sharedstudios.com.

2 See past and present locations here: http://www.sharedstudios.com/locations.

3 The examples here are endless (Bleiberg). In the art world, see the work of Annie On Ni Wan, "The Hong Kong Container"; Zhang, "The China Container"; and Wai Jim, "The Vancouver Container" among others. They are even used as art studios (Asgarian) and artists' residencies (Sargent). In terms of a construction material, shipping containers have been used for refugee housing ("Finland to House"), urban gardens ("Shipping Container Gardens"; Mims), housing (Bice; Fedele; Lewontin; Mellino), retail (Bennett; Williams; M. Wilson), restaurants (Palma; Wenk), pools (Annek), and a brewery (M. Wilson).

4 In addition, since 1980 non-Hispanic white workers have declined by approximately 25 percent, while workers born in Mexico and Central American have increased by more than 10 percent (ROC-NY, "Behind the Kitchen Door" 17).

5 See Arellano and Pilcher for the history of the taco in the United States.

6 "Those who only do graffiti with permission are not respected, to conserve the prestige of graffiti one must go out into the streets and do tags, throws, or at least put up posters."

7 "It's part of the technique," explains Sarck. "It is a form of liberty and a way to express your anger without being violent . . . and even though you paint without permission, if you do it well, you feel that. It never loses its essence, even though it is destroyed."

8 Decolonizing struggles in the Third World, the Black Power and civil rights movements, the anti–Vietnam War movement, and the emergence of the hippie counterculture also led to a rise in Latino civil rights. While Puerto Ricans mobilized as the Young Lords on the East Coast, the Chicano movement grew out of the farmworker struggle to unionize in California and Texas in the early 1960s (Ybarra-Frausto, "Panorama" 148; Goldman and Ybarra-Frausto 83). Meanwhile, by the late 1960s, urban issues such as police brutality, violations of civil rights, lack of adequate employment, inadequate housing and social services, lack of educational opportunities, and lack of political power mobilized youth into action

(C. Jackson 12–20). For more on the Chicano movement, see David Montejano, *Quixote's Soldiers: A Local History of the Movement, 1966–1981*; Armando Navarro, *Mexican American Youth Organization: Avant-Garde of the Chicano Movement in Texas*; Juan Quiñones, *Chicano Politics: Reality and Promise, 1940–1990*; and Guadalupe San Miguel, Jr., *"Brown, not White": School Integration and the Chicano Movement in Houston*. Maylei Blackwell's excellent *¡Chicana Power!: Contested Histories of Feminism in the Chicano Movement* focuses on the experiences of women and is the first book to do so.

9 Other resources on the Chicano art movement include Gary D. Keller, *Triumph of Our Communities: Four Decades of Mexican American Art*; Phillip Brookman and Guillermo Gómez-Peña's *Made in Aztlán*; Alicia Gaspar de Alba, *Chicano Art inside/outside the Master's House: Cultural Politics and the CARA Exhibition*; Guisela Latorre, *Walls of Empowerment: Chicana/o Indigenist Murals of California*; and María Ochoa, *Creative Collectives: Chicana Painters Working in Community*.

10 See, for example, Liz Sevcenko's work on *puertorriqueñidad* in Lower Manhattan. While during the fiscal crisis of the 1970s the city struggled to rid itself of abandoned properties, in the 1990s it became profitable again. Thus, the mayor's office worked to evict less profitable tenants and sell properties to developers, resulting in the gentrification of Loisaida and the shrinking of the Latino community in that area (313–314).

11 "That's the real hip-hop. We try to return to those fundamental roots. So how we talk about culture, graffiti is one of those four essential elements."

12 "Graffiti is very important. It's one of the four elements that are part of the history since the 1970s."

13 For more information on graffiti styles and history, see Cey Adams and Bill Adler's *DEFinition: The Art and Design of Hip Hop*; Roger Gastman and Caleb Neelon, *The History of American Graffiti*; Nancy MacDonald, *The Graffiti Subculture: Youth, Masculinity and Identity in London and New York*.

14 For more information about the war on graffiti, see Joe Austin, *Taking the Train: How Graffiti Became an Urban Crisis in New York City*; and James T. Murray and Karla L. Murray, *Broken Windows: Graffiti NYC*.

15 Learn more about the Mayor's anti-graffiti task force here: http://www.nyc.gov /html/nograffiti/html/aboutforce.html.

16 For examples of artwork across Mexico, see La Farge and Caris.

17 Like youth around the world, Mexican students organized in 1968 to protest the use of excessive force by the government, which included army and riot police. The movement, however, was short-lived, as on 2 Oct. 1968, ten days before the opening of the Summer Olympics in Mexico City, police officers and military troops shot into a crowd of unarmed students. Thousands of demonstrators fled in panic as tanks bulldozed over Tlatelolco Plaza, and the number of deaths is still disputed, ranging from 4 to 3,000. For an account of the massacre, see Elena Poniatowska's now-classic chronicle, *La Noche de Tlatelolco: Testimonios de historia oral*.

18 "the street and the wall are spaces of socialization that symbolize freedom of expression, freedom to be. Being young in Mexico is difficult, access to educational and work spaces is restricted, many of the urban young people who dedicate themselves to graffiti belong to a low social stratum, so leaving school to go to work is very common in addition to the fact that labor guarantees are precarious.

Belonging to a family where the pressure to contribute an income is constant and in which living spaces are reduced—two or more families live in small houses—encourages them to look for spaces where it is possible to project their identity and experience their youth" (Cruz Salazar, "Yo me aventé" 200).

19 For more about graffiti in Mexico, see Cruz Salazar, "Instantáneas sobre" and "Yo me aventé" and Dokins.

20 "It represents the transitory aspect of life, but also, the beauty. Life and death are part of the same system."

21 "If you do it well, people will see it differently. Even if it is destroyed, it never loses its essence."

22 "They know we leave a footprint wherever we go."

23 "This is who I am, from beginning to end."

24 For more about the legalized racialization of immigrants, see Ngai and Molina, *How Race Is Made in America*.

25 Across the world, the increasing disparity of wealth is decidedly visible—in the past twenty years, for example, there has been a 60 percent increase in the wealth of the top 1 percent. This extreme wealth coincides with a disconnect to the world's less fortunate, as in 2012 the richest "100 billionaires added $240 billion to their wealth. This amount was enough to end world poverty four times over—however, they did not" (Sassen, *Expulsions*, Kindle locations 214–216). As Sassen describes this historical moment, "Rich individuals and global firms by themselves could not have achieved such extreme concentration of the world's wealth. They need what we might think of as systemic help: a complex interaction of these actors with systems re-geared toward enabling extreme concentration" (220–222). Containers are a clear part of the systems that enabled this concentration. For more on inequality and the top 1 percent, see Semuels.

26 See full address here: https://livestream.com/CornellCast/events/7427799/videos/157095361.

Epilogue

See full announcement speech: http://www.c-span.org/video/?326473-1/donald-trump-presidential-campaign-announcement.

1 All quotes from this chapter come from a personal interview with Juan Carlos Romero on 14 Nov. 2018.

Works Cited
and Consulted

Abrego, Leisy. *Sacrificing Families: Navigating Laws, Labor, and Love across Borders*. Palo Alto: Stanford UP, 2014.

Ackleson, James. "Constructing Security on the U.S.–Mexico Border." *Political Geography* 24.2 (2005): 165–184.

"Across the World, Shock and Uncertainty at Trump's Victory." *New York Times*, 9 Nov. 2016. Web. 14 July 2017. https://www.nytimes.com/2016/11/09/world/europe /global-reaction-us-presidential-election-donald-trump.html?_r=1.

Adams, Cey, and Bill Adler. *DEFinition: The Art and Design of Hip Hop*. New York: Harper Design, 2008.

Adams, Sam. "The Future Is Now in *Sleep Dealer*." *Museum of the Moving Image*. Sloan Science and Film. 16 Nov. 2008. Web. 22 May 2017. http://scienceandfilm.org/articles /338/the-future-is-now-in-sleep-dealer.

Adamson, Joni. "'¡Todos Somos Indios!' Revolutionary Imagination, Alternative Modernity, and Transnational Organizing in the Work of Silko, Tamez, and Anzaldúa." *Journal of Transnational American Studies* 4.1 (2012): n. pag. Web. 14 July 2017. http://escholarship.org/uc/item/2mj3c2p3.

Afatsiawo, Mawuli. "Man in a Box." 2000. Single-channel video.

———. "On a Journey . . ." 2001. Single-channel video.

Aguilar, Daniel. "Solace." Personal interview. 2 Feb. 2014.

———. Personal interview. 1 Nov. 2013.

Alba, Richard, and Victor Nee. *Remaking the American Mainstream: Assimilation and Contemporary Immigration*. Cambridge: Harvard UP, 2003.

Aldama, Arturo, Chela Sandoval, and Peter García, eds. *Performing the US Latina and Latino Borderlands*. Bloomington: Indiana UP, 2012.

Alexander, Michelle. *The New Jim Crow: Mass Incarceration in the Age of Colorblindness*. New York: New Press, 2012.

Alexanders, Ignacio. "Gabino Abraham Castelán: For the People." *Creative Sugar Magazine*, n.d. Web. 7 June 2017. http://www.creativesugarmagazine.net/gabino -abraham-Castelán-people/.

Alim, H. Samy, Awad Ibrahim, and Alastair Pennycook, eds. *Global Linguistic Flows: Hip Hop Cultures, Youth Identities, and the Politics of Language*. New York: Routledge, 2009.

Allatson, Paul. *Key Terms in Latino/a Cultural and Literary Studies*. Malden: Blackwell Publishing, 2007.

Allegretto, Sylvia A., and Kai Filion. "Waiting for Change: The $2.13 Subminimum Wage." *Economic Policy Institute & Center on Wage and Employment Dynamics Briefing Paper*. 297 (23 Feb. 2011): 1–19. Web. 27 Nov. 2011. https://www.epi.org/publication/waiting_for_change_the_213_federal_subminimum_wage/.

Allen, Dan. "14 Latino Art Shows Not to Miss in 2017." *NBC News*, 28 Apr. 2017. Web. 31 May 2017. http://www.nbcnews.com/news/latino/14-latino-art-shows-not-miss-2017-n751366.

Alvarado, Li Yun. "Latina New York: Feminist Poetics and the Empire City." Diss. Fordham U, 2015.

Alvarez, Luis. "From Zoot Suits to Hip-Hop: Towards a Relational Chicana/o Studies." *Latino Studies* 5 (2007): 53–75.

———. *The Power of the Zoot: Youth Culture and Resistance during World War II*. Berkeley: U of California P, 2009.

Amaya, Hector. *Citizenship Excess: Latino/as, Media, and the Nation*. New York: New York UP, 2013.

Anderson, Benedict. *Imagined Communities: Reflections on the Origin and Spread of Nationalism*. Rev. ed. Brooklyn: Verso, 2006.

Andreas, Peter. *Border Games: Policing the U.S.-Mexico Divide*. Ithaca: Cornell UP, 2009.

Andres, Hugo. Personal interview. 21 Oct. 2013.

Annek, Collen. "Australian Company Reveals Design for Shipping Container Pool." *San Francisco Globe*, 6 Nov. 2015. Web. 10 Nov. 2015. http://sfglobe.com/2015/11/02/australian-company-reveals-design-for-shipping-container-pool/.

Anzaldúa, Gloria. *Borderlands / La Frontera: The New Mestiza*. 1987. 4th ed. San Francisco: Aunt Lute, 2012.

———. "Interview by Karin Ikas." *Borderlands / La Frontera: The New Mestiza*. 1999. San Francisco: Aunt Lute, 2012. 267–284.

———, ed. *Making Face, Making Soul / Haciendo Caras: Creative and Critical Perspectives by Feminists of Color*. San Francisco: Aunt Lute, 1990.

Anzaldúa, Gloria, and AnaLouise Keating, eds. *This Bridge We Call Home: Radical Visions for Transformation*. New York: Routledge, 2002.

Appadurai, Arjun. *Modernity at Large: Cultural Dimensions of Globalization*. Minneapolis: U of Minnesota P, 1996.

Apter, Andrew, and Lauren Derby, eds. *Activating the Past: History and Memory in the Black Atlantic World*. London: Cambridge Scholars, 2010.

Archer, Petrine. "Negrophilia, Diaspora, and Moments of Crisis." *Afro Modern: Journeys through the Black Atlantic*. Ed. Tanya Barson, Peter Gorschlüter, and Petrine Archer. Liverpool: Tate, 2010. 26–40.

Arellano, Gustavo. *Taco USA: How Mexican Food Conquered America*. New York: Simon, 2013.

Arredondo, Gabriela F. *Mexican Chicago: Race, Identity and Nation, 1916–39*. Urbana: U of Illinois P, 2008.

Arreola, Daniel D., ed. *Hispanic Spaces, Latino Places: Community and Cultural Diversity in Contemporary America*. Austin: U of Texas P, 2004.

Asante, Molefi K. *It's Bigger Than Hip-Hop: The Rise of the Post-Hip-Hop Generation*. New York: St. Martin's, 2008.

Asgarian, Roxanna. "Art Studios Made from Shipping Containers Coming to Houston's Fifth Ward." *Biz Journal*, 20 Nov. 2015. Web. 11 Oct. 2016. http://www.bizjournals .com/houston/blog/breaking-ground/2015/11/art-studios-made-from-shipping -containers-coming.html.

Associated Press. "'Inspired' by Trump, Brothers Beat Up Homeless Migrant." *Inquirer .Net*, 17 May 2016. Web. 30 Dec. 2016. http://newsinfo.inquirer.net/785984/inspired-by -trump-brothers-beat-up-homeless-migrant.

———. "Mexican Police Find 513 US-Bound Migrants in Two Trucks." *FOX News*, 18 May 2011. Web. 14 July 2017. http://www.foxnews.com/world/2011/05/18/mexican -police-find-513-bound-migrants-trucks/.

Austin, Joe. *Taking the Train: How Graffiti Became an Urban Crisis in New York City*. New York: Columbia UP, 2001.

Avant-Mier, Roberto. *Rock the Nation: Latin/o Identities and the Latin Rock Diaspora*. New York: Continuum International Publishing, 2010.

Baca, Damian. *Mestiz@ Scripts, Digital Migrations and the Territories of Writing*. New York: Palgrave, 2008.

Bacon, David. *The Children of NAFTA: Labor Wars on the U.S./Mexico Border*. Berkeley: U of California P, 2004.

———. *Illegal People: How Globalization Creates Migration and Criminalizes Immigrants*. Boston: Beacon, 2009.

———. *The Right to Stay Home: How US Policy Drives Mexican Migration*. Boston: Beacon, 2013.

Bada, Xóchitl. *Mexican Hometown Associations in Chicagoacán: From Local to Transnational Civic Engagement*. New Brunswick: Rutgers UP, 2014.

Badillo, David A. "An Urban Historical Portrait of Mexican Migration to New York City." *New York History* 90.5 (2009): 107–124. JSTOR. Web. 7 July 2017. www.jstor.org /stable/23185100.

Bagri, Neha Thirani. "A Record Half-Million Cases Are Waiting to Be Heard by US Immigration Courts." *Quartz*, 7 Sept. 2016. Web. 21 Sept. 2016. http://qz.com /771583/a-record-half-million-cases-are-waiting-to-be-heard-by-us-immigration -courts/.

Bailey, Thomas. "A Case Study of Immigrants in the Restaurant Industry." *Industrial Relations* 24.2 (1985): 205–221.

Banerjee, Sukanya, Aims McGuinness, and Steven McKay, eds. *New Routes for Diaspora Studies*. Bloomington: Indiana UP, 2012.

Baquet, Dean. "Trump Says He Didn't Know He Employed Illegal Aliens." *New York Times*, 13 July 1990. Web. 12 Sept. 2016. http://www.nytimes.com/1990/07/13/nyregion /trump-says-he-didn-t-know-he-employed-illegal-aliens.html.

Barson, Tanya. *Afro-Modern: Journeys through the Black Atlantic*. Liverpool: Tate Publishing, 2010.

Basilia Valenzuela, M., and Margarita Calleja Pinedo, eds. *Empresarios Migrantes Mexicanos En Estados Unidos*. Zapopan, Jalisco: U of Guadalajara, 2009.

Basu, Dipannita, and Sidney J. Lemelle, eds. *The Vinyl Ain't Final: Hip Hop and the Globalization of Black Popular Culture*. London: Pluto, 2006.

Bauer, Fred. "A Refusal to Enforce Immigration Law Helped Pave the Way for the Abuse of New York's Nail-Salon Workers." *National Review*, 7 May 2015. Web. 14 July 2017. http://www.nationalreview.com/corner/418056/refusal-enforce-immigration-law -helped-pave-way-abuse-new-yorks-nail-salon-workers.

Beckel, Michael. "Herman Cain Touts Outside Status Despite Numerous Financial Ties to

Politicians." *Cutting Edge*, 9 May 2011. Web. 4 Dec. 2011. http://www
.thecuttingedgenews.com/index.php?article=52001.

Beckman, G. "'Adventuring' Arts Entrepreneurship Curricula in Higher Education: An
Examination of Present Efforts, Obstacles, and Best Practices." *Journal of Arts
Management, Law, and Society* 37.2 (2007): 87–112. doi:http://dx.doi.org/10.3200
/JAML.37.2.87-112.

Beckwith, Ryan Teague. "Donald Trump Paid $1.4 Million in a Dispute over Undocu-
mented Workers. Read the Newly Unsealed Legal Papers." *Time*, 28 Nov. 2018. Web. 11
Jan. 2019. http://time.com/5039109/donald-trump-undocumented-polish-trump-tower
-bonwit-teller/.

Bedolla, Lisa Garcia. *Introduction to Latino Politics in the U.S.* Cambridge: Polity, 2009.

Behnken, Brian. *Fighting Their Own Battles: Mexican Americans, African Americans, and
the Struggle for Civil Rights in Texas.* Chapel Hill: U of North Carolina P, 2014.

———. *Justice and Social Inquiry: Struggle in Black and Brown: African American
and Mexican American Relations during the Civil Rights Era.* Lincoln: U of
Nebraska P, 2012.

Bello Cornejo, Jair "Kortezua." Personal interview. 8 Oct. 2013.

Benavidez, Max. "Chicano Art: Culture, Myth and Sensibility." *Chicano Visions: American
Painters on the Verge.* Ed. Cheech Marin. New York: Bulfinch, 2002. 10–21.

Bendick, Marc, Jr., Rekha Eanni Rodriguez, and Sarunmathi Jayaraman. "Employment
Discrimination in Upscale Restaurants: Evidence from Matched Pair Testing." *Social
Science Journal* 47 (2010): 802–818. doi:https://doi.org/10.1016/j.soscij.2010.04.001.

Bennett, Sarah. "L.A.'s First Food Court in a Shipping Container Has Smog City, Ramen
and Waffles." *LA Weekly*, 12 Nov. 2015. Web. 14 Nov. 2015. http://www.laweekly.com
/restaurants/las-first-food-court-in-a-shipping-container-has-smog-city-ramen-and
-waffles-6265813.

Bentacourt, Gabriela S., Lisa Colarossi, and Amanda Perez. "Factors Associated with
Sexual and Reproductive Health Care by Mexican Immigrant Women in New York
City: A Mixed Method Study." *Journal of Immigrant and Minority Health* 15.2 (2013):
326–333.

Berelowitz, Jo-Anne. "The Spaces of Home in Chicano and Latino Representations of
the San Diego-Tijuana Borderlands (1968–2002)." *Society and Space* 23 (2005):
323–350.

Bergad, Laird. *The Concentration of Wealth in New York City Changes in the Structure of
Household Income by Race/Ethnic Groups and Latino Nationalities 1990–2010.* Latino
Data Project. Report 56. New York: Center for Latin American, Caribbean, and Latino
Studies Graduate Center, January 2014. Web. 5 Nov. 2015. http://clacls.gc.cuny.edu
/files/2014/01/Household-Income-Concentration-in-NYC-1990-2010.pdf.

———. *Demographic, Economic and Social Transformations in the Mexican-Origin
Population of the New York City Metropolitan Area, 1990–2010.* Latino Data Project.
Report 49. New York: Center for Latin American, Caribbean, and Latino Studies
Graduate Center, September 2013. Web. 7 July 2017. https://www.gc.cuny.edu/CUNY
_GC/media/CUNY-Graduate-Center/PDF/Centers/CLACLS/Mexicans-in-New
-York-Metro-Area-and-Surrounding-Counties-1990-2010.pdf.

———. *Have Dominicans Surpassed Puerto Ricans to Become New York City's Largest
Latino Nationality?* Latino Data Project. Report 61. New York: Center for Latin
American, Caribbean, and Latino Studies Graduate Center, November 2014. Web. 7
July 2017. http://clacls.gc.cuny.edu/files/2014/11/AreDominicansLargestLatinoNation
ality.pdf.

———. *Latino Population of New York City, 1990–2015*. Latino Data Project. Report 65. New York: Center for Latin American, Caribbean, and Latino Studies Graduate Center, December 2016.

———. *Mexicans in New York 1990–2005*. Latino Data Project. New York: Center for Latin American, Caribbean, and Latino Studies Graduate Center, September 2014. Web. 5 Nov. 2015. http://clacls.gc.cuny.edu/files/2013/10/Mexicans-in-New-York-City -1990–2005.pdf.

Bernier, Celeste-Marie. "'The Slave Ship Imprint': Representing the Body, Memory and History in Contemporary African American and Black British Painting, Photography and Art." *Callaloo* 37.4 (2014): 990–1022.

Betancur, John J., and Douglas Gills, eds. *The Collaborative City: Opportunities and Struggles for Blacks and Latinos in U.S. Cities*. New York: Garland, 2000.

Bice, Allie. "1st Shipping-Container Apartments in Phoenix Open for Viewing." *AZcentral.com*, 13 Nov. 2015. Web. 16 Nov. 2015. http://www.azcentral.com/story/news/local /phoenix/2015/11/13/1st-shipping-container-apartments-phoenix-open-viewing /75677898.

Biemann, Ursula. "Performing the Border: On Gender, Transnational Bodies, and Technology." *Globalization on the Line: Gender, Nation, and Capital at U.S. Borders*. Ed. Claudia Sadowski-Smith. New York: Palgrave, 2002. 99–120.

Bittman, Mark. "The 20 Million." *New York Times*, 12 June 2012. Web. 4 Dec. 2012. http://opinionator.blogs.nytimes.com/2012/06/12/the-20-million/?smid=tw -bittman&seid=auto.

Blackmon, Douglas. *Slavery by Another Name: The Re-enslavement of Black Americans from the Civil War to World War II*. New York: Anchor, 2009.

Blackwell, Maylei. *¡Chicana Power!: Contested Histories of Feminism in the Chicano Movement*. Austin: U of Texas P, 2011.

Bleiberg, Larry. "10 Best: Cool Shipping-Container Conversions." *USA Today*, 13 Nov. 2016. Web. 15 Oct. 2016. http://www.usatoday.com/story/travel/destinations /10greatplaces/2015/11/13/shipping-containers/75640534/.

Bliss. Personal interview. 2 Feb. 2014.

Bonacich, Edna, Sabrina Alimahomed, and Jake B. Wilson. "The Racialization of Global Labor." *American Behavioral Scientist* 52.3 (2008): 342–355. doi:10.1177/0002764208323510.

Bosniak, L. "Citizenship of Aliens." *Social Text* 56 (1998): 15–30. doi:10.2307/466764.

Bosworth, Mary, and Jeanne Flavin, eds. *Race, Gender, and Punishment: From Colonialism to the War on Terror*. Newark: Rutgers UP, 2006.

Bosworth, Mary, and Emma Kaufman. "Foreigners in a Carceral Age: Immigration and Imprisonment in the U.S." *Stanford Law & Policy Review* 22.1 (2011): 102–126.

Boucher, Brian. "Comedian Cheech Marin Wants to Champion Chicano Art with a New LA Center." *Art World*, 1 May 2017. Web. 29 May 2017. https://news.artnet.com/art -world/cheech-marin-chicano-art-943415.

Boullosa, Carmen. *Azucar Negra*. México City: Fondo de Cultura Económica/Cenzontle, 2013.

Brady, Mary Pat. *Extinct Lands, Temporal Geographies: Chicana Literature and the Urgency of Space*. Durham: Duke UP, 2002.

Braziel, Jana Evans, and Anita Mannur, eds. *Theorizing Diaspora: A Reader*. Kindle ed. Malden: Blackwell, 2003.

Brookman, Phillip, and Guillermo Gómez-Peña. *Made in Aztlán*. San Diego: Centro Cultural de La Raza, 1986.

Brotherton, David, and Philip Krestsedemas, eds. *Keeping Out the Other: A Critical Introduction to Immigration Enforcement Today*. New York: Columbia UP, 2008.

Brown, Vincent. "Social Death and Political Life in the Study of Slavery." *American Historical Review* 114.5 (2009): 1231–1249. doi:10.1086/ahr.114.5.1231.

Browne, Simone. *Dark Matters: On the Surveillance of Blackness*. Durham: Duke UP, 2015.

Bryant, Jonathan N. *Dark Places of the Earth: The Voyage of the Slave Ship Antelope*. New York: Norton, 2015.

Cacho, Lisa Marie. *Social Death: Racialized Rightlessness and the Criminalization of the Unprotected*. New York: New York UP, 2012. E-Book.

Cadigan, Hilary. "Alexandria Ocasio-Cortez Learned Her Most Important Lessons from Restaurants." *Bon Appétit*, 7 Nov. 2018. Web. 12 Jan. 2019. https://www.bonappetit .com/story/alexandria-ocasio-cortez-lessons-from-restaurants.

Cain, Herman. "Minimum Wage Hearing: Statement by Herman Cain, CEO & President Godfather's Pizza, Inc. Joint Economic Committee Hearing on President Clinton's Proposal to Increase the Minimum Wage. February 22, 1995." Joint Economic Committee. n.d. Web. 4 Dec. 2011. http://www.house.gov/jec/cost-gov/regs/minimum /caintest.htm.

Calavita, Kitty. *Inside the State: The Bracero Program, Immigration, and the I.N.S.* New York: Routledge, 1992.

Camacho-Gingerich, Alicia, ed. *The Immigrant Experience in New York City: A Resource Guide*. New York: St. John's U, 2007.

Camp, Stephanie. *Closer to Freedom: Enslaved Women and Everyday Resistance in the Plantation South*. Chapel Hill: U of North Carolina P, 2004.

Canclini, Néstor García. *Hybrid Cultures: Strategies for Entering and Leaving Modernity*. Minneapolis: U of Minnesota P, 1995.

Cardalda Sánchez, Elsa B., and Amílcar Tirado Avilés. "Ambiguous Identities! The Affirmation of Puertoriqueñidad in the Community Murals of New York City." *Mambo Montage: The Latinization of New York*. Ed. Agustin Laos-Montes and Arlene Davila. New York: Columbia UP, 2001. 263–289.

Carillo, Daniel. Personal interview. 2 Sept. 2015.

Castelán, Gabino Abraham. Personal interview. 3 Sept. 2015.

———. Personal interview. 12 Dec. 2016.

———. Personal interview. 5 Dec. 2018.

Castillo, Debra. "Anzaldúa and Transnational American Studies." *PMLA* 12.1 (2006): 260–265. doi:https://doi.org/10.1632/003081206X129819.

Castillo-Garsow, Melissa. "Opinion: What Not to Love about Latinas on TV." *CNN in America*. 22 Nov. 2011. Web. 12 Jan. 2019. http://inamerica.blogs.cnn.com/2011/11/22 /the-sadly-sexy-legacy-of-latinas-on-tv/.

———. "Yo Soy Hip Hop: Performing an Authentic Mexican Hip Hop in New York." *Words. Beats. Life: The Global Journal of Hip-Hop Culture* 6.1 (2015): n. pag.

———. "Yo Soy Hip Hop: Transnationalism and Authenticity in Mexican New York." *La Verdad: The International Reader of Hip Hop Latinidades*. Ed. Melissa Castillo-Garsow and Jason Nichols. Columbus: Ohio State UP, 2016. 133–152.

Chabram-Dernersesian, Angie. *The Chicana/o Cultural Studies Reader*. New York: Routledge, 2006.

Chang, Jeff. *Can't Stop, Won't Stop: A History of the Hip-Hop Generation*. New York: St. Martin's, 2005.

———, ed. *Total Chaos: The Art and Aesthetics of Hip-Hop*. New York: Basic Civitas, 2006.

Chang, Woong Jo, and Margaret Wyszomirski. "What Is Arts Entrepreneurship? Tracking the Development of Its Definition in Scholarly Journals." *Artivate: A Journal of Entrepreneurship in the Arts* 4.2 (2015): 11–31. Web. 7 July 2017. https://artivate.hida .asu.edu/index.php/artivate/article/viewFile/94/44.

Charnas, Dan. *The Big Payback: The History of the Business of Hip-Hop.* New York: New American Library, 2010.

Chassot, Joanne. "'Voyage through Death / To Life upon These Shores': The Living Dead of the Middle Passage." *Atlantic Studies* 12.1 (2015): 90–108. doi:10.1080/14788810.2014. 993825.

Chavez, Leo. *The Latino Threat: Constructing Immigrants, Citizens and the Nation.* 2nd ed. Stanford: Stanford UP, 2013.

Chavoya, C. Ondine. "Collaborative Public Art and Multimedia Installation: David Avalos, Louis Hock and Elizabeth Sisco's *Welcome to America's Finest Tourist Plantation.*" *Ethnic Eye: Latino Media Arts.* Ed. Chon Noriega and Ana Lopez. Minneapolis: U of Minnesota P, 1996. 208–227.

——. "Customized Hybrids: The Art of Rúben Ortiz Torres and Lowriding in South California." *CR: The New Centennial Review* 4.2 (2004): 141–184.

Chen, Yiwei, dir. *Audry Funk: A Documentary on Hip Hop, Womanhood and Social Justice.* 2019.

Chomsky, Aviv. *Undocumented: How Immigration Became Illegal.* Boston: Beacon, 2013.

Clarkson, Thomas. *The History of the Rise, Progress and Accomplishment of the Abolition of the African Slave-Trade.* London: Taylor, 1808. Web. 12 July 2017. http://www .gutenberg.org/files/10633/10633-h/10633-h.htm.

Clay, Andrea. *The Hip Hop Generation Fights Back: Youth, Activism, and Post-Civil Rights Politics.* New York: New York UP, 2012.

Clayton, Daniel W. *Islands of Truth: The Imperial Fashioning of Vancouver Island.* Vancouver: U of British Columbia P, 2000.

Coates, Ta-Nehisi. "The Case for Reparations." *The Atlantic,* June 2014. Web. 12 July 2017. https://www.theatlantic.com/magazine/archive/2014/06/the-case-for-reparations/361631/.

Cohen, Deborah. *Braceros: Migrant Citizens and Transnational Subjects in the Postwar United States and Mexico.* Chapel Hill: U of North Carolina P, 2011.

Cohen, D'Vera, and Jeffery Passel. "Overall Number of U.S. Unauthorized Immigrants Holds Steady Since 2009." *Pew Hispanic Center,* 20 Sept. 2016. Web. 14 Dec. 2017. http://www.pewhispanic.org/2016/09/20/overall-number-of-u-s-unauthorized -immigrants-holds-steady-since-2009/.

——. "A Portrait of Unauthorized Immigrants in the United States." *Pew Hispanic Center,* 14 Apr. 2009. Web. 4 Dec. 2011. http://www.pewhispanic.org/2009/04/14/iv -social-and-economic-characteristics/.

——. "20 Metro Areas Are Home to Six-in-Ten Unauthorized Immigrants in U.S." *Pew Hispanic Center,* 9 Feb. 2017. Web. 18 Sept. 2017. http://www.pewresearch.org/fact -tank/2017/02/09/us-metro-areas-unauthorized-immigrants/.

Cohen, Robin. *Globalizing Diasporas: An Introduction.* New York: Routledge, 2008.

Constable, Nicole. *Maid to Order in Hong Kong: Stories of Migrant Workers.* Ithaca: Cornell UP, 2007.

Contreras, Franc. "Children among the Millions Sent from US to Mexico." *CCTV America,* 9 Aug. 2016. Web. 9 Sept. 2016. www.cctv-america.com/2016/08/09/children -among-the-millions-sent-from-us-to-mexico.

Corona, Ignacio, and Alejandro Madrid. *Postnational Musical Identities.* Lanham: Lexington, 2008.

Corsi, Jerome R. "Mexicans Blame Americans for 'Death Train.'" *World Net Daily*, 13 July 2014. Web. 18 Sept. 2016. http://www.wnd.com/2014/07/mexicans-blame -americans-for-death-train/.

Costa Vargas, João H. *Never Meant to Survive: Genocide and Utopias in Black Diaspora Communities*. New York: Rowman, 2010.

Cox, Wendell. "Escape from New York." *City Journal*. Special Issue 2009. Web. 12 Dec. 2016. https://www.city-journal.org/html/escape-new-york-13193.html.

Crosthwaite, Luis Humbert, and John William Byrd, eds. *Puro Border: Dispatches, Snapshots & Graffiti from the US/Mexico Border*. El Paso: Cinco Puntos, 2003.

Cruz Salazar, Tania. "Instantáneas sobre el *graffiti* mexicano: Historias, voces y experiencias juveniles." *Última Década* 29 (2008): 137–157.

———."Yo me aventé como tres años haciendo tags, ¡sí, la verdad, sí fui ilegal! Grafiteros: arte callejero en la ciudad de México." *Desacatos* 14 (2004): 197–226.

C-SPAN. "Donald Trump Presidential Campaign Announcement." 16 June 2016. Web. 5 Sept. 2016. www.c-span.org/video/?326473-1/donald-trump-presidential-campaign -announcement.

Cutler, John Alba. *Ends of Assimilation: The Formation of Chicano Literature*. New York: Oxford UP, 2015.

David, Marianne, and Javier Muñoz-Basols, eds. *Defining and Re-defining Diaspora: From Theory to Reality*. Oxford: Inter-Disciplinary, 2011.

Dávila, Arlene. *Barrio Dreams: Puerto Ricans, Latinos, and the Neoliberal City*. Oakland: U of California P, 2004.

———. *Culture Works: Space, Value, and Mobility across the Neoliberal Americas*. New York: New York UP, 2012.

———. *Latinos, Inc.: The Marketing and Making of a People*. Berkeley: U of California P, 2012.

———, ed. "On Latin@s and the Immigration Debate." *American Anthropologist* 116.1 (2014): 1–14. doi:10.1111/aman.12069.

Dávila, Arlene, and Augustín Láo-Montes, eds. *Mambo Montage: The Latinization of New York*. New York: Columbia UP, 2001.

Davis, Angela. *Are Prisons Obsolete?* New York: Seven Stories, 2003.

Decena, Carlos Ulises, and Margaret Gray. "Putting Transnationalism to Work: An Interview with Filmmaker Alex Rivera." *Social Text* 88.3 (2006): 131–138. doi:10.1215/01642472-2006-008.

De Certeau, Michel. *The Practice of Everyday Life*. Los Angeles: U of California P, 1984.

De Genova, Nicholas. "'American' Abjection 'Chicanos,' Gangs, and Mexican/Migrant Transnationality in Chicago." *Aztlán: A Journal of Chicano Studies* 33.2 (2008): 141–178.

———. "Border Struggles in the Migrant Metropolis." *Nordic Journal of Migration Research* 5.1 (n.d.): 2015. doi:10.1515/njmr-2015-0005.

———. "Migrant 'Illegality' and Deportability in Everyday Life." *Annual Review of Anthropology* 31 (2002): 419–447. doi:10.1146/annurev.anthro.31.040402.085432.

———. "The Production of Culprits: From Deportability to Detainability in the After-math of 'Homeland Security.'" *Citizenship Studies* 11.5 (2007): 421–448. doi:10.1080/13621020701605735.

———. "The Queer Politics of Migration: Reflections on 'Illegality' and Incorrigibility." *Studies in Social Justice* 4.2 (2010): 101–126. Web. 10 Sept. 2015. https://brock .scholarsportal.info/journals/SSJ/article/view/997/967.

———. *Working the Boundaries: Race, Space and "Illegality" in Mexican Chicago*. Durham: Duke UP, 2005.

De Genova, Nicholas, and Nathalie Peutz, eds. *The Deportation Regime: Sovereignty, Space and the Freedom of Movement*. Durham: Duke UP, 2010.

DeHart, Monica. *Ethnic Entrepreneurs: Identity and Development Politics in Latin America*. Stanford: Stanford UP, 2010

Deidrich, Maria, Henry Louis Gates Jr., and Carl Pedersen, eds. *Black Imagination and the Middle Passage*. New York: Oxford UP, 1999.

De la Garza, Rodolfo O., and Briant Lindsay Lowell. *Sending Money Home: Hispanic Remittances and Community Development*. Lanham: Rowman, 2002.

Délano, Alexandra. *Mexico and Its Diaspora in the United States: Politics of Emigration since 1848*. Cambridge: Cambridge UP, 2011.

Del Bosque, Melissa, Gus Bova, Jen Reel, and Emma Pérez-Treviño. "American beyond Detention." *Texas Observer*, 29 Dec. 2016. Web. 30 Dec. 2016. https://www
.texasobserver.org/america-beyond-detention/.

Dennis, Christopher. *Afro-Colombian Hip-Hop: Globalization, Transcultural Music, and Ethnic Identities*. Lanham: Lexington, 2012.

Department of Commerce. "U.S. Exports Hit New Annual Record." *Commerce.gov*, 5 Feb. 2015. Web. 23 May 2017. https://www.commerce.gov/news/press-releases/2015/02
/us-exports-hit-new-annual-record-reaching-235-trillion-2014.

Detroit Free Press Staff. "Sexual Assault Investigation into Chef Mario Batali Closed without Charges." *Detroit Free Press*, 10 Jan. 2019. Web. 12 Jan. 2019. https://www.freep
.com/story/news/local/michigan/2019/01/10/chef-mario-batali-sexual-assault
/2538427002/.

Diaz, David, and Rodolfo D. Torres, eds. *Latino Urbanism: The Politics of Planning, Policy and Redevelopment*. New York: New York UP, 2012.

Díaz-Sánchez, Micaela. "'Yemaya Blew that Wire Fence Down': Invoking African Spiritualities in Gloria Anzaldúa's *Borderlands / La Frontera*. Ed. Otero, Solimar, and Toyin Falola. *Yemoja: Gender, Sexuality, and Creativity in the Latina/o and Afro-Atlantic Diasporas*. Albany: State U of New York P, 2013. 153–186.

"Digital Africa." *African Film Festival Program*. Electronic Arts Intermix News, Nov. 2003. Web. 7 July 2017. http://www.eai.org/user_files/supporting_documents
/1103DigitalAfrica_pr_2.pdf.

Dimitriadis, Greg. *Performing Identity / Performing Culture: Hip Hop as Text, Pedagogy, and Lived Practice*. New York: Peter Lang, 2009.

Dokins, Said. "La participación de la mujer en el arte urbano." *Desbordamientos de una periferia femenina*. Ed. Laura García. Mexico City: Sociedad Dokins, 2008. 55–64.

Domínguez Michael, Christopher. *Diccionario Crítico de La Literatura Mexicana*. México City: Fondo de Cultura Económica, 2007.

Donato, K. M., and B. Sisk. "Shifts in the Employment Outcomes among Mexican Migrants to the United States, 1976–2009." *Research in Social Stratification and Mobility* 30.2 (2013): 63–77. doi:10.1016/j.rssm.2011.12.002.

Douglass, Frederick. "The Meaning of Fourth of July for the Negro." *Frederick Douglass Selected Speeches and Writing*. Ed. Philip S. Foner. Chicago: Chicago Review, 2000. 188–205.

Dow, Mark. *American Gulag: Inside U.S. Immigration Prisons*. Berkeley: U of California P, 2004.

Dowling, Julie A., and Jonathan Xavier Inda, eds. *Governing Immigration through Crime: A Reader*. Stanford: Stanford Social Sciences, 2013.

Duany, Jorge. *Blurred Borders: Transnational Migration between the Hispanic Caribbean and the United States*. Chapel Hill: U of North Carolina P, 2011.

Duggan, Lisa. "Neoliberalism." *Keywords for American Studies*. Ed. Bruce Burgett and Glenn Hendler. New York: New York UP, 2014.

Dunlap, Eloise, and Bruce D. Johnson. "The Setting for the Crack Era: Macro Forces, Micro Consequences (1960–1992)." *Journal of Psychoactive Drugs* 24.4 (1992): 307–321. doi:10.1080/02791072.1992.10471656.

Duquette, Lauren. "Making Democracy Work from Abroad: Remittances, Hometown Associations and Migrant-State Coproduction of Public Goods in Mexico. Diss. U of Chicago, 2011.

Durand, Jorge, and Douglas S. Massey, eds. *Crossing the Border: Research from the Mexican Migration Project*. New York: Russell Sage, 2004.

Dyson, Michael Eric. *Between God and Gangsta Rap: Bearing Witness to Black Culture*. New York: Oxford UP, 1996.

Eagly, Ingrid, and Steven Shafer. "Access to Counsel in Immigration Court." *American Immigration Council*, 28 Sept. 2016. Web. 17 May 2017. www .americanimmigrationcouncil.org/research/access-counsel-immigration-court.

Ehrenreich, Barbara, and Arlie Russell Hochschild, eds. *Global Woman: Nannies, Maids, and Sex Workers in the New Economy*. New York: Metropolitan, 2002.

Eichler, Alexander. "Former Windows on the World Employees Become Advocates of Fair Treatment of Service Workers." *Huffington Post*, 9 Sept. 2011. Web. 11 Oct. 2011. http://www.huffingtonpost.com/2011/09/09/windows-on-the-world-fair-treatment-of -workers_n_951026.html.

Eikhof, D., and A. Haunschild. "For Art's Sake! Artistic and Economic Logics in Creative Production." *Journal of Organizational Behavior* 28.5 (2007): 523–538. doi:10.1002/job.462.

———. "Lifestyle Meets Market: Bohemian Entrepreneurs in Creative Industries." *Creativity and Innovation Management* 15.3 (2006): 234–241. doi:10.1111/j.1467-8691.2006.00392.x.

Elk, Mike. "Herman Cain, the Other NRA and the Stagnant Minimum Wage." *Working in These Times*, 26 Sept. 2011. Web. 4 Dec. 2011. http://www.inthesetimes.com /working/entry/12005/herman_cain_the_other_nra_and_the_stagnant_minimum _wage/.

Elmer, Jonathan. "The Black Atlantic Archive." *American Literary History* 17.1 (2005): 160–170. doi:https://doi.org/10.1093/alh/ajioo9.

Eltis, David. *Economic Growth and the Ending of the Transatlantic Slave Trade*. New York: Oxford UP, 1987.

Engler, Mark. "Science Fiction from Below." *Foreign Policy in Focus*, 13 May 2009. Web. 5 Sept. 2016. fpif.org/science_fiction_from_below/.

Epstein, Reid J. "NCLR Head: Obama 'Deporter-in-Chief.'" *Politico*, 4 Mar. 2014. Web. 21 Sept. 2016. www.politico.com/story/2014/03/national-council-of-la-raza-janet-murguia -barack-obama-deporter-in-chief-immigration-104217.

Erickson, Mary, Pat Villeneuve, and Gary D. Keller. *Chicano Art for Our Millennium: Collected Works from the Arizona State University Community*. Tempe: Bilingual Review, 2004.

Ezequiel. Personal interview. 14 Oct. 2011.

Faniel, Maco. *Hip-Hop in Houston: The Origin and the Legacy*. Charleston: History, 2012.

Farley, Robert. "Trump Challenges Birthright Citizenship." *FactCheck.org*, 13 Nov. 2015. Web. 22 Sept. 2016. www.factcheck.org/2015/11/trump-challenges-birthright -citizenship/.

Farr, Marcia. *Rancheros in Chicagoacán: Language and Identity in a Transnational Community*. Austin: U of Texas P, 2006.

Fassin, Didier. "Policing Borders, Producing Boundaries. The Governmentality of Immigration in Dark Times." *Annual Review of Anthropology* 40 (2011): 213–226. doi:https://doi.org/10.1146/annurev-anthro-081309-145847.

Featherstone, David. "Atlantic Networks, Antagonisms and the Formation of Subaltern Political Identities." *Social and Cultural Geography* 6.3 (2005): 387–404. doi:10.1080/14649360500111311.

———. *Resistance, Space and Political Identities: The Making of Counter-Global Networks.* Oxford: Wiley, 2008.

Fedele, Angela. "Container-Skyscrapers Could Help Vulnerable Communities." *Architecture News,* 17 Nov. 2015. Web. 22 Nov. 2015. https://sourceable.net/container -skyscrapers-could-help-our-most-vulnerable-communities/.

Feixa, Carles. "Tribus urbanas and chavos banda: Being a Punk in Catalonia and Mexico." *Global Youth? Hybrid Identities, Plural Worlds.* Ed. Pam Nilan and Carles Feixa. New York: Routledge, 2006. 149–166.

Felisbret, Eric. *Graffiti New York.* New York: Abrams, 2009.

Fernandes, Sujatha. *Close to the Edge: In Search of the Global Hip Hop Generation.* New York: Verso, 2011.

Fernández, Lilia. *Brown in the Windy City: Mexicans and Puerto Ricans in Postwar Chicago.* Chicago: U of Chicago P, 2012.

Feuer, Alan. "On the Waterfront, Rise of the Machines." *New York Times,* 28 Sept. 2012. Web. 17 Oct. 2016. http://www.nytimes.com/2012/09/30/nyregion/in-new-yorks-port -the-rise-of-the-machines.html?_r=0.

Fillis, I. "Art for Art's Sake or Art for Business Sake: An Exploration of Artistic Product Orientation." *Marketing Review* 6.1 (2006): 29–40.

Fine, Janice. *Worker Centers: Organizing Communities at the Edge of the Dream.* Cambridge: Belknap, 2007.

"Finland to House Asylum Seekers in Tents & Shipping Containers." *Eyewitness News,* 11 Nov. 2015. Web. 11 Oct. 2016. http://ewn.co.za/2015/11/11/Finland-readies-to-house -asylum-seekers-in-tents-containers.

Finley, Cheryl. *Committed to Memory: The Slave Ship Icon in the Black Atlantic Imagination.* Princeton: Princeton UP, 2018.

———. "Schematics of Memory." *Small Axe* 35 (2011): 96–116. Project Muse. Web. 7 July 2017. https://muse.jhu.edu/article/446649.

Flores, Juan. *From Bomba to Hip Hop: Puerto Rican Culture and Latino Identity.* New York: Columbia UP, 2000.

———. "Puerto Rocks: Rap, Roots and Amnesia." *That's the Joint! The Hip Hop Studies Reader.* Ed. Murray Forman and Mark Anthony Neal. New York: Routledge, 2004. 69–96.

Flores, Juan, and George Yudice. "Living Borders / Buscando America: Languages of Latino Self-Formation." *Social Text* 8.2 (1990): 57–84. JSTOR. Web. 7 July 2017. http://www.jstor.org/stable/827827.

Flores, William V. "New Citizens, New Rights: Undocumented Immigrants and Latino Cultural Citizenship." *Latin American Perspectives* 30.2 (2003): 87–100. JSTOR. Web. 7 July 2017. http://www.jstor.org/stable/3184978.

Flores, William V., and Rina Benmayor, eds. *Latino Cultural Citizenship: Claiming Identity, Space, and Rights.* Boston: Beacon, 1997.

Foldy, Erica Gabrielle. "'Managing' Diversity: Identity and Power in Organizations." *Gender, Identity and the Culture of Organizations.* Ed. Iiris Aaltio and Albert J. Mills. London: Routledge, 2002.

Foley, Neil. *The White Scourge: Mexicans, Blacks and Poor Whites in Texas Cotton Culture.* Berkeley: U of California P, 1997.

Foner, Eric. *Gateway to Freedom: The Hidden History of America's Fugitive Slaves.* Oxford: Oxford UP, 2015.

Foner, Nancy. *In the New Land: A Comparative View of Immigration.* New York: New York UP, 2005.

———. *New Immigrants in New York.* New York: Columbia UP, 2001.

———. *One Out of Three: Immigrant New York in the Twenty-First Century.* New York: Columbia UP, 2013.

Food Chain Workers Alliance. *The Hands That Feed Us: Challenges for Workers along the Food Chain.* 6 June 2012. Web. 4 Dec. 2012. http://foodchainworkers.org/wp-content /uploads/2012/06/Hands-That-Feed-Us-Report.pdf.

Food Labor Research Center and the Food Chain Workers Alliance. "A Dime a Day: The Impact of the Miller/Harkin Minimum Wage Proposal on the Price of Food." 24 Oct. 2012. Web. 29 Nov. 2012. http://rocunited.org/dime-a-day/.

Forman, James, Jr. "Racial Critiques of Mass Incarceration: Beyond the New Jim Crow." *Faculty Scholarship Series,* Paper 3599 (26 Feb. 2012): 101–147.

Forman, Murray. *The 'Hood Comes First: Race, Space, and Place in Rap and Hip-Hop.* Middletown: Wesleyan UP, 2002.

Forman, Murray, and Mark Anthony Neal, eds. *That's the Joint! The Hip-Hop Studies Reader.* New York: Routledge, 2004.

Foucault, Michel. *Discipline and Punish.* New York: Random, 1975.

Fox, Jonathan, and Xóchitl Bada. "Migrant Organization and Hometown Impacts in Rural Mexico." *Journal of Agrarian Change* 8.2–3 (2008): 435–461.

Francis, Jacqueline. "The Brookes Slave Ship Icon: A 'Universal Symbol'?" *Slavery and Abolition* 30.2 (2009): 327–338. doi:http://dx.doi.org/10.1080/01440390902819045.

Frank, Robert. "For Millionaire Immigrants, a Global Welcome Mat." *New York Times,* 25 Feb. 2017. Web. 17 May 2017. https://nyti.ms/2IGnJY9.

Fránquiz, Maria E., and Maria del Carmen Salazar-Jerez. "Ni de aquí, ni de allá: Latin@ Youth Crossing Linguistic and Cultural Borders." *Journal of Border Education Research* 6.2 (2007): 101–117.

Frates, Chris. "Donald Trump's Immigrant Wives." *CNN.com,* 24 Aug. 2015. Web. 12 Jan. 2019. https://www.cnn.com/2015/08/24/politics/donald-trump-immigrant-wives /index.html.

Fredrickson, George. *Racism: A Short History.* Princeton: Princeton UP, 2002.

Funk, Audry. "In Mexico We Are Not All Blonde and Skinny." *Global Beats.* BBC World, 4 Dec. 2015. Web. 22 July 2017. http://www.bbc.co.uk/programmes/po3b2ck4.

———. Personal interview. 10 Dec. 2018.

The Furman Center for Real Estate and Urban Policy. "Trends in New York City Housing Appreciation." *State of New York City's Housing & Neighborhoods,* 2008. Web. 10 Sept. 2015. http://furmancenter.org/files/Trends_in_NYC_Housing_Price_Appreciation.pdf.

Gabilondo, Joseba. "The Hispanic Atlantic." *Arizona Journal of Hispanic Cultural Studies* 5.1 (2001): 92–111.

Galbraith, James. *University of Texas Inequality Project,* 2016. Web. 21 Sept. 2016. utip.lbj .utexas.edu/papers.html.

Gálvez, Alyshia. *Eating NAFTA: Trade, Food Policies, and the Destruction of Mexico.* Berkeley: U of California P, 2018.

———. *Guadalupe in New York: Devotion and the Struggle for Citizenship Rights among Mexican Immigrants.* New York: New York UP, 2009.

———. "Immigrant Citizenship: Neoliberalism, Immobility and the Vernacular Meanings of Citizenship." *Identities: Global Studies in Culture and Power* 20.6 (2013): 720–737. doi:10.1080/1070289X.2013.842475.

———. "I Too Was Immigrant: An Analysis of Differing Modes of Mobilization in Two Bronx Mexican Migrant Organizations." *International Migration* 45.1 (2007): 87–121. doi:10.1111/j.1468-2435.2007.00397.x.

———. "*La Virgen* Meets Eliot Spitzer: Articulating Labor Rights for Mexican Immigrants." *Social Text* 24.3 (2006): 99–130. doi:10.1215/01642472-2006-007.

———. *Patient Citizens, Immigrant Mothers: Mexican Women, Public Prenatal Care, and the Birth Weight Paradox*. New Brunswick: Rutgers UP, 2011.

———. "Resolviendo: The Response of a New York City Mexican Immigrant Organization to September 11th and the Formation of a Movement." *Politics and Partnerships: The Transformation of the Nonprofit Sector in the Era of the Declining Welfare State*. Ed. Elisabeth Clemens and Doug Guthrie. Chicago: U of Chicago P, 2010. 297–326.

———. "'She Made Us Human': The Virgin of Guadalupe, Popular Religiosity and Activism in Mexican Devotional Organizations in New York City." *Performing Religion in the Americas: Media, Politics, and Devotional Practices in the 21st Century*. Ed. Alyshia Gálvez. Chicago: Seagull, 2007. 141–157.

Gamboa, Erasmo. *Bracero Railroaders: The Forgotten World War II Story of Mexican Workers in the U.S. West*. Seattle: U of Washington P, 2016.

———. *Mexican Labor and World War II: Braceros in the Pacific Northwest, 1942–1947*. Austin: U of Texas P, 1990.

Ganster, Paul. *The US-Mexican Border into the Twenty-First Century*. Lanham: Rowman, 2007.

García, Christina, ed. *Bordering Fires: The Vintage Book of Contemporary Mexican and Chicano/a Literature*. New York: Random, 2006.

García, Jorge J. E., ed. *Race or Ethnicity? On Black and Latino Identity*. Ithaca: Cornell UP, 2007.

García, Matt. "Memories of El Monte: Intercultural Dance Halls in Post-World War II Greater Los Angeles." *Generations of Youth: Youth Cultures and History in Twentieth-Century America*. Ed. Joe Austin and Michael Nevin Willard. New York: New York UP, 1998. 157–173.

Gaspar de Alba, Alicia. *Chicano Art inside/outside the Master's House: Cultural Politics and the CARA Exhibition*. Austin: U of Texas P, 1998.

———. "There's No Place Like Aztlán: Embodied Aesthetics in Chicana Art." *CR: The New Centennial Review* 4.2 (2004): 103–140.

Gastman, Roger, and Caleb Neelon. *The History of American Graffiti*. New York: Harper, 2011.

Gates, Henry Louis, Jr. "How Many Slaves Landed in the US?" *The Root*, 6 Jan. 2014. Web. 21 Sept. 2016. www.theroot.com/articles/history/2014/01/how_many_slaves_came_to _america_fact_vs_fiction/.

Gay, John. "As Immigration Issue Resurfaces, Operators Must Make Voices Heard." *Nation's Restaurant News* 43.26 (2009): 52–53.

Gendreau, Mónica, and Regina Cortina, eds. *Immigrants and Schooling: Mexicans in New York*. New York: Center for Migration Studies, 2013.

Gentic, Tania. *Everyday Atlantic: Time, Knowledge, and Subjectivity in the Twentieth-Century Iberian and Latin American Newspaper Chronicle*. Albany: State U of New York P, 2013.

George, Nelson. *Hip Hop America*. New York: Viking, 1998.

George, Rose. *Ninety Percent of Everything: Inside Shipping, the Invisible Industry That Puts Clothes on Your Back, Gas in Your Car, and Food on Your Plate.* New York: Metropolitan, 2013.

Gil, Daniel. Personal interview. 10 Apr. 2011.

Gilroy, Paul. *The Black Atlantic: Modernity and Double Consciousness.* Cambridge: Harvard UP, 1993.

———. *Darker Than Blue: On the Moral Economies of Black Atlantic Culture.* Cambridge: Harvard UP, 2010.

———. *Postcolonial Melancholia.* New York: Columbia UP, 2005.

———. "Sounds Authentic: Black Music, Ethnicity, and the Challenge of a 'Changing.'" *Black Music Research Journal* 11.2 (1991): 111–136. doi:10.2307/779262.

Givens, Terri E., Gary P. Freeman, and David L. Leal, eds. *Immigration Policy and Security: U.S., European and Commonwealth Perspectives.* New York: Routledge, 2009.

Gladstein, Hanna, Annie Lai, Jennifer Wagner, and Michael Wishnie. "Blurring the Lines: A Profile of State and Local Police Enforcement of Immigration Law Using the National Crime Information Center Database, 2002–2004." *Migration Policy Institute Occasional Paper.* 13 Dec. 2015. Web. 7 July 2017. http://www.migrationpolicy.org /research/blurring-lines-profile-state-and-local-police-enforcement-immigration-law -using-ncic.

Golash-Boza, Tanya María. "The Immigration Industrial Complex: Why We Enforce Immigration Policies Destined to Fail." *Sociology Compass* 3.2 (2009): 295–309. doi:10.1111/j.1751-9020.2008.00193.x.

———. *Immigration Nation: Raids, Detentions, and Deportations in Post-9/11 America.* Boulder: Paradigm, 2011.

Goldman, Francisco. *The Ordinary Seaman.* New York: Grove, 1998.

Goldman, Shifra M., and Tomás Ybarra-Frausto. "The Political and Social Contexts of Chicano Art." *Chicano Art: Resistance and Affirmation, 1965–1985.* Ed. Richard Griswold del Castillo, Teresa McKenna, and Yvonne Yarbro-Beharano. Los Angeles: Wight Art Gallery / U of California P, 1991. 83–95.

Goldring, Luin. "Gender, Status and the State in Transnational Spaces: The Gendering of Political Participation and Mexican Hometown Associations." *Gender and U.S. Immigration: Contemporary Trends.* Ed. Pierrette Hondagneu-Sotelo. Berkeley: U of California P, 2003. 341–356.

Gomez-Peña, Guillermo. "Interview by Gabrielle Banks—Culture Tracffiking for the 21st Century." *Colorlines,* 15 June 2003. Web. 12 Apr. 2011. http://colorlines.com /archives/2003/06/culturetracfficking_for_the_21st_century.html.

Gonzales, Alfonso. *Reform without Justice: Latino Migrant Politics and the Homeland Security.* Oxford: Oxford UP, 2013.

González, Rita, Howard N. Fox, and Chon A. Noriega. *Phantom Sightings: Art after the Chicano Movement.* Berkeley: U of California P, 2008.

Gordon, Jennifer. "Law, Lawyers and Labor: The United Farmworkers Legal Strategy in the 1960s and 1970s and the Role of Law in Union Organizing Today." *Fordham University School of Law,* Feb. 2006. Web. 12 Dec. 2012. http://scholarship.law.upenn .edu/cgi/viewcontent.cgi?article=1232&context=jbl.

———. *Sweatshops: The Fight for Immigrant Rights.* Cambridge: Belknap, 2007.

———. "Tensions in Rhetoric and Reality at the Intersection of Work and Immigration." *Fordham University School of Law,* 17 Apr. 2012. Web. 27 Nov. 2012. http://ssrn.com /abstract=2045621.

Gordon, Jennifer, and R. A. Lenhart. "Rethinking Work and Citizenship." *Fordham University School of Law*, June 2008. Web. 12 Dec. 2012. http://ssrn.com/abstract =1147134.

Gosa, Travis L., and Erik Nielson, eds. *The Hip Hop & Obama Reader*. New York: Oxford UP, 2015.

Greene, Judith A., Bethany Carson, and Andrea Black. "Indefensible: A Decade of Mass Incarceration of Migrants Prosecuted for Crossing the Border." *National Network for Immigrant and Refugee Rights*, July 2016. Web. 12 July 2017. http://www.nnirr.org /drupal/sites/default/files/indefensible_-_grassroots_leadership_-_web.pdf.

Gruesser, John Cullen. *Confluences: Postcolonialism, African American Literary Studies, and the Black Atlantic*. Athens: U of Georgia P, 2007.

Guidotti-Hernández, Nicole M. "Petra Santa Cruz Stevens and the Sexual and Racial Modalities of Property Relations in the Nineteenth-Century Arizona-Sonora Borderlands." *Cultural Dynamics* 26 (2014): 347–378.

Guillen, Michael. "Q&A: Alex Rivera, 'Sleep Dealer.'" *SF360*, 14 May 2008. Web. 10 Sept. 2015. http://www.sf360.org/page/11194.

Gurdus, Elizabeth. "Trump: 'We Have Some Bad Hombres and We're Going to Get Them Out.'" *CNBC.com*, 19 Oct. 2016. Web. 14 July 2017. http://www.cnbc.com/2016/10/19 /trump-we-have-some-bad-hombres-and-were-going-to-get-them-out.html.

Guridy, Frank Andre. *Forging Diaspora: Afro-Cubans and African Americans in a World of Empire and Jim Crow*. Chapel Hill: U of North Carolina P, 2010.

Gutierres, Fernando "Pisket HAR INK." Personal interview. 15 Nov. 2014.

———. Personal interview. 19 July 2015.

Gutiérrez, David G., ed. *Between Two Worlds: Mexican Immigrants in the United States*. Wilmington: Scholarly Resources, 1996.

———. *Walls and Mirrors: Mexican Americans, Mexican Immigrants, and the Politics of Ethnicity*. Berkeley: U of California P, 1995.

Gutiérrez, Laura G. "'El derecho de re-hacer': Signifyin(g) Blackness in Contemporary Mexican Political Cabaret." *Arizona Journal of Hispanic Cultural Studies* 16 (2012): 163–176.

Habell-Pallán, Michelle. *Loca Motion: The Travels of Chicana and Latina Popular Culture*. New York: New York UP, 2005.

Hall, Stuart. "Cultural Identity and Diaspora." *Theorizing Diaspora: A Reader*. Malden: Blackwell, 2003, 222–237.

Hanson, Alan R. "Dear Director Glazer." 21 Apr. 2017. Letter. U.S. Department of Justice, Office of the Assistant District Attorney, Washington, DC.

Harcourt, Bernard E. *Illusion of Order: The False Promise of Broken Windows Policing*. Cambridge: Harvard UP, 2001.

Harding, David. "Illegal Immigrants Discovered in Shipping Container, One Dead." *New York Daily News*, 16 Aug. 2014. Web. 14 July 2017. http://www.nydailynews.com/news /world/illegal-immigrants-found-shipping-container-dead-article-1.1905666.

Harris, Leslie. *In the Shadow of Slavery: African Americans in New York City, 1626–1863*. Chicago: U of Chicago P, 2003.

Harris, Leslie, and Ira Berlin. *Slavery in New York*. New York: New Press, 2005.

Hartman, Saidiya. *Lose Your Mother: A Journey along the Atlantic Slave Route*. New York: Farrar, 2008.

———. *Scenes of Subjection: Terror, Slavery, and Self-Making in Nineteenth-Century America*. Oxford: Oxford UP, 1997.

Hasty, William, and Kimberley Peters. "The Ship in Geography and the Geographies of Ships." *Geography Compass* 6.11 (2012): 660–676. doi:10.1111/gec3.12005.

Hayes, Brent Edwards. "Diaspora." *Keywords for American Cultural Studies*. Ed. Bruce Burgett and Glenn Hendler. New York: New York U, 2007.

Hebdige, Dick. *Cut 'N' Mix: Culture, Identity, and Caribbean Music*. London: Methuen, 1987.

Helm, MacKinley. *Mexican Painters: Rivera, Orozco, Siqueiros, and Other Artists of the Social Realist School*. New York: Dover Fine Art, 1989.

Henderson, Timothy. *Beyond Borders: A History of Mexican Migration to the United States*. New York: Wiley, 2011.

Henry. Personal interview. 23 Sept. 2011.

Henry, Collete, ed. *Entrepreneurship in the Creative Industries: An International Perspective*. Cheltenham: Elgar, 2007.

"Herman Cain Debates Bill Clinton." Video file. YouTube, 2 Feb. 2011. Web. 4 Dec. 2011. http://www.youtube.com/watch?v=ptrTa8C_Pl4.

Hernández, David Manuel. "Pursuant to Deportation: Latinos and Immigrant Detention." *Latino Studies* 6 (2008): 35–63. doi:10.1057/lst.2008.2.

Hernández, Raul "Meck." Personal interview. 31 Jan. 2011,

———. Personal interview. 12 Apr. 2011.

———. Personal interview. 18 June 2013.

Hernandez, Rod. "Between Black, Brown & Beige: Latino Poets and the Legacy of Bob Kaufman." *Callaloo* 25.1 (2002): 190–196. JSTOR. Web. 7 July 2017. http://www.jstor.org/stable/3300407.

Herr, Cheryl Temple. *Critical Regionalism and Cultural Studies: From Ireland to the American Midwest*. Gainesville: U of Florida P, 1996.

Hinojosa, Hugo Alberto. *Desiertos*. Mexico City: Programa Cultural Tierra Adentro, 2010.

Hispanos Causando Pániko. Personal interview. 7 Feb. 2011.

Hodkinson, Paul, and Wolfgang Deicke, eds. *Youth Cultures: Scenes, Subcultures and Tribes*. New York: Routledge, 2007.

Hoffnung-Garskof, Jesse. *A Tale of Two Cities: Santo Domingo and New York after 1950*. Princeton: Princeton UP, 2010.

Hondagneu-Sotelo, Pierrette. *Doméstica: Immigrant Workers Cleaning and Caring in the Shadows of Affluence*. Berkeley: U of California P, 2001.

Hong, Christina, Linda Essig, and Ruth S. Bridgstock. "The Enterprising Artist and the Arts Entrepreneur: Emergent Pedagogies for New Disciplinary Habits of Mind." *Exploring More Signature Pedagogies: Approaches to Teaching Disciplinary Habits of Mind*. Ed. Nancy Chick, Aeron Haynie, and Regan A. R. Gurung. Sterling: Stylus, 2012. 68–81.

Hong, Grace Kyungwon. "Existentially Surplus: Women of Color Feminism and the New Crises of Capitalism." *GLQ: A Journal of Lesbian and Gay Studies* 18.1 (2012): 87–106.

Huus, Kari. "Illegal Chinese Immigrants Land in US Legal Limbo." *MSNBC.com*, April 2016. Web. 14 July 2017 http://www.nbcnews.com/id/12174500/ns/us_news-life/t/illegal-chinese-immigrants-land-us-limbo/#.VYXAmmCd5UQ.

Ignatiev, Noel. *How the Irish Became White*. New York: Routledge, 2008.

Ilich, Fran. *Metro-Pop*. Mexico City: Ediciones S.A. de C.V., 1997.

Innis-Jiménez, Michael. *Steel Barrio: The Great Mexican Migration to South Chicago, 1915–1940*. New York: New York UP, 2013.

Institute for Urban Strategies. "Global Power City Index 2015." 14 Oct. 2015. Web. 18 Sept. 2016. www.mori-m-foundation.or.jp/english/ius2/gpci2/.

Isacson, Adam, Maureen Meyer, and Gabriela Morales. "Mexico's Other Border: Security, Migration, and the Humanitarian Crisis at the Line with Central America." *Washington Office of Latin America*, June 2014. Web. 18 Sept. 2016. www.wola.org/files/mxgt /report/.

Jackson, Carlos Francisco. *Chicana and Chicano Art: ProtestArte*. Tucson: U of Arizona P, 2009.

Jackson, David. "Obama: I'm 'Champion in Chief' on Immigration." *USA Today*, 7 Mar. 2014. Web. 16 Aug. 2016. www.usatoday.com/story/theoval/2014/03/07/obama -immigration-deportations-hispanic-town-hall/6157409/.

Jacobs, Clyde H. "Border Crisis: Industry Needs Immigration Reform." *Nation's Restaurant News*, 8 Nov. 2010. 18.

Jacobs, Elizabeth. *Mexican American Literature: The Politics of Identity*. Oxon: Routledge, 2006.

Jamieson, Dave. "Herman Cain's Distrust of Minimum Wage Goes Back to Restaurant Days." *Huffington Post*, 27 Oct. 2011. Web. 27 Oct. 2011. http://www.huffingtonpost .com/2011/10/27/herman-cain-minimum-wage_n_1035157.html.

Jayaraman, Saru. *Behind the Kitchen Door*. Ithaca: Cornell UP, 2013.

———. *Forked: A New Standard for American Dining*. Oxford: Oxford UP, 2016.

———. "Herman Cain, the National Restaurant Association and Sexual Harrasment." ROC-United. 3 Nov. 2011. Web. 2 Dec. 2011. http://rocunited.org/uncategorized /herman-cain-the-national-restaurant-association-and-sexual-harassment/.

———. "Making Movement: Communities of Color and New Models of Organizing Labor. Morning Keynote." *Berkeley La Raza Law Journal* 16 (2005): 177–185. doi:http://dx.doi.org/doi:10.15779/Z38ZK8F.

Jayaraman, Saru, and Aarti Shahani. "Collective Prosperity: The Power of a Multiethnic Agenda, a New York Model." *Harvard Journal of Hispanic Policy* 20 (2007–2008): 15–31.

Jiménez, Maria. "Humanitarian Crisis: Migrant Deaths at the U.S.-Mexico Border." American Civil Liberties Union San Diego and Imperial Counties. 1 Oct. 2009. Web. 23 Nov. 2013. https://www.aclu.org/immigrants-rights/humanitarian-crisis-migrant -deaths-us-mexico-border.

Jiménez, Tomás R. *Replenished Ethnicity: Mexican Americans, Immigration and Identity*. Berkeley: U of California P, 2010.

Johannessen, Lene M. *Threshold Time: Passage of Crisis in Chicano Literature*. New York: Book Amsterdam, 2008.

Johnson, Gaye T. M. "A Sifting of Centuries: Afro-Chicano Interaction and Popular Musical Culture in California, 1960–2000." *Decolonial Voices: Chicana and Chicano Cultural Studies in the 21st Century*. Ed. Arturo J. Aldama and Naomi H. Quiñonez. Bloomington: Indiana UP, 2002. 316–330.

Jones, Jennifer A. "'Mexicans Will Take the Jobs That Even Blacks Won't Do': An Analysis of Blackness, Regionalism, and Invisibility in Contemporary Mexico." *Ethnic and Racial Studies* 36.10 (2013): 1561–1581. doi:http://dx.doi.org/10.1080/01419870.2013 .783927.

Jordan, Miriam. "Making President Trump's Bed: A Housekeeper without Papers." *New York Times*, 6 Dec. 2018. Web. 12 Jan. 2019. https://www.nytimes.com/2018/12/06/us /trump-bedminster-golf-undocumented-workers.html.

Joseph, Cameron. "Trump Claims Immigrants Pouring into Country 'So They Can Vote.'" *New York Daily News*, 7 Oct. 2016. Web. 11 Oct. 2016. http://www.nydailynews.com /news/election/trump-claims-immigrants-pouring-vote-article-1.2821337.

Judis, John B. "Trade Secrets." *New Republic*, 9 Apr. 2008. Web. 7 July 2017. https://newrepublic.com/article/63888/trade-secrets.

Judy, Ronald A. T. "On the Question of Nigga Authenticity." *That's the Joint! The Hip Hop Studies Reader*. Ed. Murray Forman and Mark Anthony Neal. New York: Routledge, 2004. 105–117.

Kasinitz, Philip, John Mollenkopf, and Mary Waters, eds. *Becoming New Yorkers: Ethnographies of the New Second Generation*. New York: Russell Sage, 2004.

Kaufman, Florian K. *Mexican Labor Migrants and U.S. Immigration Policies: From Sojourner to Emigrant*. El Paso: LFB Scholarly Publishing, 2011.

Kaye, Jeffrey. *Moving Millions: How Coyote Capitalism Fuels Global Immigration*. New York: Wiley, 2010.

Keating, AnaLouise, ed. *Entre Mundos / Among Worlds: New Perspectives on Gloria E. Anzaldúa*. New York: Palgrave, 2005.

———. *The Gloria Anzaldúa Reader*. Durham: Duke UP, 2009.

Keller, Gary D. *Triumph of Our Communities: Four Decades of Mexican American Art*. Tempe: Bilingual, 2005.

Kelley, Robin D. G. "Kickin' Reality, Kickin' Ballistics: Gangsta Rap and Postindustrial Los Angeles." *Droppin' Science: Critical Essays on Rap Music and Hip Hop Culture*. Ed. William Eric Perkins. Philadelphia: Temple UP, 1996. 117–158.

Kelley, Sean M. *The Voyage of the Slave Ship Hare: A Journey into Captivity from Sierra to South Carolina*. Chapel Hill: U of North Carolina P, 2016.

Kelly, Reagan. "Hip Hop Chicano: A Separate but Parallel Story." *That's the Joint! The Hip Hop Studies Reader*. Ed. Murray Forman and Mark Anthony Neal. New York: Routledge, 2004. 95–105.

Kershaw, Sarah. "Immigration Crackdown Steps Into the Kitchen." *New York Times*, 7 Sept. 2010. Web. 27 Nov. 2011. http://www.nytimes.com/2010/09/08/dining/08crackdown.html?pagewanted=print.

Keyes, Scott. "Undocumented Trump Hotel Worker Speaks Out against His Employer, Despite Risk of Losing His Job." *ThinkProgress*, 19 Aug. 2015. Web. 12 Sept. 2016. http://thinkprogress.org/politics/2015/08/19/3692940/undocumented-worker-trump-hotel/.

King, John. *The Hip Hop Generation: Young Blacks and the Crisis in African American Culture*. New York: Basic Civitas, 2002.

———. "The Security of Merchant Shipping." *Marine Policy* 29.3 (2005): 235–245.

Kitwana, Bakari. *Why White Kids Love Hip Hop: Wankstas, Wiggers, Wannabes, and the New Reality of Race in America*. New York: Basic Civitas, 2005.

Klein, Milton M. *The Empire State: A History of New York*. Ithaca: Cornell UP, 2005.

Kochhar, Rakesh, and Richard Fry. "Wealth Inequality Has Widened along Racial, Ethnic Lines since End of Great Recession." *Pew Hispanic Center*, 12 Dec. 2014. Web. 2 Jan. 2017. http://www.pewresearch.org/fact-tank/2014/12/12/racial-wealth-gaps-great-recession/.

Koegeler-Abdi, Martina. "Shifting Subjectivities: Mestizas, Nepantleras, and Gloria Anzaldúa's Legacy." *MELUS* 38.2 (2013): 71–88. JSTOR. Web. 14 July 2017. http://www.jstor.org/stable/42001223.

Korte, Gregory, and Alan Gomez. "Trump Ramps Up Rhetoric on Undocumented Immigrants: 'These Aren't People. These Are Animals.'" *USA Today*, 16 May 2018. Web. 28 Nov. 2018. https://www.usatoday.com/story/news/politics/2018/05/16/trump-immigrants-animals-mexico-democrats-sanctuary-cities/617252002/.

Koulish, Robert. *Immigration and American Democracy: Subverting the Rule of Law*. New York: Routledge, 2010.

Kretsedemas, Philip. *The Immigration Crucible: Transforming Race, Nation, and the Limits of Law*. New York: Columbia UP, 2012.

———. *Migrants and Race in the US: Territorial Racism and the Alien/Outside*. New York: Routledge, 2014.

———. "What Does an Undocumented Immigrant Look Like?" *Keeping Out the Other: A Critical Introduction to Immigration Enforcement Today*. Ed. David C. Brotherton and Philip Kretsedemas. New York: Columbia UP, 2008. 334–365.

Krishna, Priya. "NYC's Chef of the Year Is a 27-Year-Old Prodigy Upending New York Kitchen Culture." *Thrillist.com*, 6 Nov. 2017. Web. 12 Jan. 2019. https://www.thrillist .com/eat/new-york/chef-of-the-year-2017-cosme-atla-nyc-daniela-soto-innes.

Kubrin, Charis E., Majorie S. Zatz, and Ramiro Martínez Jr., eds. *Punishing Immigrants: Policy, Politics, and Injustice*. New York: New York UP, 2012.

Kugelberg, Johan. *Born in the Bronx: A Visual Record of the Early Days of Hip Hop*. New York: Rizzoli, 2007.

Kun, Josh. *Audiotopia: Music, Race, and America*. Berkeley: U of California P, 2005.

———. "Hecho en El Lay." *Los Angeles Magazine* 55.9 (2010). Web. 14 July 2017. http:// www.lamag.com/laculture/hecho-in-el-lay/.

———. "What Is an MC If He Can't Rap to Banda? Making Music in Nuevo L.A." *American Quarterly* 56.4 (2004): 741–758. JSTOR. Web. 7 July 2017. http://www.jstor .org/stable/40068241.

Kun, Josh, and Laura Pulido. *Black and Brown in Los Angeles: Beyond Conflict and Coalition*. Oakland: U of California P, 2013.

La Farge, Phyllis, and Magdalena Caris. *Painted Walls of Mexico / Paredes Pintadas de Mexico*. Mexico City: Turner Libros, 2008.

LaRocco, Lori Ann. *Dynasties of the Sea: The Shipowners and Financiers Who Expanded the Era of Free Trade*. Stamford: Marine Money, 2012.

Lashua, Brett, Karl Spraklen, and Stephen Wagg, eds. *Sounds and the City: Popular Music, Place, and Globalization*. New York: Palgrave, 2014.

Latina Feminist Group. *Telling to Live: Latina Feminist Testimonios*. Durham: Duke UP, 2001.

Latorre, Guisela. *Walls of Empowerment: Chicana/o Indigenist Murals of California*. Austin: U of Texas P, 2008.

Lavina, Javier, and Michael Zeuske, eds. *The Second Slavery: Mass Slaveries and Modernity in the Americas and in the Atlantic Basin*. Berlin: LIT, 2014.

Leal, David L., and José E. Limón. *Immigration and the Border: Politics and Policy in the New Latino Century*. Notre Dame: U of Notre Dame P, 2013.

Lears, Rachel, and Robin Blotnick. *The Hand That Feeds*. April 2014 (Film).

Lee, Sonia Song-Ha. *Building a Latino Civil Rights Movement: Puerto Ricans, African Americans and the Pursuit of Racial Justice in New York City*. Chapel Hill: U of North Carolina P, 2014.

Leong, Nancy. "Racial Capitalism." *Harvard Law Review* 126.8 (2014): 1251–2226.

Lerman, Amy E., and Vesla M. Weaver. *Arresting Citizenship: The Democratic Consequences of American Crime Control*. Chicago: U of Chicago P, 2014.

Levario, Miguel Antonio. *Militarizing the Border: When Mexicans Became the Enemy*. College Station: Texas A&M UP, 2012.

Levin, Brian. "Hate Crime in U.S. Survey Up 6 Percent; but Anti-Muslim Rise 89 Percent, NYC Up 24 Percent So Far in 2016." *Huffington Post*, 22 Oct. 2016. Web. 30 Dec. 2016. http://www.huffingtonpost.com/brian-levin-jd/hate-crime-in-us-survey-u_b _12600232.html.

Levine, Sam. "Chris Christie Wants to Track Immigrants Like FedEx Packages." *Huffington Post*, 14 Oct. 2015. Web. 29 Aug. 2015. www.huffingtonpost.com/entry /chris-christie-fedex_us_55e20081e4b0b7a963393e0a/.

Levinson, Marc. *The Box: How the Shipping Container Made the World Smaller and the World Economy Bigger*. Kindle ed. Princeton: Princeton UP, 2008.

Levitz, Eric. "The Obama Administration's $1 Billion Giveaway to the Private Prison Industry." *New York Magazine*, 18 Aug. 2016. Web. 22 May 2017. http://www.occupy .com/article/obama-administration%E2%80%99s-1-billion-giveaway-private-prison -industry#sthash.G8H6YVQC.ceq7enQt.dpuf.

Lewontin, Max. "Could Shipping Container Homes Offer a Solution for Urban Housing Crunch?" *Christian Science Monitor*, 29 Apr. 2016. Web. 12 Oct. 2016. http://www .csmonitor.com/USA/Society/2016/0429/Could-shipping-container-homes-offer-a -solution-for-urban-housing-crunch.

Light, Alan. "About a Salary or Reality? Rap's Recurrent Conflict." *That's the Joint! The Hip Hop Studies Reader*. Ed. Murray Forman and Mark Anthony Neal. New York: Routledge, 2004. 137–145.

Limón, José E. *American Encounters: Greater Mexico, the United States, and the Erotics of Culture*. Boston: Beacon, 1999.

Limón, Lazaro. *The Latino Body: Crisis Identities in American Literary and Cultural Memory*. New York: New York UP, 2007.

Lionnet, Françoise, and Shu-mei Shih, eds. *Minor Transnationalism*. Durham: Duke UP, 2005.

Lipsitz, George. *Time Passages: Collective Memory and American Popular Culture*. Minneapolis: U of Minnesota P, 1990.

Lopez, Antonio. *Unbecoming Blackness: The Diaspora Cultures of Afro-Cuban America*. New York: New York UP, 2010.

López, Gerald P. "The Health of Undocumented Mexicans in New York City." *Chicana/o Latina/o Law Review* 32.1 (2013): 1–250.

López, Mahoma. Personal interview. 15 Sept. 2015.

Lorentzen, Lois Ann, ed. *Hidden Lives and Human Rights in the United States: Understanding the Controversies and Tragedies of Undocumented Immigration*. Santa Barbara: Praeger, 2014.

Loyd, Jenna M., Matt Michelson, and Andrew Burridge, eds. *Beyond Walls and Cages: Prisons, Borders, and Global Crisis*. Athens: U of Georgia P, 2012.

Loza, Mireya. *Defiant Braceros: How Migrant Workers Fought for Racial, Sexual, and Political Freedom*. Chapel Hill: U of North Carolina P, 2016.

Loza, Steven. *Barrio Rhythm: Mexican American Music in Los Angeles*. Urbana: U of Illinois P, 1993.

Luis Brown, David. *Waves of Decolonization: Discourses of Race and Hemispheric Citizenship in Cuba, Mexico, and the United States*. Durham: Duke UP, 2008.

Lytle Hernandez, Kelly. *Migra! A History of the US Border Patrol*. Berkeley: U of California P, 2010.

MacDonald, Nancy. *The Graffiti Subculture: Youth, Masculinity and Identity in London and New York*. New York: Palgrave, 2003.

Macías, Anthony. *Mexican American Mojo: Popular Music, Dance, and Urban Culture in Los Angeles, 1935–1968*. Durham: Duke UP, 2008.

Maciel, David R. "Mexico in Aztlán and Aztlán in Mexico: The Dialectics of Chicano-Mexicano Art." *Chicano Art: Resistance and Affirmation, 1965–1985*. Ed. Richard Griswold del Castillo, Teresa McKenna, and Yvonne Yarbro-Beharano. Los Angeles: Wight Art Gallery / U of California P, 1991. 109–118.

Madrid, Alejandro L. *Music in Mexico: Experiencing Music, Expressing Culture*. Cambridge: Oxford UP, 2013.

———. *Postnational Musical Identities: Cultural Production, Distribution and Consumption in a Globalized Scenario*. Lanham: Lexington, 2007.

———. *Transnational Encounters: Music and Performance at the U.S. Mexico Border*. Oxford: Oxford UP, 2011.

Maira, Sunaina. *Desis in the House: Indian American Youth Culture in New York City*. Philadelphia: Temple UP, 2002.

Mancini, Matthew. *One Dies, Get Another: Convict Leasing in the American South, 1866–1928*. Raleigh: U of South Carolina P, 1996.

Mansfield, Jeffrey. Personal interview. 14 Oct. 2011.

Manzanas, Ana, ed. *Border Transits: Literature and Culture across the Line*. Amsterdam: Editions Rodopi, 2007.

Mariani, John. "America's Best Restaurant Cities: 2010 Edition." *Esquire*, 22 Dec. 2011. Web. 8 Dec. 2011. http://www.esquire.com/blogs/food-for-men/best-restaurant-cities -122210.

Márquez, John D. *Black-Brown Solidarity: Racial Politics in the New Gulf South*. Austin: U of Texas P, 2014.

Martínez, Óscar. *The Beast: Riding the Rails and Dodging Narcos on the Migrant Trail*. Kindle ed. London: Verso, 2014.

Martínez-Cruz, Paloma. "Farmworker-to-Table Mexican: Decolonizing Haute Cuisine." *The Routledge Companion to Latina/o Culture*. Ed. Frederick Luis Aldama. New York: Routledge, 2016. 239–255.

Martín-Junquera, Imelda, ed. *Landscapes of Writing in Chicano Literature*. New York: Palgrave, 2013.

Maslin, Nir. "The Price of Nice Nails." *New York Times*, 7 May 2015. Web. 25 May 2017. https://www.nytimes.com/2015/05/10/nyregion/at-nail-salons-in-nyc-manicurists-are -underpaid-and-unprotected.html.

Massey, Douglas. *For Space*. London: Sage, 2005.

———. *New Faces in New Places: The Changing Geography of American Immigration*. New York: Russell Sage Foundation, 2008.

Massey, Douglas S., Jorge Durand, and Nolan Malone. *Beyond Smoke and Mirrors: Mexican Immigration in an Era of Economic Integration*. New York: Russell Sage Foundation, 2002.

Massey Douglas S., Jorge Durand, and Karen A. Pren. "Explaining Undocumented Migration to the U.S." *International Migration Review* 48.4 (2014): 1028–1061. doi:10.1111/imre.12151.

Mcardle, Andrea, and Tany Erzen. *Zero Tolerance: Quality of Life and the New Police Brutality in New York City*. New York: New York UP, 2001.

McCarthy, Jim. *Voices of Latin Rock: The People and Events That Shaped the Sound*. Milwaukee: Hal Leonard, 2004.

McFarland, Pancho. *The Chican@ Hip Hop Nation: Politics of a New Millennial Mestizaje*. East Lansing: Michigan State UP, 2013.

———. *Chicano Rap: Gender and Violence in the Postindustrial Barrio*. Austin: U of Texas P, 2008.

———. "Chicano Rap Roots: Black-Brown Cultural Exchange and the Making of a Genre." *Callaloo* 39.3 (2006): 939–957.

McKiernan-González, John. *Fevered Measures: Public Health and Race at the Texas-Mexico Border, 1848–1942*. Durham: Duke UP, 2012.

McWhorter, John H. *All about the Beat: Why Hip-Hop Can't Save Black America*. New York: Gotham, 2008.

Melamed, Jodi. *Represent and Destroy: Rationalizing Violence in the New Racial Capitalism*. Minneapolis: U of Minnesota P, 2011.

Melgar Pernías, Yolana. *Los Bildungsromane Femeninos de Carmen Boullosa Y Sandra Cisneros: Mexicanidades, Fronters, Puentes*. Woodbridge: Tamesis, 2012.

Mellino, Cole. "6 Super Cool Tiny Houses Made from Shipping Containers." *Ecowatch*, 18 Nov. 2016. Web. 10 Oct. 2016. http://www.ecowatch.com/6-super-cool-tiny-houses -made-from-shipping-containers-1882120631.html.

Menchaca, M. *Recovering History, Constructing Race: The Indian, Black, and White Roots of Mexican Americans*. Austin: U of Texas P, 2001.

Menjívar, Cecilia. "Immigration Law beyond Borders: Externalizing and Internalizing Border Controls in an Era of Securitization." *Annual Review of Law and Social Science* 10 (2015): 353–369.

Menjívar, Cecilia, and Leisy Abrego. "Legal Violence: Immigration Law and the Lives of Central American Immigrants." *American Journal of Sociology* 117.5 (2012): 1380–1421.

Menjívar, Cecilia, and Daniel Kanstroom, eds. *Constructing Immigrant "Illegality": Critiques, Experiences, and Responses*. New York: Cambridge UP, 2014.

Mercer, Kobena. *Travel & See: Black Diaspora Art Practices since the 1980s*. Durham: Duke UP, 2016.

Meric, Linda. "Golden Opportunity for the National Restaurant Association to Do the Right Thing." *Huffington Post*, 17 Nov. 2011. Web. 3 Dec. 2011. http://www .huffingtonpost.com/linda-meric/sexual-harassment-restuarants_b_1098261.html.

Milan, Claudia. *Latining America: Black Brown Passages and the Coloring of Latino/a Studies*. Athens: U of Georgia P, 2013.

Miller, Matt. *Bounce: Rap Music and Local Identity in New Orleans*. Amherst: U of Massachusetts P, 2012.

Miller, Stephen. *Walking New York: Reflections of American Writers from Walt Whitman to Teju Cole*. New York: Empire State Editions, 2015.

Mills, Albert J. *Sex, Strategy and the Stratosphere: Airlines and the Gendering of Organizational Culture*. New York: Palgrave, 2006.

Mims, Christopher. "Are Shipping Containers the Future of Farming?" *Wall Street Journal*, 8 June 2016. Web. 11 Oct. 2016. http://www.wsj.com/articles/are-shipping -containers-the-future-of-farming-1465393797.

Mirabal, Nancy Raquel, and Agustin La6-Montes, eds. *Technofuturos: Critical Interventions in Latina/o Studies*. Lanham: Lexington, 2007.

Miranda, Caroline A. "Border Drones and Labor-Bots: Alex Rivera's Prescient 'Sleep Dealer.'" *Los Angeles Times*, 2 Aug. 2014. Web. 5 Sept. 2016. www.latimes.com /entertainment/arts/miranda/la-et-cam-alex-rivera-sleep-dealer-prescient-border -drones-20140801-column.html.

Miyares, Inés M. "Changing Latinization of New York City." *Hispanic Spaces, Latino Places*. Ed. Daniel Arreola. Austin: U of Texas P, 2004. 145–165.

Mize, Ronald, and Alicia Swords. *Consuming Mexican Labor: From the Bracero Program to NAFTA*. Toronto: U of Toronto P, 2011.

Mocombe, Paul C., Carol Tomlin, and Christine Callender. *The African-Americanization of the Black Diaspora in Globalization or the Contemporary Capitalist World-System*. Lanham: UP of America, 2017.

Molina, Natalie. *How Race Is Made in America: Immigration, Citizenship, and the Historical Power of Racial Scripts*. Berkeley: U of California P, 2014.

———. "The Long Arc of Dispossession: Racial Capitalism and Contested Notions of Citizenship in the U.S.-Mexico Borderlands in the Early Twentieth Century." *Western Historical Quarterly* 45 (2013): 431–447.

Montejano, David. *Quixote's Soldiers: A Local History of the Movement, 1966–1981*. Austin: U of Texas P, 2010.

Morales, Richard A. "Contending Tradeoffs: IRCA, Immigrants, and the Southern California Restaurant Industry." *Policy Studies Review* 11.2 (1992): 143–152. doi:10.1111/j.1541-1338.1992.tb00397.x.

Morgan, Joan. "Hip-Hop Feminism." *The Women's Movement Today: An Encyclopedia of Third-Wave Feminism*. Ed. Leslie Heywood. Westport: Greenwood, 2006. 172–175.

———. *When Chickenheads Come Home to Roost: My Life as a Hip-Hop Feminist*. New York: Simon, 1999.

Morgan, Marcyliena H. *The Real Hiphop: Battling for Knowledge, Power, and Respect in the LA Underground*. Durham: Duke UP, 2009.

Morrison, Amanda Maria. "Musical Trafficking: Urban Youth and the Narcocorrido-Hardcore Rap Nexus." *Western Folklore* 6.4 (2008): 379–396. JSTOR. Web. 25 Nov. 2015. http://www.jstor.org/stable/25474938.

Mountz, Alison, and Jennifer Hyndman. "Feminist Approaches to the Global Intimate." *Women's Studies Quarterly* 34.1–2 (2006): 446–463. JSTOR. Web. 7 July 2017. http://www.jstor.org/stable/40004773.

Moynihan, Colin. "Can El Museo's Leader Build a Bridge to Its Latino Future?" *New York Times*, 3 Dec. 2017. Web. 12 Jan. 2019. https://www.nytimes.com/2017/12/03/arts /design/el-museo-del-barrio-patrick-charpenel.html.

Muhammad, Khalil Gibran. *The Condemnation of Blackness: Race, Crime, and the Making of Modern Urban America*. Cambridge: Harvard UP, 2010.

Murray, James T., and Karla L. Murray. *Broken Windows: Graffiti NYC*. Berkeley: Ginko, 2010.

Naimou, Angela. *Savage Work: U.S. and Caribbean Literatures amid the Debris of Legal Personhood*. New York: Fordham UP, 2015.

Naples, Nancy A. "Borderlands Studies and Border Theory: Linking Activism and Scholarship for Social Justice." *Sociology Compass* 4.7 (2010): 505–518.

Nathan, Debbie. "David and His 26 Roommates." *New York Magazine*, 16 May 2005. Web. 2 Aug. 2015. http://nymag.com/nymetro/news/features/1869/.

"National Restaurant Assn." *Opensecrets.org*, n.d. Web. 4 Dec. 2012. http://www .opensecrets.org/orgs/summary.php?id=D000000150&cycle=2012.

National Restaurant Association. "National Restaurant Association Voices Support for Workforce Democracy and Fairness Act." 30 Nov. 2011. Web. 4 Dec. 2011. http://www .restaurant.org/pressroom/pressrelease/?id=2203.

———. "New York Restaurant Industry at a Glance." 2012. Web. 27 Nov. 2012. http:// www.restaurant.org/pdfs/research/state/newyork.pdf.

———. "Restaurant Industry Sales Turn Positive in 2011 after Three Tough Years: National Restaurant Association's 2011 Restaurant Industry Forecast Reveals Economic, Workforce, Consumer and Menu Trends." 1 Feb. 2011. Web. 20 Oct. 2011. https:// restaurant.org/research/reports/state-of-restaurant-industry.

———. "Restaurant Industry Will Grow, Outpace National Job Growth in 2013 Despite Sustained Challenges." 11 Dec. 2012. Web. 14 Dec. 2012. http://www.restaurant.org /pressroom/pressrelease/?id=2352.

———. "2017 National Restaurant Association Restaurant Industry Outlook." 28

Apr. 2017. Web. 25 May 2017. http://www.restaurant.org/Downloads/PDFs/News
-Research/2017_Restaurant_outlook_summary-FINAL.pdf.

National Women's Law Center. "NWLC Resource: The Lifetime Wage Gap, State by
State." 25 March 2019. Web. 8 Sept. 2019. https://nwlc.org/resources/the-lifetime-wage
-gap-state-by-state/.

Navarro, Armando. *Mexican American Youth Organization: Avant-Garde of the Chicano
Movement in Texas.* Austin: U of Texas P, 1995.

Nembrand, Jessica Gordon. *Collective Courage: A History of African American Cooperative
Economic Thought and Practice.* University Park: Penn State UP, 2014.

Neufeld, Stephen, and Michael Matthews, eds. *Mexico in Verse: A History of Music, Rhyme,
and Power.* Tucson: U of Arizona P, 2015.

Neuhauser, Alan. "Supreme Court to Consider Indefinite Detention for Immigrants." *US
News & World Report,* 29 Nov. 16. Web. 7 Jan. 2017. http://www.usnews.com/news
/national-news/articles/2016-11-29/supreme-court-to-consider-indefinite-detention-for
-immigrants.

Nevins, Joseph. *Operation Gatekeeper: The Rise of the "Illegal Alien" and the Making of the
U.S.-Mexico Boundary.* New York: Routledge, 2002.

———. *Operation Gatekeeper and Beyond: The War on "Illegals" and the Remaking of the
U.S.-Mexico Boundary.* New York: Routledge, 2010.

New York City Department of Planning. "The Newest New Yorkers." 2013. Web. 14
July 2015. https://www1.nyc.gov/site/planning/data-maps/nyc-population/newest-new
-yorkers-2013.page.

New York City Planning, Department of City Planning. "NYC 2010 Results from the
2010 Census: Population Growth and Race/Hispanic Composition." n.d. Web. 7
July 2017. https://www1.nyc.gov/assets/planning/download/pdf/data-maps/nyc
-population/census2010/pgrhc.pdf.

New York Civil Liberties Union. "Voices from Varick: Detainee Grievances at New York
City's Only Federal Immigration Detention Facility." 19 Feb. 2010. Web. 14 July 2017.
http://www.nyclu.org/files/publications/Varick_Report_final.pdf.

New York State Department of Labor. "Wage Theft Prevention Act: Frequently Asked
Questions." 2011. Web. 8 Dec. 2011. http://www.labor.ny.gov/workerprotection
/laborstandards/PDFs/wage-theft-prevention-act-faq.pdf.

New York University School of Law Immigrant Rights, Immigrant Defense Project, and
Families for Freedom. *Insecure Communities, Devastated Families: New Data on
Immigrant Detention and Deportation Practices in New York City.* 23 July 2012. Web. 7
July 2017. https://immigrantdefenseproject.org/wp-content/uploads/2012/08/NYC
-FOIA-Report-2012-FINAL-Aug.pdf.

Ngai, Mae M. *Impossible Subjects: Illegal Aliens and the Making of Modern America.* Kindle
ed. Princeton: Princeton UP, 2004.

Nir, Sarah Maslin. "The Price of Nice Nails." *New York Times,* 7 May 2015. Web. 14
July 2017. http://www.nytimes.com/2015/05/10/nyregion/at-nail-salons-in-nyc
-manicurists-are-underpaid-and-unprotected.html?_r=1.

NRA Staff. "Denver Rejects Mandatory Paid-Leave Proposal." *National Restaurant
Association,* 2 Nov. 2011. Web. 3 Nov. 2011. http://www.restaurant.org/nra_news_blog
/2011/11/denver-rejects-mandatory-paid-leave-proposal.cfm.

———. "NRA Comments on New Health Care Requirements." *National Restaurant
Association,* 26 Oct. 2011. Web. 27 Oct. 2011. http://www.restaurant.org/News
-Research/News/NRA-comments-on-new-health-care-requirements.

Nuño, Luis F. "Notes from the Field: Mexicans in New York City." *Societies without Borders.* 8.1 (2013): 80–101.

NYC.com. "New York Restaurant and Dining Guide." 2011. Web. 8 Dec. 2011. http://www.nyc.com/restaurants/.

NYCDCP (New York City Department of City Planning, Population Division). *The Newest New Yorkers 2000: Immigrant New York in the New Millennium.* Report NYC-DCP #04-09, 2004.

Nyers, Peter. "Abject Cosmopolitanism: The Politics of Protection in the Anti-Deportation Movement." *The Deportation Regime: Sovereignty, Space and the Freedom of Movement.* Ed. Nicholas De Genova and Nathalie Peutz. Durham: Duke UP, 2010.

Oboe, Annalisa, and Anna Scacchi, eds. *Recharting the Black Atlantic: Modern Cultures, Local Communities, Global Connections.* New York: Routledge, 2008.

Oboler, Suzanne. *Latinos and Citizenship: The Dilemma of Belonging.* New York: Palgrave, 2006.

Ochoa, María. *Creative Collectives: Chicana Painters Working in Community.* Albuquerque: U of New Mexico P, 2003.

Ogborn, M. *Global Lives: Britain and the World 1550–1800.* Cambridge: Cambridge UP, 2008.

Oliva, Jose. "National Restaurant Association—Keeping the Minimum Wage Down for 20 Years." ROC-United, 3 June 2010. Web. 8 Dec. 2011. http://rocunited.org/home-news/national-restaurant-association-keeping-wages-down-for-20-years/.

Oliveira, Gabrielle. *Motherhood across Borders: Immigrants and Their Children in Mexico and New York.* New York: New York UP, 2018.

Olivo, Antonio. "At Trump Hotel Site, Immigrant Workers Wary." *Washington Post,* 6 July 2015. Web. 12 Sept. 2016. www.washingtonpost.com/local/they-say-they-arrived-in-the-us-illegally-now-theyre-working-on-trumps-dc-hotel/2015/07/06/9a785116-20ec-11e5-84d5-eb37ee8eaa61_story.html.

Ong, Aihwa. *Flexible Citizenship: The Cultural Logic of Transnationality.* Durham: Duke UP, 1999.

Ong Hing, Bill. *Ethical Borders: NAFTA, Globalization, and Mexican Migration.* Philadelphia: Temple UP, 2010.

On Ni Wan, Annie. "The Hong Kong Container." *Leonardo* 39.4 (2006): 295–296.

Opie, Frederick Douglas. *Upsetting the Apple Cart: Black-Latino Coalitions in New York City from Protest to Public Office.* New York: Columbia UP, 2015.

Orleck, Annelise. "The Soviet Jews: Life in Brighton Beach, Brooklyn." *New Immigrants in New York.* Ed. Nancy Foner. New York: Columbia UP, 1987. 273–304.

Otero, Solimar, and Toyin Falola eds. *Yemoja: Gender, Sexuality, and Creativity in the Latina/o and Afro-Atlantic Diasporas.* Albany: State U of New York P, 2013.

Overmeyer-Velázquez, Mark. *Beyond La Frontera: The History of Mexico-U.S. Migration.* New York: Oxford UP, 2011.

Palma, Kristi. "Shipping Container Restaurants Are Opening This Week on the Waterfront." *Boston.com,* 17 Nov. 2015 Web. 11 Oct. 2016. https://www.boston.com/culture/restaurants/2015/11/17/shipping-container-restaurants-are-opening-this-week-on-the-waterfront.

Parreñas, Rhacel Salazar. *The Force of Domesticity: Filipina Migrants and Globalization.* New York: New York UP, 2008.

Passel, Jeffrey S., D'Vera Cohen, and Ana Gonzalez-Barrera. "Migration between the U.S. and Mexico." Pew Hispanic Center, 23 Apr. 2013. Web. 24 Nov. 2013. http://www.pewhispanic.org/2012/04/23/ii-migration-between-the-u-s-and-mexico/.

Patterson, Orlando. *Slavery and Social Death: A Comparative Study.* Cambridge: Harvard UP, 1982.

Payan, Tony. *The Three U.S.-Mexico Border Wars: Drugs, Immigration, and Homeland Security.* Santa Barbara: Praeger Security International, 2016.

Pearson, M. "Class, Authority and Gender on Early-Modern Indian Ocean Ships: European and Asian Comparison." *South African History Journal* 61.4 (2009): 680–701. doi:http://dx.doi.org/10.1080/02582470903500376.

Pennycock, Alastair. *Global English and Transcultural Flows.* London: Routledge, 2007.

Pérez, Emma. *The Decolonial Imaginary: Writing Chicanas into History.* Bloomington: Indiana UP, 1999.

Pérez Romero, Gonzalo. Personal interview. 23 Sept. 2011.

Pérez Rosario, Vanessa, ed. *Hispanic Caribbean Literature of Migration: Narratives of Displacement.* New York: Palgrave, 2010.

Perry, Imani. *Prophets of the Hood: Politics and Poetics in Hip Hop.* Durham: Duke UP, 2004.

Pescador, Juan J. "¡Vamos Taximaroa! Mexican/Chicano Soccer Associations and Transnational/ Translocal Committees, 1967–2002." *Latino Studies* 2.3 (2004): 352–376. doi:10.1057/palgrave.lst.8600098.

Peza Casares, Maria del Carmen del la. *El Rock Mexicano: Un Espacio En Disputa.* Coyoacán: Universidad Autónoma Metropolitana, 2013.

Pico, Miguel. Personal interview. 23 Sept. 2011.

Pilcher, Jeffrey M. *Planet Taco: The Global History of Mexican Food.* New York: Oxford UP, 2012.

Poniatowska, Elena. *La Noche de Tlatelolco: Testimonios de historia oral.* 2nd ed. Mexico City: Ediciones Era, 1998.

Portes, Alejandro, and Ruben Rumbaut. *Legacies.* Berkeley: U of California P, 2001.

Portes, Alejandro, and Min Zhou. "The New Second Generation: Segmented Assimilation and Its Variants." *Annals of the American Academy of Political and Social Science* 22.2 (1993): 217–238. JSTOR. Web. 7 July 2017. http://www.jstor.org/stable/1047678.

Pough, Gwendolyn. *Check It While I Wreck It: Black Womanhood, Hip Hop Culture, and the Public Sphere.* Boston: Northeastern UP, 2004.

Pough, Gwendolyn, et al., eds. *Home Girls Make Some Noise: Hip Hop Feminism Anthology.* Mira Loma: Parker, 2007.

Pratt, M. L. *Imperial Eyes: Studies in Travel Writing and Transculturation.* London: Routledge, 2002.

Preston, Julia. "Illegal Workers Swept from Jobs in 'Silent Raids.'" *New York Times,* 9 July 2010. Web. 14 July 2017. http://www.nytimes.com/2010/07/10/us/10enforce.html.

Price, Laura. "Cosme's Rising Star Chef, Daniela Soto-Innes on Entering the 50 Best, Her Mentor Enrique Olvera and Plans for a New Restaurant." *The World's 50 Best Restaurants.* n.d. Web. 8 Sept. 2019. m.theworlds50best.com/blog/News/cosme-rising-star -chef-daniela-soto-innes-on-entering-the-50-best-her-mentor-enrique-olvera-and-plans -for-a-new-restaurant.html.

PRNewswire. "Michelin Welcomes 2 New 3-Star Restaurants for 2012." 4 Oct. 2011. Web. 8 Dec. 2011. http://www.prnewswire.com/news-releases/michelin-welcomes-2-new-3 -star-restaurants-for-2012-131074913.html.

Provine, Doris Marie, and Paul G. Lewis. "Shades of Blue: Local Policing, Legality and Immigration Law." *Constructing Immigrant 'Illegality': Critiques, Experiences, and Responses.* Ed. Cecilia Menjívar and Daniel Kanstroom. New York: Cambridge UP, 2014. 298–326.

Pugliese, Joseph. "Civil Modalities of Refugee Trauma, Death and Necrological Transport." *Social Identities* 15.1 (2009): 149–165.

Pulido, Laura. *Black, Brown, Yellow, and Left: Radical Activism in Los Angeles.* Los Angeles: U of California P, 2006.

Qatar Financial Center. "The Global Financial Centres Index 17." March 2015. Web. 17 Sept. 2016. www.longfinance.net/publications.html?id=929.

Quijano, Aníbal. "Coloniality of Power, Eurocentrism and Latin America." *Nepantla: Views from South* 1.3 (2000): 533–580.

———. *Questiones Y Horizontes: De La Dependencia Histórico-Estructural A La Colonialidad/Descolonialidad Del Poder.* Buenos Aires: CLACSO, 2014.

Quijano, Aníbal, and Immanuel Wallerstein. "Americanity as a Concept: Americas in the Modern World-System." *International Social Science Journal* 134 (1992): 549–557.

Quinn, Eithne. *Nuthin' but a "G" Thang: The Culture and Commerce of Gangsta Rap.* New York: Columbia UP, 2005.

Quiñones, Juan. *Chicano Politics: Reality and Promise, 1940–1990.* Albuquerque: U of New Mexico P, 1990.

Rabaka, Reiland. *The Hip Hop Movement: From R&B and the Civil Rights Movement to Rap and the Hip Hop Generation.* Lanham: Lexington, 2013.

———. *Hip Hop's Amnesia: From Blues and the Black Women's Club Movement to Rap and the Hip Hop Movement.* Lanham: Lexington, 2012.

———. *Hip Hop's Inheritance: From the Harlem Renaissance to the Hip Hop Feminist Movement.* Lanham: Lexington, 2011.

Radcliffe, Kendahl, Jennifer Scott, and Anja Werner, eds. *Anywhere but Here: Black Intellectuals in the Atlantic World and Beyond.* Jackson: U of Mississippi P, 2015.

Ragland, Cathy. "Communicating the Collective Imagination: The Sociospatial World of the Mexican Sonidero in Puebla, New York, and New Jersey." *Cumbia!* Ed. Fernández L'Hoeste, D. Hector, and Pablo Vila. Durham: Duke UP, 2013. 119–137.

———. *Música Norteña: Mexican Migrants Creating a Nation between Nations.* Philadelphia: Temple UP, 2009.

Ramakrishan, S. Karthick, and Cecilia Viramontes. "Civic Spaces: Mexican Hometown Associations and Immigrant Participation." *Journal of Social Issues* 66.1 (2010): 155–173.

Ramírez López, Xochitl "Rhappy." Personal interview. 11 Nov. 2013.

Ramor, Ryan. "Mexican Immigration, Labor, and Fathering beyond Borders: An Interview with Marta Sánchez." *Toward Freedom,* 10 Apr. 2017. Web. 14 July 2017. https://towardfreedom.com/archives/americas/mexican-immigration-labor-fathering-beyond-borders-interview-marta-sanchez/.

Ramos, Jorge. *Dying to Cross: The Worst Immigrant Tragedy in American History.* Kindle ed. New York: HarperCollins ebooks, 2005.

RD Staff. "Entrevista: Audry Funk—Sobre El Proyecto Con Mujeres Trabajando." *Hip Hop RD,* 11 May 2016. Web. 27 July 2017. https://www.hiphoprd.com/2016/05/11/entrevista-audry-funk-sobre-el-proyecto-con-mujeres-trabajando/.

Reddy, Meghana. "Worker & Roc-NY Dispute at Del Posto Resolved, Star Chef Mario Batali to Become 'High Road Employer.'" 24 Sept. 2012. Web. 4 Dec. 2012. http://rocunited.org/worker-roc-ny-dispute-at-del-posto-resolved-star-chef-mario-batali-to-become-high-road-employer/.

Reddy, Sumathi. "Restaurateurs under Siege: Multiple High-Profile Names Being Targeted in Lawsuits Alleging Wage Violations." *Wall Street Journal,* 2 Sept. 2010. Web. 8 Dec. 2011. http://online.wsj.com/article/SB10001424052748703882304575465913350852120.html.

Rediker, Marcus. *The Slave Ship: A Human History.* New York: Penguin, 2007.

Reitano, Joanne. *New York State: Peoples, Places, and Priorities: A Concise History with Sources.* New York: Routledge, 2016.

Resnik, Judith, and Seyla Benhabib, eds. *Migrations and Mobilities: Citizenship, Borders, and Gender.* New York: New York UP, 2009.

Reuters. "New Yorkers Eating Out More, Zagat Survey Finds." *New York Daily News,* 1 Oct. 2013. Web. 18 Sept. 2017. http://www.nydailynews.com/life-style/eats/new -yorkers-eating-zagat-survey-finds-article-1.1473133.

Reznowski, Gabriella. "Hip Hop Mundial: Latino Voices, Global Hip Hop, and the Academy." *Conference Presentation at the Fifty-Seventh Annual Meeting of the Seminar on the Acquisition of Latin American Library Materials, Port-of-Spain, Trinidad, 2012.* New Orleans: SALALM Secretariat, Latin American Library, Tulane University, 2014. 85–94.

Rice, Alan. "Tracing Slavery and Abolition's Routes and Viewing inside the Invisible: The Monumental Landscape and the African Atlantic." *Atlantic Studies* 8.2 (2011): 253–274. doi:http://dx.doi.org/10.1080/14788810.2011.563830.

Ridgeway, Greg. *Analysis of Racial Disparities in the New York City Police Department's Stop, Question, and Frisk Practices.* Santa Monica: RAND, 2008.

Rios, Victor M. *Punished: Policing the Lives of Black and Latino Boys.* New York: New York UP, 2011.

Risomena, Fernando, and Douglas S. Massey. "Pathways to El Norte: Origins, Destinations, and Characteristics of Mexican Migrants to the United States." *International Migration Review* 46.1 (2012): 3–36.

Ritter, Jonathan, and Martin J. Daughtry, eds. *Music in the Post-9/11 World.* New York: Routledge, 2007.

Rivera, Alex, dir. *The Borders Trilogy,* 2002. Film.

———. *The Sixth Section,* 2003. Film.

———. *Sleep Dealer,* 2008. Film.

Rivera, Raquel. *New York Ricans from the Hip Hop Zone.* New York: Palgrave, 2003.

Rivera, Raquel, Wayne Marshall, and Deborah Pacini Hernandez. *Reggaeton.* Durham: Duke UP, 2009.

Rivera-Rideau, Petra. *Remixing Reggaetón: The Cultural Politics of Race in Puerto Rico.* Durham: Duke UP, 2015.

Rivera-Servera, Ramón H., and Harvey Young, eds. *Performance in the Borderlands.* New York: Palgrave, 2010.

Robinson, Cedric. *Black Marxism: The Making of the Black Radical Tradition.* 2nd ed. Chapel Hill: U of North Carolina P, 2000.

ROC-NY (Restaurant Opportunities Center of New York). "The Great Service Divide: Occupational Segregation & Inequality in the New York City Restaurant Industry." ROC-NY, 31 Mar. 2009. Web. 7 Oct. 2011. http://rocny.org/what-we-know.

———. "If You Care, Eat Here: The NYC Diner's Guide to High Road Restaurants." ROC-NY, 1 Aug. 2011. Web. 4 Dec. 2011. http://rocny.org/what-we-know.

ROC-NY (Restaurant Opportunities Center of New York) and the New York City Restaurant Industry Coalition. "Behind the Kitchen Door: Pervasive Inequality in New York City's Thriving Restaurant Industry." ROC-NY, 25 Jan. 2005. Web. 10 Oct. 2011. http://rocny.org/what-we-know.

ROC-NY (Restaurant Opportunities Center of New York) et al. "Burned: High Risk and Low Benefits for Workers in the New York City Restaurant Industry." ROC-NY, 11 Sept. 2009. Web. 7 Oct. 2011. http://rocny.org/what-we-know.

ROC-United (Restaurant Opportunities Centers United). "Behind the Kitchen Door: A Multi-Site Study of the Restaurant Industry." ROC-United, 14 Feb. 2011. Web. 8 Dec. 2011. http://rocunited.org/research-resources/reports/2011-behind-the-kitchen -door-multi-site-study/.

———. "Immigration Laws Enforced in Certain Restaurants While Wage and Tip Theft, Discrimination, and Illegal Health and Safety Conditions Allowed to Persist." ROC-United, 6 May 2011. Web. 11 Dec. 2011. http://rocunited.org/blog/immigration -laws-enforced-in-certain-restaurants-while-wage-and-tip-theft-discrimination-and -illegal-health-and-safety-conditions-allowed-to-persis/.

———. "Picking Up the NRA's Tab: The Public Cost of Low Wages in the Full-Service Restaurant Industry." ROC-United, 14 Apr. 2015. Web. 15 May 2017. http://rocunited .org/publications/picking-up-the-nras-tab-the-public-cost-of-low-wages-in-the -restaurant-industry/.

———. "ROC National Diners' Guide 2012: A Consumer Guide on the Working Conditions of American Restaurants." ROC-United, 2011. Web. 4 Dec. 2011. http://rocunited.org/research-resources/our-reports/.

———. "Working Below the Line: How the Subminimum Wage for Tipped Restaurant Workers Violated International Human Rights Standards." ROC-United, 12 Dec. 2015. Web. 25 May 2017. http://rocunited.org/publications/working-below-the-line/.

ROC-United (Restaurant Opportunities Centers United) et al. "Tipped Over the Edge: Gender Inequity in the Restaurant Industry." ROC-United, 13 Feb. 2012. Web. 4 Dec. 2012. http://rocunited.org/tipped-over-the-edge-gender-inequity-in-the-restaurant -industry/.

ROC-United (Restaurant Opportunities Centers United) and Rosemary Batt. "Taking the High Road: A How to Guide for Successful Restaurant Employers." ROC-United, January 2012. Web. 4 Dec. 2012. http://rocunited.org/taking-the-high-road-a-how-to -guide-for-successful-restaurant-employers/.

ROC-United (Restaurant Opportunities Centers United) and Forward Together. "The Glass Floor: Sexual Harassment in the Restaurant Industry." ROC-United, 7 Oct. 2014. Web. 27 July 2017. http://rocunited.org/wp-content/uploads/2014/10 /REPORT_TheGlassFloor_Sexual-Harassment-in-the-Restaurant-Industry.pdf.

ROC-United (Restaurant Opportunities Centers United) and Steven Pitts. "Blacks in the Restaurant Industry Brief." ROC-United, 3 Jan. 2012. Web. 4 Dec. 2012. http:// rocunited.org/roc-releases-blacks-in-the-industry/.

Rodriguez, Eric. Personal interview. 24 Oct. 2014.

Rodríguez, Richard T. "The Verse of the Godfather: Unwrapping Masculinity, *Familia*, and Nationalism in Chicano Rap Discourse." *Velvet Barrios: Popular Culture & Chicana/o Sexualities*. Ed. Alicia Gaspar de Alba. New York: Palgrave, 2003. 107–124.

Rogers, David. "Child Migrants Lose Major Case in Federal Court." *Politico*, 20 Sept. 2016. Web. 21 Sept. 2016. www.politico.com/story/2016/09/child-migrants -immigration-228432#ixzz4KtsDyBse.

Rohrleitner, Marion, and Sarah E. Ryan, eds. *Dialogues across Diasporas: Women Writers, Scholars, and Activists of Africana and Latina Descent in Conversation*. Lanham: Lexington, 2013.

Rollins, Judith. *Between Women: Domestics and Their Employers*. Philadelphia: Temple UP, 1985.

Román, Ediberto. *Those Damned Immigrants: America's Hysteria over Undocumented Immigration*. New York: New York UP, 2013.

Romero, Juan Carlos. Personal interview. 22 Sept. 2011.

———. Personal interview. 1 Oct. 2011.

———. Personal interview. 14 Nov. 2018.

Romero, Mary. *Maid in the U.S.A.* New York: Routledge, 1992.

Romo, Harriet D., and Olivia Mogollon-Lopez. *Mexican Migration to the United States: Perspectives from Both Sides of the Border.* Austin: U of Texas P, 2016.

Ronero-Lar, Fernando. *Hyperborder: The Contemporary U.S.-Mexican Border and Its Future.* New York: Princeton Architectural, 2008.

Rooney, Jim. *Organizing the South Bronx.* Albany: State U of New York P, 1995.

Rosaldo, Renato. "Cultural Citizenship, Inequality and Multiculturalism." *Latino Cultural Citizenship: Claiming, Identity, Space, and Rights.* Ed. William Flores and Rina Benmayor. Boston: Beacon, 1997. 27–38.

———. "Cultural Citizenship and Education Democracy." *Cultural Anthropology* 9 (1994): 402–411. JSTOR. Web. 7 July 2017. http://www.jstor.org/stable/656372.

Rosas, Gilberto. "The Managed Violences of the Borderlands: Treacherous Geographies, Policeability, and the Politics of Race." *Latino Studies* 4 (2006): 401–418.

Rose, Tricia. *Black Noise: Rap Music and Black Culture in Contemporary America.* Hanover: Wesleyan UP, 1994.

———. "Flowing, Layering, and Rupture in Postindustrial New York." *Signifyin(g), Sanctifyin', and Slam Dunking: A Reading in African American Expressive Culture.* Ed. Gena Dagel Caponi. Amherst: U of Massachusetts P, 1999. 192–220.

———. *The Hip Hop Wars: What We Talk about When We Talk about Hip Hop–and Why It Matters.* New York: BasicCivitas, 2008.

Rossini, Jon D. *Contemporary Latina/o Theatre: Writing Ethnicity.* Carbondale: Southern Illinois UP, 2008.

Ruggless, Ron. "U.S. Restaurant Sales to Reach Record $863B in 2019, NRA Says." *Nation's Restaurant News.* 5 April 2019. Web. 8 Sept. 2019. www.nrn.com/sales-trends /us-restaurant-sales-reach-record-863b-2019-nra-says.

Rumbaut, Ruben. "The Making of a People." *Hispanics and the Future of America.* Ed. Marta Tienda and Faith Mitchell. Washington, DC: Committee on Transforming Our Common Destiny, National Research Council, 2006. 16–65.

Saiz-Álvarez, José Manuel. *Handbook of Research on Social Entrepreneurship and Solidarity Economics.* Hershey: Business Science Reference IGI Global, 2016.

Salamon, Julie. "Celebrating Mexican Life in New York." *New York Times,* 8 Dec. 2004, late ed., E101.

Saldívar, José David. *The Dialectics of Our America: Genealogy, Cultural Critique, and Literary History.* Durham: Duke UP, 1991.

———. *Trans-Americanity: Subaltern Modernities, Global Coloniality, and the Cultures of Greater Mexico.* Durham: Duke UP, 2011.

Saldívar, Ramón. *The Borderlands of Culture: Américo Paredes and the Transnational Imaginary.* Durham: Duke UP, 2006.

Saldívar-Hull, Sonia. *Feminism on the Borderlands: Chicana Gender Politics and Literature.* Berkeley: U of California P, 2000.

Saluny, Susan. "A Defiant Herman Cain Suspends His Bid for Presidency." *New York Times,* 3 Dec. 2011. Web. 4 Dec. 2011. http://www.nytimes.com/2011/12/04/us/politics /herman-cain-suspends-his-presidential-campaign.html?pagewanted=all.

Sampson, H. "Transnational Drifters or Hyperspace Dwellers: An Exploration of the Lives of Filipino Seafarers Aboard and Ashore." *Ethnic and Racial Studies* 26.2 (2003): 253–277. doi:http://dx.doi.org/10.1080/0141987032000054420.

Sampson, H., and T. Schroeder. "In the Wake of the Wave: Globalization, Networks, and

the Experiences of Transmigrant Seafarers in Northern Germany." *Global Networks* 6.2 (2006): 61–80. doi:10.1111/j.1471-0374.2006.00133.x.

Sampson, H., and M. Zhao. "Multilingual Crews: Communication and the Operation of Ships." *World Englishes* 22.1 (2003): 31–43. doi:10.1111/1467-971X.00270.

Sánchez, George J. *Becoming Mexican American: Ethnicity, Culture, and Identity in Chicano Los Angeles, 1900–1945.* New York: Oxford UP, 1995.

Sanchez, Hector E., Andrea L. Delgado, and Rosa G. Saavedra. "Latino Workers in the United States 2011." *Labor Council for Latin American Advancement*, April 2011. Web. 7 July 2017. http://latinosforasecureretirement.org/resources/LCLAA_Report .pdf.

Sánchez, Marta. *Fathering within and beyond the Failures of the State with Imagination, Work and Love: The Case of the Mexican Father.* Rotterdam: Sense, 2017.

Sánchez López, Jorge Francisco. *La construcción simbólica del paisaje urbano: La disputa por la significación del grafitti en Tijuana.* Master's thesis. Tijuana: COLEF, 2010.

Sandoval, Anna Marie. *Toward a Latina Feminism of the Americas: Repression and Resistance in Chicana and Mexicana Literature.* Austin: U of Texas P, 2008.

Sandoval, Chela. *Methodology of the Oppressed.* Minneapolis: U of Minnesota P, 2000.

San Miguel, Guadalupe, Jr. *"Brown, not White": School Integration and the Chicano Movement in Houston.* College Station: Texas A&M UP, 2001.

Sarck Har. Personal interview. 14 Oct. 2013.

———. Personal interview. 24 Oct. 2014.

———. Personal interview. 1 Aug. 2015.

Sargent, Antwaun. "7 Artists Hit the High Seas for a Shipping Container Artist Residency." *Creators Project*, 23 Feb. 2016. Web. 3 March 2016. http://thecreatorsproject.vice .com/blog/shipping-container-artist-residency.

Sassen, Saskia. *Expulsions: Brutality and Complexity in the Global Economy.* Kindle ed. Cambridge: Harvard UP, 2014.

———. "Global Cities and Survival Circuits." *Global Woman: Nannies, Maids, and Sex Workers in the New Economy.* Ed. Barbara Ehrenreich and Arlie Russel Hochschild. New York: Holt, 2002. 254–274.

———. "The Global City: Introducing a Concept." *Brown Journal of World Affairs* 11.2 (2005): 27–41. Web. 7 July 2017. http://www.saskiasassen.com/pdfs/publications/the -global-city-brown.pdf.

———. *Globalization and Its Discontents.* New York: New York Press, 1998.

———. "The Language of Expulsion." *Truthout*, 30 July 2014. Web. 25 May 2017. http:// www.truthout.org/opinion/item/25235-the-language-of-expulsion.

———. "Nomadic Territories and Times." 2014. Web. 5 Aug. 2015. http://www .saskiasassen.com/PDFs/publications/nomadic-territories-and-times.pdf.

———. "Regulating Immigration in a Global Age: A New Policy Landscape." *Parallax* 11.1 (2005): 35–45.

———. "A Savage Sorting of Winners and Losers: Contemporary Versions of Primitive Accumulation." *Globalizations* 7.1 (2010): 23–50. doi:http://dx.doi.org/10.1080 /14747731003593091.

———. "Weaponized Fences and Novel Borderings: The Beginning of a New History?" Forward to *Beyond La Frontera: The History of Mexico-U.S. Migration.* New York: Oxford UP, 2011.

———. "Women's Burden: Counter-Geographies of Globalization and the Feminization of Survival." *Journal of International Affairs* 53.2 (2000): 503–524. JSTOR. Web. 7 July 2017. http://www.jstor.org/stable/24357763.

Saucier, P. Khalil, and Tyron P. Woods. "Hip Hop Studies in Black." *Journal of Popular Music Studies* 26.2–3 (2014): 268–294. doi:10.1111/jpms.12077.

Schloss, Joseph G. *Making Beats: The Art of Sample-Based Hip Hop*. Middletown: Wesleyan UP, 2004.

Schmelling, Michael, Kelefa Sanneh, and Will Welch. *Atlanta: Hip Hop and the South*. San Francisco: Chronicle, 2010.

Schmidt, Bettina E. "The Many Voices of Caribbean Culture in New York City." *Constructing Vernacular Culture in The Trans-Caribbean*. Ed. Holger Henke and Karl-Heinz Magister. Lanham: Rowman, 2007. 23–37.

Schmidt Camacho, Alicia. *Migrant Imaginaries: Latino Cultural Politics in the U.S.-Mexico Borderlands*. New York: New York UP, 2008.

Schoenauer-Alvaro, Iris. *Mexican Hometown Associations in the US: Migrants as Emerging Actors in Development*. Münich: GRIN, 2008.

Schonfeld, Roger, and Mariët Westermann. "The Andrew W. Mellon Foundation Art Museum Staff Demographic Survey." 28 July 2015. Web. 12 Jan. 2019. https://mellon .org/media/filer_public/ba/99/ba99e53a-48d5-4038-80e1-66f9ba1c020e/awmf _museum_diversity_report_aamd_7-28-15.pdf.

Schoolman, Morton, and Alvin Magid. *Reindustrializing New York State: Strategies, Implications, Challenges*. Albany: SUNY P, 1986.

Schreiber, Rebecca. *The Undocumented Everyday: Migrant Lives and the Politics of Visibility*. Minneapolis: U of Minnesota, 2018.

Schulman, Amy, and Scarlett Lindeman. "The 16 Best Mexican Spots in NYC." *Thrillist .com*, 23 Apr. 2018. Web. 12 Jan. 2019. https://www.thrillist.com/eat/new-york/best -mexican-in-nyc.

Schultheis, Emily. "Under Cain, NRA Launched Sex Harassment Fight." *Politico*, 5 Nov. 2011. Web. 27 Nov. 2011. http://dyn.politico.com/printstory.cfm?uuid =C7AB4A22-78B5-4ABF-AEB1-8AF29CFEF39D.

Segura, Denise A., and Patricia Zavella, eds. *Women and Migration in the U.S.-Mexico Borderlands: A Reader*. Durham: Duke UP, 2007.

Semple, Kirk. "Amid Joblessness, Mexican Workers Are a Steady Force." *New York Times*, 23 Sept. 2010, A27.

———. "Immigrants Face Darkest Housing Picture." *New York Times*, 29 Mar. 2011. Web. 30 July 2015. http://www.nytimes.com/2011/03/30/nyregion/30mexicans.html.

———. "Immigrant in Run for Mayor, Back Home in Mexico." *New York Times*, 1 June 2010. Web. 7 Sept. 2019. https://www.nytimes.com/2010/06/02/nyregion /02mexican.html.

———. "When the Kitchen Is Also a Bedroom." *New York Times*, 29 Feb. 2016. Web. 30 Feb. 2016. https://www.nytimes.com/2016/03/01/nyregion/overcrowding-worsens-in -new-york-as-working-families-double-up.html.

Semuels, Alana. "Why So Few American Economists Are Studying Inequality." *The Atlantic*, 13 Sept. 2016. Web. 18 Sept. 2016. www.theatlantic.com/business/archive/2016 /09/why-so-few-american-economists-are-studying-inequality/499253/.

Sen, Rinku. "Back of the House, Front of the House: What a Campaign to Organize New York Restaurant Workers Tells Us about Immigrant Integration." *National Civic Review* 10.1002 (2009): 43–51.

Sen, Rinku, with Fekkak Mamadough. *The Accidental American: Immigration and Citizenship in the Age of Globalization*. San Francisco: Berrett-Koehler, 2008.

Sevcenko, Liz. "Making Loisaida: Placing Puertorriqueñidad in Lower Manhattan."

Mambo Montage: The Latinization of New York. Ed. Agustin Laos-Montes and Arlene Davila. New York: Columbia UP, 2001. 293–317.

Seyfu Hinds, Selwyn. *Gunshots in My Cook-up: Bits and Bites from a Hip Hop Caribbean Life*. New York: Atria, 2002.

Shah, Nayan. *Stranger Intimacy: Contesting Race, Sexuality, and the Law in the North American West*. Berkeley: U of California P, 2011.

"A Shameful Round-Up of Refugees." *New York Times*, 1 Aug. 2016. Web. 21 Sept. 2016. www.nytimes.com/2016/01/08/opinion/a-shameful-round-up-of-refugees.html?_r=0.

Shams, Alex. "'Obama Built the Structures for Trump': A Terrifying Legacy of Mass Deportation." *Truthout*, 16 Oct. 2016. Web. 22 Jan. 2017. www.truth-out.org/news/item/38007-obama-built-the-structures-for-trump-a-terrifying-legacy-of-mass-deportation.

Sharma, Nitasha Tamar. *Hip Hop Desis: South Asian Americans, Blackness, and a Global Race Consciousness*. Durham: Duke UP, 2010.

Sharman, Russell Leigh. *The Tenants of East Harlem*. Berkeley: U of California P, 2006.

Shaw, Rosalind. *Memories of the Slave Trade: Ritual and the Historical Imagination in Sierra Leone*. Chicago: University of Chicago Press, 2002.

Shaw, William. *Westside: The Coast-to-Coast Explosion of Hip Hop*. New York: Cooper Square, 2002.

Sheridan, Lynnaire M. *"I Know It's Dangerous": Why Mexicans Risk Their Lives to Cross the Border*. Tucson: U of Arizona P, 2009.

"Shipping Container Gardens among Solutions Discussed at Urban Ag Summit." *AFP Magazine*, 31 Oct. 2015. Web. 11 Oct. 2016. http://augustafreepress.com/shipping-container-gardens-among-solutions-discussed-at-urban-ag-summit/.

Short, Doug. "Charting the Incredible Shift from Manufacturing to Services in America." *Business Insider*, 5 Sept. 2011. Web. 15 Dec. 2012. http://www.businessinsider.com/charting-the-incredible-shift-from-manufacturing-to-services-in-america-2011-9.

Shrestha, Shailsesh. Personal interview. 14 Oct. 2011.

Siemerling, Winfried. *The Black Atlantic Reconsidered: Black Canadian Writing, Cultural History and the Presence of the Past*. Montreal: McGill-Queen's UP, 2015.

Simon, Jonathan. "Refugees in a Carceral Age: The Rebirth of Immigration Prisons in the United States." *Public Culture* 10.3 (1998): 577–607.

Simonett, Helena. *Banda: Mexican Musical Life across Borders*. Middletown: Wesleyan UP, 2001.

Sisk, Christina. *Mexico, Nation in Transit: Contemporary Representations of Mexican Migration to the United States*. Tucson: U of Arizona P, 2011.

Smallwood, Stephanie. *Saltwater Slavery: A Middle Passage from Africa to American Diaspora*. Cambridge: Harvard UP, 2007.

Smith, Michael Peter, and Micahel MacQuarrie, eds. *Remaking Urban Citizenship: Organizations, Institutions and the Right to the City*. New Brunswick: Transaction, 2012.

Smith, Robert C. *Mexican New York: Transnational Lives of New Immigrants*. Berkeley: U of California P, 2005.

———. "'Mexicanness' in New York: Migrants Seek New Place in Old Racial Order." *NACLA Report on the Americas* 35.2 (2001): 14–17.

———. "Mexicans: Civic Engagement, Education, and Progress Achieved and Inhibited." *One Out of Three: Immigrant New York in the 21st Century*. New York: Columbia UP, 2013. 246–265.

———. "Racialization and Mexicans in New York City." *New Destinations: Mexican Immigration in the United States*. Ed. Víctor Zúñiga and Rubén Hernández-León. New York: Russell Sage Foundation, 2005. 220–243.

Smyth, Araby. "Mexican Hometown Associations in New York City: A Study of Transnational Solidarity." MA thesis, Hunter College, 2015.

Snodgrass, Michael. "The Bracero Program, 1942–1964." *Beyond the Border: The History of Mexican-U.S. Migration*. Ed. Mark Overmyer-Velásquez. New York: Oxford UP, 2011. 79–102.

Solís, Jocelyn. "Immigration Status and Identity: Undocumented Mexicans in New York." *Mambo Montage: The Latinization of New York*. Ed. Agustin Laos-Montes and Arlene Davila. New York: Columbia UP, 2001. 337–362.

———. "Re-thinking Illegality as a Violence *against* not *by* Mexican Immigrants, Children, and Youth." *Journal of Social Issues* 59.1 (2003): 15–31. doi:10.1111/1540-4560.00002.

———. "The (Trans)formation of Illegality as an Identity: A Study of the Organization of Undocumented Mexican Immigrants and Their Children in New York City." PhD thesis, City University of New York, 2002.

Solís, Jocelyn, and Liliana Rivera-Sánchez. "Recovering the Forgotten: The Effects of September 11 on Undocumented Latin American Victims and Families." *Canadian Journal of Latin American and Caribbean Studies / Revue canadienne des études latino-américaines et caraïbes*. 29.57–58 (2004): 93–115.

Solorzano-Thompson, Nohemy. *Act Like a Man: Portrayals of Lower-Class Mexican and Chicano Masculinity, 1950–2000*. Ithaca: Cornell U, 2003.

Soriano-Castillo, Eduardo. "Nationwide Actions Shame Wage-Stealing Bosses." *Labor Notes*, 19 Nov. 2010. Web. 7 July 2017. http://labornotes.org/blogs/2010/11/nationwide-actions-shame-wage-stealing-bosses/.

Sorick. Personal interview. 2 Nov. 2013.

Spark-Smith, Laura. "68 Migrants Found Locked in Containers at UK Port." *CNN.com*, 5 June 2015. Web. 14 July 2017. http://www.cnn.com/2015/06/05/europe/uk-migrants-containers/.

Standish, Katherine, Vijay Nandi, Danielle C. Ompad, Sandra Momper, and Sandro Galea. "Household Density among Undocumented Mexican Immigrants in New York City." *Journal of Immigrant Minority Health* 12.3 (2010): 310–318.

Stepler, Renee, and Anna Brown. "Statistical Portrait of Hispanics in the United States." *Pew Research Center*, 19 Apr. 2016. Web. 21 Sept. 2016. www.pewhispanic.org/2016/04/19/statistical-portrait-of-hispanics-in-the-united-states-key-charts/#share-mexican-origin.

Stevenson, Deborah. *The City*. Cambridge: Polity, 2013.

Swiss, Thomas, John Sloop, and Andrew Herman, eds. *Mapping the Beat: Popular Music and Contemporary Theory*. Malden: Blackwell, 1998.

Tellez, Edward, and Vilma Ortiz. *Generations of Exclusion: Mexican Americans, Assimilation, and Race*. New York: Russell Sage Foundation, 2008.

Thabit, Walter. *How East New York Became a Ghetto*. New York: New York UP, 2003.

Thompson, Krissah, and Aaron C. Davis. "Cain Was Known for Casual Style with Staff at Association." *Washington Post*, 11 Nov. 2011. Web. 4 Dec. 2011. http://www.washingtonpost.com/politics/cain-was-known-for-casual-style-with-staff-at-association/2011/11/10/gIQAdRBy9M_story.html.

Tickner, Arlene. "Aquí en el Ghetto: Hip-hop in Colombia, Cuba and Mexico." *Latin American Politics and Society* 50.4 (2008): 121–146. doi:10.1111/j.1548-2456.2008.00024.x.

Tinajero, Robert. "Black and Brown in Hip Hop: Tenuous-Solidarity." *La Verdad: The International Reader of Hip Hop Latinidades.* Ed. M. Castillo-Garsow and Jason Nichols. Columbus: Ohio State UP, 2016. 17–40.

Tobar, Hector. "Hollywood's Obsession with Cartels." *New York Times,* 5 Jan. 2019. Web. 12 Jan. 2019. https://www.nytimes.com/2019/01/05/opinion/sunday/latinos-cartels-trump-narcos-hollywood.html.

Tölölyan, Khachig. "The Contemporary Discourse of Diaspora Studies." *Comparative Studies of South Asia, Africa and the Middle East* 27.3 (2007): 647–655.

Tomich, Dale W., ed. *The Politics of the Second Slavery.* Albany: SUNY P, 2016.

Toohey, David E. *Borderlands Media: Cinema and Literature as Opposition to the Oppression of Immigrants.* Lanham: Lexington, 2012.

The Trans-Atlantic Slave Trade Database. Emory U, 2013. Web. 21 Sept. 2016. www.slavevoyages.org/about/history.

Trebay, Guy. "Frida Kahlo Is Having a Moment." *New York Times,* 8 May 2015. Web. 25 May 2017. https://www.nytimes.com/2015/05/10/style/frida-kahlo-is-having-a-moment.html.

Trejo, Enrique. Personal interview. 12 Apr. 2011.

Treschan, Lazar, and Apurva Mehrotra. *Young Mexican Americans in New York City: Working More, Learning and Earning Less.* New York: Community Service Society of New York, 2013. Web. 5 Jan. 2019. http://www.cssny.org/publications/entry/young-mexican-americans-in-new-york-city.

Tsui, Bonnie. "Making Art on the Open Seas." *New York Times Magazine,* 15 Jan. 2016. Web. 25 Jan. 2016. http://nyti.ms/1RSZJKq.

Turino, Thomas, and James Lea, eds. *Identity and the Arts in Diaspora Communities.* Warren: Harmonie Park, 2004.

Tyree, Omar. "I Don't Know Herman Cain." *Huffington Post,* 23 Nov. 2011. Web. 4 Dec. 2011. http://www.huffingtonpost.com/omar-tyree/herman-cain-2012_b_1108540.html.

United States Department of Justice. "CRIPA Investigation of the New York City Department of Correction Jails on Rikers Island." 4 Aug. 2014 Web. 25 May 2017. https://www.nytimes.com/interactive/2014/08/05/nyregion/05rikers-report.html?_r=0.

United States Department of Labor. "Minimum Wages for Tipped Employees." 1 Jan. 2012. Web. 8 Dec. 2012. http://www.dol.gov/whd/state/tipped.htm.

Upadhaya, Kayla Kumari. "Hit Restaurant Alleges NYPD Arrested Undocumented Immigrant Owner without Cause." 15 Jan. 2019. Web. 20 Jan. 2019. https://ny.eater.com/2019/1/15/18182318/la-morada-nypd-immigration-raid-south-bronx.

Vaca, Nicolás C. *The Presumed Alliance: The Unspoken Conflict between Latinos and Blacks and What It Means for America.* New York: Harper, 2004.

Valdez, Sulema. *The New Entrepreneurs: How Race, Class, and Gender Shape American Enterprise.* Stanford: Stanford UP, 2011.

Valdivia, Angharad N., and Matthew Garcia, eds. *Mapping Latina/o Studies: An Interdisciplinary Reader.* New York: Peter Lang, 2012.

Valenzuela Arce, José Manuel. *Nosotros: Arte, cultura e identidad en la frontera México-Estados Unidos.* Mexico City: Conaculta, 2012.

Valle, Imuris and Eduardo Weiss. "Participation in the Figured World of Graffiti." *Teaching and Teacher Education.* 26.1 (2010): 128–135.

Vampiro. Personal interview. 24 Oct. 2014.

Vazquez, Alexandra. *Listening in Detail: Performances of Cuban Music.* Durham: Duke UP, 2013.

Verdaguer, María Eugenia. *Class, Ethnicity, Gender and Latino Entrepreneurship.* New York: Routledge, 2009.

Versos. Personal interview. 19 Oct. 2013.

Viesca, Victor Hugo. "The Battle of Los Angeles: The Cultural Politics of Chicana/o Music in the Greater Eastside." *American Quarterly* 56.3 (2004): 719–739.

Vivancos Pérez, Ricardo F. *Radical Chicana Poetics.* New York: Palgrave, 2013.

Wai Jim, Alice Ming. "The Vancouver Container." *Leonardo* 39.4 (2006): 297–298.

Wald, Elijah. *Narcocorrido: A Journey into the Music of Drugs, Guns and Guerrillas.* New York: Harper, 2001.

Waldinger, Roger. *Still the Promised City?* Cambridge: Harvard UP, 1996.

Walsh, Kevin J. "The Port of New York and New Jersey, a Critical Hub of Global Commerce." *Forbes,* 25 Oct. 2011. Web. 18 Oct. 2016. http://www.forbes.com/sites /gcaptain/2011/10/25/the-port-of-new-york-and-new-jersey-a-critical-hub-of-global -commerce/#44a8c11b6fee.

Walsh, Robert. "Illegal Immigrants in the Restaurant Industry: Mexican Immigrant Hugo Ortega Went from Washing Dishes to Owning Houston's Best Mexican Restaurant— Now He Has a Few Things to Say about Immigration." *Houston Press,* 20 Dec. 2007. Web. 27 Nov. 2011. http://www.houstonpress.com/content/printVersion/674988/.

Walters, William. "Bordering the Sea: Shipping Industries and the Policing of Stowaways." *Borderlands* 7.3 (2008). Web. http://www.borderlands.net.au/vol7no3_2008/walters _bordering.pdf.

Warren, Robert, and Donald Kerwin. "The 2,000 Mile Wall in Search of a Purpose: Since 2007 Visa Overstays Have Outnumbered Undocumented Border Crossers by a Half Million." *Journal on Migration and Human Security* 5.1 (2017): 124–136.

Washington Post Staff. "Full Text: Donald Trump Announces a Presidential Bid." *Washington Post,* 16 June 2015. Web. 10 Sept. 2015. http://www.washingtonpost .com/news/post-politics/wp/2015/06/16/full-text-donald-trump-announces-a -presidential-bid/#.

Watkins, S. Craig. *Hip Hop Matters: Politics, Pop Culture, and the Struggle for the Soul of a Movement.* Boston: Beacon, 2005.

Weaver, Jace. *The Red Atlantic: American Indigenes and the Making of the Modern World, 1000–1927.* Chapel Hill: U of North Carolina P, 2014.

Welch, Michael. *Detained: Immigration Laws and the Expanding I.N.S. Jail Complex.* Philadelphia: Temple UP, 2002.

———. "The Role of the Immigration and Naturalization Service in the Prison-Industrial Complex." *Social Justice* 27.3 (2000): 73–88.

Wenk, Amy. "Chick-fil-A Plans Shipping Container Restaurant for SkyView Atlanta." *Biz Journals,* 16 Nov. 2015. Web. 18 Oct. 2016. http://www.bizjournals.com/atlanta/blog /peachtree-plate/2015/11/chick-fil-a-plans-shipping-container-restaurant.html.

West, James. "Former Models for the Agency Say They Violated Immigration Rules and Worked Illegally." *Mother Jones,* 30 Aug. 2016. Web. 12 Sept. 2016. www.motherjones .com/politics/2016/08/donald-trump-model-management-illegal-immigration.

Whalen, Carmen Teresa, and Victor Vázquez-Hernandez. *The Puerto Rican Diaspora: Historical Perspectives.* Philadelphia: Temple UP, 2005.

Whelan, Robbie. "Port of New York and New Jersey Saw Record Container Traffic in July." *Washington Journal,* 26 Aug. 2015. Web. 11 Oct. 2016. http://www.wsj.com/articles/port -of-new-york-and-new-jersey-saw-record-container-traffic-in-july-1440621964.

White, Miles. *From Jim Crow to Jay-Z: Race, Rap, and the Performance of Masculinity.* Chicago: U of Illinois, 2011.

Whiteley, Sheila, Andy Bennett, and Stan Hawkins, eds. *Music, Space and Place: Popular Music and Cultural Identity.* Hants: Ashgate, 2004.

Wicks, David, and Pat Bradshaw. "Investigating Gender and Organizational Culture: Gendered Value Foundations That Reproduce Discrimination and Inhibit Organizational Change." *Gender, Identity and the Culture of Organizations*. Ed. Iiris Aaltio and Albert J. Mills. London: Routledge, 2002. 137–159.

Williams, William. "Spring Start Eyed for Shipping Container Project in The Nations." *Nashville Post*, 5 Nov. 2015. Web. 11 Oct. 2016. http://www.nashvillepost.com/home /article/20486794/spring-start-eyed-for-shipping-container-project-in-the-nations.

Wilson, Mark. "A Budget Brewery Built From Shipping Containers." *CO.Design*, 23 Nov. 2015. Web. 11 Oct. 2016. https://www.fastcodesign.com/search?q=Mark%20 Wilson&author=mark-wilson&limit=10&offset=260.

Wilson, Thomas M., and Donnan Hastings. *A Companion to Border Studies*. Hoboken: Wiley, 2012.

Wise, Timothy. "Agricultural Dumping under NAFTA: Estimating the Costs of U.S. Agricultural Policies to Mexican Producers." *Woodrow Wilson International Center for Scholars*, 2010. Web. 22 May 2017. www.ase.tufts.edu/gdae/Pubs/rp /AgricDumpingWoodrowWilsonCenter.pdf.

Wishnie, Michael J. "Prohibiting the Employment of Unauthorized Immigrants: The Experiment Fails." *University of Chicago Legal Forum* 193 (2007). Web. 12 Dec. 2012. http://heinonline.org.

Wright, Anthony. "Herman Cain, the NRA, and Bill Clinton on Health Reform." *California Progress Report*, 9 Nov. 2011. Web. 27 Nov. 2011. http://www .californiaprogressreport.com/site/herman-cain-nra-and-bill-clinton-health-reform.

Yakupitiyage, Thanu. "Coalition and Partners Launch 'Black Immigrant Engagement Initiative' to Support and Uplift Black Immigrant Communities." *New York Immigration Coalition*, 2 May 2016. Web. 30 May 2016. http://www.thenyic.org/PR /BIEILaunch.

Yan, Holly, and Jason Morris. "San Antonio Driver Says He Didn't Know Immigrants Were in Truck." *CNN.com*, 25 July 2017. Web. 18 Sept. 2017. http://www.cnn.com/2017 /07/24/us/san-antonio-trailer-migrants/index.html.

Ybarra-Frausto, Tomás. "Imagining a More Expansive Narrative of American Art." *American Art* 19.3 (2005): 9–15.

———. "A Panorama of Latino Arts." *American Latinos and the Making of the United States*. National Park Service, n.d. Web. 25 July 2015. http://www.nps.gov/history /heritageinitiatives/latino/latinothemestudy/arts.htm.

———. "Rasquachismo: A Chicano Sensibility." *Chicano Art: Resistance and Affirmation (CARA)*. Los Angeles: Wright Art Gallery of the U of California-Los Angeles, 1990. 155–163.

Zayas, Luis H. *Forgotten Citizens: Deportation, Children, and the Making of American Exiles and Orphans*. New York: Oxford UP, 2015.

Zayas, Luis H., Sergio Aguilar-Gaxiola, Hyunwoo Yoon, and Guillermina Natera Rey. "The Distress of Citizen-Children with Detained and Deported Parents." *Journal of Child and Family Studies* 24.11 (2015): 3213–3223.

Zhang, Ga. "The China Container." *Leonardo* 39.4 (2006): 291–295.

Zolberg, Aristide R. *A Nation by Design: Immigration Policy in the Fashioning of America*. Cambridge: Harvard UP, 2006.

Zolov, Eric. *Refried Elvis: The Rise of the Mexican Counterculture*. Berkeley: U of California P, 1999.

Zúñiga, Victor, and Rubén Hernández-León, eds. *New Destinations: Mexican Immigration in the United States*. New York: Russell Sage Foundation, 2005.

Discography

Bocafloja. *JazzyTurno*. 2006.
Hispanos Causando Pániko. *De Las Calles Para Las Calles* (forthcoming).
Hispanos Causando Pániko. Mixtape. 2007
Mauro Espinal. *Voluntad*. 2014.
T-Killa. *LP INKietud*. 2010.
T-Killa. *INKsanidad*. 2012.
Versos. *Osiris*. 2015.

Index

Page numbers in italics refer to figures.

Habell-Pallán, Michelle, 89
Hall, Stuart, 123
Hand that Feeds, 45, 68. *See also* López,
Mahoma
Harcourt, Bernard E., 172n5
Har'd Life Ink, xiii, *72*–81, *80,* 83–84,
86–93, 96–97, 117, 127–*128,* 142, 148–151,
160, 167; collective, 4, 26, 31, 76, 80, *90,*
92; location, *72,* 75, 79, 80, 91, *128*; tag,
22, 76. *See also* art collectives; arts
entrepreneurship; HAR-NYC;
Kortezua; Pisket; Sarck; Sorick
HAR-NYC, 71, 76, 78–79, 81, 83, 95, 98,
138, 145, 150–154, 167; Mexico roots, 76,
78, 81. *See also* Har'd Life Ink
Hecho en México (HEM), 83, 143. *See also*
graffiti
hermandad, vii, 32, 71, 76, 81, 168
Hernández, Kelly Lytle, 174n15, 174n20
Hernández, Raul "Meck", vi, ix, *xi,* 40, *110,*
112, 116–117, 122, 126, 164, 167. *See also*
Hispanos Causando Pániko
Hinojosa, Hugo Alberto, 138
hip-hop, ix–xiv, 1, 29, 101–106, 132–137,
141–143, 148–151, 158, 163–164, 187n35;
arts/ artist, xii–xii, 4, 10, 12, 116–117,
130–131, 133, 137; authenticity vii, 32, 101,
109–112, 114–117, 119, 123, 130, 137, 142,
169, 185n16, 186n22; Chicano, 102–103,
111–112, 114, 116, 119, 122, 127, 182n17,
185n11, 185n20, 186n24; chopper style,
121; collective, 4, 103, 111, 136; crew, 4, 31,
103, 125–126; culture, 31, 87, 106,
108–109, 115, 126, 130–132; en español, x,
77, 106, 109, 113, 122; four elements, 80,
109, 129, 148, 155, 158, 188n11, 188n13;
group, *xi,* 109, 112; history, 2, 104, 106,
108, 111, 119, 129–130, 132, 151, 158, 160,
184n7, 185n11, 188n13; in Latin America,
111, 185n17; Mexican, 29, 31–32, 77, 79,
98, 102, 106, 108–109, 111–128, 132–137,
141–143, 167, 185n11, 185n15, 185n18; in
Mexico, 31, 111, 117, 127, 133–135; in
Midwest, 118, 186n24; music, 31–33, 118,
122, 124, 130, 167, 186n22; in New York,
106–109, 111–130, 132–137, 142–143,
187n35; practice, 28, 87; Puerto Rican,
104, 117; sampling, 28, 118, 122, 150;
shows, 26, 72, *80*; in Southwest/ West

Coast, 103, 105, 107, 116, 117, 122, 127,
185n16, 185n20; space, 72, 79, 101–102,
105–106; studies, 104–105, 108, 169,
184n8, 185n9, 185n10, 185n17; transna-
tional, 87, 102, 105, 128, 132, 151, 185n15;
underground, 130, 169, 186n22; and
women, 12, 29, 77, 133–135, 182n7.
See also Chang, Jeff; Forman, Murray;
McFarland, Pancho; rap; Rivera,
Raquel
Hispanos Causando Pániko, ix, *xi*–xii, 4,
31, 40, 76, 107, 109–*110,* 113, 115–116, 121,
142
Homeland Security, 12, 107
hometown association, 80, 102, 125, 183n2
Hondagneu-Sotelo, Pierrette, 178n3
housing, 9, 22, 59, 74, 158, 187n3, 187n8

Ilich, Fran, 83
illegality, xv, 3, 29, 46, 77, 84–85, 155–156,
168, 172n4, 175n28, 183n19; and blackness,
21, 85; and criminalization, 75, 137, 156;
and graffiti, 144, 150–151, 153, 155, 160; and
Mexicans, 3, 13, 17, 21, 86, 107, 118–119,
123, 151, 155, 172n4, 175n23, 175n28,
183n19. *See also* detention; deportation;
New York Police Department (NYPD)
immigrant status, 62. *See also* DACA;
undocumented
Immigration and Customs Enforcement
(ICE), 12, 21
immigration enforcement, 18, 22, 76,
180n19
immigration policy, xii, 14, 18, 46, 50, 52,
174n15, 175nn22–23; Bracero Program,
75, 175n22, 177n40; in the 1920s, 17;
1986 Immigration Reform and Control
Act, 6, 10; Proposition 187, 20; SB1070,
20; 2006 Secure Fence Act, 15; under
Barack Obama, 12, 13, 64, 78, 174n17;
under Bill Clinton, 12, 13; under Donald
Trump, 12, 71, 137, 139, 144; under
George W. Bush, 12, 18. *See also*
deportation; detention
imperialism, 25, 172n7
INK, 31, 78, 87–88, 104, 127, 129, 131, 138,
153–154; *See also* Buendia BK; Har'd Life
Ink; T-Killa; Versos
International Monetary Fund, 26, 42

About the Author

MELISSA CASTILLO PLANAS is editor of the anthology *¡Manteca!: An Anthology of Afro-Latin@ Poets*, co-editor of *La Verdad: An International Dialogue on Hip Hop Latinidades*, author of the poetry collection *Coatlicue Eats the Apple*, and co-author of the novel *Pure Bronx*. She is an assistant professor of English at Lehman College.